THE SEARCH
FOR EUROPE
Contrasting Approaches

THE SEARCH FOR EUROPE
Contrasting Approaches

SUMMARY

THE UNRESOLVED LIMITS OF EUROPE AND THE NEW GLOBAL POWERS

BIBLIOGRAPHY

PROLOGUE

This book, *The Search for Europe*, is the eighth instalment in the annual series published by BBVA as part of its OpenMind project, an initiative dedicated to the dissemination of knowledge on the key issues of our time. Continuing our now consolidated editorial policy, we turned to leading experts around the world with different perspectives on the European question and asked them to provide a simple, straightforward exposition of their ideas that any layperson could understand. Once again, this year we were able to enlist the participation of twenty-three immensely prestigious authors, influencers of global opinion in their respective fields, proudly adding their names to the list of more than 150 individuals who have already written essays for our books. In short, our project is predicated on the originality, quality, and popular appeal of our authors' contributions, and I would therefore like to thank each and every one of them for generously agreeing to join our ambitious mission of spreading knowledge and contrasting ideas.

This project was launched in 2008, and since then it has experienced what can only be described as an extraordinary growth. Our books received a tremendous boost in terms of visibility and impact after 2011, when we created our online community OpenMind (www.bbvaopenmind.com), designed as a space for sharing knowledge.

In addition to all of the books we publish, OpenMind contains articles, interviews, videos, and infographs, all available in Spanish and English. In our constant quest to find fresh material and reach an increasingly wider audience, we have partnered with academic institutions and specialized publications of the highest calibre—such as the *MIT Tech Review* and the *Harvard Business Review*—as well as with leading online publications devoted to popularizing science and technology. By the end of 2015, some 1.3 million users will have read, commented on, debated, or downloaded our fully accessible contents free of charge.

The fundamental idea behind this project is a desire to help people understand the forces that are shaping our world and influencing—sometimes

quite obviously, and at other times in a much more subtle yet equally powerful way—our daily lives and future prospects. We firmly believe that the improvement of this understanding is important because it will allow us all to make better decisions, thereby expanding the horizons of our own lives and those of generations to come.

The last two books in the series were dedicated to analysing the impact of the technological revolution we are going through: the first focused on how it affects our daily lives, and the second examined its repercussions for companies and the way we work.

This year we have changed tack to offer an analysis of the present and future of Europe and its integration project.

This process has profound implications for our lives, affecting not just Europeans but every citizen of the world, because Europe, as a whole, is still the world's first economic and trade power—and, perhaps more importantly, because it is the most ambitious economic and political integration project ever attempted in the history of humanity, setting an example for similar processes in other regions.

THE FUNDAMENTAL IDEA THAT FUELS THIS PROJECT IS A DESIRE TO HELP PEOPLE UNDERSTAND THE FORCES THAT ARE SHAPING OUR WORLD

Since the first steps were taken in the 1950s, the process has experienced five decades of success. Proof of this success is the expansion from six original founding members to the current total of twenty-eight—with over a dozen more seeking to join—and the European Union's evolution from a free trade zone to a full monetary union by the late 1990s.

For five decades, European integration has been a driving force of economic growth in the region and has clearly helped to strengthen the institutions of the countries that have joined the process along the way, many of which were newly-fledged democracies still struggling to find their footing.

This astonishing growth spurt has had its share of problems and disparities. However, the key to this success is undoubtedly the fact that, when faced with any major crisis, the European Union has always stepped up to the plate, tackling difficulties by strengthening the ties between its members.

At this time, the European integration process is facing the impact of the economic and financial crisis that began eight years ago now. The crisis has had a very negative effect on growth throughout the area, though some

member states have been hit harder than others, and it has highlighted the flaws and weaknesses in the present stage of the European integration process, principal among them the fact that a monetary union was created without a banking union or appropriate mechanisms to ensure the compatibility of the member states' respective economic policies. In addition, the monetary union has divided the EU into countries with a common currency and countries outside the Eurozone, further complicating the already difficult task of the European Union's governance. Yet undoubtedly the area's most serious shortcoming is the relatively low level of political integration compared to the strides made on the economic front. This has created an imbalance between the democratic processes for electing national leaders, whose powers and scope of action are increasingly limited, and the much more distant—at least from the citizens' perspective—decision-making processes at the European level. These decisions, whose impact on the lives of ordinary citizens is growing day by day, are made in the course of relatively opaque negotiations among a large number of national governments and handled by a technocracy that does not have the direct support of the electorate.

As has occurred in the past, the latest crisis acted as a powerful catalyst for further European integration, particularly with regard to achieving a banking union and coordinating national economic policies. However, these steps are being taken in a context marked by the conflicting interests of countries that want to take the process to the next level and those reluctant or unwilling to yield greater sovereignty to supranational institutions. Meanwhile, social tensions and nationalistic attitudes are on the rise in different member states, and until the Union solves its current internal problems, it has little chance of overcoming the increasing difficulties of attending to other countries that aspire to EU or Eurozone membership.

Finally, the EU now finds itself involved in an escalation of geopolitical tensions in neighbouring regions: the biggest concern is Russia, which is highly suspicious of the EU's influence on former Soviet countries; but we must also keep a close eye on the Middle East and North Africa, where wars and political instability are creating intense migratory pressure and a rising tide of refugees. All of this has exposed yet another shortcoming of the European Union: the lack of a truly common foreign policy.

These are the central themes addressed in this book, which is divided into three sections:

In the first, "The Economic Foundations of the European Project", the authors review Europe's current economic situation and outlook and propose

different alternatives in the area of economic policy and institutional re-form for getting Europe back on the track of sustained growth and job creation, essential ingredients for the project's economic, political, and social success.

The second section, "Europe and Its Nations: Politics, Society and Culture", examines the problems inherent in the political coordination of the European supranational project with current national realities, and discusses what can be done to help citizens identify more with that project. The perception of Europe as a truly democratic space where citizens can make themselves heard, the future of social welfare policies, and the construction of a framework based on shared "European" values where people of different cultures can live side by side in harmony are just some of the topics addressed in this part of the book.

Finally, the third section, entitled "The Unresolved Limits of Europe and the New Global Powers", broaches questions related to Europe's external borders and geopolitics: which countries will or will not become members in the future, and what are the principal challenges that European foreign policy faces, not only with regard to its closest neighbours but also to where Europe fits in the new global order now taking shape, as the economic and political power of emerging areas continues to grow.

Europe is such a broad and complex subject that, despite the length of this book and the wide variety of perspectives reflected in the essays it contains, there are clearly many relevant topics and valuable opinions which have not found their way into its pages. This is unavoidable, but it is not our intention to be exhaustive; we have merely aimed to convey the ideas and proposals of some of today's finest thinkers and analysts, which we hope will encourage others to study the issues in greater depth and compare and contrast these ideas with other viewpoints. In short, our goal—in keeping with the OpenMind motto, "Sharing knowledge for a better future"—is to spark a debate, which we will continue to fuel on our OpenMind website, in order to help our readers learn about and understand the key aspects of our reality as European and/or global citizens and enable them to make wiser decisions. It is my sincere hope and desire that our readers and users will learn from and enjoy this book as much as we have in the process of compiling and publishing it.

Francisco González
BBVA Chairman & CEO

THE ECONOMIC FOUNDATIONS OF THE EUROPEAN PROJECT

ECONOMIC IMPACT OF THE CRISIS

EUROZONE GDP

In millions of euros and 2008-2014 variation rates (in percentages)

2014 variations
2008 +% -%

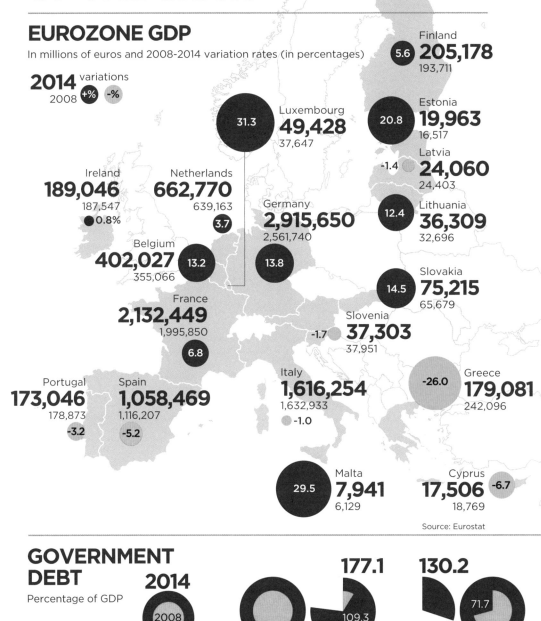

Finland 5.6 **205,178** 193,711

Luxembourg 31.3 **49,428** 37,647

Estonia 20.8 **19,963** 16,517

Latvia -1.4 **24,060** 24,403

Ireland **189,046** 187,547 ●0.8%

Netherlands **662,770** 639,163 3.7

Germany **2,915,650** 2,561,740 13.8

Lithuania 12.4 **36,309** 32,696

Belgium **402,027** 13.2 355,066

France **2,132,449** 1,995,850 6.8

Slovakia 14.5 **75,215** 65,679

Slovenia -1.7 **37,303** 37,951

Portugal **173,046** 178,873 -3.2

Spain **1,058,469** 1,116,207 -5.2

Italy **1,616,254** 1,632,933 ●-1.0

Greece -26.0 **179,081** 242,096

Malta 29.5 **7,941** 6,129

Cyprus **17,506** -6.7 18,769

Source: Eurostat

GOVERNMENT DEBT

Percentage of GDP

2014
2008

177.1 / 109.3
Greece

130.2 / 71.7
Portugal

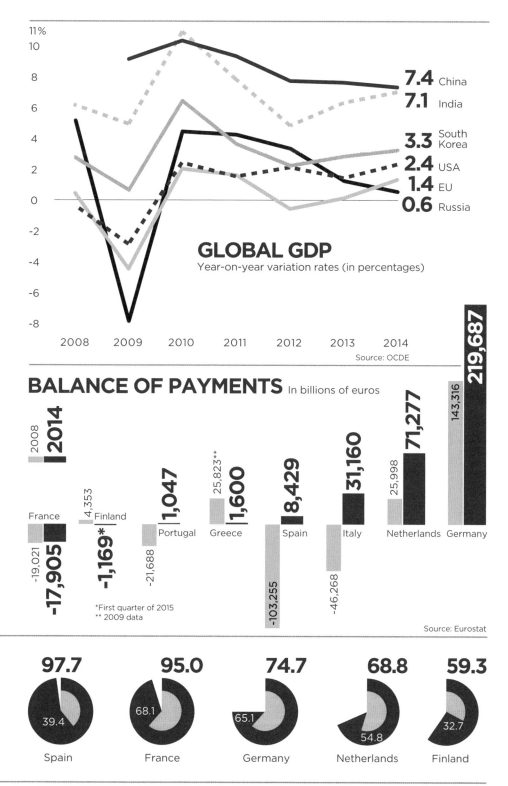

GLOBAL GDP
Year-on-year variation rates (in percentages)

7.4 China
7.1 India
3.3 South Korea
2.4 USA
1.4 EU
0.6 Russia

Source: OCDE

BALANCE OF PAYMENTS In billions of euros

2008 **2014**

France −19,021 **−17,905**

Finland 4,353 **−1,169***

Portugal −21,688 **1,047**

Greece 25,823** **1,600**

Spain −103,255 **8,429**

Italy −46,268 **31,160**

Netherlands 25,998 **71,277**

Germany 143,316 **219,687**

*First quarter of 2015
** 2009 data

Source: Eurostat

97.7 Spain 39.4
95.0 France 68.1
74.7 Germany 65.1
68.8 Netherlands 54.8
59.3 Finland 32.7

Source: Eurostat

UNEMPLOYMENT

UNEMPLOYMENT RATES

Percentage

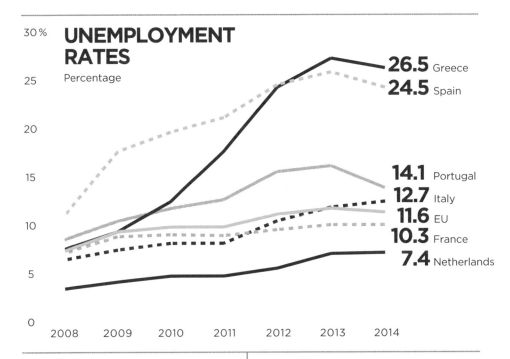

30%

25

20

15

10

5

0

26.5 Greece
24.5 Spain
14.1 Portugal
12.7 Italy
11.6 EU
10.3 France
7.4 Netherlands

2008 2009 2010 2011 2012 2013 2014

YOUTH UNEMPLOYMENT

Percentage of people under 25 (2015)

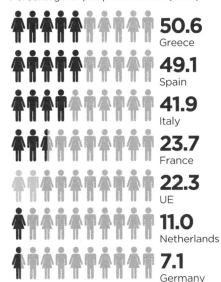

50.6 Greece
49.1 Spain
41.9 Italy
23.7 France
22.3 UE
11.0 Netherlands
7.1 Germany

LONG-TERM UNEMPLOYMENT

Percentage of persons unemployed for the last 12 months or longer

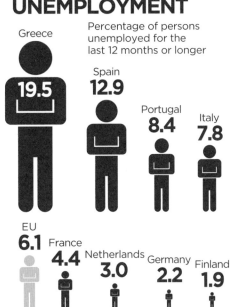

Greece **19.5**
Spain **12.9**
Portugal **8.4**
Italy **7.8**
EU **6.1**
France **4.4**
Netherlands **3.0**
Germany **2.2**
Finland **1.9**

Source: Eurostat

POVERTY & SOCIAL EXCLUSION

PEOPLE AT RISK OF POVERTY AFTER SOCIAL TRANSFERS

Percentage (2013)

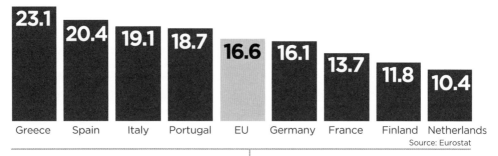

Greece	Spain	Italy	Portugal	EU	Germany	France	Finland	Netherlands
23.1	20.4	19.1	18.7	16.6	16.1	13.7	11.8	10.4

Source: Eurostat

VARIATIONS IN DISPOSABLE HOUSEHOLD INCOME

Percentage (2015)

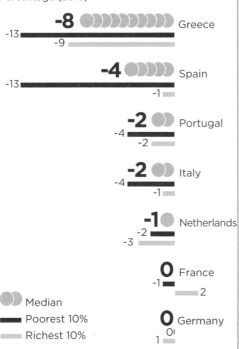

-8 Greece
-13
-9

-4 Spain
-13
-1

-2 Portugal
-4
-2

-2 Italy
-4
-1

-1 Netherlands
-2
-3

0 France
-1
2

●● Median
━━ Poorest 10%
▬▬ Richest 10%

0 Germany
0
1

Source: OCDE

INCOME INEQUALITY

Gini coefficient (2013) Scale of 0 to 100
Where 0 = perfect equality
(everyone has the same income)
and 100 = perfect inequality (one has
all the income and the rest have none)

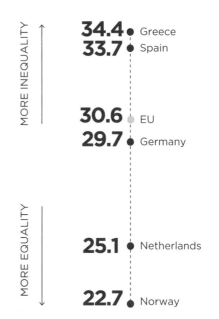

MORE INEQUALITY

34.4 Greece
33.7 Spain

30.6 EU
29.7 Germany

MORE EQUALITY

25.1 Netherlands

22.7 Norway

Source: Eurostat

FRANCISCO GONZÁLEZ, Chairman & CEO of BBVA, graduated from the UCM in Economics and Business Science. Prior to the merger between Banco Bilbao Vizcaya and Argentaria, he was chairman of Argentaria, where he spearheaded the integration, transformation, and privatization of a group of state-owned banks. He sits on the board of directors of the Institute for International Finance and the TransAtlantic Business Dialogue. He is a member of the European Financial Services Round Table, the Institut International d'Études Bancaires, and the International Advisory Committee of the Federal Reserve of New York, and he is Vice-Chairman of The Conference Board.

This article reviews the specific factors that are hindering growth in Europe. It concludes that a more efficient banking system is a structural reform that would facilitate better resource allocation, reduce the cost of capital, and improve the transmission of monetary policy. Only through technological advances can productivity in banking be improved. As an example, the article illustrates the process towards the digital banking of tomorrow, based on BBVA's own experience, and underscores the need for sweeping changes in the industry's regulatory framework to guarantee its stability and protect consumers while also capitalizing on the vast potential of technology.

EUROPE, BETWEEN STAGNATION AND TECHNOLOGICAL REVOLUTION: DIGITAL BANKING AS A DRIVER OF ECONOMIC GROWTH

Today, European banking institutions face tremendous uncertainty in the medium and long term, a situation that challenges the very foundations of their current business model.

The sources of that uncertainty are several and diverse, but in all of them we find, in addition to specifically European elements, factors which, though often the most important, have a global scope that makes them much more difficult to control.

The first is a puzzling macroeconomic scenario, characterized by very modest growth (at least compared to other post-crisis recovery periods), very low—and, in many countries, negative—inflation, and interest rates close to zero (negative rates, in real terms). Diverse explanations have been given for this situation, each with very different implications for the future of the European economy and, by extension, of the financial system.

THE RADICAL TRANSFORMATION OF THE BANKING INDUSTRY AND THE SOCIAL CHANGES IT ENTAILS WILL ULTIMATELY BE TRIGGERED BY TECHNOLOGICAL PROGRESS

The second factor of uncertainty is the drastic and as yet unfinished overhaul of the regulatory framework of banks. The new regulations are and will be much stricter, with higher capital and liquidity requirements and more rigorous measures to ensure transparency and consumer protection. This process of tightening regulations is a worldwide phenomenon, but in Europe it will have particularities linked to the development of a European banking union.

Technological change is the third source of uncertainty and undoubtedly the most important in the long term, given its formidable potential to disrupt financial institutions across the globe. However, its effects should be felt earlier and stronger in developed societies such as Europe, which are technologically more advanced and where consumer demands and habits are changing more rapidly.

In the following pages, I will briefly review these major factors that are spurring the banking system to make a drastic change. I will also defend my conviction that the radical transformation of the industry will ultimately be triggered by technological progress and the social changes it entails. Next, I will draw on BBVA's experience to briefly illustrate the nature of the change that financial institutions must make in order to survive and prosper in the new banking industry that is now taking shape. The article concludes with a commentary on the need for a parallel transformation of the industry's regulatory framework, creating a regime that guarantees financial and macroeconomic stability and adequate protection for consumers while also making the most of technology's tremendous potential to build a much more efficient and productive banking system, one that will improve the wellbeing of ordinary people and stimulate productivity and growth in the medium and long term.

The Global Economy in Uncharted Territory

Global economic trends in recent years, especially those of developed countries and, within that group, of Europe, have raised a number of increasingly complicated questions.

The financial crisis initiated eight years of ultra-expansionary monetary policies, led by the United States and later adopted by Europe and Japan. For eight years now, real short-term interest rates have hovered close to zero and even dipped into negative numbers. Despite these policies, economic recovery in the wake of the recession is weak, especially in Europe.

The most striking fact is that the extraordinary global monetary expansion of the last several years has not produced noticeable inflationary tensions. Quite the contrary: in developed countries and at the global level, inflation is now lower than it has been for decades. Meanwhile, long-term interest rates show no sign of incipient inflationary pressure; even after government debt levels have soared, they remain surprisingly low.

All of this has sparked a heated debate among economists as to the reasons for this unusual pattern. The implications of the debate are very relevant, because the underlying causes of the phenomenon will determine its potential consequences, some of which bode ill for the future of the global economy. And, of course, the most suitable policies for recovering growth and avoiding new crises would differ depending on what caused the current situation.

In this controversy, one end of the spectrum of opinion could be represented by the ideas of Ben Bernanke, former Chairman of the United States Federal Reserve, who tends to take a relatively benign view of the current trends, and the other by those of Larry Summers, Secretary of the Treasury in the Clinton administration and Director of the National Economic Council during President Obama's first term, who in late 2013 put forward the much more worrying hypothesis of "secular stagnation",[1] reviving a term coined by Alvin Hansen in the 1930s and making waves in the economic community.

According to Bernanke, we are essentially in the midst of what we might call a "savings glut"—too much saving and not enough investment—that is depressing interest rates. He argues that this excess saving is largely a result of economic policy decisions made in the past: after the crisis of the late 1990s, the Asian countries—especially China—chose to limit the expansion of domestic demand in order to build up their reserve holdings of financial instruments issued by the most developed countries, thereby driving interest rates down.

When the 2007-2008 crisis reared its head, the sudden drop in demand and the consequent relaxation of monetary policies only intensified this downward trend.

According to Bernanke and others who defend this position, we still have a significant savings glut because the emerging economies of Asia and oil producers have only moderately reduced their current account surpluses, and the major correction experienced in other raw material-producing countries, like Russia and Latin American nations, has been offset by an improvement in the current accounts of European countries, primarily Germany and the so-called periphery (in the case of the latter, an obvious effect of the crisis and the policies adopted to mitigate it).

In this scenario, policies of low rates and quantitative easing would be the appropriate tools for stimulating global economic recovery and, to a certain extent, correcting imbalances in global flows.

This is undoubtedly a highly simplified summary of the "savings glut hypothesis", but it is nevertheless useful for contrasting it with Summers's alternative theory of "secular stagnation".

Secular stagnation defines a situation where there is a chronic deficit of investment with respect to savings, leading to less growth in the

1 For a general overview of this controversy, see Bernanke's blog (http://www.brookings.edu/blogs/ben-bernanke).

medium and long term. In other words, the root of the problem is not excess saving—due to policies adopted in the past—but the existence of structural factors that depress investment demand. These factors are usually manifested in two areas: firstly, an ageing and/or declining population; and secondly, a drop in the productivity of new investments due to an exhaustion of technological change—or, perhaps more alarmingly, because new technologies require somewhat less capital investment than their predecessors.

If this were true, we would be facing a future of low growth, possibly exacerbated by deflation and chronically high unemployment. In this scenario, interest rates might remain low for quite some time without ever having a truly stimulating effect on the economy, while causing major distortions in the distribution of income and asset allocation and creating a high risk of recurrent asset bubbles.

> SECULAR STAGNATION DEFINES A SITUATION
> WHERE THERE IS A CHRONIC DEFICIT OF INVESTMENT
> WITH RESPECT TO SAVINGS, LEADING TO LESS
> GROWTH IN THE MEDIUM AND LONG TERM

Of course, these two alternatives are not mutually exclusive: the reality could be a combination of both. But the critical question is this: are we essentially in the final stages of a "savings glut" or in the early stages of a secular stagnation process?

No one can deny that there is evidence of a savings surfeit. However, even if this were the fundamental cause of the current situation, it is not at all clear that the problem can be solved quickly or solely by resorting to demand-stimulating policies. I say this for two reasons: firstly, because changing the policies of the countries that are generating this current account surplus will not be easy, as China's recent difficulties clearly prove; and secondly, because excess saving also has long-term causes related to demographic factors.

Over the past decade, in addition to a very steep rise in the current account balance of emerging economies, we have also witnessed a rapid increase of pension funds accumulated by "baby boomers", the largest and most prosperous generation in the history of the world's developed countries.

This has triggered a staggering rise in the demand for premium financial assets, fixed-income instruments issued in the most advanced

nations, which has helped to keep interest rates low. The "baby boomers" are now nearing retirement age, and in fact many of them are already pensioners, but it will be another decade before the process is concluded.

On the other hand, categorically diagnosing our global problems as a case of "secular stagnation" would be very risky. At this point we do not have sufficient data, and the data we do have is far from conclusive. Yet the global economy does seem exposed to that risk, which must be assessed in terms of two factors. The first is demography, and the second is technology.

With regard to the demographic factor, the global population growth rate has been steadily declining, from the highest recorded rate of 2.2% per annum in the early 1960s to around 1% per annum today. By 2050, it will be less than 0.5%. Meanwhile, the world's population is growing older, and not just in developed countries. By circa 2050, one-third of China's population will be over the age of sixty (compared to 12% at present). And Europe's demographic outlook is much worse than that of other regions, with the exception of Japan.

Naturally, as the population shrinks and/or moves into retirement, economic growth tends to slow down and can even become negative unless productivity rises to offset the diminishing workforce.

Therefore, the real issue is: what will happen to productivity? And in economics there is probably no question harder to answer than this.

In order to address this issue, it may be helpful to turn the clock back to the late 1930s, when Alvin Hansen first coined the term "secular stagnation" (Hansen 1938). Hansen observed that the expansionary policies of Roosevelt's New Deal were only having a modest effect on economic growth in the United States, and that recovery from the Great Depression was proving to be slower and weaker than after past recessions. He concluded that this was due to a slowing of both population growth and technological progress, and that it would lead to a prolonged period of low growth for the US economy.

Of course, Hansen could not have foreseen the impact of World War II and the economic boom that followed, thanks to the accelerated pace of technological development and the surge in population growth (the "baby boom").

Today, the question is whether or not developed nations will be able to capitalize on the demographic momentum that emerging countries are expected to maintain for at least another generation, and, above all, how the technological change currently underway will affect investment and productivity.

The Impact of Technological Change on Growth

When attempting to assess the impact of technology, our greatest difficulty probably lies in the nature of today's technological progress, which differs in many ways from what we have experienced in the past.

It seems clear that we are in the midst of a period of rapidly accelerating scientific and technological change, which might aptly be called a revolution. Every revolution in the history of humanity, from the Neolithic Revolution of agriculture and the first settlements to the Industrial Revolution that began in the late 18th century, has created a dramatic increase in the need for capital to develop the infrastructures and tools of new production systems and a very clear and significant rise in productivity.

In contrast, the data we have regarding the current technological revolution's impact on productivity show absolutely no recent improvement in total factor productivity. In fact, different sources—for example, Robert Gordon's (2012) statistics on total factor productivity in the United States, the world leader of the tech revolution—show that since the 1970s total factor productivity has risen at fairly steady rates (between 0.5 and 1% per annum), which contrasts sharply with the period between 1920 and 1970 when the annual growth rate was consistently above 1.5%.

If this were the case, the prospects for future growth (with or without secular stagnation, a theory that Gordon also rejects) would be quite disheartening.

However, there are several arguments that seem to refute this conclusion. The first is that this technological revolution is more about the provision of services than about goods; theoretically, more and better services are being produced and offered to customers. And, as Joel Mokyr (2014) points out, conventional tools of statistical measurement are designed for a "steel-and-wheat economy", not one in which information and data constitute the key inputs and outputs in many sectors.

Many of the new goods and services are expensive to design, but once they work they can be mass-reproduced and copied in almost infinite quantities at very low or zero cost. Consequently, they have a huge impact on consumer welfare but contribute very little to product output, as we measure it. Moreover, many of these services are provided free of charge via the internet in exchange for benefits such as advertising, customer recruitment, or information that are very difficult to quantify.

A growing percentage of investments are also being made in intangible assets, especially software.

InMoov animatronic android robot, made from 3-D printed parts.

All of this leads to widely acknowledged problems with the measurement (undervaluation) of GDP, investment, and productivity which, if corrected, would probably paint a very different picture of future growth. Finally, as Mokyr observes, technological revolutions develop and bear fruit over a very long period of time and often in unexpected ways. Today we have increasingly powerful technology (tools and instruments) for scientific progress, which in turn will eventually lead to new technological breakthroughs. The technological revolution is just beginning.

Even limiting ourselves to what we know today, we can come up with an infinite list of ways to spur investment and future growth: new materials, multiple advances in life sciences, artificial life, the Internet of Things (IoT), nanotechnology, 3-D printing, more/better use of all kinds of physical assets, from property to transport infrastructures and cars, thanks to initiatives like Airbnb, Uber, and Lyft, the development of smart cities and all types of intelligent buildings and infrastructures...

All things considered, it is quite likely that the breakthroughs of this technological revolution will require less investment than that needed in earlier tech boom periods. Let us compare, for example, the capital investment needed to set up Amazon with the amount required to open the countless bookshops and other establishments where purchases had to be made in the past, or consider the effects of Airbnb and Uber

on investments in hotels and transport. Everywhere we turn, we find evidence that the information revolution is turning out to be less capital-intensive than earlier "analogue" revolutions.

In fact, the information revolution may be reducing investment through other channels: the accelerated pace of change itself and uncertainty about how the technological revolution will affect different sectors and industries may be dissuading many companies from making investments, simply because they are not sure how, where, or in what they should invest. Support for this theory is found in the fact that, at least in developed countries, companies are accumulating unprecedented amounts of financial assets.

In short, despite the serious problems with our measuring instruments, it could be true that the technological revolution has brought investment levels down. But that does not necessarily mean that this effect is permanent or that productivity will be low in the future, for two good reasons.

First of all, at some point companies will decide to invest their liquid assets or return them to shareholders, who in turn will seek profitable investments for their funds. Secondly, many of the breakthroughs now being announced in biotechnology, artificial intelligence, IoT, self-driving cars, and other fields will eventually require much larger capital infusions in order to realize their full potential.

Even if the information revolution needs relatively low levels of fixed capital, this does not mean that it lacks the potential to boost productivity. Quite the contrary: it is hard to imagine that the information revolution could create stagnation in the medium and long term. It seems much more likely that, as in the past, scientific and technological progress will increase productivity and improve living conditions in the medium and long term.

The global economy is undoubtedly facing what Robert Gordon calls "headwinds". Chief among them are the demographic issue and burgeoning government debt, which would pose a much more serious problem in a future without growth or inflation. Gordon also cites the plateau in educational attainment since the 1970s (in developed nations) and rising inequality, which means that a larger proportion of total income and wealth is concentrated in the hands of those least inclined to spend it.

Even some of the economists who are most optimistic about the effects of technological progress, like Brynjolfsson and McAfee (2013), have expressed concern, not over the future of global production but over the

future of employment: firstly, because demographic changes promise a drop in the labour force participation rate; and secondly, because advances in technology herald the disappearance of a large number and variety of existing jobs, whose current occupants will be replaced by robots or simply deemed unnecessary as the stunningly rapid pace of technological development increasingly allows us to meet our own needs without the intervention of others. In fact, in both Europe (with the possible exception of Spain) and the United States, fewer jobs are being created during this economic recovery than in previous post-recession periods.

However, past experience tells us that the "new economy" may end up creating a much greater number of "new jobs". At the same time, higher global productivity could eventually increase the amount of leisure time available to each person. Nonetheless, it is impossible to know what direction and how long this adjustment will take, because it largely depends on the policies implemented to facilitate it. If the right measures are not taken, the transition phase could be very painful for many individuals, industries, and geographical areas.

These types of concerns and radical changes in the economy and labour market are nothing new. And despite the buffeting headwinds, the tailwind of science and technology is potentially much stronger in the long term.

I say "potentially" because it is important to create the right conditions for capitalizing on the positive effects of technological progress, solving the global economy's current problems, and facilitating or driving the transition to a new environment.

As Barry Eichengreen (2014), one of the authors featured in this book, has noted, if the global economy—or the economies of developed countries or, more specifically, the European economy—does experience secular stagnation, it will be self-inflicted, signalling a failure to repair the damage caused by the Great Recession and adopt effective policies for boosting demand and correcting the structural flaws that pose a hindrance to rising productivity and economic growth.

Europe's Diminishing Global Clout

The preoccupation with secular stagnation—or, more generally, the possibility of a prolonged period of weak growth, with deflation and very low interest rates—was fuelled by an observation of recent economic trends in the most developed countries: the United States, Europe, and Japan.

However, the trend in emerging countries has been quite different. In many of these economies, the effects of the crisis were much less severe and recovery was swifter and more vigorous.

During the two decades leading up to the crisis, the growth differential between emerging and developed countries had been three percentage points on average, but it rose to nearly five points in 2010.

As a result, the global economic clout of emerging areas has continued to grow. In 2004, emerging countries accounted for 46% of world GDP (at PPP) compared to the 54% produced by developed nations. In 2007-2008, they reached 50%. Today they represent nearly 60%, and within ten years they will account for three-quarters of the world's economic growth. Furthermore, over 75% of global growth is concentrated in the Asia-Pacific region (which includes Eastern Pacific coastal areas of the Americas).

THE WORLD'S ECONOMIC CENTRE OF GRAVITY HAS CONTINUED TO DRIFT EASTWARDS AT A SPEED NEVER SEEN BEFORE

Consequently, the world's economic centre of gravity, formerly located on the shores of the Atlantic Ocean, has continued to drift eastwards at a speed never seen before.

Meanwhile, the major emerging economies—China, India, Russia, Brazil, Turkey, Mexico, Indonesia, etc.—have gained power and influence on the world stage (all of these aspects are illustrated on the page preceding the third section of this book).

However, the recent problems of the Chinese economy and their effects on oil and raw material exporters—countries already hard hit by the drop in demand from developed nations—have narrowed the growth differential between emerging and developed regions by at least two points in 2015.

In this context, there is growing concern about the impact that a very low growth scenario in developed countries might have on the future growth of the rest of the world.

Although a situation of permanently debilitated demand in developed nations would undoubtedly affect growth in emerging countries, it is foreseeable that their demographic growth potential and cost advantages will allow the process of income convergence to continue in coming decades. In the medium term, however, there is a risk for emerging countries—at least for many of them—linked to the disruptive nature of new technologies and the possible persistence of a "digital divide" between

the most and least advanced economies. Automation may eliminate the advantages of low wage levels, and the availability of highly skilled workers is more important when choosing a location for high added-value business activities than any cost considerations.

Therefore, though emerging countries are less vulnerable to the risk of a "secular stagnation" scenario, they have good reason to be wary of this possibility and, of course, to avoid falling behind in the process of technological change.

The Economic Policy Debate

The policies required to achieve these goals are not substantially different from those needed in developed countries, although they do need to be tailored to address the most serious shortcomings of emerging countries, essentially with a view to promoting institutional stability and governance, levels of education, and fiscal systems capable of financing infrastructure improvements, reducing informality, fighting poverty, and improving social cohesion.

But what policies should be adopted at the global level? The answer depends on whether or not secular stagnation is a real risk.

A number of very radical policies have been suggested to overcome a scenario of secular stagnation in which extremely low interest rates and even major quantitative monetary easing proved insufficient to stimulate growth.

For example, some have proposed a reformulation of monetary policy, raising the inflation target to, say, 4%, and of fiscal policy to create a much stronger and more enduring stimulus, with the consequent increase in debt. Yet these options could create very serious difficulties in the future if the problem we are facing is not as acute and persistent as some fear.

There are also grounds for doubting their feasibility. For instance, if inflation today is clearly below the target rate of 2%, is it plausible that the announcement of a higher target would trigger a rise in inflation expectations? As for fiscal policy, there is a limit beyond which debt ceases to be sustainable; and, unfortunately, most developed countries have already accumulated a massive debt stock that comes close—too close, in some cases—to that limit.

On the other hand, it does seem possible (and necessary) to maintain current expansionary monetary policies for some time yet—even

intensifying them temporarily in some areas, like Europe—and to adjust the correction of fiscal imbalances until such time as we begin to see evidence of sustained improvement. These expansionary policies may be combined with other measures that contribute to debt sustainability and potential growth, such as raising retirement age or offering incentives to hire members of social groups with lower employment rates.

There is a package of suitable measures for combating the global economy's current problems, which would also have a very positive effect in any future scenario.

I am referring to what are known as "structural reforms" to improve infrastructures, increase market flexibility (including job mobility), simplify the creation of new businesses, reform antitrust laws, stimulate research and development, and—a crucial reform in the long term—improve education.

At the same time, it is essential to create a suitable global framework for migration. Immigration can be a very positive tool for helping to solve the long-term problems of developed countries while simultaneously addressing the needs of many less prosperous regions.

We also need to devise a free, balanced, and fair scheme for global trade and investment flows. Within this scheme, it is vital to establish a set of basic common rules for the development of the digital economy.

Finally, it is both possible and necessary to improve the efficacy of our monetary policies. For any level of official interest rates, the most important rate to those seeking financing is the one they can obtain from the banks or, in the case of large corporations, on the markets. When the official rate cannot be lowered any further, the economy's financial conditions can be improved by increasing the efficiency of the financial markets and intermediaries. This topic is the focus of the second part of my article, and I will come back to it shortly.

Europe: A Critical Case?

In the ongoing debate about the severity and persistence of the problems that wreaked havoc on the global economy during the 2007-2008 financial crisis and the great recession that followed, the case of Europe seems to be particularly serious; growth is very weak in comparison with the United States, where concerns about secular stagnation were first voiced.

In fact, British economist Nicholas Crafts (2014) has stated that this preoccupation in the US might merely be a case of hypochondria, whereas in Europe it may be a well-founded fear.

In his article for this book, Bart van Ark illustrates the correlation between Europe's slower growth and poorer productivity performance. This, in turn, is linked to much less promising demographic projections.

In the case of Europe, in addition to these unfavourable base factors, there are also a series of limitations and difficulties when it comes to designing and implementing common policies with the necessary agility and decisiveness, owing to its peculiar structure and weak governance regime.

At this point in time, Europe does not have a unanimous opinion on how much leeway exists for adopting a more expansionary monetary policy, or for stimulating the economy with fiscal measures (although it must be said that this leeway is different in each country and in some cases is dangerously narrow due to the accumulation of heavy debt).

These difficulties in dealing with problems reflect a deeper political and social division between different countries and even within each country; some see the EU and/or the Eurozone as valid mechanisms for stimulating growth and wellbeing, while others consider them part of the problems that Europeans face today.

Confidence in the Eurozone is diminishing and, for the first time, a member-state (the United Kingdom) has formally proposed a referendum to decide if it wants to leave the European Union.

In other words, worsening prospects of future growth for Europe are being exacerbated by a political and social crisis.

Even so, and despite the shortcomings of the EU's institutional framework, political discrepancies, and social tensions, the way that the European Union and the Eurozone have reacted to their problems proves that this project still has great resilience.

Though belated and far from comprehensive, very positive steps have been taken on three critical fronts. The first is the creation of mechanisms to help countries that find themselves in dire straits. This managed to avert disaster in several nations of the European periphery, which could have been fatal to the monetary union.

Secondly, the ECB has finally begun to wield its power as a very effective instrument for promoting growth and cohesion in the region. And thirdly, a road map for the institutional reform of the Eurozone has been clearly set out in the so-called Five Presidents' Report, released in June

The retirement age reform has triggered resilience
within the EU. In the image, a worker over 65 years old.

2015. The stated objective of this plan is to achieve a true monetary
union in the next ten years, completing the banking union and moving
towards fiscal and political union.

Within this package of institutional reforms, significant progress has
been made in several areas, most notably the banking union. A sole su-
pervisor and a resolution fund are already in place. Two fundamental
pieces are still missing: the creation of a common last-resort financing
mechanism for that resolution fund and the design of a common deposit
guarantee scheme. However, substantial headway has been made, and
the extreme fragmentation of the Eurozone's financial systems brought
on by the crisis has been drastically reduced.

The road ahead is long and arduous. Yet it seems clear that a more
integrated Europe has a better chance of weathering the storms its
faces—economic stagnation, political and social instability, and geopo-
litical irrelevance in the new world order now taking shape—than a
fragmented, divided Europe.

Certain critical problems can only be solved with common strategies
and programmes.

The demographic problem is the first and undoubtedly the most com-
plex, because it is especially acute in Europe and has built up a strong
momentum.

According to the United Nations, in the year 2000 there were four people of working age (between age twenty and twenty-four) for every person aged sixty-five or older in Europe. Today that proportion is nearly three to one, and by 2050 it will be two to one. Even assuming a rise in the birth rate and immigrant influx in the coming years, the proportion of retired to working persons will remain high (in absolute terms and in comparison with other parts of the world) and maintain its upward trend.

However, the effects of this tendency could be mitigated by strengthening the political and economic union. First of all, a stronger union would facilitate a better distribution of the existing labour force within the Eurozone, putting workers where they can be most productive and slashing the general unemployment rate. Secondly, experience has taught us that European agreements make it easier to undertake reforms that may meet with resistance, such as raising retirement age. And it goes without saying that a concerted European plan is the best way to maximize the benefits and minimize the tensions derived from immigration flows, which will be increasingly necessary in the years to come.

Reform policies aimed at stimulating productivity will remain in the hands of national decision-makers, and predictably for quite some time, until a very high degree of political integration is finally achieved (if it ever is). Yet the gradual strengthening of the fiscal union will force national governments to increasingly rely on these instruments in order to correct trends in their respective economies, as they gradually lose the ability to act autonomously in other policy areas.

The scope of reforms for improving productivity in Europe is very broad. In the first place, recent research (CompNet Task Force 2014) has revealed that, within the Eurozone, there are enormous differences between the most and least productive companies, and that productivity distribution is heavily skewed, with a large number of relatively unproductive firms and a few highly productive enterprises.

For this reason, reforms designed to make labour markets more flexible (Europe's are clearly more rigid than in the US or the majority of other OECD countries) and streamline the procedures for starting up and winding down companies, which vary significantly from one country to the next, could have a tremendous impact on productivity. Moreover, these measures would encourage the free movement of both labour and capital resources among countries, another way of increasing efficiency.

One OECD study (Bouis and Duval 2011) quantified the impact of a broad package of structural reforms: it would increase the GDP of

European countries by around 11% in ten years (compared to a gain of less than 5% in the United States).

In summary, Europe's growth is being stunted by a number of highly complex problems. But Europe also has the potential to make vast improvements and the capacity to take effective action. Structural reforms can bring about a remarkable increase in the region's productivity and growth potential. And advances in the ongoing process of European integration could be a very powerful catalyst for these reforms.

Specifically, a more integrated financial system would mean a better allocation of resources in the region. In this respect, the banking union—accompanied by steady progress towards the Capital Markets Union—represents a structural reform that would lead to the creation of a more open, competitive, and efficient European financial market. Every new step taken in this direction is particularly important today for reducing the cost of capital and improving the transmission of monetary policy in a context where official interest rates are currently at zero.

The Imminent Revolution of the Banking Industry

As it heads into that integration process, the European banking industry undoubtedly finds itself at an especially difficult juncture. The current scenario is marked by, on the one hand, very low interest rates and an extremely flat yield curve, and on the other, very sluggish credit demand, primarily owing to the situation of low economic growth and the ongoing process of corporate and household deleveraging.

In addition, banks must now operate in a much stricter regulatory environment. The new regulations enacted after the 2007-2008 crisis, while undoubtedly serving to stabilize the system, have a negative effect on the banking industry's capacity to grow and generate profits. These are not transitory factors; the economic pillars of the banking business have changed in such a way that, for the foreseeable future, banking will grow at a slower pace and be less profitable than in the past.

These problems are not limited to European banking. Economic growth and rates are low in all developed regions, and regulations are tougher across the globe. However, in Europe the demographic and growth prospects are more worrisome.

This problem is not unique to the banking industry. As experts have repeatedly pointed out, the current situation poses an obstacle to

monetary policy transmission and increases the cost of capital, under-mining the efficacy of the ECB's efforts to spur growth. The European banking system therefore needs to dramatically improve its efficiency.

One method of improving efficiency and profitability, used frequently in every industry, is consolidation. Like other developed regions, Europe is witnessing the gradual consolidation of its banking sector, a process that picked up speed when the financial crisis hit. But this process is still pro-ceeding very slowly and cannot keep up with the mounting pressure on

> **OVER THE PAST FIFTEEN YEARS, NEITHER THE SINGLE MARKET NOR THE EURO NOR THE FINANCIAL CRISIS HAVE MANAGED TO RADICALLY ALTER THE EUROPEAN BANKING MAP**

the banking business. In the countries that now form the European Union, there were approximately 9,500 banks in 2001 (i.e., at the beginning of the century); today, after fifteen years of a single market, advances in integra-tion, and a severe financial crisis, over 7,100 banks still remain. In other words, the number has been reduced by 25%. In Eurozone countries, which have the additional factor of a common currency, in 2001 there were around 7,700 banks, and today there are 5,500, meaning that the ranks have been thinned by less than 30%. Statistics on the diminishing number of banks are similar or even slightly higher in the US.

It should also be noted that most of the eliminated banks were very small, so the reduction in installed productive capacity was actually even less significant. And there have been very few cross-border acquisitions or mergers.

In summary, over the past fifteen years, neither the single market nor the euro nor the financial crisis have managed to radically alter the European banking map, although certain countries (Spain, for one) where the banking crisis was especially severe have registered a higher level of consolidation. Progressing towards a European banking union and increasing pressure on margins and growth could accelerate this process, but it is highly unlikely that consolidation alone will suffice to achieve the substantial improvements in efficiency required today. In the past, political and regulatory issues were the primary obstacles to consolidation; now, these are joined by the fact that, for most banks, inorganic growth operations are less of a priority than the need to meet regulatory requirements and revise their business models.

Of course, another mechanism for increasing income and margins is branching out into other areas with better growth prospects and higher interest rates. But this is not an option for all banks, and it is also affected by the existence of the abovementioned priorities.

There is, however, another much more powerful factor, which simultaneously demands and facilitates a swift, substantial improvement in the efficiency of the financial system: technological progress.

Technological change has already forced a large number of industries—communications, the media, music, travel, different distribution sectors, etc.—to reinvent themselves and reap staggering gains in productivity and efficiency thanks to the network economy, a dramatically reduced need for physical investments, and the relative ease of reaching a global audience, among other factors.

The financial industry has certain features that make it a prime candidate for a radical IT-based switchover, because its basic raw materials are data and money. And money can be turned into accounting ledger entries—in other words, data.

For this reason, I have long been convinced that banking, and the financial industry in general, is due for a radical and rapid change.

While significant changes have transpired over the last two decades, they are not comparable to the revolutions we have seen in other sectors. This can be chalked up to a number of factors: the historically high levels of customer trust in banks; the industry's high rates of return and growth (up until the financial crisis) which discouraged experimentation

THERE IS A NEW GENERATION OF CONSUMERS WHO HAVE GROWN UP IN THE DIGITAL WORLD AND DEMAND OTHER SERVICES AND OTHER WAYS OF ACCESSING THEM

and change; the fact that, until quite recently, banks probably did not put enough effort into developing the infrastructures they needed to harness the full potential of new technologies; and, of course, regulation that limited the freedom of institutions to engage in disruptive innovation and protected them from the possible competition of newcomers.

But all of this is changing, and now, at long last, the banking industry has embarked upon a rapidly accelerating transformation process. The economic foundations of the business have changed for the worse, making transformation even more urgent and necessary. But customers are also changing: the crisis severely tarnished the reputation of banks and

shook people's trust in them. Most importantly, today there is a new generation of consumers, people who have grown up in the digital world, who demand other services and other ways of accessing them, and who are willing to accept banking services from other companies: recent surveys reveal that between one quarter and one half of all US consumers would, if they were offered, pay for financial services provided by firms like PayPal, Apple, Google, or Amazon, or by major telecom companies.

Meanwhile, infrastructure improvements are accelerating the spread of technological innovations. We are already at the stage where new-fangled innovations have an immediate and visible impact on the daily activities of people (and, therefore, on banking activity). And this in turn accelerates technological development, resulting in so-called exponential technologies: smartphones, blockchain technology, artificial intelligence, natural language processing, cloud computing, biometrics, IoT, big data… all of this is going to radically alter the banking industry. I am not talking about things that will happen in some unknown or distant future. They are happening right now. Hundreds of startups are already attacking different links in the banking value chain. These companies, unburdened by the "legacies" of costs that banks carry, take full advantage of technology and their own flexibility and low costs to offer customers a better experience at very low prices: payments, loans, share purchases/sales, and asset management are probably some of the areas under heaviest attack. But initiatives with tremendous potential to shatter the status quo are also making inroads in insurance, deposits, risk management, cybersecurity, capital markets, and other fields.

Just as it happened in other sectors, these new "fintech" initiatives are growing by leaps and bounds. In 2014, they attracted investments amounting to over 12 billion dollars, three times more than the previous year. And in the first half of 2015, investments in fintechs were estimated at more than 13 billion dollars, already exceeding the amount invested over the entire previous year. Many of these firms are not so small anymore. Recent estimates indicate that more than thirty of them have attained "unicorn" status, a term used to describe companies with a valuation of 1 billion dollars or more. And this number is going to double or triple each year.

Hardly any segment of the banking industry has escaped the invasion of these new competitors, and virtually no domestic market is "safe" from them. This is true because their activity is global—if not now, at least potentially—and because important developments are not limited

to the United States (where about 60% of these firms are located). Another 20% are established in Europe, and there is considerable activity in the emerging world. China, India, Latin America, and even Africa have some very interesting proposals, largely aimed at providing banking services at a very low cost to the extremely high proportion of the world's population with low income levels, for whom conventional banking is not affordable.

These companies could have a very strong impact on bank income and profits in the medium term. A recent McKinsey report (2015) estimates that banks could lose 40% of their profits in consumer finance, 30% in payments, and 25% in loans to SMEs.

However, the majority of these new competitors in the banking/financial industry rely on conventional banks to "deliver" their services. In most cases, they lack the organization and/or financial capacity to offer an end-to-end service. As Marc Andreessen, co-creator of Mosaic and Netscape and now a venture capitalist in the field of technology, recently said, fintech companies "are reinventing the user experience but not 'the whole thing'".

Even the big digital corporations (Amazon, Google, Apple, etc.) that are already combining their range of products and services with certain financial services have so far been reluctant to offer a broad, complete range of banking solutions, primarily because they would rather not have to comply with the industry's strict regulations.

But all of this will change. And banks that hope to prosper in this new technological world have to react quickly, because the window of opportunity that is open today will close at some point.

For some, no doubt, it is already too late. The pressure of technological progress will be the true driver of the sweeping consolidation that this sector must undergo. More importantly, it will be the driver of a dramatic improvement of productivity and efficiency in banking, on the same scale as that experienced in other already "digitized" industries. And all of this will benefit investment, economic growth, and, ultimately, the consumers.

We are already moving towards a new banking industry, and this process involves several very different agents.

On the one hand, we have "conventional" banks, which on the plus side have the vast majority of customers and a wealth of information on them, production and distribution infrastructures, the licences required by regulations, and financial resources. But they are also burdened by very inflexible, costly structures, cumbersome processes, and obsolete corporate

A group of PayPal workers in front of the Nasdaq headquarters in New York.

cultures and they are far removed from the arena where the latest technologies and the most disruptive innovations are being developed.

On the other hand, we have newly-formed companies that are highly agile and flexible, creative, innovative, and in tune with the technological world. What they do not have are customers or the infrastructure needed to get them, a consolidated brand, significant financial resources, or experience in the banking business to broaden their initial scope of activity.

Finally, we have the big names in online business, with customers, a brand, and the resources to make up for any lack of infrastructure or experience they might have, but for whom financial services are not a top priority (undoubtedly because of their reluctance to enter such a tightly regulated sector).

These three groups are the key components of the new digital banking ecosystem that is beginning to take shape. The million-dollar question is: who will be at the centre of this ecosystem? Or, to put it another way, who will "own" the customers?

Few banks will be able to fill this position, because it requires a long, complicated, and costly process that will entail not only a radical technological transformation but also a profound organizational and cultural change. Consequently, many banks will disappear; others will become generic brands, providing infrastructure services for other financial firms;

and a few will evolve in time and become information and software companies that offer a much wider range of products and services (including non-financial services), capable of making a radically different and better customer value proposition with the ultimate goal of providing the best possible experience for each individual customer.

The banks that conclude this transformation most successfully will become the "regulators", owners, and managers of a very wide and heterogeneous platform, on which "banking" will interact and cooperate with a large number of specialized suppliers and with the customers, turning data into knowledge that will allow them to design and deliver the best solutions and the best experience to each customer.

The Transformational Experience of BBVA

This is what we at BBVA understand by the term "digital transformation". And this is what we are doing.

Of course, this does not mean we neglect our day-to-day business concerns: we are one of the most efficient and profitable big banks in the world, and we have increased our market share in Spain in the consolidation process following the financial crisis. We have also established a solid presence in regions with better prospects than Europe for long-term growth: the US, Mexico and other Latin American countries, Turkey, and East Asia are currently key markets for our group.

But the pillar of our strategy, our vision, and our future is digital transformation. In my article for the book added to this collection last year (González 2014), I described the foundations of this transformation and the process it has followed, so here I will simply offer a very brief overview and explain the latest advances.

At BBVA, we describe this transformation by likening it to the process of building a house: in that digital "house", the foundation is technology; the floors and walls are processes, products, organizational structure, and corporate culture; and the roof represents the channels or points of contact with our customers.

With regard to the foundation, after eight years of hard work, at BBVA we now have a modular, scalable, state-of-the-art technological platform that is already fully functional. This platform is capable of processing the exponentially growing number of transactions we will have to handle as the digital revolution sweeps across the banking industry. It also gives

us an advantage over the vast majority of other banks, because most of them are still operating in what Professor Weill from MIT calls "spaghetti-like" IT landscapes, technological platforms designed in the 1970s that they have attempted to update with countless patches, modifications, and add-ons. Such platforms are not up to the task of handling the volume and increasing complexity of future data processing requirements.

Today, our platform lets us work in real time; manage an ecosystem open to third parties (other service providers); deploy much more sophisticated cybersecurity and data protection architecture; glean much more knowledge from our raw data; and turn that knowledge into products and services, drastically reducing our time to market.

IN THE DIGITAL "HOUSE", THE FOUNDATION IS TECHNOLOGY; THE FLOORS AND WALLS ARE PROCESSES, PRODUCTS, ORGANIZATIONAL STRUCTURE, AND CORPORATE CULTURE; AND THE ROOF IS THE CHANNELS

However, the technological platform is not the answer to everything. It is merely a tool in the hands of people, one that enables them to design and build a better customer experience.

Once the foundation has been laid, we must put in the walls and floor slabs. This translates into a transformation of operations and processes. And to effect that transformation, a new organizational structure is needed.

For this reason, in 2014 we created a Digital Banking Division endowed with broad powers and substantial resources for accelerating the transformation. This decision had positive results that motivated us to go one step further: a year later, in May 2015, we completely reorganized BBVA's management structure, and the head of our Digital Banking Division became the COO.

From that moment on, "Digital" BBVA has led the process of transforming the entire group, heading up a structure with two basic objectives: first, to boost results in all of the group's business areas in the medium and long term, and second, to endow our group with the means (human and technological resources) to successfully compete in the new digital banking industry.

Of course, in these years we have also taken measures to improve our roof, the channels through which our products and services are distributed. Today, our digital channels serve 14 million customers (over 20% of

our total client base), including 7.5 million customers via mobile phone. These channels are growing rapidly and proving to be a highly effective method for increasing sales of loans, consumer products, pension funds, and other products.

At the same time, we are establishing different collaboration schemes with fintech startups and developers: we have opened up our platform to some of them (Dwolla, for one); we have partnered with others on different development projects; we have acquired startups that offer us special capacities and knowledge; and we have created a venture capital fund to invest in innovative firms in our industry.

All this is helpful for our transformation, but the most important factor is involving all of our employees in the process. To this end, we completely overhauled our Human Resources Department (now the Talent and Culture Division), which has the mission of creating a more flexible, agile, enterprising corporate culture.

At BBVA we are always evolving and improving our digital house. We have come a long way, and I believe we are in a position to lead the transformation of our industry and become one of the world's first knowledge banks (and hopefully the best), fully integrated in the digital ecosystem.

Even so, we know that much work remains to be done; our transformation is far from complete. In any case, the pace of technological change is still accelerating, and society continues to change.

Digital transformation is a race that has no finish line or predetermined courses. The rulebook for the digital banking industry has not even been written yet.

The Future of the Financial Industry:
Regulation and Digital Transformation

Regulation is a crucial issue that will determine, in one way or another, the future course of the digital banking industry.

Today's technologies have tremendous disruptive potential and offer countless opportunities to improve the quality, convenience, and cost of financial services. This would be highly beneficial for consumers in Europe and round the world, especially the billions of low-income individuals who currently do not have access to financial services. At the same time, a more efficient system will bring down the cost of capital, boosting investment and growth.

However, in order to realize those potential benefits, we need proper regulation. Today the digital banking industry is practically unregulated. Consequently, we are left with a vast no-man's land in such crucial matters as macroeconomic and financial stability, the spread of shadow banking, consumer protection, data privacy, cybersecurity, and the issues of money laundering and financing illegal or criminal activities.

Two different types of agents are operating in the financial industry today: the traditional players, the banks, whose activity is governed by very tight, exacting regulations; and the new digital players, who have a much more permissive set of rules or no rules at all. This gives one team a huge competitive advantage over the other, in a highly favourable situation for the development of the industry segment flying below the radar of regulators and supervisors.

Until now, these watchdogs have not kept pace with changes in the industry. The financial crisis and all its consequences and ramifications have been, quite understandably, their principal and practically only concern.

But this has to change. In fact, it is already starting to change. It is important to develop a system to regulate and supervise digital financial activities, a system that will have to strike a difficult and delicate balance in several areas.

First of all, it must strike a balance between stability and efficiency, establishing an appropriate degree of control without suffocating innovation and combining the need to protect consumers from potential harm with the need to maintain the benefits of better costs and greater convenience for them.

Secondly, balance must be achieved in the conditions of competition between banks and digital newcomers. Regulation should allow banks to use technology to offer their customers better, cheaper, and more convenient services. At the same time, newcomers should be regulated to a certain extent, depending on the kind of business activities they pursue.

And all of this should be done at the global level, because digital banking is, and can only be, global. This is certainly a daunting task, but an absolutely necessary one if we want to guarantee future financial and macroeconomic stability and harness the vast potential of technology to boost productivity, growth, and personal wellbeing.

PETER A. HALL is the Krupp
Foundation Professor of Euro-
pean Studies at the Minda de
Gunzburg Center for European
Studies at Harvard University
and a Centennial Professor at
the London School of Economics.
He is the author of *Governing
the Economy* and more than a
hundred articles on European
politics and comparative polit-
ical economy. His many edited
works include *Varieties of Capi-
talism* (with David Soskice) and
*Social Resilience in the Neoliberal
Era* (with Michèle Lamont).

For decades, the European Union has been a
vehicle for peace and prosperity in Europe, but
it is in trouble today. The response to the crisis
has had negative economic and political ef-
fects. The decision to subsidize debt in return
for austerity has stymied growth in southern
Europe. Although European elites favor
deeper integration, the response to the crisis
has reduced popular support for it. A deeper
fiscal union threatens to intensify technocracy.
However, the Euro may endure without deeper
union provided some institutional reforms are
consolidated and economic growth can be
revived in southern Europe.

THE EURO CRISIS AND THE FUTURE OF EUROPEAN INTEGRATION

From a long-term historical perspective, the European Union is one of the most distinctive political creations of the late twentieth century–a vehicle for supranational cooperation just short of a political federation but more robust than an international regime. After half a century marked by economic depression and two world wars, the economic community established by the 1957 Treaty of Rome became the vehicle for one of the longest periods of peace and prosperity the European continent has ever enjoyed.

However, the European Union is in trouble today, seemingly unable to deliver the peace and prosperity that has always been its promise. The long-running Euro crisis is the most prominent manifestation of its problems. A slow-moving debacle, the crisis has laid bare the fault lines of the European Union. But the problems with which the EU must cope extend well beyond it. Annual economic growth among the 28 member states now in the EU was lagging well before the crisis, at 2.6 percent versus the 3.3 percent growth rate in the U.S. between 1997 and 2006.

> **THE EUROPEAN UNION IS**
> **SEEMINGLY UNABLE TO DELIVER**
> **THE PEACE AND PROSPERITY THAT**
> **HAS ALWAYS BEEN ITS PROMISE**

Moreover, low birth rates will make it difficult for Europe to achieve high rates of economic growth in the coming years. The old-age dependency ratio in the EU is expected to double by 2080, leaving only two people of working age for each one over the age of 65. Immigration offers a solution to that problem, but it is meeting fierce resistance in the polities of Europe, where radical right parties opposed to immigration and the policies of the European Union are on the rise. The EU itself lacks an effective policy for coping with boatloads of refugees crossing the Mediterranean in unprecedented numbers.

Meanwhile, the European Union's record as a guarantor of peace and democracy in Europe is being tarnished by its inability to prevent a resurgent Russia, under Vladimir Putin, from absorbing pieces of Ukraine or to deter Hungary, one of its own member states, from sliding back towards semi-authoritarian rule. Of course, Europe has always faced challenges, but to many people, the European Union now seems to be part of the problem rather than the solution. In order to understand why, we need to look back at the evolution of European integration.

The Evolution of the European Union

From its inception in the European Coal and Steel Community of 1951, institutional integration in Europe has always been multiply motivated. On the one hand, for some, it has been animated by the ideals of an "ever closer union" culminating in the European polity envisioned by its founders, Jean Monnet, Robert Schuman, and Alcide De Gaspari. On the other hand, integration has moved forward only when national governments could see how European institutions would serve their own country's interests.[1]

EACH NEW STEP TOWARD
INTEGRATION HAS BEEN BASED ON LONG
TERM GAINS, EVEN IF THEY REQUIRED
SHORT-TERM SACRIFICES

Conceptions of national interest are circumscribed by economic and geopolitical conditions, but they are ultimately a social construction. As such, they are affected by the discount rate that governments attach to future gains, by officials' confidence in how a new set of institutions will function, and by a government's sense of the opportunity costs of moving in one direction rather than another.[2] In this respect, visions of what Europe could be influence the pragmatic decisions taken to get there. Charles de Gaulle was not the only leader motivated by *une certaine idée de l'Europe.*

1 A. Moravcsik, *The Choice for Europe* (Ithaca: Cornell University Press, 1998).
2 J. Goldstein and R. Keohane, eds., *Ideas and Foreign Policy* (Ithaca: Cornell University Press, 1993).

Therefore, European integration has often been served by a certain "constructive ambiguity" about what its next steps would mean for each of the member states. For the most part, however, each new step toward integration has been based on the perception that it would offer the member states positive-sum returns, namely, long-term gains for all, even if they required short-term sacrifices by some. This point is important for understanding the dilemmas Europe faces today.

During the 1950s and 1960s, European integration offered gains that were relatively clear. The European Economic Community provided a vehicle for economic reconstruction and peace in Western Europe. A generation decimated by war took those as superordinate goals. The Single European Act of 1986, which was to create a single continental market by 1992 on the basis of qualified-majority voting, was presented as a means to secure prosperity after a decade of Eurosclerosis.[3] The member states knew that liberalization would require some sacrifices but were persuaded that the long-run outcome would be greater prosperity for all.

In large measure, these ends dictated the means used to secure them. Since its core objective was greater economic efficiency, the European Community of the 1960s and 1970s was designed and presented largely as a technocratic enterprise. Of course, national governments retained the final say, and the Community acquired a patina of popular participation when the European Parliament became an elected body. But the actions of the European Community were legitimated largely by reference to their technical efficiency. The committees of the Council were enjoined to base their decisions on technical expertise, and the Commission justified its proposals on the basis of economic efficiency.[4]

As the ambit of European decision-making expanded, however, cracks began to appear in this facade. When the EC focused on narrow realms of regulation with few distributive consequences, its policies could be justified on the grounds of technical efficiency. But, after the Single European Act, the liberalizing regulations of the EU began to affect large segments of the workforce, generating losers as well as winners. European officials had complained for decades that their efforts went

3 N. Jabko, *Playing the Market* (Ithaca: Cornell University Press, 2006).
4 C. Joerges and J. Neyer,. 'From Intergovernmental Bargaining to Deliberative Political Processes: The Constitutionalisation of Comitology,' *European Law Journal 3* (1997):), 273-99.

unnoticed. Suddenly, they acquired much higher political visibility, and people who felt disadvantaged by liberalization or globalization began to blame their fate on the EU. The result is a legitimacy crisis from which the European Union has yet to emerge fully.

Of course, democratic governments often allocate gains and losses among social groups, and they legitimate those decisions on the grounds that the last elections gave them a mandate to do so and the next elections will hold them accountable for their actions. This is the basis for the "political capacity" of democratic governments in contexts where "to govern is to choose." But the European Union lacks such political capacity. Its Commission is unelected, and its Council strikes deals under a veil of secrecy for which none of its members can readily be held accountable.[5]

In the treaties of Maastricht and Lisbon, the response of the European Union to this legitimacy crisis was to increase the powers of its Parliament while extending the jurisdiction of the EU even further. But complex decision-rules obscure the role of the Parliament, and elections to it are generally decided on national rather than European issues, in the absence of a cohesive continental electorate or Europe-wide parties. In the eyes of many of its citizens, the EU continues to look like a technocracy. Europe suffers from the kind of sharp divide between the *pays légal* and the *pays réel* once said to have characterized France during the Third Republic. As a result, the legitimacy of the EU turns heavily on its capacity to promote prosperity across the continent.[6] That is why the Euro crisis raises deep political as well as economic dilemmas for Europe.

The Origins of the Euro Crisis

Like all such initiatives, the decision to establish the Economic and Monetary Union in Europe was multiply motivated: EMU was both an economic and political construction. Officials, such as Jacques Delors, the president of the European Commission, saw EMU as a way to deepen the single market. President François Mitterrand of France hoped monetary union would reduce the influence that the German

5 S. Cox, *What's Wrong with the European Union & How to Fix It* (Cambridge: Polity, 2008).
6 F. W. Scharpf, *Governing in Europe* (Oxford: Oxford University Press, 1999).

Bundesbank held in the prior European monetary system. Chancellor Helmut Kohl of Germany saw it as a way to bind a newly-unified Germany to Europe, ensuring its trading partners could not gain advantages over German products by devaluing their currencies. Each leader had reasons for pursuing monetary union, even though economists warned that Europe was not an "optimal currency area." It lacked the capacities to adjust to economic shocks conferred by high rates of labor mobility and social insurance schemes capable of automatically redistributing revenues to regions suffering from recession.[7]

THE ECB WAS CHARGED WITH MAINTAINING FINANCIAL STABILITY BUT FORBIDDEN FROM PURCHASING SOVEREIGN DEBT

The institutions constructed for the new monetary union were minimal at best. The new European Central Bank was charged with maintaining financial stability but forbidden from purchasing sovereign debt. Therefore, it lacked the tools most central banks wield for fending off speculative attacks in the bond markets. The premise was that monetary union should never entail transfers between the member states, thereby establishing monetary solidarity without any corresponding foundation of social solidarity, a flaw that was to haunt it in future years.

Despite these limitations, the single currency worked well enough for the European Commission to declare, ten years after its establishment, that "The single currency has become a symbol of Europe, considered by euro-area citizens to be among the most positive results of European integration." Within months, however, the Euro crisis had erupted. So what went wrong? Why did Europe face a sovereign debt crisis from which it has yet to fully emerge?

The basic answer is that Europe suffered from the same kind of profligate lending and borrowing, fueled by new types of financial derivatives and light-touch regulation, which precipitated a financial crisis in the U.S. and global recession in 2008. The most egregious case is that of Greece, whose revelation, in October 2009, that its budget deficit would be almost three times the projected level (later found to be 15.6 percent of GDP), touched off the crisis of confidence in sovereign debt. As skittish

7 For a review, see: F. P. Mongelli, 'New Views on the Optimum Currency Area Theory: What is EMU Telling Us?" ECB Working Paper no. 138, 2002.

investors bailed out of Greek bonds, contagion spread to Ireland, Portugal, and Spain, where private sector lending had expanded exponentially on the back of asset booms in housing and construction, even though levels of public debt were relatively modest. In many respects, the problems in these countries paralleled those in the United States. But, unlike the U.S. or U.K., they did not have a central bank prepared to purchase sovereign debt. Instead, they began the torturous process of negotiating rescue programs with the ECB and EU.

MANY OF THE PROBLEMS FACING THE EU FLOWED FROM THE INSTITUTIONAL ASYMMETRIES IN THE POLITICAL ECONOMIES OF ITS MEMBER STATES

Beneath the surface, however, the Euro crisis reflected some of the structural dilemmas of operating a single currency that encompassed multiple varieties of capitalism. The monetary union joined together states at different levels of political development and political economies structured in quite different ways. Many of the problems facing the union flowed not from the asymmetric economic shocks that optimal currency theory anticipated, but rather from institutional asymmetries in the political economies of its member states.[8] The Stability and Growth Pact limiting public debt and deficits was hard to enforce and little more than a fig leaf covering these structural differences. Some believed that the experience of competing within a monetary union would gradually erase these institutional asymmetries, but they have deep historical roots that do not yield easily to incremental reform.

Among the most important differences in the organization of the political economy are those that distinguish the "coordinated market economies" of northern Europe, including Germany, Belgium, Austria, Finland, and the Netherlands, from the "Mediterranean" of southern Europe, including Spain, Portugal, Greece, and Italy.[9] Germany is a classic example of these northern European economies. With well-developed trade unions and employers' associations organized along sectoral lines and accustomed to bargaining with one another, it has the capacity

8 A. Boltho and W. Carlin, "The Problems of European Monetary Union: Asymmetric Shocks or Asymmetric Behaviour?" http://www.voxeu.org/article/problems-eurozone.

9 P. A. Hall and D. Soskice, *Varieties of Capitalism* (Oxford: Oxford University Press, 2001).

Germany based its growth on export. In the image, the port of Hamburg.

to hold down unit labor costs in the interest of promoting exports. An elaborate system of vocational training operated by these producer groups and underpinned by works councils in large firms, gives German firms significant advantages in the production of high-quality and high value-added goods for which export demand is relatively stable. Like its northern neighbors, Germany was institutionally well-equipped to operate an export-led growth strategy.

By contrast, the political economies of southern Europe are organized quite differently. Spain, Portugal, Greece, and Italy developed fractious labor movements divided into competing confederations, which face rel-atively-weak employers' associations that allow for periodic social pacts but make sustained wage coordination difficult. As a result, under EMU, foreign competition held down wages in the export sectors, but rising wages in the sheltered sectors raised unit labor costs in the economy as a whole.[10] These countries also lack the institutional capacities for coordinated skill formation that make high value-added production and continuous innovation more feasible. As a result, more of their firms relied on low-cost labor, and after 1989, their exports were hit hard by low-cost competition from East Central Europe.

10 B. Hancké, *Unions, Central Banks and EMU* (Oxford: Oxford University Press, 2013).

Monetary union had different implications for these two types of political economies. Inside EMU, the countries of northern Europe could pursue their longstanding export-led growth strategies. The ECB helped by keeping a close eye on German wage settlements, and Germany's neighbors targeted the latter to hold down their own wages. Moreover, they now enjoyed new advantages because their neighbors could no longer devalue against them, while the variegated membership of the union held down the external exchange rate of the Euro. As a result, the trade surpluses of northern Europe began to grow, in the case of Germany dramatically.

However, entry into monetary union posed serious dilemmas for the countries of southern Europe. In the years before Maastricht, without capacities for coordinating wage bargaining, they had often relied on periodic devaluations of the exchange rate to reduce the prices of their products vis-à-vis foreign competition. Under EMU, they lost this capacity for economic adjustment just when emerging economies began to eat into their market share for exports of low-cost goods. The alternative route to growth for these economies lay in the expansion of domestic demand. Entry into EMU rendered this strategy even more attractive because it lowered the cost of capital in southern Europe, as investors from the north sought sites in which to invest their growing trade surpluses. However, the natural concomitant to a growth strategy led by domestic demand is wage and price inflation, which the one-size-fits-all monetary policies of the ECB could not contain without precipitating recession in northern Europe. As inflation reduced the real cost of capital, asset booms drew resources away from export sectors already struggling with rising prices for inputs.

In short, one of the effects of monetary union was to encourage a set of unbalanced growth paths that saw the export sectors of northern Europe expand often at the expense of domestic consumption, while many export sectors in southern Europe languished alongside growing sheltered sectors, often dominated by construction. To blame these outcomes on southern European governments, as some do, is to ignore ineradicable differences in the organization of the political economies and the ways in which they provide countries with different types of adjustment mechanisms. For the most part, southern European governments pursued the growth strategies most available to them and often with considerable success. Between 1997 and 2007, Spain and Greece grew at rates close to 4 percent per year. More should have been

done to dampen construction booms and ensure the solvency of the banks funding them, but to expect southern Europe to have emulated the growth strategies of the north is to misunderstand how export-led growth is achieved.

THE MONETARY UNION ENCOURAGED UNBALANCED GROWTH PATHS WHICH FAVOURED THE EXPANSION OF EXPORTERS IN THE NORTH

In the case of Greece, the structure of the polity was equally important to the origins of the crisis. Greek governments used flows of funds from the north to fund consumption rather than investment, often in order to shore up political support for the ruling party among public employees and pensioners.[11] Greece lacked the administrative capacities to collect and spend funds effectively: tax evasion may have accounted for half of the budget deficit reported in 2008. Clientelism was a problem elsewhere in southern Europe, as it is in parts of the north, but in Italy, Spain, and Portugal, product market regulation was reduced as much or more during the early 2000s as it was in most countries of northern Europe.

The Response to the Euro Crisis and its Consequences

The crisis of the Euro began in 2010 when international investors, already skittish as a result of the American banking crisis, lost confidence in the ability of European banks and sovereigns to repay their debts. The same herd instincts in the financial markets that had lowered the cost of capital in southern Europe suddenly raised its cost across much of the continent. In any circumstances, this would have been a difficult moment, but the single currency lacked any effective institutional mechanism for adjustment. Although the ECB gradually invented ways of providing emergency liquidity to banks under stress and finally restored confidence by announcing in mid-2012 that it was willing to buy sovereign debt on the secondary markets, initially, it was unable

11 M. Mitsopoulos and T. Pelagidis, Understanding the Crisis in Greece (Houndmills: Palgrave Macmillan, 2012).

to purchase government bonds in order to stave off panic in sovereign debt markets. A Eurozone built only on a minimalist set of rules had no centralized fiscal capacities of its own and limited abilities for decision-making, which depended on reaching unanimity among its member governments.

WITH THE RESCUE, GERMANY WAS ENSURING THAT LOANS MADE BY ITS OWN FINANCIAL INSTITUTIONS WOULD BE REPAID

In this context, the fact that European governments were eventually able to assemble rescue packages for the Greek, Irish, and Portuguese governments, as well as a credit line for Spanish banks, is a striking achievement, reflecting unprecedented levels of intergovernmental cooperation. Paradoxically, however, the torturous process whereby that cooperation was secured put strains on the European system of governance that threaten the prospects for further European integration in the coming years.

The initial fateful choices concerned Greece, which was running out of money in 2010 and unable to borrow at affordable rates on international bond markets. Runaway public spending over the previous decade had fueled rapid rates of economic growth but taken public sector deficits and debt to dangerously high levels. Its partners in the Eurozone faced a choice. They could organize a restructuring that would see Greece default on much of its debt, perhaps accompanied by some financial support to ease the pain as the country moved toward a primary surplus. Or, they could lend Greece the funds to continue making payments on its debt in return for promises of reform designed to bring the country back to fiscal stability.

Neither option was an attractive prospect. In either case, the Greek people would suffer greatly as the government cut spending to eliminate a deficit worth 12 percent of its GDP. Prominent economists urged restructuring on the grounds that it was the best way to cope with a debt crisis and best done early. Some argued that adjustment would be more successful if the country also left the Euro and devalued its currency rather than rely entirely on internal deflation to reduce real wages to internationally-competitive levels.

However, the member states of the European Union chose the alternative route, assembling two bailout packages, in May 2010 and July

2011, which provided the Greek government with about €225 billion in return for its adherence to stringent conditions designed to reduce its outlays and increase its revenue in order to improve the prospects that the funds would be repaid. A third loan, worth about €86 billion, followed in 2015. Historians will long debate why this path was chosen over the default. Amidst the uncertain financial circumstances of 2010, governments were clearly concerned about the possibility of contagion. If a state within the single currency had defaulted, it might have become more difficult for other members to fund their national debts, including Italy, an economy too large to rescue. Moreover, the Greek default would have created serious problems for the European financial system, since large segments of Greek debt were held by northern European banks. If the other governments had not rescued Greece, they would likely have had to rescue some of their own banks. As a result of the bailout, those banks eventually recovered more than €70 billion lent to Greece.

Following the Greek precedent, another bailout of approximately €85 billion was provided to Ireland, in November 2010, and one of €78 billion to Portugal, in May 2011, followed by a credit facility on which Spain drew for €41 billion to recapitalize its troubled banks. These funds were granted only on stringent conditions specifying limits on fiscal deficits and structural reforms to liberalize various labor or product markets. At the insistence of the ECB, Ireland was prohibited from writing down the debt bondholders held in the failing Irish banks. The ostensible objective was to sustain confidence in European financial markets, but the effect was again to limit the penalties paid by the private sector for making risky loans and to transfer the costs of resolving the crisis onto the public sector.

Many commentators, especially in the northern European media, presented these bailout programs as acts of unprecedented largesse. Led by Germany, the north was said to have come to the rescue of the south, allowing indebted countries to avoid the perils of default. In hindsight, however, judgments about what happened must be more nuanced. Germany was sustaining a single currency that had been of benefit to its export sectors and was ensuring that loans made by its own financial institutions would be repaid. Moreover, the approach taken to these bailouts had unfortunate economic and political consequences that will haunt Europe for some years to come.

The negative economic consequences are most evident in the case of Greece, although there are some parallel features in the treatment

of Portugal and Ireland as well. Greece suffered a classic debt crisis as a result of profligate public spending and inadequate systems for tax collection. While fiscal cutbacks are necessary in the wake of such a crisis, experiences of other debt crises suggest that countries will emerge from them only if most of the debt is written off, inflation reduces the real value of the debt or a revival of economic growth reduces the scale of the debt relative to GDP.[12] In the opening years of the crisis, however, the European response ruled out each of these alternatives.

The policies of the ECB and global economic circumstances militated against inflation, and the rescue packages of the EU initially ruled out writing off the debt. Although Greek debt was written down by a large amount, equivalent to two-thirds of Greek GDP in March 2012, this initiative came too late to offer adequate relief. Thus, the capacity of Greece to emerge from the crisis has depended largely on its capacity to grow economically. But the terms of the bailout programs specified such high levels of fiscal austerity that economic growth became virtually impossible. These programs required Greece to move from a 15 percent fiscal deficit to a 3 percent primary surplus within the space of three years, something few other countries have ever accomplished. Time and time again, the rosy projections for growth offered by the troika (the European Commission, ECB, and IMF) supervising the bailout conditions proved illusory. By 2015, Greek GDP remained 25 percent below its level in 2009. The loans offered to Greece were not sufficient to allow it any sort of fiscal stimulus: 90 percent of those loans went to pay the interest and principal due on existing loans. There was no room left to support aggregate demand in the context of deep cuts to wages and social benefits. As gross domestic product shrank, Greek debt as a proportion of GDP grew ever larger, further reducing confidence in the economy.

The response of the creditor governments to such concerns has been to emphasize the value of the structural reforms to liberalize product and labor markets imposed on Greece as a condition of the bailout. Some of those reforms are likely to have desirable effects on economic performance, but only in the long run. In the short run, structural reforms undertaken in the context of fiscal austerity often have negative effects.[13]

12 C. M. Reinhard and K. F. Rogoff, This Time is Different (Princeton: Princeton University Press).

13 B. Eichengreen, "How the Euro Crisis Ends: Not with a Bang but a Whimper," *Journal of Policy Modeling* 37 (2015): 415-22.

The suggestion that they could be the basis for a revival of economic growth was a mirage.

Why then did the creditor countries of northern Europe insist that structural reforms in the context of fiscal austerity were the best basis for growth? To some extent, this stance was simply pragmatic politics. The creditors were already lending Greece sums equivalent to its total annual GDP. To reduce Greek deficits more slowly in order to revive the economy, higher levels of lending would have been required, and the creditor governments worried about an electoral backlash, especially amidst multiple *Länder* elections in Germany in 2011. Structural reforms were seen as a priority because the roots of Greece's problems were widely ascribed to the clientelist politics of an overly-regulated economy.

IN THE SHORT RUN, STRUCTURAL REFORMS UNDERTAKEN IN THE CONTEXT OF FISCAL AUSTERITY OFTEN HAVE NEGATIVE EFFECTS

Such views had resonance in northern Europe because they conformed to the modes of macroeconomic management that worked best there. In coordinated market economies operating an export-led growth strategy based on high levels of inter-sectoral wage coordination to hold down unit labor costs, a restrained macroeconomic stance is desirable because it reduces the incentives of trade unions and employers to exceed desirable wage norms.[14] Moreover, Germany had developed an approach to economic policy-making that foreswore activist government in favor of the promulgation of rules, in which coordination among well-organized producer groups was to take place.[15] However, as I have noted, the organization of the southern European economies does not lend itself to export-led growth strategies of this type. In their case, economic growth depends more heavily on the expansion of domestic demand.

Accordingly, economic growth is returning to Ireland, whose liberal market economy, oriented toward foreign direct investment, which is

14 W. Carlin and D. Soskice, "German Economic Performance: Disentangling the Role of Supply-Side Reforms, Macroeconomic Policy and Coordinated Economy Institutions", Socio-Economic Review 7 (2009):), 69-99.

15 P. A. Hall, "Varieties of Capitalism and the Euro Crisis," West European Politics 37 (2014):), 1223-43.

The European Central Bank.

attracted by favorable tax treatment and a skilled, English-speaking population, has been buoyed by a resurgence in global demand. But growth remains elusive in southern Europe where multiple years of austerity have taken a toll on productive capacity and levels of investment. Spain is growing again but at rates not yet high enough to reduce an unemployment rate close to 25 percent, and growth remains sluggish in Portugal where the unemployment rate is close to 15 percent. In Greece, 26 percent of the workforce is still unemployed despite a decline in nominal wages of 25 percent since 2009. The bailout program has left it floundering in political as well as economic terms. In retrospect, it looks as if it would have been better if the country had been allowed to restructure its debt in 2010 and given aid designed to ease its transition toward a primary surplus rather than focused on paying back lenders. Such an approach would have imposed a larger share of the adjustment costs on European financial institutions (and those who invest in them) but potentially lower levels of suffering on the Greek people.

The response to the Euro crisis also laid bare a series of political paradoxes consequential for the future of European integration. In the context of coping with the crisis, the heads of government of the Eurozone met together or with other EU leaders an extraordinary fifty-four times between January 2010 and August 2015. On the one hand, these high-level meetings reflected unprecedented levels of consultation and

cooperation among the member states. On the other, this modus operandi sidelined the Parliament and Commission, institutions that were supposed to gain influence under the Treaty of Lisbon, in the name of advancing European democracy. Just when it was supposed to become more democratic, the EU began to look more technocratic, and the "troika" seemed to some as if it were operating like an imperial power.

The crisis years have also been marked by the ascendance of Germany to a position of virtual hegemony with the councils of the EU, a paradoxical result given that France initiated the move to EMU partly in order to reduce German influence over European economic affairs. Although it was inevitable that a reunified Germany would gradually become more willing to assert its national interests because it paid the largest share of the bailout bills, the Euro crisis rapidly thrust it to prominence and power, arguably before the German government had time to reflect carefully about how to balance national and European interests. In many respects, Germany is a reluctant hegemon–less willing to pay the costs of providing public goods for a large number of states than the U.S. was when it assumed that mantle after World War II. In the coming years, much will depend on what Germans think their leadership role in Europe entails.

In another paradoxical result, a crisis that ultimately called forth intensive cooperation among the political elites of the member states has ended up fostering hostility among the citizenry at large. In the wake of the crisis, a wave of popular stereotypes poured forth from the media, rooted on images of "lazy Greeks" and "jackbooted Germans." As a result, it is clearer than ever before that social solidarity in Europe currently stops at national borders. Political leaders bear some responsibility for this state of affairs. The initial response of many northern European politicians was to treat the crisis not as the existential dilemma that it was for Europe, but as a moral issue about whether the citizens of other countries had been adequately self-disciplined. When Syriza took office in Greece, it was repaid by accusations that the Germans were behaving like Nazis. Sentiments such as these have eroded the sense of transnational solidarity on which electoral support for effective cooperation within the EU depends.

The most serious issues raised here bear on the EU's commitment to democracy, for which it was awarded the Nobel Peace Prize in 2012. The extensive conditions attached to its bailout agreements, and policed by the troika, have often been forced on reluctant national governments,

notably in Ireland, which was forbidden from imposing a haircut on the holders of bonds in its failing banks, and in Greece, where the troika dictated highly-detailed sets of spending, tax, and industrial policies. The reasoning, of course, is that European officials know better than their national counterparts how to secure the growth necessary to pay back substantial European loans, and there are precedents in the conditions imposed by the IMF on debtor countries. But the European Union has pretensions to democratic governance that the IMF does not, and many wonder why it could not have negotiated a required level for budget surpluses in the debtor countries while leaving the decisions about how to meet those levels to elected governments. This new assertiveness is gradually altering the relationship between the EU and its constituent states. The commitment to principles of "subsidiarity," which it once advanced in order to guarantee the political autonomy of its members, has dissolved in the face of an overweening enthusiasm for imposing "structural reform" on them.

The Future of the Euro and European Integration

In this context, the most pressing issue is whether the single currency can endure and operate successfully without deeper political integration. Among the European political elites, there is currently a strong impetus to centralize economic power in Brussels. Many in the north want to give the EU more substantial powers over national budgets in order to avoid a repeat of the fiscal foibles that brought Greece to the brink of bankruptcy. Politicians from the south are more likely to argue for an economic government equipped with new sources of funding and the capacity to promote reflation in Europe. They are supported by many economists who argue that the single currency will survive only if the Eurozone moves toward this type of fiscal union with supervisory powers over national budgets and ideally with a budget of its own to provide the social insurance benefits that might cushion the member states facing recession from such shocks.[16]

The capacities to decide whom to tax and how to allocate the proceeds, however, are the most important powers of a democratic state.

16 H. Enderlein et al., "Completing the Euro – A Roadmap towards Fiscal Union in Europe," Report of the Tommaso Padoa-Schioppa Group, Notre Europe Study no. 92 (2012).

As William Gladstone once said, "Budgets are not merely matters of arithmetic, but in a thousand ways go to the root of prosperity of individuals, and relations of classes, and the strength of Kingdoms." To pass budgetary powers on to Brussels might be economically efficient, but it is hardly democratically legitimate. Accordingly, many observers have argued that a Eurozone authority equipped with such powers must be democratically governed, and diverse sets of schemes for doing so have been produced, including proposals to elect the President of the Commission and to strengthen greatly the powers of the European Parliament. On this view, deeper fiscal union requires a political union based on the development of more democratic European institutions.[17]

IT IS DIFFICULT TO SEE WHERE THE POPULAR SUPPORT NECESSARY TO ALTER THE EUROPEAN TREATIES SO AS TO BUILD NEW EUROPEAN INSTITUTIONS WOULD COME FROM

However, none of these schemes for turning the European Union or its Eurozone into a supranational democracy are really viable. In the absence of effective competition among genuinely European political parties, even the most ambitious schemes for making European institutions more democratic offer, at best, highly tenuous lines of electoral accountability, and, in the wake of the Euro crisis, popular support for passing more powers to Brussels is at a low ebb. Majorities in most European electorates continue to favor the Euro and membership in the EU, but enthusiasm for further political integration has declined, and radical right parties opposed to European integration are on the rise across Europe.[18] In the foreseeable future, it is difficult to see where the popular support necessary to alter the European treaties so as to build new European institutions would come from in either southern or northern Europe.

Moreover, the torturous negotiations accompanying the Euro crisis have worn away the sense that the single currency is a positive-sum enterprise offering manifest benefits to all. Because those negotiations

17 J. Habermas, *The Crisis of the European Union* (Cambridge: Polity, 2012); M. Matthijs and M. Blyth, eds., *The Future of the Euro* (New York: Oxford University Press, 2015).
18 Pew Research Center, *European Unity on the Rocks* (Washington: Pew Research Center, 2012).

have been dominated by a search for national advantage, as well as endemic conflict between the ECB and European governments about which would bear the risks associated with new initiatives, the response to the Euro crisis has looked like a zero-sum enterprise in which the risks or costs of new initiatives are borne more heavily by some actors than others. As a result, it has become more difficult to argue that further European integration is an enterprise from which all the member states will gain.

> ## THE EUROZONE MAY BECOME LOCKED INTO A DEFLATIONARY MACROECONOMIC STANCE THAT CONDEMNS SOME OF ITS MEMBER STATES TO SLOW RATES OF ECONOMIC GROWTH FOR YEARS TO COME

Therefore, the EU finds itself on the horns of a dilemma. Influential figures are arguing that the single currency will survive only if the Eurozone has an economic government of its own. But, since there seems no way of making such a government truly democratic, moves in this direction threaten to replace embryonic democratic institutions with a new technocracy. Caught between Scylla and Charybdis, the member states are currently temporizing. With a fiscal compact committing the member states to budgetary balance and new regulations for the supervision of national budgets, the European authorities have acquired unprecedented powers of purview over national budgets, but it remains unclear whether those powers will ever really be exercised.

Moreover, a fiscal compact that marries a "one-size-fits-all" fiscal policy to the "one-size-fits-all" monetary policy of the single currency is not a recipe for economic success. As I have noted, because the political economies of the member states are organized in different ways, they cannot all emulate the export-led growth strategies of Germany. Some can prosper only via demand-led growth strategies that require more relaxed fiscal policies. The clear-cut danger is that the Eurozone may become locked into a deflationary macroeconomic stance that condemns some of its member states to slow rates of economic growth for years to come.

In this respect, institutional reform will not in itself solve Europe's economic problems. The important issue is what sorts of decisions would emerge from any new set of European institutions, and those decisions will depend on the relative power and positions of the national states represented there. A new set of institutions dominated by

a German government convinced that the budgets of every member state should always be balanced (and that trade surpluses reflect virtue while deficits result from vice) might yield policies no more conducive to growth than the current ones. Macroeconomic coordination at the European level will not be successful until those supervising it realize that there is more than one route to economic success.

Does this mean that, if the member states of the Euro do not move closer to fiscal and political union, the single currency is doomed to disintegrate? Not necessarily. The Eurozone does not yet have robust institutional mechanisms for economic adjustment. But it is arguable that, with a slightly more-developed institutional exoskeleton built on recent practice, the single currency may be able to endure.[19] Based on the experience of the Euro crisis, national governments may be more careful about letting public or private sector debt balloon beyond control and, if yields in sovereign debt markets become more responsive to such developments, they will have more incentives to do so. One key condition for economic success is a robust banking union capable of identifying and winding down insolvent banks so as to maintain transnational financial flows. Although stalled on the issue of cross-national deposit insurance and equipped with a bank resolution fund that is currently too small, plans for such a banking union are proceeding.

Another condition underlined during the Euro crisis is the presence of a European central bank with the capability to act as a lender of last resort both to banks and to sovereigns in order to deter speculative attacks in the financial markets. Although it is still formally enjoined from purchasing sovereign debt, the ECB has moved in this direction over recent years with its program of outright monetary transactions (OMT) backed by an announced resolve "to do what it takes" to preserve the Euro. Much depends on whether these practices are accepted as legitimate modes of operation going forward, and it is conceivable that they might be.

From my perspective, the key issue is whether the single currency can be sustained even if some member states run endemic deficits on their current account while others run persistent surpluses, since the presence of multiple varieties of capitalism inside the Euro makes that likely. In principle, this need not be a problem: after all, some states in

19 For an argument to this effect, see D. Soskice and D. Hope, "The Eurozone and Political Economic Institutions: A Review Article," in preparation for the *Annual Review of Political Science* (2016).

the American currency union run endemic deficits or surpluses vis-à-vis one another. For that to be possible, investors in the states that acquire funds by running surpluses must be willing to invest some of those funds in states running deficits. A banking union offering reassurance about the solvency of counterparties helps make that possible. However, the growth prospects of the states running deficits must also look good enough to justify such investment. Thus, the fate of the Euro hangs to some extent on future prosperity in southern Europe.

In previous decades, a catch-up process that leads countries at lower levels of economic development to converge toward the standard of living of those at higher levels of development has provided incentives for investment in southern Europe. The Euro crisis has disrupted that process, and investors will be more wary about the types of asset booms that appeared over the last ten years. Therefore, much will depend on the capacity of the states on the southern and eastern boundaries of Europe to generate growth in new ways and, in particular, to move towards the production of higher value-added commodities in the context of global markets where the comparative advantages for low-cost production lie elsewhere. That will require, in turn, that these countries adjust to the modalities of an emerging knowledge economy.

To date, the record of southern Europe on these fronts is spotty. Except in some regions, levels of vocational training and tertiary education lag behind those of northern Europe, and spending on research and development is at relatively low levels. But there is opportunity for improvement to be found here. The larger lesson is that the survival of the Euro and the prosperity of much of the continent will depend not simply on the short-term decisions taken about how to survive the crisis, but on the decisions that are made in the countries of southern and eastern Europe about how to invest in the levels of human capital and infrastructure that will position them for effective long-term growth.

In this regard, the future of Europe lies as much in the hands of national governments as it does in extended European cooperation. In many parts of Europe, the public evinces lower levels of trust in national governments than it does in the European Union, and there is corresponding turmoil in national politics.[20] Whether political coalitions capable

20 J. Frieden, "The Crisis, the Public and the Future of European Integration." Paper presented to a conference on Transition and Reform: European Economies in the Wake of the Economic Crisis, Lisbon, May 2015.

of constructing effective national growth strategies can emerge from that turmoil remains to be seen. But, provided Europe gives its member states adequate room for maneuver, this is not an impossible dream.

ALBERTO ALESINA is the
Nathaniel Ropes Professor of
Political Economy at Harvard
University, where he served as
Chairman of the Department
of Economics. He is a member
of the National Bureau of Eco-
nomic Research, the Center for
Economic Policy Research, the
Econometric Society and the
American Academy of Arts and
Sciences. He has been a Co-ed-
itor of the *Quarterly Journal of
Economics* and Associate Editor
of many academic journals. He
has published five books, among
them *The Future of Europe:
Reform or Decline and Fighting
Poverty in the US* and *Europe: A
World of Difference*.

Trust amongst citizens is a fundamental feature which facilitates economic and financial trans- actions. Without it, we need often ineffectual, detailed regulation to prevent uncooperative be- havior, cheating, and contract breaching. Without trust courts get overwhelmed and public policies are unfeasible. In Europe, the recent Greek crisis has reduced the level of trust amongst Europe- ans, especially along the North-South axis. Thus, it will become more difficult to engage in the necessary regulatory reforms needed in the Euro area, including a more integrated fiscal policy, a European level unemployment subsidy legisla- tion and banking union.

RULES, COOPERATION AND TRUST IN THE EURO AREA

The argument

Mutual trust is a key element for the functioning of a polity to run smoothly. A large body of evidence shows that mutual trust promotes investment and growth, makes international trade easier, causes financial markets to work more efficiently, encourages citizens to participate in socially productive activity, and heightens their involvement in politics, a fundamental necessity for a working democracy[1]. Laws are followed not only because they are enforced but as part of a mutually beneficial social contract. With mutual trust, cooperation amongst individuals is easier to sustain. Thus, litigation becomes less prevalent and private contracts are more widely respected.

> LAWS ARE ALSO FOLLOWED BECAUSE
> THEY ARE PART OF A SOCIAL CONTRACT
> THAT BENEFITS EVERYONE

On the contrary, when individuals do not trust each other, we have instead heavy involvement of courts in individuals' lives and invasive economic rules and regulations. These are poor substitutes; courts may be overused in a non-trusting and litigious society. In addition, lack of trust may also imply that courts are also untrustworthy, with the obvious costs associated with uncertainty of the legal system. Regulation becomes excessive when many contracts or many individual behaviors require detailed prescriptions in order to prevent cheating and litigation. In fact, in many cases it is impossible (or very hard) to eliminate cheating through legislation, and often, regulation involves heavy economic costs with mediocre achievement. The more complicated regulations are, the easier it is for corrupt bureaucrats to extract bribes to circumvent them.

1 For a classic treatment of the negative effects of lack of trust, see Banfield (1959) and, more recently, Fukuyama (1995)

Thus, regulations meant to enforce law-abiding behavior, such as honesty in paying taxes, may yield the exact opposite effect.

The available evidence suggests that individuals place more trust in society's members who are similar to themselves in terms of culture, ethnicity, and religion. In particular, mutual trust is stronger within a country than across citizens of different countries. In addition, citizens of certain countries are generally trusted more than citizens of other countries and patterns of mutual trust vary across countries.[2] Thus, trust across citizens of different countries in Europe travels less well than amongst citizens of the same country, even in the absence of any particular problem at the community level.

PEOPLE PLACE MOST TRUST IN THOSE WHO ARE SIMILAR TO THEM IN TERMS OF CULTURE, ETHNICITY, AND RELIGION: MUTUAL TRUST IS STRONGER BETWEEN CITIZENS OF THE SAME COUNTRY

The argument of the present chapter is that the larger and more long-lasting consequence of the recent Greek crisis in the Euro Area will be a sharp reduction in the level of trust across citizens of different countries in Europe. Traditional views or stereotypes about "lazy southerners," "ungenerous Germans," "rigid northerners," and "deficit-prone Mediterraneans" have certainly been reinforced in recent years. In addition, opinions about the progress of European integration have suffered. The problem is that when individual members of a polity (the European Union or the Euro Area) do not trust each other, the polity does not work properly.

The effect of this decline in mutual trust will be to make progress in fixing the obvious problems in the Euro Area more difficult. Decreasing trust in the European Union will be an obstacle in many policy areas. In this chapter, we consider two examples in particular: fiscal policy and deficit managements, and a European unemployment insurance policy. In both areas, substantial progress in mutual cooperation would be necessary and useful, but lack of trust (aggravated by the Greek crisis) will make them more difficult to implement. There will be an even heavier reliance on fixed rules, which are a second best (very far from the first best) solution of managing a common fiscal policy in a monetary union.

2 See data from the Word Value Survey and the review article by Alesina and Giuliano (2015)

Indeed, it is true that the Greek crisis has forced Euro countries to adopt new policies regarding bail-outs and common funds for this purpose. My sense, however, is that the more pronounced effect of the Greek crisis will be a step backwards in the process of building common economic institutions and a common area that is relatively regulation free and based on trust.

Trust and rules: what do we know?

Several papers have recently established that heavy regulation is often a poor substitute for trust; in other words, non-trusting countries tend to legislate onerous forms of regulation. A case in point is France. In this country, the level of trust as measured by World Value Survey is extremely low (given the high level of this country's GDP per capita), and regulation in this country is notoriously extensive.

More generally, Aghion et al. (2010) show that in countries where trust is low, regulation is higher. When trust is low, individuals prefer the inefficiency of regulation in exchange for partial "protection" against cheating and non-cooperative behavior. When trust is high, regulation is less necessary and people demand less of it. These authors provide a model with two equilibria, one with high trust and low regulation, and one with low trust and high regulation. Both are self-sustaining equilibria. Thus, if the level of trust evolves slowly, this model also explains why inefficient regulation may last for a long time.

These authors provide evidence on these points by showing that results hold using three different datasets: the World Values Survey, the International Social Survey Program, and the Life in Transition Survey. The World Values Survey poses general questions concerning attitudes towards competition or state intervention, in addition to trust, for about 80 countries. The International Social Survey Program contains specific questions on the regulation of wages and prices. The Life in Transition survey provides evidence on 28 post-Communist countries in Europe and Central Asia, and it has questions on preferences for market versus planned economies. Using all these surveys, the authors find consistent evidence that distrust leads to support for government regulation. The less people trust each other, the more they want the government to regulate social interactions. In addition, the authors look at the change in attitudes from 1990 and 2000 in transition economies

relative to OECD countries. Liberalization of entrepreneurial activity in transition economies starting from a low level of civic trust demands greater state control of economic activity, thus eroding trust even more.

Francois and Ypersele (2009), using data from the General Social Survey (a well-respected and widely used survey for the US), found a strong positive relationship between individual trust and the competitiveness of the sector in which an individual works. Their idea is that competition mitigates incentives for free riding by imposing a costly shutdown on poor-performing firms, making employees more trustworthy.

Aghion, Algan, and Cahuc (2011) provide a model in which higher minimum wage regulation reduces the benefits to workers of trying to cooperate with firms. Therefore, more stringent minimum wage regulations crowd out cooperation between firms and workers. In turn, less cooperative firm-worker relationships increase the demand for minimum wage regulation.

Alesina et al. (2015) show that labor market regulation may be related to the general sense of trust in society. In countries with a low level of trust, individuals are willing to move geographically to search for the available jobs, and matching is efficient in an unregulated competitive market. In countries were trust is limited to one's family, individuals are reluctant to move. In order to prevent monopsonistic power of local firms, labor market regulation is viewed as a second best option relative to a completive labor market with geographical mobility. Unemployment and poor matching are accepted as the cost necessary to avoid moving from the only trustworthy environment of the family and the neighborhood. These authors show compelling evidence of these effects using a variety of sources.

Ample evidence also suggests that trust travels less well across countries than within a country. Guis, Sapienza, and Zingales (2004), for example, show how relatively low international trust explains home bias in financial investments. In addition, mutual trust amongst pairs of countries is related to their level of international trade in goods and FDI.

Therefore, a fall in the level of trust amongst Europeans may very well be associated with more demand for regulation and less integration. Indeed, this may be problematic because the European Union in general has a tendency for overregulation, as argued by Alesina and Perotti (1998). The authors, using the example of the (in)famous and fortunately now forgotten "Lisbon agenda," show how the European tendency to overregulate can lead to almost bizarre extremes. For instance, the Lisbon agenda

prescribed a target for the share of children of various age groups who had to be in preschool institutions subsidized by the taxpayers, among hundreds of other goals. This is an example of how the lack of trust for countries to do what is best for them and Europe, combined with an innate tendency for Europeans to resort to state intervention, leads to at the very least an enormous waste of time, given that the Lisbon agenda is now forgotten. However in many other cases, as discussed below, the cost of excessive regulation goes well beyond a waste of time.

EUROPEANS ARE TRAPPED IN A DILEMMA: THEY ARE RELUCTANT TO MOVE TOWARD GREATER INTEGRATION, BUT ARE NOT WILLING TO GIVE UP THE EUROPEAN PROJECT

The crisis in Greece, and more generally the divergence of economic performance between northern and southern Europe, has put Europeans into something of a "trap," as argued by Guis, Sapienza, and Zingales (2015). The argument by the supporters of European integration was the so-called Monnet's doctrine. According to this view, every step, no matter which, in the direction of more integration would have created incentives to move further towards more integration in other areas. For instance, monetary union would have automatically created the incentives to move towards more fiscal integration and eventually toward political integration. In other words, the response of European enthusiasts to the critics, who had argued that a monetary union cannot work without a political union, was precisely Monnet's doctrine. Recent events and the accompanying reduction in trust amongst Europeans have put Monnet's doctrine on hold. Europeans are in a trap: on one hand, they are reluctant to move toward more integration (given that they do not trust each other and disagree on major policy issues such as fiscal policy); on the other hand, they are not willing to give up the current level of integration. According to recent surveys, enthusiasm for the European project remains, but the question is: can a monetary union in this trap survive?

Fiscal rules in a monetary union

When the Euro was introduced, there were two views about how fiscal policy should have been handled. One view was that since monetary

The German Parliament approves the ratification
of the Stability Pact on June 2012.

policy was not in the hands of the national monetary authority, fiscal policy had to be flexible to allow for anticyclical adjustments, allowing automatic stabilizers to do their job fully. Within the limits of how much discretionary fiscal policy can be used as an anticyclical tool (and these limits are indeed restrictive), the argument is theoretically solid. The other view was that rules had to be imposed to prevent countries that generated large deficits from imposing negative externalities (high interest rates, risk of defaults, potential bailouts) on other countries. Given the relatively low level of trust amongst the members of the Union, the second approach gained traction.

Here we have another example of regulation instead of trust. Since Europeans could not trust each other regarding fiscal policy (perhaps correctly so), they had to introduce regulations, like the Stability and Growth Pact, which was a sort of elaborately balanced budget rule with escape clauses.

Balanced budget rules are suboptimal because they interfere with anticyclical movements of deficits. They are, however, a second best solution when political disruptions generate large and persistent deficits.[3]

3 See Alesina and Passalacqua (2015) for a review of the literature on political influences on budget deficits and a discussion of pros and cons of balanced budget rules. On the latter point, with special reference to Europe, see also Wyplosz (2014)

Clearly, Europeans thought that some countries could not be trusted and that a regulation on the deficit was necessary.

However, as is well known, this regulatory policy did not work. Rules were not followed. In fact, Germany was the first country to break the stability and growth path in the early 2000s, but many other countries followed. After a round of deficit reduction policies in line with the criteria for joining the union, after year 2000, countries "relaxed". Despite the reasonably high level of growth in Europe at that time, deficits generally increased.

The reasons why Germany violated the rules can be debated. It could have been a way of helping the labor market and liberalization by Chancellor Kohl, or the aftershock of the reunification, or simply a slippage of the traditional rigorous German stance on the deficit. Be that as it may, Germany violated the SGP. This was the beginning of a host of other violations, including the extraordinary large one by Greece, a country that also cheated on its statistics to hide the mounting deficits.

This was the first blow to an already relative low level of intra-country trust within the Euro Area. The Greek crisis, which lasted several years ("Is it over?" one may ask), reduced mutual trust even further. The effect on the Greek-German relationship was particularly extreme. Fouka and Voth (2015) show that the sale of German cars dropped in Greece (after controlling for the effect of the recession and sale of other countries' cars), especially in places in Greece that had suffered more from Nazi violence. This is a rather worrisome result if it implies that ancient hatreds are revived by recent events.

Even the handling of the so-called austerity in Europe can be related to low (and declining) levels of trust. A vast body of recent research (see Alesina, Favero and Giavazzi (2015), Alesina et al. (2015), and the references cited therein) has established the following results regarding deficit reduction policies. First, and most importantly, spending cuts are much less costly than tax increases in terms of output losses. Second, well-designed fiscal adjustment plans, in multi-year periods by various pro-growth reforms (labor market liberalizations, etc.), may reduce the costs of fiscal adjustment to zero and in some case be expansionary.

European austerity did not follow these principles. Because of the fear of contagion from Greece and the lack of trust about the intention of countries to follow adequate policies, European institutions enforced austerity of any type at all costs. For instance, it would have been wiser to adopt spending cuts but avoid tax increases even at the cost of slowing

down the pace of fiscal adjustments. When Europe could not emerge quickly from a recession, allowing tax cuts would have been desirable. These policies would have implied "trust" that countries were not simply on a continuing unsustainable path of fiscal deficits, but instead were designing appropriate multiyear adjustment policies. However, because of the Greek contagion (which also implied lack of market trust vis-à-vis other indebted countries) and the generalized mistrust, European institutions demanded any kind of deficit reduction policies immediately.

The collapse of trust in the markets was also a factor. European institutions mishandled the Greek crisis before and during the financial crisis. The uncertainty about whether states would be bailed out or not generated market instability. Before the crisis, markets treated southern European debt, including Greek debt, basically as German debt, with no risk premium. That was an incentive for some countries to borrow since it was so cheap. When the Greek crisis exploded, the market was unsure for a while about what policymakers would do, and the crisis spread.

In an ideal world, countries could be trusted to implement well-designed fiscal adjustment polices without exporting contagion to the Euro Area. Was it reasonable for northern Europe not to trust the sincere desire of southern Europe in general (not only Greece) to adopt responsible fiscal policies? We will never know for sure, but my guess is that the collapse of trust beyond Greece surpassed what might have been reasonable. Was it reasonable for (some) southern European politicians to blame the northerners for the delays in their policy reforms and their inability to establish credibility with the markets? In most cases, the answer is no.

The result of these events is that the Euro Area is now moving even more in the direction of rules to tighten budget controls. Currently, European institutions get involved in discussions about the first decimal of deficit projections of this or that country. As expected, tightening the rules of the failed compact seems to be the answer to the collapse in trust.

Unemployment insurance in a monetary union

In the United States, the federal government finances the unemployment subsidy program. This means than when a state in the union

suffers disproportionally from a recession, other states indirectly redistribute to the badly hit states through the federal unemployment insurance program. In some cases, these redistributions are quite large when recessions hit different states in very different ways, as the Great Recession did.

In Europe, unemployment subsidies are national programs. There has been some discussion about making them supranational. Recently, the French authorities proposed a plan to introduce unemployment subsidies financed at the European level with funds provided in some proportion by national governments.

WITH SUPRANATIONAL UNEMPLOYMENT INSURANCE, THE INCENTIVES ARE LESS FOR A NATIONAL GOVERNMENT TO ENGAGE IN POLICIES THAT RESCUE THE UNEMPLOYED

This is a good idea in theory. Monetary policy cannot target the need of states in deeper recessions than others, since this is common for the Euro Area, and the European Central Bank can only target "average" European macroeconomic trends, for instance, inflation and, indirectly, income growth. As we have discussed above, even fiscal policy is constrained by the fiscal compact. In addition, labor migration within Europe is much lower than in the US, and different levels of unemployment in different European countries generated much lower response in terms of labor mobility than in the US.

I predict that this proposal will not be implemented anytime soon. The reason is, once again, the lack of mutual trust. With supranationalunemployment insurance, the incentives are less for a national government to engage in policies that rescue the unemployed. In Europe, with its highly regulated labor market, these policies would involve some sort of liberalization, with the details differing from country to country. As is well known, this issue is politically quite challenging because of the stance of local unions. If unemployment subsidies were financed by a European fund, then the political incentives to engage in the necessary struggle to implement labor market reforms would decline, and the costs of this would be transferred to the supranational level.

On the other hand, one may argue, labor market reforms that could imply some temporary unemployment in the short run, compensated by long-run gains, would be made easier by European level unemployment

subsidies. This force, however, would be at work if European partners would trust each other about the long-term commitment to labor reforms. That is, European institutions should view unemployment in this or that country as a temporary cost to pay in a period of reforms (if those cost existed), rather than a permanent attempt of that country to receive funding from Europe. Lacking this trust, I am afraid the first type of incentive and political argument would prevail.

LABOR MARKET REFORMS
THAT COULD IMPLY SOME TEMPORARY
UNEMPLOYMENT IN THE SHORT RUN, WOULD
BE COMPENSATED BY LONG RUN GAINS

If, in the future, such a system of unemployment subsidies financed at the Euro level became acceptable, it most likely would be accompanied by a set of complicated rules to avoid the behavior described above of simply accepting national unemployment subsidized by Europe (or at least not do enough to reduce it). I envision a Euro Area agreement accompanied by a complete set of prescriptions about the level of unemployment, cyclical versus structural (and who decides?); what to do about black economy employment; and under what circumstances funds would be available and potentially subsidized supranationally, etc. Whether such a set of rules would make the system work or actually be counterproductive and confusing would remain to be seen.

Conclusions

Citizens of a common monetary area need a minimum level of trust to make their union work. The European Monetary Union joins several countries with different attitudes, cultures, and histories. Critics of the euro project (for instance Martin Feldstein) suggested that the monetary union would instead add to the potential animosity amongst members, and he was proven right. The level of animosity amongst European partners is at a high point.

At this stage, I see two possibilities. The pessimistic view is that Europeans are correct in not trusting each other. Southern Europeans are indeed unable to keep their budgets in order and/or to be more efficient in managing their economies. Northern Europeans are indeed

unwilling to do any more in terms of redistribution to help southerners and continue to demand unreasonable conditions. As a result, the Euro Area might survive only with a set of stringent and inefficient rules.

The optimistic view is that the Greek crisis has taught a positive lesson to all concerned. Can trust increase in a group lacking it? This is indeed a tough question that relates more generally to the issue of how quickly certain cultural traits evolve.[4] Certain cultural attitudes are quite persistent; however, recent evidence by Giavazzi, Petkov, and Schiantarelli (2014) suggests that perhaps people can learn to trust each other relatively quickly. Their evidence is based on immigrants to the US and thus refers to individuals in contact with each other. This suggests that education and a closer interaction between Europeans may work in the right direction. For instance, Erasmus programs and other educational exchanges may help.

Geographical mobility within Euro Area countries is, in fact, notoriously low compared to the US, probably lower than what it is normally believed to be a condition for labor market adjustments in a monetary union. There is, however, a more subtle reason why more geographical mobility may help. In addition to clearing labor markets, it may also help develop more trusting Europeans.

What is certain is that without a minimum level of trust, a monetary union does not function well.

4 For an overview of this and related issues about persistence of cultural traits, see Alesina and Giuliano (2015)

BARRY EICHENGREEN
is the George C. Pardee and
Helen N. Pardee Professor of
Economics and Professor of
Political Science at the Univer-
sity of California. He was Senior
Policy Advisor at the IMF, and
he is a fellow of the American
Academy of Arts and Sciences
and one of Foreign Policy Maga-
zine's 100 Leading Global Think-
ers in 2011. His two most recent
books, *Exorbitant Privilege: The
Rise and Fall of the Dollar and the
Future of the International Mone-
tary System* and *Hall of Mirrors:
The Great Depression, the Great
Recession, and the Uses and Mis-
uses of History*, were listed for
the Financial Times awards.

The ECB has moved from part of the problem
to part of the solution. At first, it only focused
on inflation, it neglected risks to financial
stability, it opposed debt restructuring and it
hesitated to embark on quantitative easing
even when the spectre of deflation loomed.
Now it recognises its lender and liquidity
provider responsibilities, it has shown itself
capable of pursuing unconventional policies
in unusual cirucmstances, it has softened its
doctrinal opposition to debt restructuring and
it has assumed additional responsibilities for
banking and financial supervision.

THE EUROPEAN CENTRAL BANK: FROM PROBLEM TO SOLUTION

The European Central Bank is an evolving institution. Since 2007, it has evolved from being part of the problem to being part of the solution. Prior to the outbreak of the global financial crisis, which we can conveniently date to August 9, 2007, when BNP Paribus suspended three of its funds due to problems with their investments in U.S. subprime-linked securities, the ECB focused narrowly on its price stability mandate to the exclusion of financial stability-related goals. After then taking a series of exceptional steps in 2007 and 2008, in response to problems in Europe's banks and financial markets, in 2009, it prematurely concluded that its work was done and contemplated phasing out its unconventional policies. In 2010 and 2011, it opposed all talk of a Greek

THE ECB OPPOSED ALL TALK OF DEBT RESTRUCTURING, IT RAISED INTEREST RATES TWICE AND REFUSED TO MOVE TO QUANTITATIVE EASING

debt restructuring, instead saddling the Greek sovereign with additional debt that went to pay off its French and German bank creditors. In 2011, still fixated on inflation, it raised interest rates twice, tightening the screws on the crisis countries. Even when it became clear that the real and pressing danger was deflation, the central bank refused to move to quantitative easing a l'Amérique.

Yet, in the course of the crisis, the ECB learned from experience. It embarked on a series of increasingly ambitious operations designed to address liquidity problems in Europe's banks and financial markets. In 2012, Mario Draghi issued his famous "do whatever it takes" ultimatum, signalling his and the institution's commitment to take whatever measures were needed to ensure the cohesion of the euro area. The crisis having highlighted the folly of monetary union without banking union, the central bank was designated Single Supervisor of systemically important commercial banks in 2013. And at the beginning of

2015, in response to the threat of imminent deflation, the ECB "crossed the Rubicon", to use the now standard phraseology, initiating quantitative easing.

This characterization of the ECB as evolving from part of the problem to part of the solution, while containing a kernel of truth, is of course a vast oversimplification. The ECB did not entirely abdicate its responsibility for financial stability before 2007, or for the cohesion of the Eurozone before 2012. After 2011, it did not move quickly enough

THE CENTRAL BANK WAS CRITISIZED IN ITS EARLY YEARS BECAUSE OF ITS TENDENCY TO OVERSHOOT ITS 2% INFLATION TARGET

in abandoning its opposition to a deeper Greek debt restructuring and in distancing itself from matters tangential to central bank policy, in which it became embroiled as a result of its participation in the Troika of institutions negotiating with the Greek government. Quantitative easing in 2015 was long overdue.

Still, there is ample evidence that the ECB is a learning institution. A review of what it learned in the eight years ending in 2015 may therefore provide some guidance as to what it will learn, and what kind of central bank the euro area will possess, going forward.

* * * * *

The ECB was created to serve as a bulwark against inflation, reflecting German fears that inflation is always right around the corner. The Treaty on the Functioning of the European Union (Article 127, Parts 1 and 2) defines the primary objective of the ECB and the national central banks that together comprise the European System of Central Banks as "to maintain price stability." The article goes on to mention the central bank's obligation to support the general economic policies of the union, act in accordance with the principle of an open economy with free competition, and promote the smooth operation of the payment system. "Support[ing] [...] general economic policies" and "act[ing] in accordance with the principle of an open economy" can encompass many sins, but there is no question that price stability was always the institution's paramount goal. Enshrinement of such in

the relevant European treaties was Germany's price for agreeing to move to monetary union.

Much criticism of the central bank in its early years centered on its tendency to overshoot its 2 percent inflation target and on the danger that currency depreciation augured even higher inflation (see for example Galí 2002). Successive ECB presidents, Wim Duisenberg, through October 2003, and Jean-Claude Trichet, thereafter, hence sought to show that they were committed to the institution's inflation target—to demonstrate, as I put it in Eichengreen (2015), that they were as Teutonic inflation fighters as any German.

The introductory statements of the president and vice president at the press conferences following the governing council's periodic monetary policy decisions contain many more references to inflation and price stability than to financial imbalances and financial instability.[1] The ECB was notably silent in this period about the financial imbalances building up as a result of massive capital flows from Northern to Southern Europe and the risks of investments by French and German banks in the bonds of Southern European countries and U.S. mortgage-linked securities. Adjustments in the central bank's policy rates were geared toward moving actual and expected rates of inflation toward target rates. Little attention was paid to differences in credit conditions in Northern and Southern Europe and what these might imply for financial stability (Micossi 2015).

The situation changed abruptly, in 2007, with BNP Paribas' fateful August 9th announcement. The resulting scramble for liquidity created serious problems for European banks and borrowers, especially those thought to have invested in the same securities held by the three BNP Paribas funds. The ECB responded with a "full allotment at policy rate" initiative, under which it committed to providing as much liquidity as the banks might require, in the form of overnight loans, at prevailing policy rates. The ECB dispersed as much as €95 billion through this channel on the Thursday in question (Trichet 2011).

This response was ambitious even by the standards of the Federal Reserve up to this point in time, though its import was minimized by Trichet, who characterized it as a "fine-tuning operation." But the episode suggests that the ECB, while still unaware of solvency problems

1 These statements are catalogued on the ECB website at https://www.ecb.europa.eu/ press/pressconf/2015/html/index.en.html.press/pressconf/2015/html/index.en.html.

in Europe's banking system, was not entirely neglectful of its responsibility for the operation of the payments system and, relatedly, of the interbank market. Not that this indicated any diminished preoccupation with price stability: the ECB raised its policy rate by 25 basis points in July 2008—not exactly propitious timing—in order to "counteract the increasing upside risks to stability over the medium term," in Trichet's words in his introductory statement following the July 3rd governing board meeting.[2] Trichet specifically cited the contribution of food and fuel to the inflation overshoot, indicating an inability or unwillingness to distinguish headline from core inflation.[3] He further cited the relatively rapid growth of money and credit aggregates in an obligatory bow toward German monetarism, thereby failing to distinguish credit growth as a reflection of a healthy supply and demand for funds from credit growth as a reflection of an exceptional demand for liquidity. He emphasized, naïvely in hindsight, the absence of major imbalances in the European economy.

It is unsurprising, then, that the ECB's balance sheet showed little growth in the nine months leading up to the crisis sparked by the failure of the U.S. investment bank Lehman Bros., although the central bank did shift its repurchase (repo) operations toward longer-term securities, providing banks with liquidity longer than overnight.[4] In response to the post-Lehman liquidity squeeze, the ECB again ramped up its policy of fixed rate tenders with full allotment. This was an acknowledgement that the liquidity problem was now affecting more than just the interbank overnight market.

In addition, the ECB provided long-term refinancing operations (LTRO), also at a fixed rate and on a full-allotment basis, as always (up to this point) against good collateral, for up to three months.[5] The collateral requirements in question were eased a number of times, while the

2 https://www.ecb.europa.eu/press/pressconf/2008/html/is080703.en.html.
3 This is something I talk about more in Eichengreen (2015).
4 Nor, it should be noted, did the Fed's balance sheet grow dramatically in this period.
5 In addition, the ECB provided U.S. dollar liquidity to European banks that had funded themselves in dollars, in September providing overnight liquidity and then starting in October conducting regular auctions of dollar liquidity and offering as much as $100 billion for as long as 84 days, using its swap lines with the Federal Reserve. Again, the length of the commitment was an indication of the realization that more than overnight markets were now being affected. In addition, in 2010 liquidity swap arrangements with foreign central banks were reactivated, and the ECB again provided US dollar liquidity at fixed rates with full allotment against eligible collateral. See below.

maturity of LTROs was extended. The ECB introduced operations with a maturity of 6 months and then 1 year. In December 2011, and February 2012, it conducted two very long-term refinancing operations (VLTROs) with a maturity of 3 years and a cumulative magnitude of more than €1 trillion (although part of these operations only substituted previous borrowing at shorter maturities). The credit threshold for eligibility of collateral was lowered from A- to BBB- for marketable assets (with the exception of asset-backed securities) and non-marketable assets (which were subject to an additional haircut). 80 percent of this borrowing was by banks in the Eurozone's five troubled economies: Spain, Portugal, Italy, Greece, and Ireland.

FOLLOWING LEHMAN'S BANKRUPTCY, THE ECB ACKNOWLEDGED THAT THE LIQUIDITY PROBLEM WAS NOW AFFECTING MORE THAN JUST THE INTERBANK OVERNIGHT MARKET

The consequence was a lengthening of the maturity of assets on the ECB's balance sheet and some de facto increase in the credit risk of that portfolio. This now was liquidity provision big time, although it still failed to reflect an awareness of deeper solvency problems that mere liquidity-related operations could not help address.

LTRO and VLTRO were designed to address problems in the banks, understandably given that the interbank market was first to be hit by the BNP Paribas event, and appropriately given bank dominance of Europe's financial system. Following Lehman's bankruptcy, however, liquidity problems spread from the banks to securities markets. Buying private sector liabilities to address liquidity problems in specific segments of the securities market—engaging in what U.S. Federal Reserve Chair Bernanke referred to as "credit easing" to distinguish it, not always successfully, from "quantitative easing"—would be a significant departure for the ECB. It would also be controversial, given the tendency for credit easing and quantitative easing to overlap.

Thus, the ECB proceeded incrementally, starting with purchases of covered bonds (securities issued by the banks and packaged in such a way as to limit credit risk). Covered bonds, in the words of Trichet, "are different in nature from the various asset-backed securities that became so popular before turning sour with the financial crisis. Importantly, covered bonds do not involve the transfer of the credit risk

implied by underlying assets from the issuer to the investor." Of course, if the credit risk of covered bonds was so limited, one might ask why there was such a limited appetite for them from private purchasers. Be this as it may, covered bond purchases and related operations appear to have succeeded in reducing interest rate spreads in money markets to pre-crisis levels and stimulating a higher level of activity in repo markets. On this basis, the ECB concluded that its work was done and turned its attention to phasing out its nonstandard operations.

THE COVERED BOND PURCHASES ESTABLISHED THAT THE CENTRAL BANK COULD PURCHASE PRIVATE-SECTOR LIABILITIES WITHOUT DESTABILIZING THE MONETARY AGGREGATES OR PRICE EXPECTATIONS

The central bank's covered bond purchases at least established that it could purchase private-sector liabilities without destabilizing the monetary aggregates or price expectations. Purchases of government securities, which came perilously close to direct monetary financing of governments, were another matter, or so it was thought. But such purchases became relevant, indeed imperative, with the explosion of sovereign spreads following the eruption of the Greek crisis in late 2009 and early 2010. All of a sudden, it was clear, not least to the ECB, that Europe was engulfed not just in a liquidity crisis but in a full-fledged banking and sovereign debt crisis and that, contrary to prior expectations, the central bank still had plenty to do.

The ECB addressed concerns about direct money financing of budget deficits by limiting its purchases of sovereign bonds to the secondary market, under the terms of the Security Market Programme (SMP) announced in May 2010. It justified the SMP as necessary for the smooth transmission of monetary policy, given that very large sovereign spreads, reflecting concerns over sovereign debt sustainability, were preventing its policy rates from having much impact on the market rates faced by private borrowers. To address concerns about inflation, the ECB committed to sterilizing the impact of the SMP on money aggregates, auctioning fixed term deposits as a way of sequestering commensurate amounts of credit.[6]

6 And to avoid compounding problems in secondary markets, it announced that it would hold the bonds purchased to maturity.

The ex-president of the ECB, Jean-Claude Trichet.

The SMP appears to have had some positive impact on securities markets, reducing the magnitude and volatility of sovereign spreads in the short run. But the program was limited in size: the ECB ended up purchasing just €220 billion of mainly Greek, Irish, Portuguese, Italian, and Spanish government bonds, a drop in the bucket by subsequent standards. And, in and of itself, the SMP did nothing to reassure investors about the sustainability of the public finances of the crisis countries or to significantly brighten the prospects for economic growth and price stability, where deflation now constituted the primary threat to the latter.

By mid-2011, the explosive widening of spreads was back. The ECB resorted to its now tried and true instruments, "actively" implementing the SMP, conducting a second round of covered bond purchases, providing dollar liquidity through its Fed swap lines, and cutting interest rates toward zero. At the end of the year, it extended the duration of credit provided to financial institutions to up to 36 months. These operations continued into 2012. None of them sufficed, however, to contain the mounting threat to the cohesion of the monetary union.

* * * * *

That threat centered on the Greek crisis and on whether Greece's future lay within the Eurozone—a question whose implications for other

crisis countries like Spain, Portugal, Ireland, and Italy was too obvious to state. The ECB had been involved in managing the Greek crisis as one of the institutions, together with the European Commission and the IMF, negotiating with the Greek government over an emergency loan and adjustment program. A number of justifications can and have been offered for its involvement, none of which is compelling. The ECB's official reply to the European Parliament on this question, in 2010, noted that negotiations with Greece might have "implications for monetary policy." But many things have implications for monetary policy, and the central bank is not involved, automatically, in all of them.[7]

It is argued that the ECB had a pecuniary interest in the Greek government's finances, given Greek government bonds acquired through the SMP and the TARGET2 system. But central banks should be motivated by larger concerns than their profits and losses as reflected in their balance-sheet statements.[8] It can be argued that only the ECB had the institutional competence to effectively represent Europe-wide interests in the Greek negotiations—for example, because other institutions lacked expertise on the operation of the Greek banking and financial system. This seems farfetched. But if it is true that other institutions, like the Commission, lacked an adequate brigade of competent financial technicians, then this was simply an argument that it should acquire them and, if necessary, that the ECB provide them on secondment to the proper political authorities. It is argued that since the ECB would be keeping the Greek banks on life support with Emergency Liquidity Assistance (ELA), the central bank had a right to be in the room when the important policy decisions were taken. But this is a rationale for keeping it informed of those decisions, not for giving it a hand in them. Finally, it is argued that the decision of whether to eject Greece from the Eurozone ultimately lay with the ECB, which could bring this about by withholding ELA. But there is a strong counterargument that the decision of whether Greece should be in or out properly lay with elected political officials, not with technocratic central bankers with a narrow monetary mandate.

Indeed, it can be argued that the ECB's participation in the Troika constituted a conflict of interest. It put an ostensibly apolitical institution in the position of negotiating fundamentally political conditions. Its

7 See ECB (2010).
8 For more on the nature and limitations of the argument see Reis (2015).

involvement in the Troika expanded the breadth of the central bank's responsibilities beyond predominantly monetary and financial matters, what with the institutions and the Greek government negotiating over privatization, pension reform, the minimum wage, and other socially delicate matters. The broader the responsibilities of the central bank consequently became and the further it stretched its mandate, the harder it was to hold it accountable for its actions and the greater, therefore, became the threats to its independence, something whose maintenance is essential on narrow monetary policy grounds.

Finally, as the ECB acquired an interest, as a principal in the Troika, in seeing program countries carry out structural reform, economic growth became the enemy insofar as growth reduces the pressure for governments to take painful measures. The incentive to apply pressure for reform thus came into conflict with the central bank's core responsibility of promoting price stability and economic growth.

Such conflicts manifested themselves in the opposition of the ECB, in the person of its then president, Trichet, to a Greek debt restructuring. To many observers, the argument for a restructuring was compelling as early as May 2010.[9] The Troika's projections of the Greek debt/GDP ratio were so incredible as to significantly damage the credibility of the institutions. Yet the ECB continued to oppose all talk of restructuring well into 2011. In April, Trichet wrote a letter to Greek Prime Minister George Papandreou, warning of "grave risks that the Greek government would take if it were to pursue at this juncture a rescheduling of its debt, even on a voluntary basis. [...] Pursuing such a strategy would put Greece's refinancing in euro [meaning access to ECB credit] at major risk."[10] At a meeting of European finance ministers on May 16th and 17th, 2011, Trichet reportedly threatened to retaliate against any restructuring by refusing to supply the Greek banking system with further liquidity, before then storming out of the meeting.[11]

It could be that Trichet was motivated by fears of what a restructuring would do to the European banking system—in which case his fears were unfounded, since the banking system survived when a restructuring of private debt finally occurred in 2012. It could be that he was motivated by fears of what a restructuring would imply for the ECB's balance

9 There is ample documentation of the point in Blustein (2015).
10 Quoted in Xafa (2014), p.15.
11 This according to a report in FT Deutschland.

shcet—in which case his fears were inappropriate, since, to repeat, balance-sheet considerations should not be what motivate a central bank.

In the event, restructuring in 2012 focused on privately-held debt, exempting the ECB from a haircut. In talk of a second restructuring in 2015, this time of officially-held debt, there were hints that the ECB might be permitted to transfer its Greek bond portfolio to the European Stability Mechanism in return for ESM obligations. If so, this would remove the constraint, although not the fact that the ECB had no business opposing a much needed debt restructuring for years.

* * * * *

The last chapter of the tale opens with the succession of Trichet by Draghi, in November 2011, and the rapid evolution in ECB policy that followed. How much of a role was played by presidential leadership and personality will be for future historians to judge; their evaluation will have to wait on the availability of the relevant archives and memoirs. But the speed and extent of the evolution are striking.

FOLLOWING THE SUCCESSION OF TRICHET BY DRAGHI, IN NOVEMBER 2011, THE ECB BEGAN EFFORTS FOR REFORMS

The changes in question began even prior to the formal handover from Trichet to Draghi. In October 2011, just days before the transition, the ECB moderated its earlier unconditional opposition to a Greek restructuring, subject still to the proviso that officially-held debt (read "ECB-held debt") would be exempt from haircuts.[12] Although it was anticipated that Greece's bonds would be downgraded to a rating of "selective default," the ECB agreed to continue to provide liquidity to the Greek banking system through its ELA window.

One can't help but think that the timing of the shift was related to the imminent retirement of the central bank's second president. The ECB's greater flexibility on the option of restructuring did not resolve the Greek crisis or take the spectre of Grexit off the table—far from it—but it was a constructive step. By demonstrating that restructuring, done

12 For details see again Xafa (2014).

right, would not destabilize the European financial system, it made it possible to contemplate further use of the instrument.

Draghi, on assuming the presidency, also inherited the problem that the Security Market Programme had only a short-term palliative effect on bond spreads. He inherited the Greek debt crisis, notwithstanding the first restructuring in March 2012. This continued to raise the spectre of not just Grexit but also the possibility that if Greece went through the door, other troubled euro area countries would be tempted or forced to follow. Bond spreads widened sharply as a result of what ECB officials, in antiseptic central-bank argot, referred to as "redenomination risk."

As Benoit Couré, member of the Executive Board, later put in it a speech:

> For example, the spreads of Spanish and Italian ten-year government bonds relative to Germany had increased by 250 basis points and 200 basis points respectively in July 2012 compared to one year before. In neither one of the two countries, fundamentals had changed so spectacularly to justify such drastic re-pricing of sovereign risk. The Italian government had taken measures which would lead to a reduction in the deficit below the reference value of 3%. The Spanish government had just embarked on a series of reforms re-dressing long-standing problems in the labour market and in the banking sector (Couré 2014).

And yet, the possibility of an investor run on public debt markets, of the sort modeled by Cole and Kehoe (1998), threatened to produce self-fulfilling results and fracture the Eurosystem.

The intensity of the pressure, which mounted over the summer of 2012, led Draghi to issue his dramatic "do whatever it takes" pledge on July 26th. This was the sort of unconditional commitment from which the Trichet ECB had shied away, suggesting that the central bank now had more muscular leadership. The impact on bond spreads was immediate. Spanish and Italian bond yields both fell to sharply lower levels, where they stayed.

Still, the policy was subject to conditions. The popular headline, in fact, came with an important preface; the full sentence read "*Within our mandate*, the ECB is ready to do whatever it takes to preserve the euro" [emphasis added].[13] Mr. Draghi's open-ended pledge was not received happily in Germany. Bundesbank President Jens Weidmann made no secret of his reservations about the commitment to do whatever it

13 <https://www.ecb.europa.eu/press/key/date/2012/html/sp120726.en.html>.

The president of Deutsche Bundesbank, Jens Weidmann, in a press conference.

takes, especially insofar as "whatever" might include large-scale bond purchases. The within-our-mandate clause was designed to reassure Weidmann and other like-minded skeptics.

Second, when the ECB moved in August to implement Draghi's pledge with a program of Outright Monetary Transactions (OMTs)—outright purchases of the bonds of the affected countries—it made activation conditional on the country first negotiating a program with the European Stability Mechanism (ESM).[14] This approach reflected the ECB's prior experience with buying the bonds of troubled Southern European countries. In August 2011, Italian Prime Minister Silvio Berlusconi had agreed to the terms of a letter sent to him by Trichet and Draghi (the latter then still governor of the Bank of Italy but, as such, a member of the ECB governing council), setting down the reforms that the Italian government would have to pursue in return for ECB support. But when

14 As with Draghi's July 2012 pledge, subsequent justifications for OMTs ritually invoked the ECB's mandate. To quote Couré (2014), "Why were these sovereign bond market developments relevant from an ECB perspective? In any economy, the government bond market plays a prominent role in the transmission of monetary policy and ultimately matters for the effective achievement of the central bank's objective—in our case, price stability." While OMT was announced in August, it became operational only in September, potential operations having to wait on the existence of the ESM, which was formally established only toward the end of the latter month.

the ECB began buying Italian government bonds under the SMP, Berlusconi reneged on his commitment to painful reforms. Requiring a country to negotiate either direct budgetary support or a precautionary line of credit with the ESM and to sign a memorandum of understanding was a way of limiting the risk, or raising the cost, of this kind of backsliding. It was also a way of getting the ECB out of the business of negotiating fiscal and structural conditionality, something more appropriately left to politicians and to technocrats like those of the Commission and the IMF for whom this is an explicit part of their charge.

THE FACT THAT THE ECB WAS NOW READY TO ACT AS LIQUIDITY PROVIDER OF LAST RESORT TOOK THE POSSIBILITY OF MULTIPLE EQUILIBRIA, OR SELF-FULFILLING CRISES, OFF THE TABLE

The most striking aspect of OMT was that it didn't actually have to be activated to produce the desired result. Yields on the bonds of troubled European sovereigns other than Greece, obviously a special case, remained at sharply lower levels not just through the end of 2012, but through 2013, and into 2014. Efforts at structural reform and fiscal consolidation in these countries continued. But, echoing the quotation from Coeuré above, there were no dramatic changes in the stance of policy in the countries in question.[15] Reform efforts there had been, and reform efforts there continued to be. But the fact that the ECB was now ready to act as liquidity provider of last resort took the possibility of multiple equilibria, or self-fulfilling crises, off the table. The sharp shift in conditions in Europe's sovereign debt markets thus testifies to the importance of the ECB's evolution from simple inflation targeter and faithful follower of a monetary rule to true lender of last resort.[16]

While OMT removed the specter of a self-fulfilling debt run, it did nothing to address the danger of deflation that developed in the Eurozone and throughout the advanced-economy world, starting in 2012. In

15 There were changes in national political leadership, to be sure, but again it can be questioned whether these sufficed to produce the dramatic turnaround in sovereign spreads.

16 The point had been anticipated long before by Folkerts-Landau and Garber (1992), which only serves to underscore how long it took for the relevant evolution to take place. Inspired by the events of 2012, the issue is formally modelled by Corsetti and Dedola (2014).

Europe, measures of inflation expectations based on both surveys of professional forecasters and overnight inflation swaps (OIS) had been falling since mid-year. The ECB was now alert to the deflation danger, perhaps because deviations from its 2 percent inflation target spoke of the existence of a problem in familiar terms. After some hesitancy, the central bank sent increasingly urgent signals, in the course of 2014, that it was prepared to take additional measures to combat deflation. The governing council cut the deposit rate for commercial banks, keeping funds at the central bank to zero. In June, in an unprecedented step, it moved the deposit rate into negative territory at -0.1 percent. Draghi highlighted deflation risk in his speech to a Federal Reserve conference in Jackson Hole, in August. Then, in September, the ECB cut its main refinancing rate to virtually zero—actually, to 0.05 percent, but no matter. In the spirit of the earlier covered-bond program, now extended to a second tranche, it announced the intention of purchasing asset-backed securities with investment-grade ratings.

All of this fell conspicuously short of quantitative easing—that is, of unconditional purchases of government bonds on the open market—of the sort pursued by other central banks like the Fed, the Bank of England, and the Bank of Japan. The ECB's conventional policies also visibly failed at containing deflation risk; the ECB's own survey of professional forecasters showed longer-term inflation expectations falling again between the third and fourth quarters of 2014 and as being even lower for 2015 Q1. Market-based measures like OIS continued heading down as well in late 2014 and early 2015.

The result was the central bank's "crossing the Rubicon" moment on January 22nd, when Draghi announced a program of purchases of government bonds and private sector securities of €60 billion a month, extending through at least September 2016. The early returns were positive. The euro depreciated against the dollar and on an effective basis, which was desirable from the point of view of pushing up local-currency prices of exportables. The inflation forecast implicit in five year forward swaps rose from 1.5 percent in January to 1.7 percent in June. At this point, the ECB felt comfortable about revising upward its forecasts for inflation and predicting that they would approach its 2 percent target in 2017. Economic growth accelerated modestly if visibly. In the ECB's survey of financing conditions for smaller firms published in June, it reported an improvement in the availability of bank loans. After six months, it was still too early to declare victory, but these achievements at least constituted a strong start.

This, in turn, raises the question of why adoption of the policy took so long, other major central banks having turned to QE years earlier. There were doubts about the effectiveness of security purchases, given the bank-based nature of Europe's financial system. There were questions about whether there existed an adequate stock of investment-grade securities to buy. Draghi himself worried about the Berlusconi problem—that ECB purchases of government securities might relieve the pressure

THE EBA AND THE ECB ITSELF WERE CONSIDERED FOR THE ROLE OF SINGLE SUPERVISOR OF THE BAILOUT, AND THE LATTER WAS CHOSEN

on governments to pursue fiscal and structural reforms. Therefore, he used his Jackson Hole speech in August to emphasize that the central bank by itself couldn't solve all of Europe's problems and to imply that he would be comfortable about moving to QE only with assurances that governments would stay the reformist course.

But surely the most important reason it took 2 and a half years, following the development of significant deflation risk, for the ECB to take this fateful step was that it took that long for Draghi to cultivate support for the policy within the governing board. It took overwhelming evidence that the Eurozone was at risk of deflation for the skeptics to swallow their reservations. Draghi had to convince the German members of his board that QE didn't augur runaway inflation and that it wouldn't subvert reformist effort. Only at this point, almost 17 years after it came into existence, did Europe finally have a central bank prepared to pursue its core mandate—of preventing inflation from deviating dangerously from 2 percent in either direction—by using whatever tools might be required.

* * * * *

The depth of the difficulties experienced by European countries starting in 2010 highlighted the folly of monetary union without banking union. Large capital flows between Northern and Southern Europe in the period preceding the crisis had contributed to the difficulties that followed. Heavily indebted sovereigns were then hamstrung when required to recapitalize their banking systems. The institutional response had three elements: the ESM to provide emergency finance, a bail-in procedure to

ensure that bank equity and bondholders shared the burden of recapitalization, and a single bank supervisor to limit the likelihood that such problems would arise in the first place.

There were questions about whether the ESM was adequately capitalized and whether the EU's bail-in protocol was workable.[17] But perhaps the most contentious issue was where to situate the single supervisor. One option was the European Banking Authority, or EBA, which was responsible for setting regulatory standards for banking practice in the European Union. But the EBA and its predecessor, the Committee of European Banking Supervisors, had not exactly covered themselves in glory in the run-up to the crisis. And it was a problem, from the standpoint of the monetary union, that the EBA was headquartered in London.

The other obvious candidate was the ECB, since money and finance were closely intertwined and central banks effectively exercise supervisory responsibility in a number of other jurisdictions. Indeed, the experience of some countries, the United Kingdom for example, had underscored the dangers of separating supervisory and lender-of-last-resort responsibilities. (Lack of coordination between the Financial Services Authority and Bank of England having been a factor in the run on the building society Northern Rock, the decision was taken subsequently to consolidate the two functions at the central bank.) It can also be argued, in favor of the current British arrangement, that knowledge of financial conditions gained through direct supervision is useful for monetary policy.

A problem was that the ECB possessed little staff with the relevant expertise. Designating the ECB as the single supervisor also raised questions about whether it should and could have responsibility for supervising the systemically important banks of European countries that were not members of the monetary union. European Commission President Barosso reportedly favored the EBA on these grounds. There were also fears that giving the central bank responsibility for bank supervision could create a conflict between functions, when, for example, inflation control dictated higher interest rates but the needs of the banking system pointed to the need for lower ones.

Clearly, there was no perfect solution to this assignment problem. In the end, the decision was taken to make the ECB the single supervisor

17 Since many of the bondholders who would be bailed in might, in practice, be other troubled banks.

The president of the ECB, Mario Draghi, in a press conference.

and to allow EU members that had not adopted the euro to opt in to this part of the banking union. The decision reflected knowledge that other jurisdictions had been moving in the direction of consolidated supervision. It demonstrated that the ECB had shown itself as capable of growing into new responsibilities. It also showed that the ECB was an independent institution perceived as possessing, or as capable of acquiring, the relevant competencies. And it was expedient as a way of avoiding the need for a treaty change, since assigning supervisory responsibility to the Bank could be based on the existing Article 127 (6).

Finally, the assumption by the central bank of this new responsibility reflected effective lobbying by ECB officials happy to expand their domain. Chang (2015) suggests that Draghi, in particular, supported selection of the ECB, for two reasons. First, the central bank's role as lender and liquidity provider to the banks gave it a direct interest in effective supervision. Second, Draghi was a policy entrepreneur who hardly minded that his institution thereby acquired an expanded role.

The ECB subsequently embarked on a binge of hiring staff with experience in bank supervision. It sought to address potential conflicts of interests by establishing a Supervisory Board, separate from but reporting to the Governing Council, and by limiting data exchange between the two committees. The Governing Council does not have input into the decisions of the Supervisory Board but retains the power to object to those decisions and to force the board to reconsider them.

How well this arrangement will work in practice, only time will tell. But assigning significant supervisory authority over the banking and financial system to the central bank is, it increasingly appears, international best practice. And the ECB's assumption of this role is indicative of another stage of the evolution of the institution into a modern central bank.

* * * * *

Skepticism about the stability and sustainability of the Eurozone is rife. The monetary union is heavily indebted. It lacks the wage flexibility, labor mobility, and federal fiscal system of other monetary unions. But an even more fundamental reason for scepticism is that a normal monetary union needs a normal central bank and that, until recently, the Eurozone lacked one. The ECB focused single-mindedly on headline inflation, raising interest rates at the worst possible time. It neglected risks to financial stability in the run-up to the crisis. It opposed debt restructuring where debt restructuring was needed. It hesitated to embark on quantitative easing even when interest rates had fallen to zero and the spectre of deflation loomed.

It is clear that the ECB has moved a considerable distance in response to the crisis and is now evolving into a normal central bank. It acknowledges its responsibilities as lender and liquidity provider of last resort. It has shown itself capable of pursuing unconventional policies in unconventional circumstances. It has softened its doctrinal opposition to debt restructuring. It has assumed additional responsibilities for banking and financial supervision.

It can thus be argued that the ECB has moved from part of the problem to part of the solution. The question for the future is whether the institution will continue to show the capacity to adapt. If the explanation for recent developments is leadership at the top, there is little reason to be reassured, since that leadership can and, eventually, will change. If, in contrast or in addition, the explanation is deep changes in the culture of the ECB, then there is more reason for optimism.

Europe's economic model continues to benefit countries both at the core and at the periphery; however, not all have benefited. The countries in Europe that have come out well from the global economic and financial crisis are those that have harnessed the forces of economic integration most effectively and have addressed weaknesses in the organization of work and welfare, in particular. But in understanding why in parts of Europe the crisis has been so protracted, it is necessary to look beyond structural deficiencies emphasized in Golden Growth and consider the role of money and specifically the functioning of the Eurozone.

INDERMIT GILL is the Director of Development Policy in the Office of the Chief Economist of the World Bank. Between 2008 and 2013, he was the World Bank's Chief Economist for Europe and Central Asia. He directed the 2008 World Development Report "Reshaping Economic Geography", and is a principal author of several World Bank reports, including "Golden Growth: Restoring the Lustre of the European Economic Model", "Diversified Development: Making the Most of Natural Resources in Eurasia" and "An East Asian Renaissance". He has a PhD. in Economics from the University of Chicago.

MARTIN RAISER is the Country Director for Brazil of the World Bank. He holds degrees in Economics and Economic History from the LSE and a PhD in Economics from the University of Kiel. He worked for the Kiel Institute of World Economics and the European Bank for Reconstruction and Development, where he was Director of Country Strategy and Editor of the Transition Report. Since joining the World Bank, he has held positions as the Country Manager in Uzbekistan, Economic Advisor in Ukraine and Country Director for Ukraine, Belarus and Moldova, and as Country Director for Turkey.

NAOTAKA SUGAWARA holds a BA in Political Science from Meiji University, Tokyo, and a Master's degree in International Development from the University of Pittsburgh. He is an economist in the Research Department of the IMF. Previously, he worked at the World Bank in the Office of the Chief Economist and the Poverty Reduction and Economic Management Unit of Europe and Central Asia Region, and in the Development Research Group. He has numerous research publications related to international economics and finance, fiscal policy and financial sector development.

EUROPE'S GROWTH MODEL IN CRISIS

Introduction

In early 2012, the World Bank issued a report on Europe's growth model (Gill and Raiser 2012). Looking at six main elements of the model—trade, finance, enterprise, innovation, labor, and government—, we concluded, overall, that Europe's growth model had worked well during the previous 50 years. Europe had brought two hundred million people from middle to high income through the forces of economic integration. European companies had generated productivity gains, exports, and jobs, and Europeans enjoyed lifestyles that were rightfully the envy of many around the world. But while Europe's growth model was not broken, it needed improvement. European governments were slowing economic growth because they had become extremely large without becoming commensurately efficient. European labor markets and social security systems were struggling to adjust to the reality of an aging population. Too many European companies had failed to innovate, and Europe had left sizeable gains from integration in services—especially modern services—unexploited.

> EUROPE'S GROWTH MODEL HAD WORKED WELL DURING THE PREVIOUS 50 YEARS, BRINGING TWO HUNDRED MILLION PEOPLE FROM MIDDLE TO HIGH INCOME, AND COMPANIES HAD GENERATED PRODUCTIVITY GAINS

We wrote that assessment at a time when Europe was grappling with an economic and financial crisis. Today, four years later, our assessment remains fundamentally unchanged. The countries in Europe that have come out favorably from the global economic and financial crisis are those that have harnessed the forces of economic integration well and have best addressed weaknesses in the organization of work and welfare. Europe's economic model continues to benefit countries both at its core and periphery. Seeing these successes, it is not difficult to remain optimistic.

But not all countries are doing well, and their sluggishness does not help those that have been more diligent and dynamic. In understanding why the crisis has been so protracted in some parts of Europe, it is necessary to look beyond the deeper structural deficiencies emphasized in Golden Growth and to consider the role of money. In Golden Growth, we deliberately avoided a lengthy discussion of the common currency and all its complications because the scope of the study was broader—it included 45 countries, only 17 of which had the euro—and longer—it studied these economies during six decades, and the euro had existed in only the last one. Cyclical and structural factors are difficult to compartmentalize, however, and the Eurozone is a big part of the European economy. For now and in the foreseeable future, the European economic model is best understood as a combination of six components: trade, enterprise, finance, money, labor, and government.

THE PRINCIPAL FAILURE WAS NOT RECOGNIZING GREECE'S DIFFICULTIES AS A SOVEREIGN SOLVENCY EARLY ON

Our interpretation of the Eurozone crisis emphasizes the underlying failure to achieve a real convergence, which made a crisis almost unavoidable in the event of asymmetric external shocks. However, design flaws and policy mistakes arguably made matters worse. The principal failure was not recognizing Greece's difficulties as a sovereign solvency early on. In addition, European policymakers failed to sever the "doom-loop" between sovereigns and banks across the Eurozone (see also Baldwin and Giavazzi 2015).

This chapter expands and updates the 2012 Golden Growth analysis, illustrates the cases of post-crisis success and continued stagnation among Europe's economies, and expands the original framework by complementing the discussion of finance with a section on money. Our recommendations for improving Europe's growth model follow from the assessment of Europe's strengths and weaknesses: trade and enterprise, finance and money, and labor and government.

Relatively few changes are required to the organization of trade and enterprise. As in 2012, there is the need to strengthen the common market in services and to make it easier for entrepreneurs to enter new markets, invest abroad, and grow their businesses worldwide. This will contribute to a restart of what we called Europe's "Convergence Machine." Europe

remains unique in having a mechanism by which poorer and newer members of the extended European Union can quickly get to the income and productivity levels of the more advanced EU core. This is Europe's strongest and most desirable attribute, and it should be strengthened and extended to aspiring members in the Balkans and the East. It will require greater efforts in those countries that have neglected to create an attractive business environment, but it also requires a continued openness in the member states of the European Union.

More changes are needed in the two interrelated components of finance and money to insure Europe against the risks of fiscal-financial excess, especially in the Euro area. Several important steps have been taken. The most important is the establishment of a banking union to jointly supervise the Eurozone's systemically important banks with a common backstop to prevent banking sector problems from becoming sovereign debt problems. New rules have also been issued to guarantee greater fiscal discipline in the European Union. But several challenges remain. The absence of a mechanism to allow sovereign default within the Euro area means that governments do not benefit from market signals in reinforcing fiscal discipline. The small size of the common banking sector backstop, in turn, means that the doom loop between banks and sovereigns has not been completely broken. Addressing these challenges would allow finance to reemerge as the lubricant of economic convergence across the EU, a role it played successfully in the East during the 2000s, but met with spectacular failure in the South.

Before the crisis, the biggest changes needed in Europe's economic model were in the organization of labor and government. Developments during the last four years have made these changes even more urgent. With unemployment rates above 20 percent in many countries and public debt levels swollen both by chronic deficits and by the added burden of bank bailouts, a spotlight has been turned on Europe's greatest weaknesses: labor and welfare. There are some encouraging signs, however. Labor market reforms have begun in Spain, Italy, and, more recently, in France. Labor mobility has been increasing steadily across the EU. Some European countries—most notably Germany—have shown an enlightened attitude towards migration in the face of their own demographic decline. But much more remains to be done, particularly to rein in excessive and unaffordable social welfare spending and to restore sustainability to public finances. Europe has prided itself on a lifestyle that balances work and leisure. For an increasingly large number of people in Europe—especially its youth—, this has become

a distant aspiration. The organization of work and welfare will need deeper adjustments if Europe is to remain the world's "lifestyle superpower."

Europe's economic model before the crisis—a scorecard

Europe's economic model, fashioned and followed since World War II and progressively enlarged to cover much of the continent today, has distinct features. Perhaps more than others around the world, Europeans want economic growth to be smarter, kinder, and cleaner, and they are willing to accept less for "better" growth. Europe's economies are also more mature and its societies older than those of most other regions. In both respects, Europe's growth can be called "golden" (Gill and Raiser 2012). But, in parts of Europe, policies have deviated from growth's "golden rule" as current generations have consumed more than they have saved, and debts have accumulated that risk weighing down the prospects for future generations. The challenges of debt and aging have motivated calls for radical changes in Europe's economic model. Our analysis, four years ago, cautioned that in their zeal for change, Europeans should take care not to throw out the attractive attributes of their model together with the weaker ones. We start this article with a summary of our argument.

Three major achievements summarize the strong points of Europe's economic model: (i) economic convergence has lifted millions of people above the threshold to high income; (ii) design and dexterity have secured Europe's global economic heft; and (iii) the European way of life is admired and envied around the world.

The Convergence Machine

Europe has achieved unprecedented regional integration, and this has facilitated a process of economic convergence that is globally unique (Chart 1). Between 1950 and 1973, the incomes of 100 million Western Europeans converged rapidly towards those in the United States. In the subsequent two decades, another 100 million people in Southern Europe crossed the threshold to high income, following the same pattern of integration and convergence. Over the past 25 years, it has been the Eastern Europeans' turn to benefit from Europe's Convergence Machine. Today, another 100 million people in candidate countries in the Balkans and Turkey are aspiring to follow them.

Trade and finance are the two elements of Europe's economic model which have been most closely associated with this achievement. In 2008, almost half of the world's goods trade involved Europe. Compared with Asia, which has established itself as the world's factory over the past two decades, European trade remains distinct. In Asia, China serves as the gateway to the world—other countries trade with China, and China ships goods to global markets. In Europe, while two-thirds of trade remains within the region, the new member states in Eastern Europe have seen their share of trade with traditional EU members progressively decline (Chart 2). Trade with the EU has made these countries globally competitive as their trade has become ever more sophisticated. FDI and offshoring, in turn, have made Western European companies more competitive. The challenge for European trade going forward is to deepen integration in services, particularly professional services, such as ICT, legal services, and insurance, but also in transport and energy sectors. Overall, trade is the most attractive attribute of Europe's economic model.

Finance has been the second pillar of Europe's economic convergence. Economists have long been puzzled why capital in the world fails to flow

IN EUROPE, A RAPID CONVERGENCE IN LIVING STANDARDS —NOT MUCH ELSEWHERE

Annual growth of consumption per capita between 1970 and 2009, by level of consumption in 1970

N= number of countries

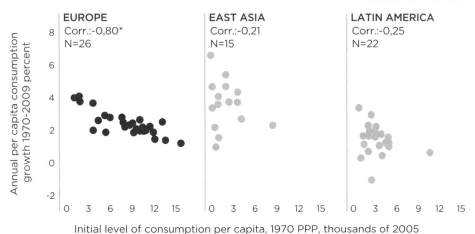

*Statistically significant at the 1 percent.

Source: Penn World Table 7.0; see Chapter 1 of Gill and Raiser (2012)

Chart 1

systematically downhill. In other words, poorer countries have often ex-
ported capital, and those that have not done so have tended to grow less
than those that have. This is not the case in Europe. The decade before
the financial crisis saw an explosion of cross-border capital flows in the
EU and its neighboring countries and—by and large—these flows have
financed higher growth in Europe's emerging markets and have contrib-
uted to convergence (Chart 3). But, as discussed further below, there
have been excesses, and their correction has proven enormously costly,
particularly in the Eurozone. In our assessment, four years ago, finance
was seen as one of Europe's strong points. This is still true in parts of
the region. But, in others, primarily in the Eurozone and some of the
countries of the Eastern Partnership, financial flows have masked the
lack of real integration, have financed consumption and real estate booms
rather than productive investments, and have left recipient countries
with a huge debt overhang when the flows stopped. Below, we assess the
changes made and the reforms still needed in the regulation of finance
to ensure it remains a catalyst of convergence.

EU TRADE WITH ITS NEW MEMBERS HAS BEEN INCREASING, BUT NEW MEMBERS HAVE DIVERSIFIED

Shares of regional trade for EU15 and EU10, 1996-2008

—————— Exports

—————— Imports

EU15: TRADE SHARE WITH EU10

EU10: TRADE SHARE WITH EU15

The EU10 includes new member states that joined the EU in 2004

Source: UN Comtrade; see Chapter 2 of Gill and Raiser (2012)

Chart 2

Brand Europe

Europe's companies have become globally recognized for the high quality and elegant design of their products and services and—the recent Volkswagen scandal notwithstanding—admired for their social and environmental responsibility. This has given Europe a distinct brand and ensured that the continent continues to enjoy global economic heft. While nurturing the brand, European companies have delivered what was expected of them: productivity, jobs, and exports (Chart 4). However, this overall positive assessment of European enterprise is subject to considerable differentiation across various parts of the region. Productivity growth in the EU15 could have been faster (and, indeed, should have been faster to allow the EU15 to catch-up with productivity levels in the US), and employment growth in the new members states has been subdued.

But the biggest worry is about productivity patterns in Southern Europe since 2002. While Greece, Italy, Portugal, and Spain created plenty of jobs between 2002 and 2008, these were mainly in cyclical activities, such as construction, or in less productive micro and small enterprises. As a

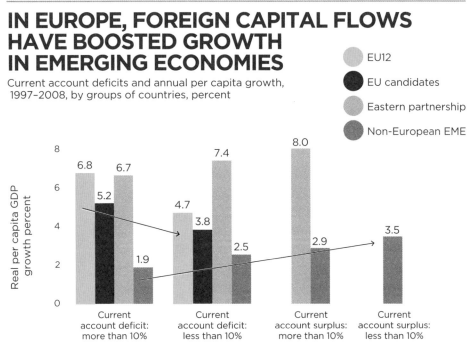

IN EUROPE, FOREIGN CAPITAL FLOWS HAVE BOOSTED GROWTH IN EMERGING ECONOMIES

Current account deficits and annual per capita growth, 1997–2008, by groups of countries, percent

- EU12
- EU candidates
- Eastern partnership
- Non-European EME

Real per capita GDP growth percent

Current account deficit: more than 10%: 6.8, 5.2, 6.7, 1.9
Current account deficit: less than 10%: 4.7, 3.8, 7.4, 2.5
Current account surplus: more than 10%: 8.0, 2.9
Current account surplus: less than 10%: 3.5

Note: Average growth rates calculated using 3 four-year periods in 1997-2008.

Source: IMF WEO outlook; see Chapter 3 of Gill and Raiser (2012)

Chart 3

result, while productivity in the rest of Europe converged, enterprises in Southern Europe, on average, became less productive (Chart 5).

One reason for these developments in the Southern EU15 has been that regulations of product and labor markets have not been conducive to the creation of productive jobs (Chart 6). Red tape and onerous tax and labor regulations have discouraged companies from growing and kept them focused on domestic markets (Dall'Olio et al. 2013). Lack of internationalization has meant that enterprises in the South have benefited less from economic integration and have fallen behind in the attraction of FDI and the integration into global value chains. For a while, the massive inflow of financing was able to mask these weaknesses and may have aggravated them by pushing up wages and production costs in the deficit countries. Increasing competitiveness has thus been rightly at the center of structural reform efforts in Europe's periphery since the global financial crisis, and in the most aggressive reformers, these efforts are starting to bear fruit.

To maintain its brand, Europe will also need to tackle the gap in innovation with the US, the world's technological leader. Here too, there is considerable variation across the region, with Scandinavia, the Benelux,

ENTERPRISES IN EUROPE HAVE DELIVERED PRODUCTIVITY, JOBS AND EXPORTS

Performance of European sub-regions and benchmark countries, 1995–2012/2013

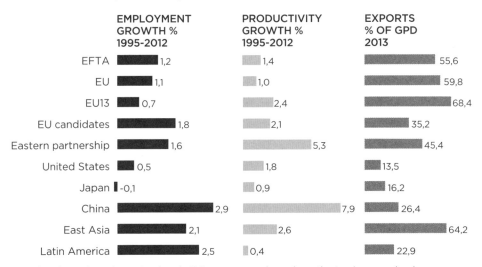

	EMPLOYMENT GROWTH % 1995-2012	PRODUCTIVITY GROWTH % 1995-2012	EXPORTS % OF GPD 2013
EFTA	1,2	1,4	55,6
EU	1,1	1,0	59,8
EU13	0,7	2,4	68,4
EU candidates	1,8	2,1	35,2
Eastern partnership	1,6	5,3	45,4
United States	0,5	1,8	13,5
Japan	-0,1	0,9	16,2
China	2,9	7,9	26,4
East Asia	2,1	2,6	64,2
Latin America	2,5	0,4	22,9

Note: Growth rates in employment and productivity are compound annual growth rates. Average values by group are shown. China and Japan are also included in the calculation of East Asia's regional average. Due to the data availability, growth rates are not always based on the full period.

Source: World Bank staff calculations, based on WDI and ILO (2014)

Chart 4

Germany, Austria, and Switzerland leading the way for the rest. But on the whole, Europe has benefited less from the ICT revolution, and after having converged with productivity levels in the US until 1995, in recent years, the gap has widened again.

The Lifestyle Superpower

European workers are accorded strong protection against abuse by employers, and have unprecedented income security after job loss and in old age. Europe's organization of work and government has made the European lifestyle admired and envied around the world. It has also been expensive. With only 10 percent of the world's population, Europe accounts for over half of the world's spending on social security, and European governments are larger than anywhere in the world (Chart 7).

As incomes have increased, Europeans have been able to work less and still enjoy rising standards of living. By and large, Europeans work fewer hours a week, fewer weeks in a year, and fewer years in their productive lives than they did in 1960. They also live a lot longer than they did 50

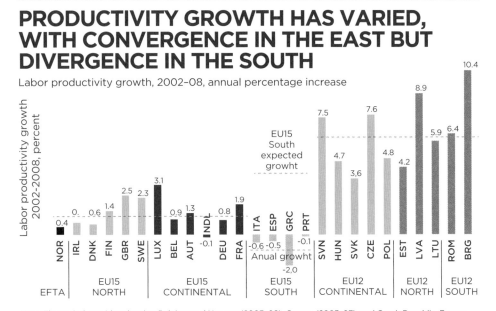

PRODUCTIVITY GROWTH HAS VARIED, WITH CONVERGENCE IN THE EAST BUT DIVERGENCE IN THE SOUTH

Labor productivity growth, 2002–08, annual percentage increase

Note: The period considered varies: Belgium and Norway (2003–08), Greece (2003–07), and Czech Republic, France, Latvia, Romania, and the United Kingdom (2002–07). The three lines in each panel show average values for countries covered by each line. Expected growth for EU15 South is obtained by computing gaps in productivity levels between EU15 South and each of the other two groups and then applying these shares to the difference in growth between the first (that is, EFTA, EU15 North, and EU15 Continental) and the third (EU12) groups.

Source: Eurostat structural business statistics; see Chapter 4 of Gill and Raiser (2012)

Chart 5

years ago (Chart 8). With aging societies, the pressure on social security systems is expected to increase even more going forward. In short, in many European countries, public pension systems have become unsustainable, and the burden of payroll taxes used to finance social security and health systems in Europe is already the highest in the world. The elderly are hardly better off for it. Southern EU15 countries, in 2007, spent around three times more as a share of their GDP on public pensions than the Anglo-Saxon countries (US, UK, Australia, New Zealand), but real public pensions in PPP US$ per retiree were only 15 percent higher. To maintain their lifestyles and sustain public finances, Europeans will have to retire later. Many already do, and the experience suggests this is good for them as well as their countries (Arias and Schwartz 2014; Bussolo et al. 2015).

In 2012, we gave Europe the highest marks for trade and finance, associated with Europe's success in economic convergence. The lowest marks were received for the way European countries organized work and government, with the performance of the environment for business and innovation somewhere in between. Our recommendations were most extensive regarding reforms of labor markets, social security, and the management of public debt. Fewer changes were recommended to reform the business climate and innovation systems and fewer still in the regulation of finance and the deepening of the Common Market. However, developments during the last five years provide reasons to reassess the European growth model.

SOUTHERN AND EASTERN EUROPE MUST MAKE IT EASIER TO DO BUSINESS

Ranking of the ease of doing business
in 2014, scaled from 1 (best) to 189 (worst)

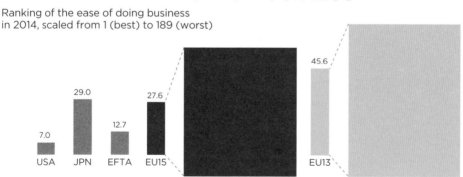

Note: Averages by group are shown. EFTA here comprises Iceland, Norway, and Switzerland. The EU15 comprises Denmark, Finland, Ireland, Sweden, and the United Kingdom (North); Austria, Belgium, France, Germany, Luxembourg, and the Netherlands (Continental); and Greece, Italy, Portugal, and Spain (South). The EU13 comprises Estonia, Latvia, and Lithuania (North); Croatia, the Czech Republic, Hungary, Poland, Slovakia, and Slovenia (Continental); and Bulgaria, Cyprus, and Romania (South).

Source: Doing Business 2015

Chart 6

What has happened since the crisis?
Convergence in one part, divergence in another

The global financial crisis initially affected mostly countries in the European periphery, such as Ukraine, which saw their economies suddenly cut-off from international capital flows. But, in October 2009, when a new government in Greece revealed that previous fiscal accounts had been fudged to hide the true size of the deficit, the crisis spread to the European Union, especially to the Eurozone. The mechanics of how the crisis spread were the same in the Eurozone and in emerging markets (Baldwin and Giavazzi 2015). Concerns about a country's ability to repay its foreign creditors led to a sudden stop in capital flows, necessitating deep adjustments in external balances. The effect of the crisis on the banking sector of deficit countries and through the banks on public debt sustainability acted as a massive amplifier, particularly in the Eurozone. But at the heart of the crisis were divergences in competitiveness that needed to be redressed. Without the ability to devalue, deficit countries in the Eurozone were forced into sharp austerity.

In this section, we examine developments in Europe since 2008, looking first at economic performance and the extent to which adjustment and structural reforms have helped close the competitiveness gap across Europe.

GOVERNMENTS IN EUROPE ARE BIG

The world resized by government spending in US Dollars, 2009

Chart 7

Source: Raiser and Gill (2012)

The European Convergence Machine after the Crisis

Europe's economic performance since 2008 has been lackluster as a whole. Real GDP barely exceeds the peak reached in 2007 in most countries in the region. However, there has been considerable regional variation (Chart 9). The new member states of Eastern Europe recovered more quickly than the European core and have continued to converge since 2009. Indeed, the largest among them—Poland—never experienced a recession, and its GDP in 2014 stood fully 21 percent above the level of 2007. The Baltics saw a dramatic fall in output and a similarly dramatic turn-around as they slashed public spending and real unit labor costs, thereby eliminating external imbalances that had exceeded 10 percent of GDP within just two years and restoring access to market financing. Bulgaria and Romania have continued to grow at rates above 3 percent since 2010. It is in the EU15 South that overall performance has continued to diverge, with median GDP now some 10 percent below the 2007 peak.

The picture is not very different if we look at labor productivity growth since the crisis (Chart 10): sluggish growth of around 1.7 percent in the EU15 North and Core, an expansion around twice that rate in the EU13, and negative productivity growth on average in the EU15 South, with significant declines in Greece and Portugal.[1]

EUROPE'S PENSION SYSTEMS HAVE TO SUPPORT PEOPLE FOR MANY MORE YEARS

Changes in life expectancy at 60 and effective retirement age, 1965–2007

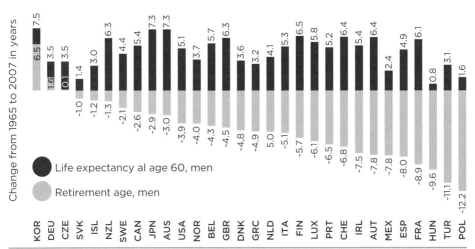

Source: OECD (2011) and updated data from OECD (2006)

Chart 8

With declining or sluggish productivity, adjustment in competitive-ness has had to come through declines in wages. Real unit labor costs have declined between 15 percent in Spain and Portugal and 20 percent in Greece and Ireland since their peak, and today they have returned to levels in the early 2000s (IMF 2015). Current account imbalances have been largely eliminated, with swings of over 10 percent of GDP in Greece and Portugal and 5 percent in Spain (Chart 11). Adjustments have also been significant in parts of the new member states. However, a parallel adjustment has failed to take place in the surplus countries, most notably Germany. This has led to criticism that the costs of ad-justments have been born only by the deficit countries. While Germany would help economic rebalancing in Europe with more robust domestic demand, it is wobbly investment rather than subdued consumption that is holding Germany back (Schmieding 2015). This reflects deleveraging in the banking sector and is unlikely to be helped by attempts to erode Germany's relative competitiveness (although more public investment spending would clearly help both Germany and its EU partners). Instead,

SOLID RECOVERY IN THE EAST, SLUGGISH GROWTH IN CENTER, DECLINE IN THE SOUTH

Real GDP index, 2005 = 100

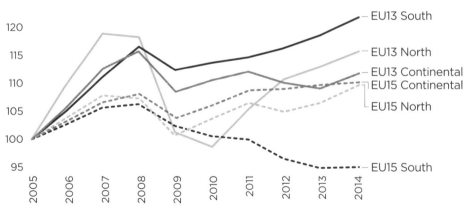

Note: Median values by group are shown.

Source: World Development Indicators.

Chart 9

1 The substantial increase of productivity in Italy reflects developments in manufactur-ing, which saw an increase in value added and a substantial reduction in employment. As noted in Dall'Olio et al. (2013), Italy represents an interesting case, with a highly pro-ductive and competitive manufacturing sector in the northern part of the country, and a large tail of very unproductive micro enterprises in the rest.

countries in the Eurozone periphery will have to reform to make their economies more attractive and their businesses more productive.

A lot of this is already happening. Eastern Europeans have continued to lead the way in making their business environments friendlier, but Greece, Portugal, and Italy have also made an effort (Chart 12). According to the OECD, Greece, Portugal, Ireland, and Spain are the top four countries when it comes to implementing reform recommendations (OECD 2015). This is true not only for the business environment, but labor markets are also being reformed and made more flexible. According to OECD's employment protection legislation (EPL) index, the EU15 South now has more flexible labor markets than the EU15 core (Chart 13). Germany's labor market reforms of 2003 are often cited as an example of the benefits that come with lowering hiring costs and moving from a system job protection to one that incentivizes job search while providing temporary income security to the unemployed. Labor market reforms are working in the South, too. By the end of 2014, unemployment was down 1.4 million in Greece, Ireland, Portugal, and Spain, a decline by 16 percent from the peak in early 2013. Except in Portugal, employment growth in the other three countries in 2014 was running at almost twice the rate as in Germany.[2]

CONTINUED CONVERGENCE IN THE EAST, DIVERGENCE IN THE SOUTH

Labor productivity growth, 2009-13, percent

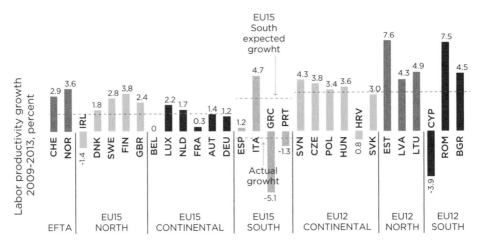

Note: Italy's high productivity growth is driven by an increase in value-added in manufacturing while employment in the sector decreases. Sample: Switzerland, Finland, Italy, Luxembourg, Poland, Romania and Sweden (2009-2012); France and Portugal (2010-2013); Ireland (2009-2011)

Source: Eurostat structural business statistics.

Chart 10

When we published Golden Growth, we said it would not be difficult to restart Europe's Convergence Machine. The evidence suggests to us that optimism was justified. Adjustment is happening faster in the countries that started to reform earlier, such as the Baltics, and less painfully in those that went into the crisis with a stronger structural position, such as Ireland and Spain. Reforms of the Common Market, particularly its extension to services, have proceeded less rapidly, but with the pressure of a possible trade agreement with the United States and the evident need for more harmonious regulations in sectors such as finance and energy, here too progress is likely.

It is on the periphery of the European Union, in the western Balkans and in Turkey, and even more in the countries of the Eastern Partnership that the European Convergence Machine has continued to splutter. Without clear accession prospects, for instance, structural reforms in Turkey have largely come to a standstill (see Acemoglu and Ucer 2015, in this volume). Growth in the western Balkans remains well below levels in the EU13, and prospects are marred by recurrent political instability. Literally torn between Russia and the EU, the countries of the Eastern Partnership

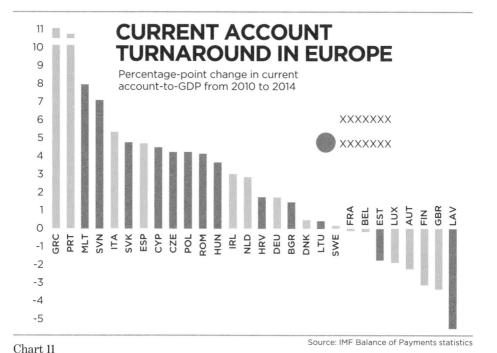

CURRENT ACCOUNT TURNAROUND IN EUROPE

Percentage-point change in current account-to-GDP from 2010 to 2014

XXXXXXX

XXXXXXX

Chart 11

Source: IMF Balance of Payments statistics

2 Greece was dragged back into recession by the brinkmanship and resulting erosion of confidence of the new government in early 2015.

have benefited from neither European nor Russian investment and have been shattered by war, scandal, and capital flight. We hope that the signs of recovery in Europe's economy and the evidence that the Convergence Machine still works will encourage politicians in both the EU and in its neighborhood to redouble their efforts at closer economic integration and ultimately re-open the process of EU enlargement. The Common Market remains Europe's most attractive attribute and its most successful policy.

Financial integration and the Euro

When the Euro was created, many expected it to yield dual benefits: it would make doing business less costly across the Eurozone and thus enhance economic integration, and it would provide a macroeconomic anchor for its weaker members, forcing them to maintain fiscal discipline and to keep the economies competitive. However, others warned that the Eurozone did not fit the requirements of an optimum currency area. Specifically, Europe's rigid labor markets were seen as a major risk since they would make adjustment much more difficult in case of an asymmetric shock. Indeed, labor mobility in Europe has remained among the lowest in any advanced country.

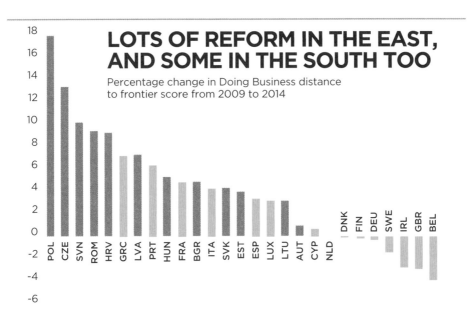

LOTS OF REFORM IN THE EAST, AND SOME IN THE SOUTH TOO

Percentage change in Doing Business distance to frontier score from 2009 to 2014

Note: The distance to frontier score is normalized and ranges between 0 and 100 (frontier).

Source: IMF Balance of Payments statistics

Chart 12

The crisis in the Eurozone has confirmed the views of the skeptics. The Euro did catalyze an enormous increase in cross-border financial flows and a resulting rapid convergence of borrowing costs, but it did not lead to greater real integration (Sugawara and Zalduendo 2010). The business cycles of countries in the Eurozone periphery did not become more synchronized with the core, and trade integration did not increase by much. In the EU15 South, convergence in per capita incomes also stalled in the 2000s. Labor market mobility remained low throughout the EU. Cross-border flows exploded but financed mainly unsustainable consumption and real estate booms. When Eurozone investors started questioning the ability of borrowers in other countries to repay, capital flowed out, yields went up, and the deficit countries—unable to devalue—were forced into a painful economic adjustment (Chart 14).

The experience in the new EU member states was quite different. Here, too, the first decade of the 2000s saw significant capital inflows. However, these flows facilitated both nominal and real integration (or at least did not reduce the level of real integration). When the tide turned, these countries, even those that had joined the Euro (Slovakia) or fixed their exchange rates to the Euro (Bulgaria, the Baltics), were able to adjust with much lower costs in terms of output and employment.

LABOR MARKETS ARE BEING REFORMED IN THE SOUTH Employment Protection Index, 2008-2013

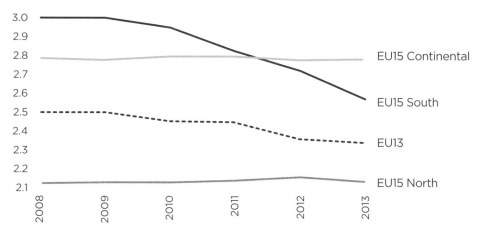

Note: OECD EPL index of strictness of employment protection. An index ranging from 0 to 6: lower values indicates less protection. EU13: Czech Republic, Estonia, Hungary, Poland, Slovak Republic and Slovenia.

Source: OECD

Chart 13

What accounts for these different experiences with financial integration? One reason has to do with the greater structural flexibility of the new member states, as reflected in generally better scores in the quality of the business environment, for instance. A second explanation is that the nature of the capital flows was quite different. Within the Eurozone, much of the cross-border flows were intermediated by banks, whereas other parts of the region saw greater reliance on equity flows (Chart 15). When the tide turned, much of the earlier banking sector inflows were reversed (Chart 16).

Equity flows involve a greater degree of risk sharing between investor and investee than debt flows do between creditor and borrower. They are thus inherently less easy to reverse. But within the Eurozone, several factors served to amplify the negative effects of excessive banking sector leverage. First, much of the cross-border lending was bank-to-bank lending. Total lending by banks in the core Eurozone countries to Greece, Italy, Ireland, Portugal, and Spain increased by a whopping 1.5 trillion Euros in the decade after the introduction of the Euro, or some 340 percent. Without Italy, the increase was 1 trillion Euro, or 495 percent (Baldwin and Giavazzi 2015). This was a significant accumulation of bank debt in both the lending and receiving countries.

However, the supervision of banks as well as national safety nets to protect depositors and prevent a bank run were left to the responsibility of

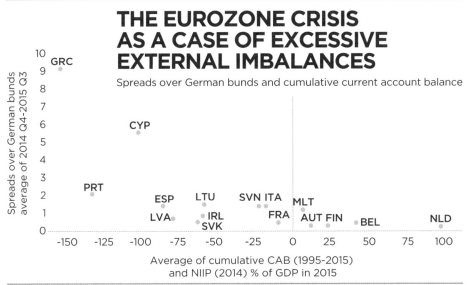

Chart 14

individual countries. When the bubble burst, debtor country governments stepped in to save their financial systems. The resulting increase in public sector liabilities pushed governments in Ireland and Spain over the edge of debt sustainability, despite their strong fiscal positions pre-crisis.

Second, in the case of Greece and, to a lesser extent, Portugal, domestic banks were heavily exposed to their own governments. When Greece revealed, in October 2009, that its fiscal deficit was over 12 percent of GDP, investors started to question the government's ability to repay. When the first bail-out was agreed in mid-2010, Eurozone governments decided against Greece going to the IMF. Greek debt to commercial banks in France and Germany was exchanged for debt to public creditors—principally the ECB and the European Stability Mechanism. This failed to stem concerns over public debt sustainability, and contagion thus spread from Greece to Portugal, Ireland, Spain, Italy, and, for a while, even to Austria, Belgium, and France.

Rising yields on public debt of the affected countries made concerns over debt sustainability a self-fulfilling prophecy. Financial markets fragmented as rising public sector yields drove up private borrowing costs and capital flooded out of all periphery countries, leaving both solvent and insolvent

EQUITY FLOWS IN THE EAST, DEBT FLOWS IN THE EU15 PERIPHERY

Aggregate external net equity and net debt exposures, percentage of GDP, 2002–11

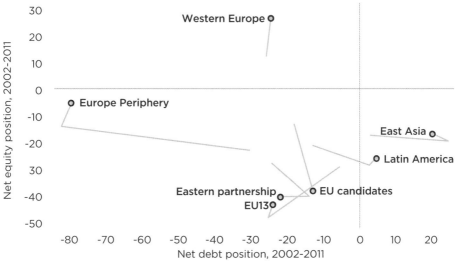

Note: Lines begin in 2002 and end in 2011, while the middle point in each line is for 2009. The arrows for each region are median values.

Source: Updated from Chapter 3 of Raiser and Gill (2012).

Chart 15

borrowers without access to liquidity (Gill et al. 2014). Only with ECB President Mario Draghi's "whatever it takes" speech, in August 2012, did calm gradually return to the Eurozone's public debt markets and eventually to its financial markets. As of mid-2015, sovereign spreads have converged again, corporate spreads have followed suit, and net banking flows to the non-financial sector have turned positive for the first time since late 2011.

Policy mistakes and design flaws combined to push the Eurozone further into the debt vortex. It can be argued that Ireland would have been better off to force creditors to share the burden of adjustment, as was done by Iceland, for example. It can also be reasoned that if Greece had been forced into a traditional IMF-led adjustment and debt restructuring program early on, the contagion across Eurozone debt markets might have been better contained.

Going forward, the doom loop between banks and sovereigns needs to be broken, and the supervision of European banks needs to be strengthened to risk-proof financial integration. European banks also need to be encouraged to deal proactively with the stock of non-performing loans (NPLs). Important steps have already been taken through the creation of the Single Supervisory Mechanism under the ECB (accounting for around

COUNTRIES WITH MORE INFLOWS PRE-CRISIS, EXPERIENCED GREATER OUTFLOWS AFTERWARDS

Cross-border bank flows, percentage of average GDP, 2004–08 and 2009–13

Note: The fitted line in the chart excludes EU15 South countries. Bank flows are exchange-rate-adjusted changes in assets of BIS-reporting banks vis-à-vis individual countries. For Serbia and Montenegro, the data begin in 2006.

Source: World Bank staff calculations, based on BIS Locational Banking Statistics.

Chart 16

80 percent of all Eurozone banking sector assets), the stress testing of European banks, the creation of a Single Resolution Fund (SRF), and the agreement for the European Stability Mechanism to directly recapitalize systemically important banks. However, the combined resources of the SRF (Euro 55 billion) and ESM recapitalization (up to Euro 60 billion) are still small relative to the size of the Eurozone banking sector (Euro 22 trillion). While deposit insurance has been harmonized, no central deposit insurance fund exists. Whether these measures would be enough in case of another systemic crisis is not clear (IMF 2015).

The Lifestyle Superpower and fiscal adjustment

In 2012, we argued that Europe's biggest adjustment needs were in the labor market and in the size and effectiveness of government. While some progress has been made in labor market reform (see above), the financial crisis has accentuated the challenge of fiscal adjustment. As of 2015, only 10 of the 28 EU member states are likely to meet the Maastricht criterion of less than 60 percent public sector debt to GDP (Chart 17).

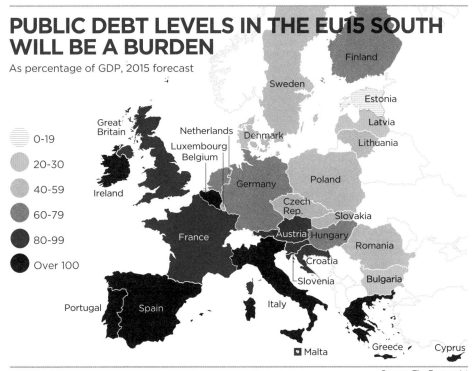

PUBLIC DEBT LEVELS IN THE EU15 SOUTH WILL BE A BURDEN

As percentage of GDP, 2015 forecast

- 0-19
- 20-30
- 40-59
- 60-79
- 80-99
- Over 100

Source: The Economist

Chart 17

Based on 2010 debt levels and structural fiscal balances, we estimated fiscal adjustment needs to range between 0.7 and 7 percentage points of GDP annually just to bring debt levels below 60 percent of GDP in Western Europe and 40 percent in emerging Europe (Chart 18). Add the cost of future health and public pension spending due to aging, and these numbers increase to between 4 and 11 percentage points of GDP across the region.

Public pension systems pre-crisis were already the main reason why governments in Europe were larger than elsewhere. The effect of the crisis has further increased the share of social security spending in GDP in most parts of Europe, most significantly in the Southern EU15 and in the new member states of Central Europe (Chart 19). Public pension spending will increase further as old-age dependency rates increase. The most effective way to keep future pension deficits in check would be an increase in the effective rate of retirement. Reductions in pension benefits and the encouragement of complementary private savings would also help. The inflow of migrant workers can temporarily smooth the increase in old-age dependency rates, but unless sustained perpetually, it will not

LARGE FISCAL ADJUSTMENT NEEDS MEDIUM-TERM, BECAUSE OF THE CRISIS AND BECAUSE OF AGING

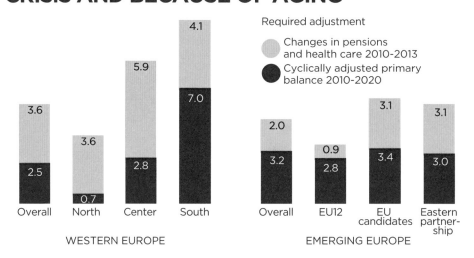

Note: The fiscal impacts of aging on pensions and health care systems are missing for EU candidate and eastern partnership countries. For this exercise, the sum of adjustment in health care spending is assumed to be the same as for the new member states. The adjustment in pension related spending is assumed to be the same as that for southern Europe.

Source: Calculations by staff of the Institute for Structural Research in Poland and the World Bank, based on IMF WEO; see Chapter 7 of Gill and Raiser (2012).

Chart 18

prevent the effects of aging (Arias and Schwartz 2014). Europe prides itself on the balance it has found between work and leisure. As Europeans get older, they will have to balance leisure and work throughout their adult lives, not just until their early 60s.

In the meantime, there is little alternative to greater fiscal discipline in the countries that allowed government spending to balloon pre-crisis (Greece, Ireland, Spain, the United Kingdom, and, to a lesser extent, Portugal). In Ireland, Spain, and the United Kingdom, this was hidden thanks to buoyant real estate linked tax revenues. But real spending in all three countries increased by close to 50 percent between 2000 and 2009, compared to less than 15 percent in Germany and Italy (Chart 20). The subsequent adjustment essentially brought spending back to pre-crisis levels, with the exception of Greece, where it declined to the level of 2002, and the UK, where it has not declined by much.

While the speed of adjustment in the EU15 periphery is remarkable, its extent is perhaps less calamitous when seen in context of the dramatic pre-crisis increase in spending. Nonetheless, concerns have been raised over the pro-cyclicality of austerity (Benassi-Quere 2015) and the impact

SOCIAL PROTECTION SPENDING IS THE MAIN REASON THAT GOVERNMENTS IN EUROPE ARE LARGE

General government spending, percentage of GDP, 2008 and 2013

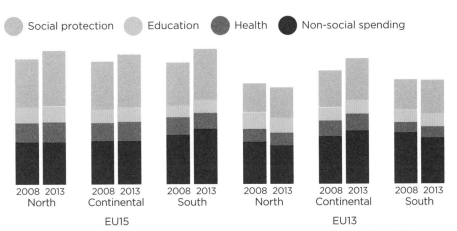

Note: "Social protection" includes benefits related to sickness and disability, old age, survivors, family and children, unemployment, and housing. Western Europe comprises Denmark, Finland, Iceland, Norway, and Sweden (North); Austria, Belgium, France, Germany, Ireland, Luxembourg, the Netherlands, Switzerland, and the United Kingdom (Center); Greece, Italy, Portugal, and Spain (South).

Source: IMF GFS and IMF WEO; updated from Chapter 7 of Gill and Raiser (2012).

Chart 19

of declines in public investment on future potential growth. There is some evidence supporting these concerns. The aggregate fiscal stance in the Euro area has been mostly pro-cyclical, as fiscal adjustment coincided with a growing output gap after 2010. Moreover, across the Eurozone, the countries with the largest fiscal adjustment during 2010 to 2015 were also those with the largest output gap (Chart 21). Correspondingly, public investment has declined by between 15 percent per annum in Spain and Cyprus, 10 percent in Ireland, Italy, and Portugal, and around 5 percent in Greece. On the other hand, public investment has been essentially flat in the Eurozone core and most of the Nordics, which have fiscal space and face record low borrowing rates that should make public investment attractive.

As of 2015, the aggregate fiscal stance in the Eurozone has become neutral. The pro-cyclicality of spending patterns across the Eurozone has also become less pronounced (IMF 2015). With recovery on the horizon for almost all countries in the region, the time may have come to leave the debate of growth versus austerity behind and begin the challenging task of long-term repair of public sector balance sheets. This is important for all European countries. In the Eurozone, it is imperative. To facilitate this process, the framework for fiscal governance in the EU

AUSTERITY HAS RETURNED GOVERNMENT SPENDING TO PRE-CRISIS LEVELS IN THE EUROZONE PERIPHERY

Real general government expenditure, 2000 = 100

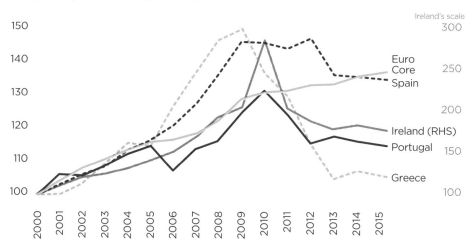

Note: Real government expenditure is computed as nominal expenditure in local currency divided by GDP deflator (in 2005 prices). Euro Core is an average of Austria, Belgium, Finland, France, Germany, Luxembourg and the Netherlands.

Source: IMF WEO data, 2015 is estimate

Chart 20

has been repeatedly revised. The resulting architecture now includes a criterion for net expenditure growth to remain in line with trend GDP, nationally differentiated rules for the structural fiscal balance and its change year on year, and a criterion for the pace of adjustment of public debt, in addition to the nominal deficit and public debt level criteria that were part of the 1997 Stability and Growth Pact (SGP).

The framework is complex, and some of the targets are mutually inconsistent (Andrle et al. 2015). National requirements, not all of which are consistent with the requirements of the SGP, further complicate the picture. Finally, concerns remain over the measurement of several of the targets, particularly those relying on estimates of underlying or projected growth. Simplification of the framework would likely facilitate monitoring and enforcement and may help reduce output volatility going forward.

Whatever the fiscal rules, reestablishing long-term fiscal sustainability will require reductions in spending in many countries. This need not come at the cost of a reduction in the quality of public services. Countries such as Sweden and Estonia have demonstrated how public spending can be reduced through administrative reforms and changes in social security arrangements without affecting public service delivery. Turkey has shown how to escape rapidly from a public debt overhang and use the resulting fiscal space to expand public services (Raiser and Wes 2014). The vast differences in health spending between the US and France (with

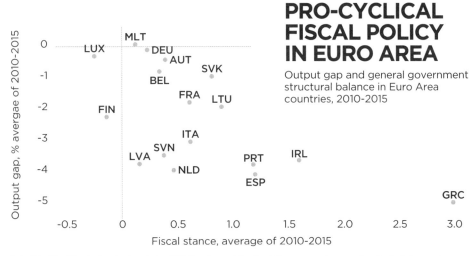

PRO-CYCLICAL FISCAL POLICY IN EURO AREA

Output gap and general government structural balance in Euro Area countries, 2010-2015

Note: The fitted line in the chart excludes EU15 South countries. Bank flows are exchange-rate-adjusted changes in assets of BIS-reporting banks vis-à-vis individual countries. For Serbia and Montenegro, the data begin in 2006.

Source: IMF WEO data, 2015 are estimates.

Chart 21

minor differences in health outcomes) and similarly striking differences in education outcomes in Finland and Italy (with similar spending levels) are suggestive of the scope for quality improvements and efficiency gains in key public services. Many Europeans would rather trade lower growth for a higher quality of life. Without sustainable public finances, they may end up with neither. If they trim their governments and make them more efficient, they can have both.

Restoring the luster of the European economic model

Europe's economic model has brought numerous benefits to Europeans since World War II. In the face of Europe's biggest economic crisis, it is worth remembering its achievements. In our 2012 report on the European model, we suggested that to keep what it had achieved, Europe needed to improve, not discard, its economic model. Our views have not substantially changed since.

The smallest improvements are required to restart Europe's Convergence Machine. As this article has shown, the machine never stopped working for the new EU member states, but it is spluttering in Europe's periphery, among the accession countries and the Eastern partnership, and went into reverse in the Eurozone. Structural reforms to make their economies more flexible are now helping Ireland and Spain rediscover their economic mojo, while Portugal has regained market access, and sentiment in Italy is turning up. Growth may finally return to all countries in the Eurozone, with the exception of Greece, which is suffering the effects of a botched bailout and political brinkmanship.

Much of the recent news is encouraging. But Europe could do more to strengthen economic momentum, including in the core economies. In France, tackling labor market rigidities and social security imbalances may be the highest priority. Germany could do more to boost public investment (Enderlein and Pisani-Ferry 2014), including improvements in education. All EU countries could do more to deepen the Common Market, particularly in services, and to reignite economic integration and, ultimately, the accession process with their neighbors to the South and East. The prospect of convergence through deeper integration is perhaps Europe's biggest attraction, and it should be nurtured.

Private finance has contributed significantly to economic integration and convergence. But the crisis revealed serious flaws in the way banking

was regulated, particularly in the Eurozone. Risk-proofing financial integration will require further strengthening Europe's common supervisory architecture for systemically important banks and fortifying the firewalls between banks and sovereigns. Europeans have become increasingly skeptical of shared responsibility. This is one area where they should overcome their hesitation. It will be easier to convince voters in surplus countries to accept greater risk sharing if it goes hand in hand with further efforts in the deficit countries to improve their competitiveness and to restore long-term fiscal sustainability.

Fixing public finances and reforming work and government remain Europe's most tricky challenges. In the short term, remarkable efforts have been made, from Greece and Ireland to Latvia and Bulgaria, to bring public spending into sink with economic potential. More could have been done in countries with the required fiscal space to ease the adjustment, in particular through greater public investment. But unless we believe that interest rates will remain low for a very long time, some fiscal adjustment will be required in almost every European country. Governments should make good use of improving economic conditions to implement difficult reforms, particularly to public pension systems. Many Europeans today live much longer and healthier lives than their parents. It is not clear why they should spend many more years in retirement, when they, in fact, have the skills, the experience, and often the desire to remain attached to the labor market.

Much can be learned from inside and outside Europe on how to tackle Europe's challenges (Iwulska 2012). The post-crisis years have added a few more successful experiences to this list: Spain's labor market reforms; the Baltics' experience with adjustment under fixed exchange rates; Portugal's patient consolidation of its public finances; Ireland's success in export-led recovery at a time of a global trade slowdown; and, of course, the growing evidence in favor of unconventional monetary policies, including in the Eurozone, and perhaps particularly since 2012. Europe's luster can be restored if policy makers build on these experiences. Europe's economic model was already distinct before the crisis. By deepening the Common Market, fixing the financial system, and restoring discipline and sustainability to public finances, European policy makers can make the model distinguished.

COLIN CROUCH is a professor emeritus of the University of Warwick and external scientific member of the Max Planck Institute for the Study of Societies at Cologne. He is vice-president for social sciences of the British Academy. He has published within the fields of comparative European sociology and industrial relations, economic sociology, and contemporary issues in British and European politics. His most recent books include *Making Capitalism Fit for Society* (2013); *Governing Social Risks in Post-Crisis Europe* (2015); *The Knowledge Corrupters: Hidden Consequences of the Financial Takeover of Public Life* (2015).

European policy strategy has shifted from maintaining a balance between expanding market forces and social development policy to an attitude espousing a neoliberal insistence for deregulation and the strengthening of markets. This change has had negative consequences for employment and labour policy. The relationship between consumption and job security has not been adequately addressed, and the implications of risk and uncertainty for the distribution of income have not been determined. Nor is there any response to the consequences of mass migration following the admission of new member states from Central and Eastern Europe.

EUROPEAN EMPLOYMENT AND LABOUR MARKET POLICY

The European project has always been primarily a market-making one, not very interested in social policy. However, for most of the history of the European Union and its predecessors, there have been compromises, often creative ones, between markets and social policy, or at least mutual respect for different spheres of competence (Scharpf 1999). Recently, however, the EU has become a more aggressively market-making force, attacking areas of social policy formerly understood to be beyond the scope of that strategy.

THE EU HAS BECOME A MORE AGGRESSIVELY MARKET-MAKING FORCE, ATTACKING AREAS OF SOCIAL POLICY FORMERLY NOT CONTEMPLATED

This move has been two-pronged, operating partly through the gradual expansion of the general powers of competition policy and the Court, and partly through explicit new policies. Central to both has been the extension of the single market into what used to be called public services, but which EU jargon now calls "services of general interest". The biggest single example of a new market-making policy likely to threaten broad areas of social policy has yet to take practical form: the proposed Transatlantic Trade and Investment Partnership (TTIP) between the EU and North America. If implemented as now envisaged, this partnership will involve rescinding large amounts of regulation that was previously deemed necessary to protect consumers, workers and the general public from the negative consequences of profit-making business activities.

TTIP is seen by its proponents and critics alike as a perfect example of neoliberal economic strategy, but it is doubtful whether it really merits the name "liberal". Its negotiations are being carried out in secret between Commission officials and business lobbyists from large global

corporations; neither secrecy nor the dominance of corporate political lobbies, rather than markets, has any legitimate place in "liberal" politics or economics. However, our task here is not to deal with the general development of the EU but with the specific field of employment and associated social policy. It will not be possible to include possible labour policy implications of TTIP because, as a result of the secrecy surrounding the exercise, very little is known.

In the first few decades of European integration, the need to reconcile market-making and social policy was largely bypassed by a division of labour. There was a consensus that the primary role of European institutions was to increase the openness of markets. This was not because of an ideological view that there should be no social policy, but rather this was the province of national states—mainly because these needed to reconstruct their legitimacy with their citizens after years of dictatorship or betrayal during the 1930s and early 1940s. This did not mean, as many British politicians claim, that Europe was initially intended to be only a "common market", and that a wider socio-political agenda was a later and never fully agreed extension.

EUROPEAN POLICY HAS BECOME INCREASINGLY NEOLIBERAL ON LABOUR MARKET DEREGULATION WITHOUT A COMPENSATING DEVELOPMENT

At the general level, the 1956 Treaty of Rome spoke clearly of "ever greater union", implying that market making was only the start of a more ambitious project. Second, even the original common market included sensitivity over the impact of intensified competition for the stability of workers' lives, especially in the two sectors that were of particular importance in the post-war years: agriculture, and coal and steel. When the first crises of deindustrialization began to hit the advanced economies in the 1970s, this approach was extended to the structural funds programme for regions hit by industrial decline or other problems of development.

Poor regions have also received help to establish infrastructure projects, the gains from which would be too long-term or too collective for the market to have taken on the burden of providing them. This has been particularly important for new member states with development problems, initially in South-Western Europe and more recently in Central

and Eastern Europe. Beyond these issues, however, and especially where policies directly affecting individuals were concerned, initial European social policy was largely limited to ensuring international transfer of various entitlements for the small numbers of workers who moved to other member states.

A period of more intense European social activity occurred during the Delors presidency, when the single market was being constructed (European Commission 1993). Political polemics suggest that market-making and social policy are opposed in a zero-sum game. The evidence, however, argues that they are complementary: advances in either one require advances in the other. The single market programme was a good example of this. Europe was seen to need both more efficient labour markets and some European-level social policy. If markets were to be intensified, so too must be compensation for the disruption they necessarily cause, action to cope with their negative externalities, and measures to provide the infrastructure that they need but often cannot provide for themselves. This resulted in some constructive redefinition between European and national levels. For example, the Treaty of Maastricht contained a "social chapter", according to which the European organisations of social partners could agree that a particular issue would be the subject of an EU directive. There was an initial flurry of these, but it then subsided.

Since that time, the emphasis of European policy has changed to an increasingly neoliberal insistence on labour market deregulation without a compensating development of new social policy. This move has been two-pronged, operating partly through the gradual expansion of the general powers of competition policy and the Court, and partly through explicit new policies (Höpner 2008, 2014).

Whereas the institutions and policies under attack have had mainly restrictive implications for the functioning of the labour market, these interventions have had some positive effects. Where they have themselves been assisting well-functioning markets, as in the Nordic countries, they threaten to be negative. In all cases, however, the refusal of neoliberal policy to recognise fundamental differences between the market for labour and that for other commodities has had a number of negative consequences. We shall here concentrate on two of these. First has been a combined failure to address the relationship between consumption and labour security in economies dependent on mass consumption and to appreciate how risk and uncertainty have different impacts at different

points of the income distribution. Second is a failure to respond to the social and political impact of the mass migration unleashed by the admission of new member states in Central and Eastern Europe to the free market in labour.

Confident consumers but insecure workers

The fundamental position in economic theory that today influences European labour policy and many individual nation states maintains that, provided they are not impeded by legal regulation or collective agreements, labour markets will clear, leading to maximum employment and overall better welfare. If wages or non-wage labour costs fall, or if employers find it easy to dismiss unwanted workers (either collectively or individually), employment levels should be expected to rise, providing higher employment levels than countries in which employees in post have secure rights, social entitlements and wage levels, but large numbers remain without work. True, employment under a flexible regime is less secure, but the evidence suggests that when job opportunities are plentiful, workers feel economically secure even if their specific current job has little formal security (Muffels and Luijckx 2008a, 2008b).

There are, however, certain negative aspects to the pure neoclassical approach. First, labour markets can take a long time to clear, and since units of labour are human beings, they experience insecurity and anxiety if, while the market is "adjusting", they suffer falling incomes and joblessness, without the support of social policy (this having been dismantled in the quest for reduced non-wage labour costs if a neoliberal programme is being thoroughly pursued). When many workers' lives are dogged by insecurity and uncertainty about the future, consideration has to be given to the fact that workers are also consumers, and that if their working lives are very insecure, they might lack consumer confidence. At times of economic recession, flexible labour markets might provoke a decline in demand, which only worsens the recession.

This problem can be tackled in various ways. (For a detailed discussion of the diversity of strategies available, with evidence on how they are used in EU countries, the USA, Japan and Russia, see Crouch 2015.) First, if an economy is overwhelmingly dependent on export trade, domestic consumption might not be important, and the low wages that make it difficult for local workers to consume may be more than

compensated by increased international competitiveness. This was temporarily part of the secret of the West German economic "miracle" in the early 1950s. The government pursued a tough fiscal strategy that restrained domestic demand, but the economy recovered from its wartime destruction through export sales to the USA, the UK, Scandinavia and other countries that sustained their own worker-consumers' demand through Keynesian policies.

A similar approach today has been an important element in the economic success of China and some other rapidly developing economies with vast supplies of surplus labour. It is, however, far more difficult to pursue this path in parts of the world where the consumption of the national working population has become important for economic activity, and/or where widespread democratic rights enable workers to express their discontent at being unable to afford to consume. This is particularly the case for post-industrial economies, where many services sector activities depend heavily on domestic demand. Whether

WHEN JOB OPPORTUNITIES ARE PLENTIFUL, WORKERS FEEL ECONOMICALLY SECURE EVEN IF THEY HAVE LITTLE JOB SECURITY

these activities comprise public services, dependent on public funding, or private ones, dependent on private purchases, they find it difficult to thrive under conditions of austerity policies involving restricted public spending and low or insecure wages. In such cases, sustained demand from mass consumers is important to a stable economy.

Another approach to the dilemma, and one that is used in virtually all advanced economies as well as in less developed ones, is for a minority of workers—defined perhaps by age, gender or ethnicity, or just by bad luck—to be excluded from the general security enjoyed by the majority. The majority have secure jobs and can consume confidently, sustaining a strong economy, while a minority bears all the burden of insecurity, consuming little. This provides a kind of solution, but it is one that leads to a generation of troubled and troublesome minorities of the socially excluded, and there must be doubts over its long-term sustainability. The puzzle of how to have confident consumers who are also insecure workers remains.

The issue is particularly acute where workers with relatively low skills are concerned. In industrial economies, such workers have the chance

to achieve reasonable incomes because their low productivity is improved by the machinery they use. In general, though, with growing exceptions, low-skill services do not make so much use of technology, and constant improvements in efficiency reduce the need for low-skilled workers. Highly skilled services are mainly found in the public sector or in internationally traded activities. Without thriving local demand for locally produced services, it is difficult to provide employment for large numbers of low-skilled people.

IF A RISE IN THE SUPPLY OF SKILLED AND EDUCATED WORKERS EXCEEDS A RISE IN EMPLOYERS' DEMAND FOR THEM, THERE CAN BE LAGS IN THE MOVE TO A HIGH-SKILLED ECONOMY

It is often a central aim of public policy to improve the overall educational and skill level of the population so that there should be a diminishing need to find such employment. However, there will continue to be a tail of low-skilled workers, for whom the only alternative to unemployment is likely to be work in local services. Indeed, if a rise in the supply of skilled and educated workers exceeds a rise in employers' demand for them, there can be lengthy lags in the move to a high-skilled economy. This can cause, for some time, a dispiriting increase in the number of young people having to take low-paid, insecure jobs below their educational capacity, with a further depressing impact on the employment prospects of those with low skill.

Faced with these arguments, neoliberals are likely to point to the example of the United States of America. Here is a country that has some of the lowest levels of social protection and unemployment support in the advanced world, as well as particularly weak employment protection laws. It is also a post-industrial economy that depends heavily on domestic demand for locally produced services. But it manages to sustain one of the advanced world's highest employment rates and bounces back quickly to those rates after periods of recession. Surely, the US case shows that social policy is not needed to support a high-performance, high-employment, high-consuming economy; left by themselves, labour markets will clear. The US, therefore, served as a major example to imitate when the OECD and other international organizations, including eventually the EU, launched their critique of European social and labour policy regimes in the 1990s (OECD 1994; European Commission 2005).

A central aim of public policy is to improve the educational and skill level of the population.

But the financial crisis of 2007-08 showed that something different from the capacity of free markets to clear lay behind US employment success. A large proportion of the US population had been able to sustain the consumption on which the economy depended only by taking on unsustainable levels of debt: credit card and other forms of consumer debt. In particular, mortgages of over 100% on houses were taken out, not to acquire further residential property, but to sustain consumption. US workers' wages had been static or slightly falling for several years, and this had certainly helped to sustain full employment, in contrast with many Western European countries, where wages had risen at the expense of the employment of the low-skilled.

But it was consumer debt and high mortgages that had made possible the paradoxical combination of low, uncertain wages and high, continuing mass consumption. As became very well known after 2008, this debt had been sustainable only because it was carried by financial markets which seemed to have discovered how to trade profitably in ever larger quantities of risk without negative consequences, but this eventually came to an extreme stop. A particularly important role had been played by "sub-prime" mortgages, fundamental to the maintenance of consumption among workers with static wages and insecure jobs, which financial traders had been buying from each other with no

idea of the size of the risks involved. Untradeable uncertainty replaced tradable risk to an alarming degree, in a crisis from which the world has yet to recover.

In fact, the OECD and some other authorities had begun to worry about growing consumer debt, not only in the US but also in the UK, Ireland, Spain and some other countries, in 2006, two years before the crash (OECD 2006a). Today, the solution of squaring the circle of flexible labour and confident consumption through the mechanism of consumer debt seems less attractive, and one hears less of the superiority of the US (and UK) model. Indeed, the OECD (2011) and International Monetary Fund (IMF 2012) have gone further and explored another example of this model that seems unsustainable. The level of income inequality has been growing rapidly across the advanced economies, initially and most dramatically in the US. Growing inequality is intrinsic to the approach of allowing wages to fall, supported only minimally by social policy, until the labour market clears. In the case of the US, where this process has proceeded furthest, the OECD suspects that consumption among the lower half of the income distribution is now at risk (Förster et al. 2014), as the wealthiest 0.1% have taken 46.9% of national economic growth since the 1980s. No other country has quite the US rate of increase in inequality, though the UK (with 24.3%) comes second.

These consequences of a threat to consumption embodied in growing inequality were long concealed by the temporary success of the markets in consumer debt and sub-prime mortgages, but they have now been laid bare. The danger now is that governments, seeking to restore mass consumer confidence but feeling politically unable to challenge the power of the wealthy by taxing them more, or being unwilling to do so because of their parties' financial dependence on wealthy donors, will gradually encourage a return to the type of financial market that brought the 2007-08 crisis.

Risk and uncertainty

Viewed in a broader theoretical perspective, we can see the general issue behind these trends as the problem of uncertainty that must be faced by populations in all kinds of society. In sophisticated, advanced economies, the problem is resolved in the following way. The wealthiest,

who are in a position to take risks and to pay for professional advice on how to take those risks intelligently, convert uncertainty into risk by assigning probabilities to it, therefore making it possible to trade in it. (This approach to seeing risk as tradable uncertainty was first developed by Knight (1921).) For them, uncertainty is transformed from being a threat to life's security into a means of making money and acquiring security.

> IN SOPHISTICATED, ADVANCED ECONOMIES,
> UNCERTAINTY IS TRANSFORMED FROM BEING
> A THREAT TO LIFE'S SECURITY INTO A MEANS OF
> MAKING MONEY AND ACQUIRING SECURITY

But there is a large residual of uncertainty that is not profitably tradable. This is passed on to the majority of the population. Many of these people, perhaps a majority, are able to hedge against the negative impact of uncertainty by having savings, especially investments in housing, and by using their skills and luck to secure forms of employment that are in strong demand. They do not become anything like as rich as the "financial" minority, but they are reasonably secure.

This leaves a further residuum of uncertainty, which is borne by those unable to do either of these things. They become the social excluded. Public social policy sometimes comes to their aid, through systems of support in periods of extreme insecurity, like unemployment, sickness or disability and, eventually, old age. But sometimes, even public policy works in socially exclusive ways, as in the case of some insurance-based social protection and employment protection laws that help those with secure jobs, but possibly at the expense of those without.

At a time of rapid economic change like the present long-term wave of globalization, uncertainty naturally rises. This means that there is more and more money to be made by those able to convert that uncertainty into tradable risk, and less and less money for those who receive the burden of those elements of uncertainty that cannot be traded. Hence, living standards among the low-paid fall, while those among the wealthy rise, and inequality grows. The financial system that initially seemed to bring a larger proportion of the population into successful risk trading has ended by doing the opposite, contributing to the growth in inequality that was causing many people have recourse to high levels of debt in the first place.

If the system of labour protection associated with the classic measures of the industrial past no longer seem to work efficiently, and if the Anglo-American combination of labour market flexibility with consumer debt has brought disaster, to what other models can we turn? During the early years of the present century, the EU took great interest in new policies being developed in Denmark and the Netherlands, whereby workers sacrificed certain older forms of legal job protection in exchange for improved help with finding work when unemployed, improved training and education, publicly funded childcare to make it easier for mothers to work and other measures for improving the employability of the working population.

"FLEXICURITY" WAS A GOOD EXAMPLE OF HOW EUROPEAN POLICY CAN COMBINE MARKET-MAKING WITH SOCIAL POLICY

Security of the old kind, security in a specific job, could no longer be guaranteed in a rapidly changing economy, but workers wanted to be able to feel confident that public policy was there to help them find, if necessary, a succession of jobs. Employment security could replace job security. It should be noted here, though it will be discussed further below, that there is an important difference between job security and employment security. The former refers to a worker's confidence that he or she can retain a specific post, while employment security includes the former and the alternative solution of being able quickly to find an alternative if a specific post is lost.

This was expected to produce a combination of flexibility and a sense of security, and was dubbed "flexicurity" (Bredgaard et al. 2007, 2008; European Commission 2007; Jørgensen and Madsen 2007). It was a good example of how European policy can combine market-making with social policy in a constructive compromise. The outcome might resemble that of the Anglo-American approach, but with support from public policy as well as from the market.

Denmark and the Netherlands had been striking cases of success in achieving high employment levels and economic efficiency after some years of crisis—and Denmark, in particular, avoids the high levels of income inequality associated with the USA. The most outstanding feature of the Dutch success was the achievement of a high level of employment

among women, mainly through the facilitation of part-time work, including granting part-time workers many of the entitlements and rights of full-timers.

The Danish example provided different lessons. The country had reduced its previously very high levels of legal job protection, but was the highest spender on active labour market policy (ALMP), including both job-related education and the provision of child care. This became the paradigm case for flexicurity. Muffels et al. (2013a, 2013b, 2014) found that high average unemployment replacement pay (URR) over a five-year period had a small positive effect on employment, even after taking account of the business cycle and demographic controls. They speculate that this might be associated with the positive effect of unemployment insurance on improving job match and on stabilizing consumption, supporting claims made on behalf of flexicurity theory for secure and enabling benefits. However, the authors also point to the positive association between URR and involuntary job mobility (dismissals), suggesting that in countries with strong income protection, employers tend to shift the costs of economic adjustment to the government, knowing that employees are well covered.

Muffels et al. (2013a, 2013b) also found that both ALMP spending and the level of encompassment of collective bargaining had a positive effect on employment. This has also been found in research on the crisis by the OECD (2013a) and is consistent with the findings of our present study. However, in Muffels et al. (2014), the positive effect of ALMP seemed to be restricted to Western Europe; it turned strongly negative when applied to CEE countries—though ALMP is in general far weaker in CEE than in the West. The effect of ALMP on employment seemed strongly dependent on the content and design of ALMP in the various countries.

Training and working-time arrangements appeared particularly successful to curtail unemployment in the recent crisis, but particularly in countries with a strong tradition in these policies. In other countries, such as France, Italy and the Netherlands, during the crisis, reform proposals were launched aimed at increasing flexibility through reducing the protection of insiders while enhancing security by improving the protection of outsiders. Overall, the authors concluded from these findings that welfare state regimes, or social models, seemed to matter in terms of the way in which institutions influence employment performance, but that each regime sought its own way in which to reform its policies in response to a crisis.

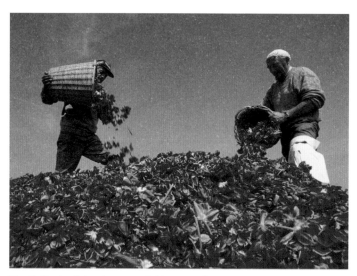

The Netherlands has been a notable case of success in achieving a high employment rate.

From both Denmark and the Netherlands, the EU took the idea of a strong role for public social policy, running alongside a reduction in classic job protection (European Commission 2007). It then began to urge the idea of flexicurity on all member states. However, given the nature of the open method of coordination, countries were left very free to interpret the idea of flexicurity.

The Commission also over-simplified the Danish system. Denmark not only has advanced active labour market and childcare policies, but also has exceptionally generous levels of unemployment support for workers who lose their jobs and strong trade unions representing a high proportion of the workforce (Bredgaard et al. 2008; Madsen 2009). Both of these features, neglected by the Commission and many other observers, contributed to flexicurity. Generous unemployment pay meant that the consequences of losing one's job were less severe than in many other countries. The existence of strong unions meant that workers did not need to fear that a low level of job protection rights would leave them exposed to managerial bullying and arbitrariness, as the union would intervene in such cases. It is true that levels of both unemployment support and union membership have declined in Denmark in recent years, but they both remain among the highest in the world.

What happened in this one-sided selection of elements of the Danish system was a concentration by the Commission's experts on what had come

to be known as the "new social risks" and a neglect of "old social risks". This distinction can be traced back to a certain interpretation of risk by the late Ulrich Beck (1986) on what he saw as a change in the nature of risk in advanced societies. Where risk in pre-industrial and industrial societies (or what Beck preferred to call "the first modern") had been a source of worry and concern for ordinary working people, in post-industrial societies ("the second modern"), risk was a matter of opportunities.

This idea was developed by Anthony Giddens (1994, 1998), David Taylor-Gooby (2004) and some other mainly British authors to argue for a shift in social policy. In industrial societies, they argued, there were old social risks associated with dangers to security that people confronted passively: risks of unemployment, sickness, accident and disability and prolonged old age. Confronting these risks with transfer payments was the role of classic 20th century social policy.

Today's working population confronted opportunities that they could tackle actively, given appropriate help from social policy. This led to the case for a "social investment welfare state". The working population of the second modern needed education and training, help with finding appropriate new jobs and new training as technological advances made it necessary to change employment, and help with child care to make possible a two-gender workforce. These constituted the new social risks, policies that were mainly a matter of providing services rather than transfer payments.

The old risks were seen as declining in importance in the confident, reliably expanding economies of high-technology, post-industrial societies. Given, therefore, a reduced need for money to be spent on dealing with the old risks, funds could be diverted to the new ones without a net increase in costs. Also, given the predominance of women among the employees of public services in nearly all countries, the shift from transfer payments to service provision would in itself assist the growth of the two-gender workforce (Esping-Andersen 1999).

There was much good sense in these arguments, and economies that confronted the new social risks enjoyed greater success in terms of production, innovation and employment levels than those that did not. In particular, the Nordic economies, with their high levels of spending on public services, performed better than those in South-Western Europe, with welfare states concentrated on transfer payments. This was partly due to the superior ability of the former to employ women, who became the main employed providers of these new expanded services.

Some of this thinking clearly influenced the Commission's interpretation of the Danish model, which stressed the new social risk aspects of ALMP and childcare and played down generous unemployment pay and strong unions—both associated with old social policy. But it was an error to ignore the fact that Danish policy operated on old and new social risks alike. After 2008, the error has become particularly clear. The old social risks have not gone away. Unregulated, unsustainable financial markets gave the impression that the laws of supply and demand had lost their force and that we had embarked on an age of limitless expansion, but that was all illusion.

Beck's analysis of a change in the nature of risk would have been better expressed in terms of the economist's distinction between uncertainty and risk discussed above, rather than as one between first and second moderns. What Beck had seen as negative risks associated with pre- and industrial societies were not risks but the phenomenon of uncertainty, in which people have been unable to assign probabilities, convert uncertainty into risk and then trade in it. His idea of new risks was the true concept of risk, but he was wrong to have seen modern populations in general as having a capacity to convert uncertainty into risk. As noted above, only those with wealth and access to professional advice could afford to do this in a highly successful way. If the bulk of the population in many countries seemed to have joined this risk market during the early 21st century, it was mainly because their consumer and mortgage debt was taken up by speculative traders. When the unstable financial system that had made this possible collapsed, many of these people were left with the untradeable uncertainty, from which, in truth, they had never really escaped.

In a further twist, governments across the world moved quickly to bail out the banks within which the market traders had worked, as they feared the consequences of a collapse of the global financial system. Accustomed to profiting from turning uncertainty into tradable risk, banks (and the incomes of highly paid traders) were protected from bearing the losses that should logically have followed when their risk calculations failed. In the long run, this will probably favour a return to irresponsible trading, as bankers have learned that states will bail them out from irresponsible risk trading. In addition, they can be expected to use their considerable lobbying power to seek a reduction of the protections against such behaviour that governments and the EU have been erecting since 2008.

More immediately, these actions by governments shifted the burden of debt onto themselves, thereby turning a crisis of private debt into one of public debt. This has had the further consequence of leading governments to ease their debt problem by cutting public expenditure. The main impact of this has been on the poor, who depend more than most on social spending. Thus, once again, if risk cannot be traded, it is converted back into untradeable uncertainty, which is dumped on those at the bottom of the income distribution. If the growth of the new risk markets produced increasing inequality, their collapse has intensified rather than reversed the trend.

IF RISK CANNOT BE TRADED, IT IS CONVERTED BACK INTO UNTRADEABLE UNCERTAINTY, WHICH IS DUMPED ON THOSE AT THE BOTTOM OF THE INCOME DISTRIBUTION

In a further reinforcement of these processes, the fact that a private debt crisis became a public one strengthened (falsely but effectively) the arguments of those both in the EU and in national governments in Europe and elsewhere, who reasoned that social spending had in any case become too high, and that both it and other forms of social policy that seemed to impede free markets needed to be restrained. But the crisis really demonstrates exactly the opposite: people without great wealth need protection against both old and new social risks—a combined protection that they receive, though decreasingly, in the Danish, other Nordic and some other North-Western European systems. There is little trade-off between old and new risks; they are cumulative. Only populations willing to support with taxes a high level of social expenditure to confront both kinds of risk are able to combine labour flexibility with confident mass consumers, a relatively low level of inequality and economic success.

The most recent developments in ideas from social policy experts for a social investment welfare state fully recognize the need for an approach to consolidated social risks (Hemerijck 2012; Vandenbroucke et al. 2011). However, they have so far had no influence on policymakers. Not only did the Commission and others fail to perceive the attributes of true flexicurity in the Danish case, but in subsequent years, although they have continued to talk in vague general terms about flexicurity, in practice they have returned to the uncompromising model of the

neoliberal labour market—a model from which the OECD (2006b) began to distance itself some years ago (see also Esping-Andersen and Regini 2000; Avdagic 2015).

In its recommendations to the debtor nations in South-Western Europe and Ireland, the Commission has advocated only the dismantling of old forms of social protection and the weakening of collective bargaining (and hence of trade unions). There has been no attempt to encourage replacement of these institutions with those of the new social risks school, let alone the combination of old and new policy that seems to be required for an optimally functioning labour market. This is seen at its clearest in the Commission's joint Memorandum of 2012 with the European Central Bank and the International Monetary Fund to Greece (Government of Greece 2012), as this spells out in particular detail the policy preferences of an uncompromising neoliberal regime. The revised memorandum of 2015 is less singularly neoliberal in its insistence on a more egalitarian fiscal regime, but the stance on social policy has not changed.

Trade unions and, to some extent, employers in the Nordic countries resent the de facto rejection of their highly successful labour market regimes, resulting from the a priori assumption of EU policy that only a neoliberal market order can function efficiently. This is leading to demands for a "renationalization" of employment and labour policy in that part of the world and among other observers critical of current EU developments (Streeck 2013). This is understandable in the context of what has been happening, but short-sighted. It is very difficult to protect the national labour-market institutions of individual countries in a globalizing economy. There is constant pressure in that environment to move to lowest-cost models that deliver the highest short-term profit. The EU does not drive this process, which is no way limited to its members. Critics can argue that the EU should be a level of creative response to it rather than, as it is increasingly becoming, simply one of its facilitators, but the call for a renationalization of social policy is Quixotic.

It is often not possible to judge in advance which aspects of economic systems are likely to deliver economic success, but in the short term, there is pressure to impose uniformity. Intense competition drives out diversity. We have seen this played out in the financial system. First, the Anglo-American system deregulated itself and was stripped down to the goal of short-term profit maximization. It was then advocated as a superior system to the rest of the world, and systems of corporate

governance and corporate accounting were rewritten to conform to it. By the time it became clear that short-term profitability could accompany long-term non-sustainability, it was too late to save the world from a financial collapse.

At the same time, unions and their associated parties in South-Western Europe are tempted to seek a return to their former social policy regimes, even though these have usually been associated systems of legal job protection that increasingly benefit just a minority of the work force, excluding many of the lowest paid, and (with the exception of France) result in high levels of inequality in the distribution of social benefits. Understandable though their rejection of neoliberal strategy may be, their own approach brings no solution and arguably makes everything worse.

Whether the national system being defended is a totally viable one compatible with universalism, egalitarianism and a high-performing economy, or one that is economically less viable and associated with unequal access to the social state, no solution can be found by pitting national social achievements against EU neoliberalism. Also, and particularly but not solely within the Eurozone, when labour markets function poorly in an individual country, the consequences impact others. Although labour market issues were not the main cause of the Southern European debt crisis, they are implicated and cannot be ignored. The idea that EU policy does not need to touch national labour market and social policy is difficult to sustain. By the same token, however, if Europe offers only strict neoliberalism, denying the success of the Nordic and some other economies and offering nothing but increased insecurity to workers in South-Western ones, it will become increasingly difficult to resist the pressure for renationalization.

The impact of immigration

Particularly important among the problems of allowing labour markets to "clear" through unimpeded competition are those relating to mass migration. For labour markets to clear where there is migration from countries with considerably lower living standards, the wages of "native" workers in the countries receiving immigrants might have to fall a long way. The neoliberal answer is that in the long term, wages will rise in the labour-exporting countries as their economies improve and

extensive emigration produces labour shortages. Meanwhile, wages will fall in the countries of immigration, reducing the incentive for workers in the countries of emigration to move. In the end, migration is reduced to small flows in both directions, and the problem disappears.

Certainly, in the long run, such a reduction in cross-national inequalities would be a desirable outcome, and eventually it will probably happen. But the long term could be very long indeed, and the process of gradually declining wages in the countries of immigration is already creating insecurity and anxiety, leading to social disturbance, xenophobia and pressure for the restriction of immigration. Immigrant communities, which can usually be distinguished as culturally and linguistically "different", are becoming vulnerable to persecution and violence. These problems are beyond the reach of economic theory; fear and anxiety leading to xenophobia and ethnic conflict are externalities to which the theory has only one answer: wait patiently for long enough and the market will clear.

National welfare states have been built on the basis of shared citizenship: we recognise each other as members of a national community and accept obligations to support each other within that community (provided we can see that others are also trying to make a contribution). Extending that idea to a small number of immigrants worked with some, but relatively minor, difficulty in several European countries (especially in the Netherlands and the UK). But as the number of immigrants grows, that generosity of spirit can become strained, and that is what is happening now.

It is necessary to distinguish between three types of immigration affecting European countries. First is immigration from former colonies or parts of the world with which a country has had a historical association. This was of major importance for people from the former empires of Western European nations in the first three post-war decades, a process that continues. But it is particularly prominent today for Spain and for some countries in Central and Eastern Europe with borders with non-EU but fellow-Slav states. These issues are specific to the countries concerned and probably have to be resolved by them, in partnership with the countries of emigration.

Second is migration from the new member states into the countries of Western Europe. This is where EU neoliberalism has been so blind. Since, for neoliberal economists, welfare states achieve nothing and human beings do not need to be considered as anything other than

units of labour power, there was no need to consider the implications of relations between native populations called upon to extend benefits of their welfare states, which have been important badges of their citizenship, and immigrants making even modest demands on those states. However, if we accept the concept of social citizenship as something meaningful that affects people's behaviour, we should be able to see that if migration is taking place under the umbrella of EU membership, then a degree of social citizenship at that level is also necessary.

NATIONAL WELFARE STATES HAVE BEEN BUILT ON THE BASIS OF SHARED CITIZENSHIP: WE ACCEPT OBLIGATIONS TO SUPPORT EACH OTHER

If the citizens of countries receiving large numbers of immigrants are to be reassured that the integrity of the contributory base of their welfare states is intact, those national systems should not have to bear the burden of immigrants' use of social services and transfer payments until those immigrants have started to make a contribution through work and taxation. Further, if the people of all Europe are to see themselves as European citizens, there needs to be a level of welfare state that operates at the EU level.

If Europe is no more than a group of markets, including a labour market, there is no reason why the citizens of individual countries should accept any obligations towards immigrants in their midst. This calls for a level of basic social entitlements to which Europeans should have access whenever they are living in an EU member state other than their own and are in need of social support. These entitlements should be funded by contributions from all member states, based on a formula that links national wealth and a country's number of emigrants. Access to citizenship services by an immigrant should at first be funded by calls on that fund by the receiving state, being gradually replaced by purely national funding as the immigrant makes a contribution within his or her new country.

Finally come immigrants who are really asylum seekers, fleeing war, famine, persecution or other disasters in countries outside Europe. These comprise a growing share of cross-national movements of people, especially for Germany, Austria and the Nordic countries, but also for Greece and Italy, often the first ports of call for people escaping some

of the world's most troubled places in North Africa and the Middle East. Even more than with EU migrants, these movements are causing stress in the receiving countries, again undermining the solidarity of the welfare state. But it is usually impossible, or extremely callous, to solve the problem by simply sending the people back to the places from which they are escaping. However, if the countries of Western Europe, North America and elsewhere are to be expected to play this kind of role in receiving the world's distressed, there again needs to be an international fund, in this case operated at the level of the United Nations, of the kind proposed here for EU member states, though at a less generous level, since membership of the UN does not involve the same obligations as that of the EU.

It would be wrong to pretend that this kind of approach could solve all the problems presented by immigration, especially illegal immigration that is not part of labour market policy. There are problems here of the relations between some forms of Islam and other parts of the world, including fears and the reality of terrorism, which are beyond our present scope. However, these issues are affecting labour markets because they are exacerbating existing tensions between host and immigrant populations. Labour market policy, therefore, has to recognise the questions involved and, for its own sake, play whatever part it can in ameliorating those tensions. This mainly includes alleviating anxieties about labour market insecurity.

Conclusions

Overall, these developments point to a need to strengthen the European level of labour-market policy-making, but with a broader, more imaginative and politically more diverse set of policy instruments than current EU policy biases allow. This requires moving beyond a neoliberal perspective and taking account of a wider range of values. The problem is that European—as well as many national—policymakers seem unwilling to embrace these wider perspectives. Instead, therefore, we are being trapped into a cycle of damaging approaches whereby intensifying labour insecurity is one of the causes of growing income inequality, which in turn creates consumption problems for large numbers of citizens, driving them to take more and more household debt, and separately reinforcing xenophobia. If EU labour and social policy continues on its

present track, further Europeanization will be an unmitigated disaster. But responding to that prospect with a renationalization of this policy area will simply fail under the pressures of globalization.

BART VAN ARK is Executive
Vice President, Chief Economist
and Chief Strategy Officer of the
research center The Conference
Board. He is a full professor at the
University of Groningen, special-
ized in economic growth, develop-
ment economics, economic history
and international economics and
business. He consulted for the
European Commission and the
OECD and has published in the
Journal of Economic Perspectives,
Brookings Papers on Economic Ac-
tivity, and *Economic Policy.* He is a
Director at the National Bureau of
Economic Research and a mem-
ber of the Board of Directors of
The Demand Institute.

This paper documents two gaps in Europe's
growth performance since 2008 and 2009.
The first refers to the slower output, invest-
ment and productivity growth rate compared
to the pre-crisis period. The second refers to
the performance gap relative to the United
States. Weak productivity growth is a major
factor slowing the speed of recovery in Eu-
rope. This slowdown has broadened from the
services sector to manufacturing, which has
been a traditional stronghold for productivity
in Europe. There is a need to accelerate
investment in the most important assets for
productivity recovery.

CONTRASTS IN EUROPE'S INVESTMENT AND PRODUCTIVITY PERFORMANCE[*]

Introduction

The economic and financial crisis which started in 2008-09 has thrown the European economy into a "double-dip" recession and overall stagnant growth for a lengthy period of time. The region now faces two significant gaps in its growth performance. The first is a gap relative to its own pre-crisis growth performance. The second is a worsening of a pre-crisis performance gap relative to the US economy, despite the latter's own challenges to revive since the Great Recession.

EUROPE NOW FACES A SIGNIFICANT GAP IN ITS GROWTH PERFORMANCE IN CONTRAST WITH THAT OF PRE-CRISIS YEARS, AND A WORSENING OF THE GAP IN RELATION TO THE US ECONOMY

Europe's growth shortfall from both perspectives is very visible at the aggregate level of GDP. In 1980, the level of GDP of what constitutes the EU-28 today was 45 percent above that of the United States, but it gradually narrowed to about 10 percent just before the 2008-09 crisis (see chart 1). By 2014, GDP in Europe was only 6 percent above the US level. GDP performance for the Euro Area has weakened even more, relative to the US. In 1995, the level of GDP of what is the Euro Area-19 today was about 10 percent lower than the US level, but the gap was as big as 25 percent in 2014.

[*] The Conference Board and University of Groningen. This contribution is in part based on a research paper for the European Commission, DG ECFIN, titled "From Mind the Gap to Closing the Gap: Avenues to Reverse Stagnation in Europe through Investment and Productivity Growth," European Economy Fellowship Initiative 2014-2015, Discussion Paper 006, September 2015; and on a recent paper co-authored with Mary O'Mahony, titled "Productivity Growth in Europe Before and Since the 2008/09 Economic and Financial Crisis," in *The World Economy: Growth or Stagnation?* Edited by D.W. Jorgenson, K. Fukao and M.P. Timmer. Cambridge University Press, 2016.

The weaker output performance in Europe is also reflected in a larger per capita income gap relative to the United States. For example, per capita income in the Euro Area-19 hovered between 75 and 80 percent of the United States level between 1980 and 1995. However, after 1995, it dropped below 75 percent of that same level, then briefly recovered during cyclical upswing around 2005 to 2006, and has yet dropped further since the crisis, especially since 2011, to only 71 percent in year 2014 (see chart 2).

Compared to per capita income, productivity showed a very different pattern relative to the United States. Between 1980 and 1995, per capita income in the Euro Area was supported by a rapid closing of the gap in output per hour from 85 percent of the US level to more than 95 percent. During this period, productivity was driven by increased capital intensity while employment growth was quite slow. Between 1995 and the start of the 2008-09 crisis, employment growth in Europe improved, but weaker productivity performance increased the gap in per capita income relative to the United States.

LEVEL OF GDP 1980-2014

In trillions of US$ as of 2014

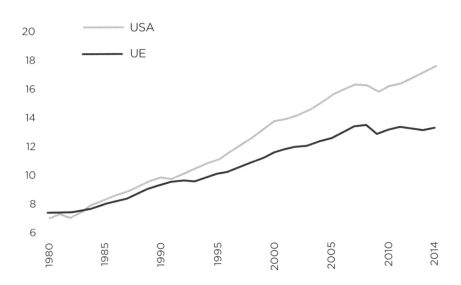

Note: GDP is converted at 2011 PPPs from the International Comparisons Project (World Bank), with GDP rebased to 2014.

Source: The Conference Board Total Economy Database, May 2015

Chart 1. Level of GDP in trillions of $US as of 2014 (PPP-converted), 1980-2014

Since the onset of the crisis, the American and most European economies experienced a drastic decline in both employment and productivity growth, creating a gap relative to their own pre-recession performance. While employment has begun to recover, there have been virtually no signs of a significant recovery in productivity growth beyond some short-lived, pro-cyclical improvements in 2010. Productivity growth, in fact, weakened substantially in both economies, and as a result, the productivity gap in terms of output per hour between Europe and the United States has remained largely unchanged since 2009. Per capita income dropped off further because of much weaker output recovery in Europe.

In this contribution, I argue that weak productivity growth is a major factor slowing the speed of growth recovery in Europe. We also find that the productivity growth slowdown has broadened from the services sector to manufacturing, which has been a traditional stronghold for productivity in Europe. These trends are all the more surprising, as the productivity slowdown seems to happen during a time of a rapid rise

LEVEL OF PER CAPITA INCOME AND LABOUR PRODUCTIVITY IN THE EURO AREA RELATIVE TO THE UNITED STATES

(PPP-converted), USA=1.00, 1980-2014

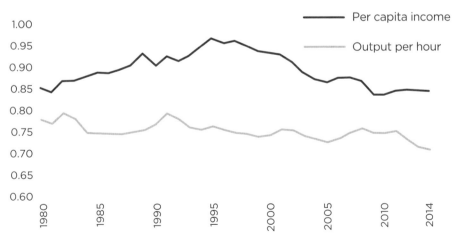

Note: GDP is converted at 2011 PPPs from the International Comparisons Project (World Bank), with GDP rebased to 2014.

Source: The Conference Board Total Economy Database, May 2015

Chart 2. Level of per capita income and labour productivity in the Euro Area relative to the United States (PPP-converted), USA=1.00, 1980-2014

of the digital economy. While the lack of demand since the onset of the crisis has held back the potential to improve productivity, the lack of investment in the most important assets for a productivity recovery, namely the intangible (or knowledge) assets in the economy, is a key factor as well. In addition to ICT capital, the intangibles include other information assets, such as data, innovative property and economic competencies, including workforce training, organizational innovations, branding and marketing. In the light of slowing labour supply across

WEAK PRODUCTIVITY GROWTH IS A MAJOR FACTOR SLOWING THE SPEED OF GROWTH RECOVERY IN EUROPE

European economies in the coming decades, I argue that the key to supporting growth in Europe is to strengthen productivity by complementing physical (tangible) assets in the economy with intangible assets that drive technological change and innovation.

An analysis of the sources of growth

A decomposition of the annual average growth rates in aggregate GDP into the contributions of labour, capital and TFP reveals some stark differences in Europe's growth performance relative to its own history and compared to the United States (see table 1). Although, from 1999 to 2007, Europe and the Euro Area saw a faster increase in the contribution of working hours to growth than the United States, hours have contributed negatively since the beginning of the crisis in Europe and have provided a zero contribution in the United States.

The contribution of past and present investments, measured as capital services from ICT and non-ICT assets, have been the main drivers of GDP growth in the aggregate EU and the US. Before the crisis, non-ICT capital accounted for about 0.8 percentage points of GDP growth in the EU, but it has declined to 0.5 percentage points since the crisis. In the Euro Area, the contribution of non-ICT capital dropped from 0.7 to 0.3 percentage points, which was comparable to the drop-off in the United States.

The US advance in the ICT capital contribution to growth was much higher (at 0.7 percentage points) than in Europe (at 0.5 percentage points) and the Euro Area (at 0.4 percentage points) during the 1995

to 2007 period. In the US, much of the faster investment pace during the "new economy" era of the late 1990s was driven by the scale effects from larger US markets, especially in market services, such as trade and transportation, which could not be easily replicated in Europe (Inklaar et al. 2008). Since 2008, the ICT capital contribution to

OUTPUT, HOURS AND LABOUR PRODUCTIVITY GROWTH, AND GROWTH CONTRIBUTIONS BY MAJOR INPUT

Log growth, 1999-2007 and 2008-2014

1999-2007	Growth rate of GDP	Contributors to GDP Growth				
		Hours worked (weighted) (1)	Labour Composition	Non-ICT Capital	ICT Capital	Total Factory Productivity Growth
EU-27*	2.6	0.5	0.3	0.8	0.5	0.6
Euro Area**	2.3	0.6	0.2	0.7	0.4	0.4
EU-15***	2.4	0.6	0.2	0.7	0.5	0.4
EU-12****	4.4	-0.1	0.3	1.2	0.8	2.2
EE. UU.	2.8	0.4	0.2	0.7	0.7	0.9
2008-2014						
EU-27*	0.2	-0.2	0.2	0.5	0.3	-0.5
Euro Area**	-0.2	-0.4	0.2	0.3	0.3	-0.6
EU-15***	0.0	-0.2	0.1	0.4	0.3	-0.6
EU-12****	1.5	-0.3	0.2	1.1	0.7	-0.2
EE. UU.	1.1	0.0	0.1	0.3	0.4	0.3

(1) Contribution of total hours worked, weighted by the share of Labour in total compensation, to the log growth rate of GDP.
*EU-27 excludes Croatia which became member of EU on 1 July 2013.
**Euro Area refers to pre-2014 membership of 18 members, excluding Latvia, which became a member on 1 January 2014.
*** EU-15 refers to pre-2004 membership of EU.
****EU-12 refers to new membership of EU since 2004, and excludes Croatia, which became member of EU on 1 July 2013.
Note: For figures by individual country, see Bart van Ark (2015), "From Mind the Gap to Closing the Gap: Avenues to Reverse Stagnation in Europe through Investment and Productivity Growth", European Economy Fellowship Initiative 2014-2015, Discussion Paper 006, September 2015.

Source: The Conference Board Total Economy Database, May 2015

Table 1. Output, Hours and Labour Productivity Growth, and Growth Contributions by Major Input, log growth, 1999-2007 and 2008-2014

growth slowed down considerably in both regions, and slightly more in the United States (from 0.7 to 0.4 percentage points) than in the EU-28 (from 0.5 to 0.3) and in the Euro Area (from 0.4 to 0.3).

The biggest concern with regard to Europe's growth rate relates to the slow rate of total factor productivity (TFP) growth, which measures the efficiency of the combined use of labour and capital. As mentioned above, this trend is all the more surprising given the rapid rise of digital technology in the past decade. The slowing trend in TFP growth can be explained in different ways. Beyond the temporary impact from the recession related to weak cyclical demand, slow total factor productivity growth might signal weakening innovation and technological change. Companies may be holding back investment in those areas due to longer term concerns about a negative spiral of weak demand and investment, in which low nominal interest rates do not help to drive up investment—the so-called secular stagnation hypothesis.[1]

However, slow total factor productivity growth may also be caused by difficulties on the supply side to implement new technologies. It is a well-known fact that new technology regimes, such as the current convergence of ubiquitous broadband and mobile, supported by cloud computing and big data analytics and reflected in the rise of apps economy and the sharing economy, take time to translate themselves into more productivity applications. In the extreme, a minority of scholars argue that the potential impacts of this latest digital technology wave fade in comparison to previous major technology booms, such as the electricity grid or the combustion engine.[2] More likely, it could be that the impact of new technologies is delayed, for example, due to a shortage of skilled workers, a lack of organizational innovations or other factors.

But for the total factor productivity growth rate to turn negative, additional explanations are needed. First, it could signal an increase in rigidities in labour, product and capital markets during the crisis, causing increased misallocation of resources, away from higher-productivity to lower-productive firms. This may especially be so in times during which scale-dependent technologies, such as communication

1 See, for example, C. Teulings, and R. Baldwin (2014), "Secular Stagnation: Facts, Causes and Cures," VoxEU, Centre for Economic Policy Research, London.

2 See, for example, Robert J. Gordon, "US Productivity Growth: The Slowdown Has Returned after a Temporary Revival," *International Productivity Monitor 25*, Spring 2013; Tyler Cowen, *The Great Stagnation: How America Ate All the Low-Hanging Fruit of Modern History, Got Sick, and Will (Eventually) Feel Better*, (New York: Dutton Adult), 2011.

technology, require flexibility across a larger economic space. Limited scale effects in Europe, related to fragmented markets and limited impacts from ICT utilization, might have played a larger role than in the United States.

Second, we can also not exclude the possibility that measurement issues hide the productivity impacts related to the introduction of new technologies and subsequent innovations. The potential productivity gains from the rise of the digital economy pose huge measurement challenges. Inadequate price measures, a failure to measure consumer surplus and, importantly, the inadequate reflection of the productivity gains from the apps economy in the output statistics may cause a potential downward bias in the output measures. However, the lack of proper investment measures reflecting the so-called intangible assets, such as human capital, information assets, innovative property and economic competencies, add to the complexity of measurement issues. In any case, from the perspective of understanding the growth gap across the Atlantic, it is unlikely that the measurement bias in technology is any bigger in Europe than it is in the United States.[3]

An industry perspective on the productivity slowdown in Europe

When looking at Europe's productivity performance from an industry perspective, a striking difference can be observed. Before the crisis, Europe was a productivity strong hold in the manufacturing sector (excluding ICT production), but a much weaker performer in ICT products and services and more generally the author's in the market services sector.[4] Since the crisis, however, Europe has also lost its productivity advantage in non-ICT manufacturing. Table 2 presents the average yearly growth rates of labour productivity for the combination of eight major Euro Area economies, the United Kingdom and the United States, for 1999-2007 and 2008-2013.

3 For a recent commentary, see the author's blog post, titled "Blaming the productivity slowdown on measurement issues takes our eyes off the ball".

4 See B. van Ark, M. O'Mahony and M.P. Timmer, "The Productivity Gap between Europe and the U.S.: Trends and Causes", *Journal of Economic Perspectives*, Vol. 22 (1), Winter 2008, pp. 25-44. And M.P. Timmer, R. Inklaar, M. O'Mahony and Bart van Ark, *Economic Growth in Europe. A Comparative Industry Perspective*, Cambridge University Press, 2010.

The productivity measures are divided between three main sectors.[5] Firms in the ICT goods and services sector often experience very strong productivity gains. Even though ICT-producing firms only represent a small part of the economy (about 8 percent of total GDP in Europe), they accounted for a much larger share of productivity growth in the market sector.[6] Before the onset of the crisis, US labour productivity in the ICT sector grew at 10.5 percent vis-à-vis 4.4 percent per year in Europe. Only Finland posted productivity growth rates in the same range as the US, whereas in other Euro Area countries, productivity growth rates in ICT production were mostly less than half of that. Even though European countries continued to grow employment in the ICT sector after the emergence of the crisis, productivity growth stayed well behind the US, although the latter's economy also saw productivity growth in the ICT sector halved— even though a downward measurement bias could play a role here.

In the goods producing sector, which mainly comprises manufacturing (excluding ICT), but also agriculture, mining, utilities and construction, productivity growth was higher than in the US in seven of the nine European economies (except for Italy and Spain) before the crisis. The average growth rate of labour productivity in the Euro Area goods production sector was 1.9 percent from 1999 to 2007 versus 1.7 percent in the United States.

Clearly, the differences in goods productivity performance reflect the specialization of goods production. For example, the US and Nordic economies strongly concentrated in high-tech ICT sectors (which are separate from the estimates for the goods producing sector). In contrast, European continental economies saw a broader range of specializations across manufacturing sectors, such as Germany's stronghold in investment goods and high-end specialized manufactured products, France's specialization in infrastructure and transportation equipment, and Belgium and the Netherlands' concentration on chemical and related industries.

5 The analysis does not include non-market services, which comprise education, health care, public administration and real estate services. Measurement problems with regard to output in non-market services are large, and, therefore, we refrain from showing those separately. Real estate activities are also included with non-market services, as the output measure includes imputed rents on owner-occupied dwellings, making the interpretation of the productivity measure problematic.

6 See Corrado, C. and K. Jäger (2014), Communication Networks, ICT and Productivity Growth in Europe, Economics Program Working Paper #14-04, The Conference Board, New York.

In the early aftermath of the recession, labour productivity growth for European goods producing sectors dropped off significantly to 0.5 percent from 2008 to 2012, to a large extent because of the cyclical impact which typically hits tradeable goods harder than less-tradeable services, and fell slightly below the US growth rate (at 0.7 percent) for the same period. With the exception of Spain, none of the European economies saw faster productivity growth than the US in goods production (even excluding ICT) after 2008. The more moderate decline in US productivity growth was largely achieved by a rapid layoff of manufacturing and construction workers. In most European

OUTPUT PER HOUR
BY MAJOR SECTOR

In percentages, 1999-2007 and 2008-2013

	ICT Goods and Services*		Goods Production excl. Electric machinery*		Market Services, excl. Information Telecom	
	1999-2007	2008-2013*	1999-2007	2008-2013*	1999-2007	2008-2013*
Eurozone	4.4	2.1	1.9	0.5	0.7	0.1
Finland	10.0	-3.4	2.7	-0.7	1.4	-0.2
Netherlands	5.0	0.3	2.9	-0.4	1.9	0.2
Austria	3.6	1.1	3.1	-1.0	1.5	0.8
Belgium	2.5	-0.4	2.8	0.7	1.4	-0.3
France	4.8	2.5	2.6	-0.1	1.1	0,2
Germany	4.8	3.6	2.5	0.6	0.7	-0.6
Italy	3.3	1.2	0.9	-0.1	-0.1	-0.7
Spain	2.3	1.2	0.1	2.9	-0.2	0.8
United Kingdom	6.1	1.1	2.5	-1.9	2.6	-0.2
United States	10.5	5.0	1.7	0.7	2.1	0.9

Note: The Euro Average refers to Austria, Belgium, Finland, France, Germany, Italy, the Netherlands and Spain. ICT goods and services includes manufacturing in electronics and telecommunication equipment, and IT and other information services, goods production includes manufacturing, excluding ICT, agriculture, mining, utilities and construction; and market services includes distribution, financial and business services and community, personal and social services, but excludes "ICT Goods and Services".

* ICT goods could not be separated for 2013, so that ICT Goods and Services, and "Goods Production (excluding ICT)" refers to 2008-2012, rather than 2008-2013.

Source: Eurostat and BLS and BEA

Table 2. Output per Hour by Major Sector in percentages, 1999-2007 and 2008-2013

countries, employment growth rates did not decline as much, with the notable exception of Spain and Italy where they fell dramatically. In several countries, in particular Germany, temporary employment subsidy programs supported labour hoarding in manufacturing. More recent estimates of manufacturing output show that the cyclical recovery effects on manufacturing have largely played out. Still, by 2014, manufacturing value added levels in Europe were still below the pre 2008 level, raising the question of whether Europe will successfully

THE DIFFERENCES IN GOODS PRODUCTIVITY PERFORMANCE REFLECT THE SPECIALIZATION OF GOODS PRODUCTION

reestablish its earlier dominant position as a top performing region in world manufacturing.

The market services sector, which includes distribution, financial, business and personal services, but excludes ICT services, showed the opposite in relative productivity performance compared to goods production. On average, labour productivity growth in market services was 0.7 percent for the eight Euro Area economies from 1999 to 2007, well below the 1.9 percent in the goods producing sector. In the US, we saw the opposite, with market services productivity at 2.1 percent from 1999 to 2007, ahead of the 1.7 percent labour productivity growth rate in goods production (excluding ICT) (see table 2).

The weak productivity performance in market services (excluding ICT) has been extensively documented in our earlier work (see footnote 5), but it has significantly worsened since the crisis—although it weakened in the US as well, dropping to a negative -0.1 percent from 2008 to 2013. In earlier work, we stressed particularly large productivity shortfalls relative to the US in trade and transportation sectors in Europe.[7] Smaller productivity effects from investment in ICT in those sectors seemed to have played a large role. Factors related to market structure, competition and lack of a European single market for services added to the perils of Europe's productivity performance in market services.

Overall, the sectoral growth accounts for why European countries show considerable declines in labour productivity and TFP growth across the board over the past two decades, even though productivity in goods

7 See footnote 5 for references.

production (excluding ICT) has remained relatively strong compared to market services. However, the distinction between goods and services, and more specifically between manufacturing and business services, is increasingly artificial. The two types of activities are increasingly integrated, especially in advanced economies, such as Europe and the United States, where the services' share in production of manufactured goods has been rapidly increasing. For example, both Europe and the United States increased its real income obtained from manufacturing production, not only through more competitive manufacturing activity in Europe, but especially through an increase in the contribution of service sector activities to the global value chain of manufactured products.[8]

While the number of workers in the manufacturing sector in the old EU-15 member states producing for global manufacturing declined from 21.2 million workers in 1995 to about 18.5 million in 2008, the number of workers in non-manufacturing industries involved with foreign production rose from 13.5 million workers in 1995 to 16.5 million in 2008. Over the same period, the United States lost workers for foreign manufacturing production in both sectors between 1995 and 2008. Hence, for Europe to compete in the global economy, one needs to widen the perspective from manufacturing productivity to services sector productivity as well (see chart 3).

The role of intangible investments in the diffusion of new technologies

Technological progress and innovation have an impact on productivity directly, through growth of the ICT sector, for example, and indirectly, through the adoption of those technologies across the economy. In particular, the latter effect, which may be referred to as the diffusion effect, should not be considered in isolation from a broad concept of investment beyond machinery and equipment. In recent years, important literature has emerged, highlighting that organisational changes and other forms of intangible investment are necessary to gain significant productivity benefits from using ICT.[9]

8 See, for example, M.P. Timmer, A.A. Erumban, B. Los, R. Stehrer, and G. J. de Vries, Slicing Up Global Value Chains," Journal of Economic Perspectives, 28(2): 99-118, 2014.
9 See, for example, M.P. Timmer, A.A. Erumban, B. Los, R. Stehrer, and G. J. de Vries, "Slicing Up Global Value Chains", *Journal of Economic Perspectives*, 28(2): 99-118, 2014.

Incorporating non-technological innovations (design and financial innovations), workforce training, improvements in organizational structures, marketing and branding, and—importantly—the creation of databases and other digital systems as part of an economy's creation of capital shows that digitalization does not happen on its own. As indicated above, traditionally, the expenses on such intangibles have not been capitalized in the national accounts (nor on company balance sheets, for that matter), but important conceptual and empirical work has transformed our view of how investment impacts productivity.[10] This work divides intangibles into three broad categories: computerized information (software and databases), innovative property (scientific R&D, design and financial innovations) and economic competencies (workforce training, improvements in organizational structures and marketing and branding).

It turns out that Europe (here the EU-15 aggregate) has a much lower investment intensity in intangibles than the United States (see table 3). The share of all measured intangible investment in value added for the

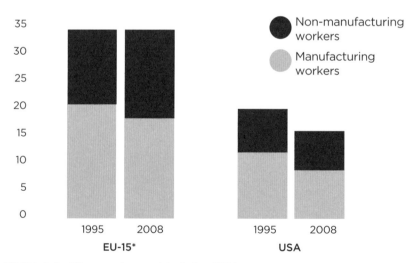

WORKERS CONTRIBUTING TO GLOBAL PRODUCTION OF MANUFACTURING PRODUCTS In millions of workers

Non-manufacturing workers

Manufacturing workers

1995 2008 1995 2008

EU-15* USA

*EU-15 includes fifteen member countries before 2004.

Source: World Input-Output Database (WIOD)

Chart 3. Number of workers in manufacturing and non-manufacturing contributing to global production of manufacturing products (1000s)

market sector in the EU-15 has increased by 1 percentage point, from 9.5 percent of market sector value added in the 1995 to 2002 period to 10.5 percent from 2008 to 2010, by which time it was about two-thirds of the US intangibles share in market GDP, which was 15.3 percent.[11] While Europe's intangibles intensity was below that of the US in all categories, it was particularly weak in R&D and other innovative property and in market research and advertising. Weaker R&D is, in part, related to the less intensive, high-tech nature of Europe's manufacturing sector compared to the United States, whereas lower market research and advertising intensity is due to a smaller share of distributional and personal services in the European economies relative to the United States. Within the EU-15, the Scandinavian countries, France and the UK have the highest intangibles intensity, but even here, the gap with the US remains significant. Many other EU-15 economies, include Italy, Greece and Portugal, currently invest less than half in intangibles as a percentage of GDP compared to the US.

The EU showed weaker growth than the US over the entire period in all three asset types and also saw lower increases especially in computerized information and economic competencies (especially organizational capital) during the late 1990s. The intensity of intangibles is, in part, related to the structure of the economy, which explains the relatively high intangible shares for the United Kingdom and the United States, which both have large shares of GDP in service sectors. These economies have relatively large shares of their intangibles concentrated in economic competencies, notably organizational investments, and in ICT. In Germany, which has a share of GDP in manufacturing, the role of innovative property, including R&D, is relatively more important.

ICT and intangible assets are connected in many ways. Some ICT assets, such as software and databases, are themselves classified as an intangible asset. ICT can also facilitate the deployment of other intangible assets and enable innovations across the economy, such as

10 See, for example, C. Corrado, C. Hulten, and D. Sichel, D., "Measuring Capital and Technology: An Expanded Framework," in C. Corrado, J. Haltiwanger and D. Sichel, eds, *Measuring Capital in the New Economy*, University of Chicago Press, pp. 11–46; C. Corrado, J. Haskel, C. Jona-Lasinio and M. Iommi (2013), "Innovation and Intangible Investment in Europe, Japan, and the United States," *Oxford Review of Economic Policy* 29 (2), 261–286.

11 The estimates refer to the "market" economy, excluding education, health and public administration.

the re-organisation of production. It can also involve the streamlining of existing business processes, for example, order tracking, inventory control, accounting services and the tracking of product delivery. At the same time, capital deepening in intangible assets also provides the foundation for ICT to impact productivity. For example, the internal organisation of a firm plays a role in its ability to use ICT more efficiently, in particular through managerial and other organisational changes.[12]

Going beyond complementarities between ICT and intangibles, there is also increasing evidence of a strong relationship between intangible capital deepening and total factor productivity growth. While consistent with the existing evidence on spillover effects from R&D, the extension to other assets suggests that many intangible capital assets have such public-good characteristics.[13] Clearly, one also requires caution by not overstating the realization of the spillover potential from intangibles. For example, spillovers might not occur if intangible capital is protected by intellectual property rules (copyright, trademarks, etc.) or tacit knowledge (internal knowledge of supply chain management, for example).

Towards closing Europe's growth gap

While Europe's economic policy agenda in the past six years has been dominated by urgent pressures to stabilize financial markets, improve macroeconomic conditions and lower unemployment rates, there is also a need to focus on closing Europe's growth gap relative to its own pre-recession performance and US performance. Policy attention needs to shift to a more medium-term focus on reigniting growth.

Despite huge political challenges, there is no shortage of possible policy solutions to accelerate Europe's growth trend. The implementation of structural policy measures, ranging from more investment in hard and soft infrastructure to smarter regulation, more innovation and greater room for entrepreneurship, will hugely matter to improve structural

12 I. Bertschek and U. Kaiser (2004), "Productivity effects of organisational change: Microeconometric evidence", Management Science, 50(3): pp 394-404. T.F. Bresnahan, E.Brynjolfsson, L.M. Hitt (2002), "Information Technology, Workplace Organization, and the Demand for Skilled Labor: Firm-Level Evidence," Quarterly Journal of Economics, 117 (1): pp 339 – 376.
13 More extensive regression analysis in Corrado et al. (2013) suggests this to be the case.

conditions. The five headline targets set out in the Europe 2020 Agenda—create more jobs, accelerate innovation, improve energy efficiency, strengthen education and reduce poverty exclusion—are fundamental components of any successful strategy to deliver positive social change and accelerate growth.

At face value, it makes much sense to direct our attention to investment as a key policy tool to revive growth, as is currently intended under the European Commission's Investment Plan. However, most of

INVESTMENT INTENSITY OF INTANGIBLE ASSETS IN THE MARKET SECTOR FOR UE-15 AND USA In percentage values of the GDP. 1995-2010

EUROPEAN UNION-15*	1995-2002	2003-2007	2008-2010
Computerized Information	1.4	1.6	1.8
Scientific R&D	1.6	1.7	1.8
Other Innovative Property	1.5	1.7	1.8
Market Research & Advertising	1.4	1.3	1.2
Training	1.3	1.3	1.3
Organisation Capital	2.2	2.5	2.7
Total intangible capital	**9.5**	**10.0**	**10.5**

UNITED STATES	1995-2002	2003-2007	2008-2010
Computerized Information	1.9	2.1	2.3
Scientific R&D	2.7	2.6	3.0
Other Innovative Property	2.0	2.7	2.9
Market Research & Advertising	2.0	2.1	2.0
Training	1.6	1.8	1.7
Organisation Capital	3.1	3.5	3.4
Total intangible capital	**13.3**	**14.7**	**15.3**

*EU-15 refers to membership of the European Union before 2004.

Source: C. Corrado. J. Haskel, C. Jona-Lasinio and M. Iommi (2013), "Innovation and Intangible Investment in Europe, Japan, and the United States", Oxford Review of Economic Policy 29 (2), 261–286

Table 3. Investment intensity of intangible assets in the market sector as a percentage of market sector GDP for EU-15 economies, 1995-2010

Europe's investment gap is related to private sector investment, requiring structural reforms that make markets function better across Europe.[14] In this contribution, we have put greater emphasis on the need to strengthen investment in the area of intangible assets to drive innovation and organizational change. Such investments can create positive externalities to productivity. However, the productivity of investment and the way it translates into total factor productivity growth depends strongly on the ability to strengthen static effects (focused primarily on cost reductions and allocative efficiency) and dynamic effects (related to competition in product, labour and capital markets and innovation) from a large single market in the European Union. Recent analysis shows that the creation of Single Digital Market and a single market for services across the European Union could contribute significantly to unleash the productivity gains from larger market size.[15]

The sluggish recovery in productivity suggests that medium-term factors are still predominant in explaining the productivity slowdown. The persistent shortfall in demand and an erosion of supply side factors, as established by the long-term slowdown of potential output, can be an important explanation for Europe's growth gap. However, it is also possible that there is a lull in the emergence of productive technology applications or that the negative productivity impact of the regulatory environment is playing a larger role than before the crisis. These factors significantly impact the timing and speed of the productivity recovery in Europe.

14 DIW, Economic Impulses in Europe, DIW Economic Bulletin, No. 7, Berlin, 2014
15 B. van Ark, Productivity and Digitalisation in Europe: Paving the Road to Faster Growth, The Lisbon Council and The Conference Board, Brussels/New York, 2014; M. Mariniello, A. Sapir, A. Terzi, "The long road towards the European Single Market," Bruegel working paper 2015/01.

PHILIP COOKE is professor at the Center of Innovation in Bergen University College, Norway. Between 1991-2014 he was university research professor of Regional Development, director of the Centre for Advanced Studies at University of Wales and professor of the Oxford Institute for Sustainable Development. Formerly, he was an adjunct professor of the School of Development Studies in Aalborg University, Denmark, and of LEREPS (Studies and Research laboratory in Economics, Policies and social systems) at the University of Toulouse, and editor of *European Planning Studies*.

This paper reviews some key conceptual and practical barriers that have hampered territorial economic development prospects. Conceptual and comparative empirical studies show that regional knowledge and innovation flows were no longer vertical, linear and cumulative but horizontal, variegated and combinative. This evolutionary economic geography discovery will be supported with insights from resilience and complexity theory and demonstrated by reference to three exemplars of transversality, which is the name for innovation and knowledge flows policy that overcomes the cognitive and policy lock-ins.

TRANSVERSALITY AND TERRITORY: ON THE FUTURE DYNAMICS OF REGIONAL KNOWLEDGE, INNOVATION & GROWTH

"By its nature, the metropolis provides
what otherwise could be given only
by travelling; namely, the strange"
(Jane Jacobs, 1961, 238)

Introduction

This paper plants the idea that territorial knowledge flows, whether at urban, regional, national or international scale, have been changed by knowledge economies. It examines questions such as: Does knowledge still flow sectorally in specific industries? Do multinationals still dictate knowledge flows within supply chains? Is policy-makers' attachment to the specialisation of economic development in vertical "knowledge silos" appropriate? Surprisingly, perhaps, the answers to these and related questions, after five years of recent research into Regional Innovation Systems (RIS), were largely negative. However, as innovation

SYSTEMIC INNOVATION HAS CAUSED KNOWLEDGE
DYNAMICS TO BECOME LESS VERTICAL, CUMULATIVE
AND PATH DEPENDENT AND MORE TRANSVERSAL,
COMBINATIVE AND PATH CREATING.

theory shows, every paradigm shift meets initial resistance from the ancien regime. Systemic innovation has caused knowledge dynamics to become less vertical, cumulative and path dependent and more transversal, combinative and path creating. This type of innovation is linked by networks of buyers and suppliers of knowledge, goods and services.

This gives an answer to the question, sometimes asked: What, exactly, is innovation for? The purpose of innovation is growth, measured in terms of productivity, efficiency and effectiveness. It seems that capitalism, which from a Schumpeterian perspective is fueled by innovation,

must grow in order to survive. Growth is implicit in markets, whose inefficiencies stimulate innovative efforts to create profits by seeking better alignments between value and price[1], whether of commodities, companies or currencies. Desiring that more citizens have access to the quality of life of the typical middle-class household in an advanced economy is not a morally indefensible position, especially given the massive inequalities that arise from the neoliberal dogma settled in many of these countries—not to mention the inequalities between them and the developing world.

THE HIGHER THE AVERAGE LEVEL OF HUMAN CAPITAL, THE MORE RAPID THE DIFFUSION OF KNOWLEDGE, THEREFORE THE HIGHER THE LEVEL OF REGIONAL PRODUCTIVITY

Growth is increasingly sought and found by firms and relevant support organisations which explore "relatedness" within and beyond regional boundaries. Relatedness describes firms that understand each other's business models, skillsets and technologies, even though they belong to different industries. These firms, although hidden in different sectors, may nevertheless offer innovative learning opportunities if they can be identified. This perspective is supported by at least three new territorial models. The first is New Economic Geography (NEG), which encourages systemic regional innovation in terms of labour pooling behaviour. Firms and workers seek out regional markets and financial spillover effects, co-locating or agglomerating when they find a region where industry has a lead due to innovation (Felsenstein 2011; Krugman 1991). Some modelling deficiencies persist in this perspective since it continues to produce misleadingly over-specialised and over-concentrated spatial results[2].

1 An anonymous referee queries this distinction. It is hoped that the following illustration is helpful. The price for a plumber to fix a burst pipe at a customer's home may be €5 for travel, €2.50 for materials and €10 for an hour's labour. However, the value of the service to the customer, who may have water leaking all over his house, is far greater than that, so the plumber typically estimates the price the customer will pay at €100. Investment bankers arbitrage such value to price differences for profit in the financial services industry.

2 Krugman (1991) displays the centrality of innovation in his theory of city agglomeration while admitting it is simplistic: "There are assumed to be two technologies for producing manufactured goods: a 'traditional' technique that produces goods under constant returns at a unit cost c1, and a 'modern' technique with a marginal cost lower than c1,

An alternative that does not fall into the trap of over-emphasising a single type of knowledge determinant of regional growth is New Growth Theory (NGT), which offers better insights into endogenous (i.e., local or regional) technological growth. Here, by analysing regional knowledge externalities and spillovers, the approach estimates the way in which human and physical capital, labour mobility and innovation impact regional productivity and growth (Martin and Sunley 2006). According to the NEG model, the increasing returns theory also supports the deduction that the higher the average level of human capital, the more rapid the diffusion of knowledge and, therefore, the higher the level of regional productivity, including earnings (Felsenstein 2011). Thus, NGT incorporates different kinds of regional knowledge and innovation into the innovation-productivity analysis. However, while human and physical capital combine positively to affect regional productivity, the model's results are weakened by a regional innovation effect.

A third approach, Evolutionary Economic Geography (EEG), receives some degree of support from this inconsistency. This perspective considers institutions, organisations and cultural practices as critical to the creation of regional growth. Cultural and institutional proximity are as important as spatial proximity, and the region represents an active innovation agent. This phenomenon has recently been termed Territorial Embeddedness Innovation (TEI), to be distinguished from Scientific and Technological Innovation (STI), and Doing, Using and Interacting (DUI) innovation (Nunes and Lopes 2015; Jensen et al. 2007).

Accordingly, this contribution summarises new arguments and findings concerning territorial knowledge dynamics, which pose problems for the prevailing understanding of innovation and knowledge theory. This paper is constructed around answers to four such problems raised by the testing of an EEG-informed theory and supported by wide-ranging and structured evidence. Our approach is marked by two sub-sections: one theoretical and the other empirical.

The first of the theoretical questions is: Does the interactive model of innovation that replaced the prevailing linear model now require

but that involves a fixed cost F per production site[...] If manufacturing is dispersed, an optimally located modern plant will be a distance of 1/4 from its average consumer, and will thus incur transport costs tx/4. On the other hand, if all manufacturing were concentrated at z=0.5, an urban plant located at the same point could serve a fraction ℗ of consumers at zero transport cost, and incur transport costs of only (1—℗) tx/4[...] This story bears an obvious resemblance to the Big Push story of Rosenstein-Rodan (1943)."

re-engineering? The linear model that proposed innovation followed a path from research and development (R&D) to prototyping and testing and then to commercial innovation on the market. This interactive model provided feedback among suppliers in value chains.

The second theoretical question, deriving from the Schumpeterian heritage, is: What counts as radical innovation? Does it only occur once every sixty years? Or does the process occur more frequently? Long wave theory proposes that the mechanisation of railways during the nineteenth century was radically overhauled by electrification and automatisation in motor vehicles in the 1900s and informatisation in computers in the late twentieth and early twenty-first centuries. Additionally, does the associated regulatory regime resistance, which is sometimes a stimulus for innovation, last for lifetimes? Does this mean there needs to be swifter paradigm and regime change, through economic drivers and government regulation, in the industries or industry platforms that display relatedness?

The next, more practical, question is: Are innovators also entrepreneurs? Or do the complexities of distributed knowledge dynamics mean there is a diversity of global actors helping to translate knowledge into commercial products and services? Does new knowledge dynamics thinking make path dependence—historical industrial development trajectories—redundant? Or, is that knowledge used for "branching" and new path creation when transversal, or crossover, knowledge dynamics are exploited? These issues will be addressed, and their resolutions illuminated by reference to EEG research findings (Frenken 2006).[3]

Evolutionary Economic Geography Theory

This section will say little about NEG or NGT but much more about EEG (Boschma and Martin 2010). Evolutionary Economic Geography

3 An anonymous reviewer holds that EEG after the Dutch approach should be cautioned against because it suffers from ergodicity, in which all future states of the model must be in the model at the beginning. A priori, this seems unlikely for any kind of economic geographer given that, in Boltzman's initial formulation, the term refers to a "...dynamical system which, broadly speaking, has the same behaviour averaged over time as averaged over space." Moreover, EEG research shows that relatedness, which equates very much to eurodite thinking on territorial knowledge dynamics (TKDs), includes revealed related variety as well as unpredictable ex ante but rather only understandable *ex post*.

theory exemplifies the evolutionary biological concept of exaptation (Vrba and Gould 1982). The late evolutionary biologist Stephen Jay Gould held that a new word was needed to account for the biological process whereby an obsolescent organ evolves a new use over time and possibly even in a different species. Examples include human inner ear bones, which were once the jawbone joints of an extinct fish species, and fish with buoyancy bladders, which have exapted the lung functions of earlier amphibious species, so the word proved useful. Evo-

THE CO-EVOLUTION OF INSTITUTIONAL REGIMES AND RELATED PARADIGMS IS AN EXTREMELY FRUITFUL WAY TO CONCEIVE OF REGIONALLY ADAPTIVE SYSTEMS OF INNOVATION

lutionary economic geography is a new discipline which has exapted concepts as old as nineteenth century classical economics, the forebear of the neoclassical perspective. "Cumulative change" Veblen"s (1898) precursor of Myrdal"s (1957) "circular cumulative causation" (CCC) was an early species of "increasing returns" (Krugman, 1995). New neoclassicals created NEG by relaxing neoclassical assumptions including "constant returns", "perfect information" and "equilibrium outcomes". Evolutionists are as interested in increasing returns, appropriated by "new neoclassicals" like Krugman, for understanding basic spatial growth processes as neoclassicals are. But that interest is far less mechanistic and reductionist, emphasising much more the institutional, co-evolutionary and path dependent (historical) aspects of change (Martin & Sunley, 2010). EEG also favours disequilibrium rather than equilibrium or even partial-equilibrium explanations for the crisis-ridden "progress" of capitalism. It does not assume economic balance and stability are normal but rather the reverse, namely that they are unusual and economic crisis conditions reflect such general conditions of instability.

The co-evolution of regional institutional regimes and related regional paradigms, including economic mixes of industries, is an extremely fruitful way to conceive regionally adaptive, or changeable, systems of innovation. To explain innovation and growth, it is as equally inadequate to privilege external shocks as it is to privilege endogeneity—that is, internally-generated growth impulses. If we think of regional regimes as varying combinations of organisational or governance structures

that interface with institutional conventions, we immediately have a conceptual grasp of regional variety.

This combination of formal governance, or regulatory rules, and informal practices, of business associations, for example, indicates an important source of regionally distinctive outcomes. We can think of these in terms of hierarchical, adaptive system interactions. Thus, economy, politics and culture are different everywhere because regions and nations vary within systems with multi-level governance, as for example, the system involving the EU, its member-states and regions.

THE NOVELTY OF INNOVATION LIES IN ITS RECOMBINATIONS RATHER THAN ITS INGREDIENTS, WHICH WERE ALWAYS THERE AWAITING DISCOVERY

If, furthermore, we add the notion of regional paradigms as related varieties of path dependent, socio-technical systems—that is, industry mixes that comprise a regional or national economy—(Geels 2007), the interaction of these knowledge flows produces innovation. Arthur (2009) calls this combinative, or combinatorial, evolution in his book on the nature of technology and innovation. For Martin (2010), this constitutes path interdependence, a far more dynamic concept than path dependence because it is in recombinant knowledge collisions that all innovation lies (Schumpeter 1934). So, we move from a vertical, linear and sectoral view of knowledge flows to one that recognises horizontal, interactive and inter-sectoral knowledge flows for innovation.

These are bold claims that require further elaboration. Put simply, Arthur's most recent statement about the ubiquity of bricolage, or recombination, as the midwife of all innovation may, from some perspectives, underestimate the role of truly novel knowledge. However, for engineering, which was Arthur's first calling and from which he gets much exemplification, including the complex path dependence of jet engine technology, it is probably a more reasonable assertion than for, say, biotechnology, which he also declaims. Even some keystone biotechnology knowledge, like DNA, nevertheless betrays a "ghost in the machine"[4]—a

4 The expression "ghost in the machine" is an allusion to the critique made by philosopher Gilbert Ryle, in 1949, about Descartes' dualism, according to which both mind and soul are heterogeneous substances. In this context, the expression could point to the occasion when concepts from certain disciplines are used in a different science.

metaphor exapted from elsewhere—, like the physicist Schrödinger's idea that DNA might resemble a non-repeating crystal.

So what constitutes truly novel knowledge? Briefly, two examples must suffice. The first was the 2000 Nobel Prize-winning research by Heeger, MacDiarmid and Shirakawa (1978), which revealed that the prevailing scientific consensus that polymers could only insulate electricity, not conduct it, was wrong. That research is now the basis for Samsung's Active Matrix Organic Light Emitting Diode (AMOLED) technology, which replaced liquid crystal in the screens of its Android 4G LTE smartphones.

The other example is the nanotechnology research of Maria Strømme and her team at Uppsala University (Nystrom et al. 2009) on the filtering properties of special paper. When their filter paper was tested in a lake suffering eutrophication (algal blooms and de-oxygenation), it produced electrolytic effects from its interaction with specific algae. A method of utilising algae to store electricity in a battery was thus discovered from a completely unknown source. The battery can be recharged much faster than a lithium battery.

The cellulose that Strømme and her colleagues used comes from a polluting type of algae whose cell walls contain cellulose with a distinctive nanostructure, giving it 100 times the normal surface area. The researchers coat paper made from this cellulose with a conducting polymer and then sandwich a filter paper soaked in a salt solution between the paper electrodes. It charges in a few seconds, and it is flexible, sustainable and non-toxic. Hence, though the battery application utilises the conducting polymer, the discovery represents novel knowledge about the electrical storage capabilities of algae, and possibly presents a solution to the age-old problem of storing electricity at scale and over long periods of time.

So, we conclude this "nothing new under the sun" debate by asserting that the novelty of innovation lies in its recombinations rather than its ingredients, which were always there in atomic, molecular or memetic forms, awaiting discovery. For example, it should be noted that algae contain many previously undiscovered yet potential commercial opportunities, including the synthesis of Omega-3 nutrients from rapeseed oil.

In complexity theory, these knowledge and innovation processes would be referred to as exploration of the adjacent possible, in the first case, and preadaptation, rather than the more biological exaptation, in the second. The adjacent possible is a search process that seeks

novel solutions, many of which are incremental innovations that begin relatively close to the existing problem. Such novelty becomes radical innovation when the knowledge recombination search swiftly reveals numerous related innovation possibilities and potentials. In the case of paper batteries, the adjacent possible was the application of old knowledge (conductive polymers) to new knowledge (electrolytic algae) to create an eco-innovation.

Preadaptation, which is a more common innovation process, starts with already existing innovation, which is then preadapted to a new setting, either by some kind of cognitive reversal or by adaptively transferring it from one industry to a wholly different one (Kauffman 2008). Kauffman's exemplar of cognitive reversal preadaptation concerns the invention of the modern tractor, specifically the early massive engines that continually broke the chassis when mounted. An engineer, noting the scale and rigidity of the engine block, suggested it could form the chassis. The historical innovation was Henry Ford's Fordson Model F, which was completed in 1916 and was the first lightweight, mass produced tractor in the world. Ford engineer Eugene Farkas successfully designed the engine block, transmission and axle housings, which bolted together to form the basic structure of the tractor. By eliminating the need for a heavy, separate chassis, costs were reduced and manufacturing was simplified.

We could also point to the Wright brothers' innovation of the aeroplane, which combined bicycle, boat, kite and automotive technologies in the form of wheels, chains, propellers and motors from different industries to fulfil the purpose of creating a flying machine.

Today, preadaptation is consciously practised by the regional cross-cluster and sectoral knowledge transfer agency Bayern Innovativ for its industry members. This process involves large numbers of variably-sized and themed meetings of industry innovators evaluating the preadaptation (or knowledge and innovation transfer) potential of innovations already implemented in other industries, as described by Cooke et al. (2010).

One interesting example of preadaptation, given by Cooke et al. (2010) occurred when BMW exhibited the nanotechnology-refined textile that kept the seats of its new model free from dirt. Nano-filters had been embedded in the seat fabric to produce this effect. Sitting in the audience were representatives of hospitals and medical clinics. They immediately thought that such an innovation could be used to reduce the

amount of bacteria and dirt that stick to medical uniforms if a suitable textile could be produced with the same filtering properties. Over time, that innovation-transfer was achieved, and the new product is now on the market.

So much innovation, in the form of commercialised recombinations, has occurred historically that transversality will typify innovation opportunities in the future. Currently, transfer occurs face-to-face and by word-of-mouth, but it is easy to see how a firm or agency could make such knowledge available as a market offer.

Territorial Knowledge Flows and Innovation Issues

Does the interactive model of innovation that replaced the prevailing linear model now require re-engineering?

The conventional wisdom about innovation is in need of an overhaul. It was noted at the outset of this contribution that transversal knowledge flows not only pose problems for the cumulative model of innovation, but also for the linear (STI) and interactive (DUI) versions of this model, which have dominated the understanding of innovation for decades (Balconi et al 2010; Kline and Rosenberg 1986). Both share verticality: STI from its emphasis on intra-corporate knowledge flows, from R&D laboratories to marketing and sales departments, and DUI from the recognition that supply chains became more clearly emergent with the onset of Japanese modes of lean production.

The older theories focused on innovation without much thought to what it was for or how knowledge acquisition to achieve innovation was related to it. This could mean one of two things. First, it could be that innovation was once linear, cumulative and closed, but that is no longer the case. This seems unlikely from a complexity perspective because Kauffman (2008) stresses that the key feature of complex adaptive socio-economic systems is that:

> The more diverse the economic web, the easier is the creation of still further novelty [...leading to...] a positive correlation between economic diversity and growth (Kauffman 2008, 151-160).

Similarly, as Arthur (2009) sees it:

> When a network consists of thousands of separate interacting parts and the environment changes rapidly, it becomes almost impossible to design top-down in any reliable way. Therefore, increasingly, networks are being designed to "learn" from experience which simple rules of configuration operate best within different environments (Arthur, 2009, 207).

What is more likely is that the framing of these innovation models was wrong. This means that observers misunderstood and over-simplified what they thought they had seen, or perhaps had not seen because most innovation occurs in confidential situations. Contrariwise, what was always present even in portrayals of intra-corporate or intra-supply chain innovation orderliness was a great mixture of purchasing or borrowing of adjacent extramural ideas, possibilities and solutions from related and even unrelated industries. Individual scientists, knowledge entrepreneurs and consultant experts come to mind as innovation contributors in this case. Even Alexander Fleming, who innovated antibiotics, was helped by his housekeeper to notice his discovery of penicillin, which she thought was cheese.

TIME AND VARIETY DISTINGUISH SYSTEMIC FROM ROUTINE INNOVATION, RENDERING THE FIRST EPOCHAL BY USHERING IN A LONG-WAVE TECHNOLOGICAL REGIME

Accordingly, other than describing such bricolage, theorists at the time lacked an interest, or a theoretical discourse, in which to position such messy processes. So, the evolution of knowledge flows around platforms of innovation, integrated by digitisation as facilitators of economic growth, has both shattered the hitherto prevailing narrative of cumulative orderliness and introduced "an image of wholeness, and within that wholeness a 'messy vitality'" (Arthur 2009, 213).

What counts as radical innovation?

If all innovation is bricolage, where one innovation builds on a preceding one, or more, to fill a niche formed by an opportunity created from what has gone before, it seems difficult to find a place for anything other than incremental innovations that explore possibilities of preadaptation or

the adjacent possible. Kauffman (2008) frequently uses the tractor metaphor to marvel at the ingenuity of mankind, but he also notes how, for example, the innovation of the remote TV channel control could simply not have been envisaged in a society without TV, or more particularly, multi-channel TV.

This gives a clue to the reasons why it is important to differentiate between innovation in gencral, which uses preadaptation and adjacency and is therefore incremental, and radical innovation. Whether that means most innovation occurs in geographic proximity is an open question to which we will return. But, for the moment, research on the history of innovations (e.g., Johnson 2010) suggests most are produced in geographic proximity to where adjacent possible opportunities arise, and most contain unexpected elements, for example, the aforementioned paper research that found electrolytic algae). Even if knowledge flow interactions are inter-continentally relational, innovation is recombined at the spatial point of the innovator, or the team. Johnson (2010) allows only one exception to this rule: the "multiple", when an innovation (e.g., the incandescent light bulb) occurs simultaneously and independently in different regions. Hughes (1983) argues that Edison gained priority for the light bulb because he also innovated a co-evolving electricity generating and lighting system. This is a clue to the difference between long-term radical innovation and short-term incremental innovation: the former swiftly stimulates a variety of related innovations.

Time and variety distinguish systemic from routine innovation, rendering the first epochal by ushering in a long-wave technological regime that envelops, protects and facilitates the exploitation of the new growth-inducing technological paradigm, both classically as well as in our contemporary informational economy. But, within that technological paradigm, many shorter-term, but still radical, innovation episodes occur today, affecting retail, newsprint, recorded music and even taxi transportation firms.

Time is also an important factor in the creation of episodic radical innovation. Change occurs more swiftly in creative design and "cognitive-culturally" inspired industries, like smartphones, than in light bulbs. Here, instant shifts in socio-cultural meaning can be captured through the phenomenon of "circles" in design driven industries, or crowdsourcing and crowdfunding as practised by apps firms in the smartphone industry (Scott 2008; Pisano and Verganti 2008; Page 2007).

So, we conclude that the original idea of radical innovation survives but needs variegation conditional to different temporal innovation frames, whose knowledge turnaround speeds are conditional to their conscious exploitation of the crossover of knowledge or actual innovations among firms or industries—transversality (Cooke 2013). Illustrative material on this phenomenon for the Swedish regions of Skåne and Västra Götaland and the French Midi-Pyrénées is presented below.

Are innovators also entrepreneurs?

This question addresses the complexities of distributed knowledge dynamics, asking if there is a diversity of global actors assisting the translation of knowledge into commercial products and services. This is not the old individualist question about believing innovation to be the product of genius. It is far more important than that and relates to a common misconception that entrepreneurship and innovation are different sides of the same coin, or worse, that they are the same thing. If that was ever true, it seems decreasingly so nowadays. Even Schumpeter (1934) is clear that the key skills were very different: the innovator recombined knowledge while the entrepreneur assembled the financial, legal and human resources to commercialise it.

EEG research has registered the rise of complexity in the intermediation of innovation processes by practitioners of knowledge-intensive business services (KIBS), who are found performing crucial coordinating, advisory and consulting roles in most industries (Strambach 2010). These include management accountants, venture capitalists, patent lawyers and so on. Even knowledge-intensive business services for farming are located in cities where insurance, credit and technical talent is found, rather than in the rural markets for such services. But KIBS are a very large platform of differentiated knowledge, which returns us, momentarily, to the question of geographic proximity.

Clearly, the phenomenon of rural services being supplied from metropolitan locations reveals how the presence of global talent pools, their knowledge spillovers, and relatedness across industry boundaries allows for fluid entrepreneurial activity to be conducted in an urban ecosystem by KIBS of many sizes. Ironically, indicators of such knowledge-intensive entrepreneurial concentrations place cities like Stockholm and London at the peak of the European hierarchy for their disproportionate shares of employment in KIBS and the lesser category

of high-tech manufacturing (Cooke and Schwartz 2008), but they also show London, at least, to underperform UK regions on innovation per capita (Chapain et al. 2010). So, it seems likely that knowledge-intensive entrepreneurs are located in different places than innovators.

THE INNOVATOR RECOMBINES KNOWLEDGE WHILE THE ENTREPRENEUR ASSEMBLES THE FINANCIAL, LEGAL AND HUMAN RESOURCES TO COMMERCIALISE IT

More precisely, most KIBS and high-tech manufacturing workers in cities are clearly neither entrepreneurs nor innovators. Rather, they are clerical, secretarial, retail and administrative workers, which corrects the discourse that emphasises the creativity of large cities, at least regarding the composition of their labour markets. From this research on cities, we conclude that entrepreneurs are increasingly divorced as actors and in geographical terms. This is a source of the difficulty innovators have in launching new start-up businesses, especially in Europe.

Does the new knowledge dynamics paradigm make path dependence redundant?

This is possibly the most interesting question posed by the EEG research. Traditionally, path dependence has been associated with somewhat negative outcomes, like the "lock-in" of older industrial regions to outdated industry and management practices (Grabher 1993). David's (1985) equilibrium perspective over-emphasised such issues. Nowadays, that research is criticised in favour of a more open and innovation-friendly perspective (Martin 2010). A second weakness was Arthur's (1994) reliance on chance or accidental explanations for innovative events that shift path dependence (Martin and Sunley 2010). Building on a more socially constructive conception of path dependence, reflective of Garud and Karnøe's (2001) notion of innovation, which also involved mindful deviation by social agency to affect change, EEG has introduced the notion of path interdependence. Martin and Sunley (2010) thus align this adjusted perspective on path dependence to another key EEG concept, namely proximity. This shift towards a mobilisation explanation for innovation, when linked to the multi-level perspective idea of co-evolving socio-technical systems, allows us to

incorporate the key complexity theory concepts of preadaptation and the adjacent possible in a rather satisfactory explanation of emergent regional knowledge flows and innovation. Allowing for the likelihood of market failure by firms which do not explore regional paradigm relatedness sufficiently, thereby delaying the onset of new path creation, opens up regional regime opportunities for government or governance organisations to introduce firms to both regional and non-regional innovation as a preadaptive form of transversality and to encourage exploration of structural holes or white spaces among regional paradigm elements (Burt 1992; Johnson 2010). Thus, we begin to see more clearly the element of path interdependence that defines key spatial forces underlying and influencing inter-organisational relations.

POLICY MAY BE ACTIVE WHEN MARKET FAILURE MEANS THAT POTENTIALLY COMPLEMENTARY FIRMS OR INDUSTRIES IN GEOGRAPHICAL PROXIMITY NEVER MEET TO DISCUSS POSSIBLE INNOVATIONS

Martin and Sunley (2010) refer largely to the economic geography dimension, including interdependent technological paradigm interaction, which will be explored in more detail under the rubric of relatedness conjoined to transversality. This moves the discourse closer to that of regional regime and paradigm interaction because transversality is the policy correlate of relatedness among industries or firms. Policy—whether created by government, public-private governance, or private governance through intermediary or lead-firm initiative—may be active when market failure means that potentially complementary firms or industries in geographical proximity never meet to discuss possible innovations. If policy is not active, then innovative structural holes (Burt 1992) will remain unidentified, unless and until a firm's search of the selection environment eventuates, possibly due to the rise or entry of new incumbents (see below). High market uncertainty in a context that values innovation as the highest virtue of the accomplished firm and region, owing to its overwhelming contribution to productivity and growth, means regional regimes or governance systems increasingly assist such searches for structural holes by inducing speed-up in the process.

Empirical Tests of the Foregoing: Brief Comparative Case Analysis

The Skåne Region

EEG and other research shows the strength of this region in Sweden to be clustered in agro-food production and services, including functional food based on biotechnology applications, like health drinks, and organic food offered in farms, public canteens and restaurants, as well as conventional mass production using industrialised productivist chemicals, pesticides, fungicides, herbicides and other conventional control technologies. A once strong but now fading path dependence was seen in the region's historical industry trajectory of shipbuilding in Malmö, but the closure of the Kockums yard in the 1980s led to redundancy and migration of shipyard workers—some to wind-turbine engineering in Jutland, Denmark.

By early 2010, the western harbour area had been reinvented as a centre of cognitive-cultural activity by the media. Activity promoted by the regional development agency also included mobile telephone companies (Mobile Heights), new media (Media Evolution), and the Skåne film industry, which included computer gaming. An emergent clean-tech industry and a systems resilience initiative were also beginning to be visible. This area prioritised regional paradigm resilience while the next regional account, also from Sweden, emphasised regional regime resilience aspects.

Mobile Heights[5]

During the 2000s, Mobile Heights' territory was invaded by rapidly expanding Asian producers, including Samsung from South Korea and Huawei from China. This resilience shock (Gunderson and Holling 2002; Folke 2006) led Sony Ericsson to reduce shipments of hardware and refocus on managing global services, such as selling network services to mobile telephone suppliers, including Telenord and Telia. To the latter, they also sold the extra service of managing the network, leaving the client to simply manage billing and cash flow. Accordingly,

5 Mobile Heights is a non profit organization whose mission is strengthening the Scania Region as a hotspot for mobile innovation. Members include companies, industries, associations, academic institutions and public organizations

Telia began cutting employment in the mid-2000s and has not filed more patents. ST Ericsson, the telephony infrastructure arm of the Ericsson Group, seemed unlikely to survive as a stand-alone company, and Sony Ericsson, the Ericsson mobile telephone joint venture, was dissolved. Nokia, Finland's flagship with a telecoms presence, also nosedived at that time.

The main competition for key Mobile Heights' member Sony Ericsson was Huawei, which had an office in Lund, Mobile Heights' home base, for the development of basic components of mobile phones. This augmented their offices at Kista Science Park in Stockholm, and Gothenburg, to employ 250 engineers. Huawei took advantage of cutbacks by Ericsson in Lund, which had made hundreds of qualified engineers available. The range of Huawei manufactures increased from base stations to mobile Internet modems and its own telephone handsets.

Resilience theory from EEG promises a response to resilience shock, so what was the regional and firm response to these perturbations? On the regional level, an emergent clean-tech industry (Sustainable Hub) and a systems resilience initiative (Training Regions) began to become visible around 2010. Both related to an EU Europe 2020 Grand Challenge shared with the Västra Götaland region to contribute Swedish expertise to the construction of sustainable cities (see fig. 1 below). On the firm level, Sony Ericsson rather fruitlessly began evolving "open innovation" relationships with innovative start-ups. Even S.T. Ericsson, which was a classic "closed innovation" firm, began to buy from external suppliers while actively seeking to contract or acquire them.

There were quality entrepreneurial firms in Skåne; for example, the near bankrupt Canadian mobile telephony firm RIM, which produces BlackBerry, acquired user-interface maker The Astonishing Tribe (TAT) in 2010. Moreover, Polar Rose, a Malmö startup which built a facial recognition programme that linked to Facebook photos, was bought by Apple for $29 million, also in late 2010. Other open innovation connections involved Mobile Heights' start-ups that joined AstraZeneca in the Life Sciences platform for remote diagnostics telephones and biosensors. Lateral linkages were also in position with the Media Evolution (Nordic Game) cluster member.

Media Evolution

This Skåne regional cluster concentrated on convergent media, or new media. It promoted the emergence and growth of start-ups in relevant fields. Most such new firms had entrepreneurial leaders with at least two to three years of experience in larger companies, while a minority came from Lund or Malmö University. Polar Rose, for example, grew out of computer vision research—the analysis of digital images and

AN EMERGENT CLEAN-TECH INDUSTRY ('SUSTAINABLE HUB') AND A SYSTEMS RESILIENCE INITIATIVE ('TRAINING REGIONS') WERE BEGINNING TO BE VISIBLE AROUND 2010

video—at the Universities of Lund and Malmö. Polar Rose entered the Teknopol Mobile Heights Business Centre in 2004. Teknopol was a tailored business advice agency specialising in start-up activity for the Mobile Heights Business Centre, Sustainable Hub and Life Sciences Business Centre, each of which related to the Skåne region's white spaces, or cluster-platform programmes. Polar Rose was given an initial loan of €30,000, as a Sony Ericsson spin-out, to develop academically originated face-recognition software.

TAT, purchased in 2010 by Research in Motion, was started in 2002. TAT was to fit its user experience-user interface (UX-UI) applications into BlackBerry's PlayBook and smartphone platform. This was a pioneer user of novel social media forms like crowdsourcing (Shirky 2010) and crowdfunding of anything from film projects to start-ups. Accordingly, crowdsourcing was another open innovation response to global, corporate competitive forces impinging on large Swedish ICT incumbents.

Another cross-sector media-ICT innovation link included Qubulus, a system platform for indoor positioning on which location based services could be developed by Qubulus or by an application developer community through a shared application programming interface. The platform aggregates positioning input from proprietary web services and mobile apps to hardware installations. By using the best technology to fit the usage and purpose of the customer case, Qubulus can meet user demand and solve the problem of indoor positioning. Crowdsourced positioning activities are a focus in designing space syntax for people flows, shopper movements in retail malls and product finder smartphone applications.

The Västra Götaland Region:
"Iconic Projects" Innovation Platform Management

Transversal policies were, at this time, also the characteristic approach taken in the Västra Götaland region, in Gothenburg. A strategic decision was taken to concentrate initially on meeting the Europe 2020 Grand Challenges of Climate Change and Healthcare. In 2003, the region had been one of the first in the world to publish a climate change response strategy report, Gothenburg 2005, involving policies for "smart energy". This report then evolved into a strategic target for the Västra Götaland region to be totally free of fossil fuels by 2030, in what became known as the Gothenburg Model of the Lisbon Strategy. However, working out the region's position on that Grand Challenge in advance gave scope for the new environmental strategy to be down-to-earth and practical. This meant focusing on iconic projects committed to innovation, learning and collaborative platform management laboratories (see fig. 1).

Thus, the particularisation of the Climate Change Grand Challenge involved translating it into a sustainable cities initiative triggered by a large infrastructure commitment to a new tunnel, which brought together numerous regional clusters involved in renewable automotive fuels, forest plastics, petroleum and health. At a more detailed level, these assembled pilot projects mixed expertise in cluster firm logistics, public transport, visioning (computer graphics and imaging) and green accounting.

They also linked with Chalmers University and specialist firms like Asta AB. A comparable iconic project approach was taken in healthcare, and the project in question involved a new health complex centred on a Medical Health Imaging Facility at the University Medical School. This connected transversally to digital signals processing (data compression) and medical diagnostics engineering expertise at Chalmers University and one of its spinout firms, Medfield Diagnostics.

Midi-Pyrénées

The interest here is in an economically strong but over-specialised region that has a narrow path dependence paradigm composed of agro-food, aerospace and healthcare with biotechnology inputs, but a strong regional regime that emphasises transversality as a policy model. In

the French Pôles de Compétitivité contest, the region was successful in accessing national cluster-building funding to complement abundant regional and European resources. Remarkably, the regional government practises a policy, which it calls transversalité, to populate its narrow regional paradigm with greater path interdependence. Chart 2 represents a process diagram of the regime methodology for inducing transversality from the regional paradigm in a strong way. The steps involved in this process first prioritise the formation of a large, consolidated pool of financial resources derived from the Midi-Pyrénées region, the French government and the EU.

The next step was to build a methodology for determining how new and greater innovation could be extracted from the region's leading industries by emphasising transversality among them. This led to two parallel exercises. The first, CAVALA, was a statistical review of the

MODULARISATION & 'EMERGENCE' OF INNOVATION POLICIES

Chart 1. Västra Götaland's Iconic Projects Cluster-Platform Approach.
Source: Center of Innovation, Bergen University College.

strengths and weaknesses of the main clusters and leading firms with respect to innovation and innovation potential. This led to recognition that, in effect, only two types of existing and established firms were likely to be good innovation candidates: lead firms, like EADS and Thales in aerospace, and hub firms or firmes pivots, which are important systems integrators or aggregator firms in supply chains. To these were added innovative spin-out or start-up businesses.

Leading candidates from agro-food, aerospace and bio-healthcare were then put in a transversality group to consider methodologies, incentives and conventions by which they might proceed to talk across sector and cluster boundaries, known to be an especially difficult task where tacit knowledge is concerned (Janowicz-Panjaitan and Noorderhaven 2009). In these group discussions, the key focus was on technology, its known properties and cross-pollination potentialities, barriers to innovation from cognitive research or resources and, as noted, methodologies by which firms might find each other, despite their apparent un-relatedness, in order to generate regional innovation through the exploitation of relatedness. This is a new, French, top-down model that

MIDI-PYRÉNÉES TRANSVERSAL INNOVATION GROUP MODEL

Chart 2. Path Inter-dependences and Transversality

seeks to induce innovation by a formal imposition of the conventions of transversality on regional firms.

Confusion and Contradiction in EU Innovation and Growth Policy

Between March 2013 and June 2015, we researched innovation in Portugal at both national and regional levels (Algarve, Centro and Norte regions). The aim of the research was to measure the distance between the transversality theory of innovation outlined above and the new Regional Innovation Strategies 3 (RIS3) methodology promoted by the European Commission under the rubric of "smart specialisation." Specialisation is clearly the opposite of variety or diversification, so we were interested to see how this contradiction worked in practice. Were regions sacrificing valued industries to promote smart specialisation? Was the idea even understood? And how, after the Commission was criticised for its linear, sectoral and specialisationist approach so that it had to propose in footnotes that related variety and DUI-type innovation were also examples of smart specialisation did its regional and national clients manage the resulting confusion (Kroll 2015)?

This proved to be an interesting laboratory for observing multi-level governance tensions, from regional to national to supranational levels of interaction. The context is unique in that a slow-moving, cumbersome and—as many see it—spatially myopic and conceptually chaotic European Commission belatedly sought to induce a new, post-program budget and linear regional economic development model to promote growth while imposing major constraints in the form of austerity policy, budget cuts and draconian debt repayment conditions. At its worst, the austerity strategy has massively impoverished Eurozone member Greece, and while Portugal emerged from the imposed fiscal straitjacket without the same devastating results, the hallmarks of contradictory thinking remain evident about how the EU believes it promotes growth by imposing conditions that ensure the opposite.

In brief, the studied regions and even, to some extent, the state ignored the precepts of specialisation and pursued the common-sense potential of optimising their regional diversity to promote regional innovation (Cooke 2015). This meant Algarve aimed to escape its narrow over-specialisation in "sun and beach" tourism by pushing for DUI applications of renewable energy, marine biology, ICT and creative

industries to diversify their tourism and—with the help of a regional innovation agency—to develop new industries, including some with STI-type innovation from universities and research centres. These could be located outside Algarve if necessary. However, it was a very horizontal set of aspirations.

Centro and Norte already had high related variety scores, as judged by the Portuguese National Research Council (FCT 2013), so they used matrix methods to identify crossover innovation opportunities and projects in biotechnology, flexible manufacturing systems, robotics, renewables and footwear, among other intersecting innovation platforms. In the last two cases, their strategies were accepted by the state, which retained control of project evaluation (dependent on the EU Regional Operational Programmes into which RIS3 allocations fit). But for Algarve, and other regions, the state's innovation ministries and agencies opposed their diversity plans on grounds of lack of critical mass, thus condemning Algarve to remain specialised but not especially smartly so. A better governance model for regional innovation was approved, but it was not a full-blooded regional innovation agency.

> ## THE STUDIED REGIONS AND EVEN, TO SOME EXTENT, THE STATE, IGNORED THE PRECEPTS OF SPECIALISATION AND PURSUED THE COMMON-SENSE POTENTIAL OF OPTIMISING THEIR REGIONAL DIVERSITY TO PROMOTE REGIONAL INNOVATION

So, the adoption of a specialisationist model in the field of ERDF allocations via ROPs to subsidise regional innovation and growth was rejected by Portugal's regions and even in limited ways by the state. In its stead, diverse regions either sought to initiate or, where conditions were more evolved, consolidate growth opportunities and gains by adopting regional diversity through building on the concept of related variety and fashioning transversal innovation policies. That this was given approval in the RIS3 documentation promoting smart specialisation merely underlies the conceptual confusion and spatial myopia of the EU and its Commission. This shows that the EU and even its member-states are slow-moving, backward-thinking policy action entities.

Even weak regional administrations, such as those anatomised above, can respond and, in limited ways, even anticipate needed economic

policy actions more swiftly. However, at the edge of chaos, as under-stood in EEG and complexity theory, where change is imminent or unavoidable, "fortune favours the prepared mind", as Louis Pasteur saw it. Centro and Norte saw clear advantages in exploiting innovation opportunities arising from past R&D infrastructural investments, and their sense-making, crossover thinking was hard to oppose by the state. Algarve had great difficulty extracting its future innovation profile from the specialised sun and beach frame endowed upon it by its state and fellow regions. The key problem lies in institutional failure by big, slow organisations, like the EU and member states, to leave their neoclas-sical industrial economic comfort zone and embrace the full meaning of innovation, which is recombinant, interactive and unconfined to a sector or even a cluster. Rather, innovation is geographical, interactive and based on crossover innovation at interfaces.

Conclusions

It is clear that the transversality perspective can be considered success-ful at path-breaking in three significant dimensions. First, the theoreti-cal sophistication of its approach places its evolutionary economic geog-raphy approach in a primary position, from the viewpoint of advanced regional analysis. This utilises evolutionary concepts from economic geography, complexity and resilience theory, such as the multi-level perspective, complex adaptive systems, external shocks and internal perturbances, preadaptation, adjacency, cognitive reversal, relatedness, proximity, path dependence and transversality, in a coherent, innovative and intellectually penetrative way. Much further research is likely to fol-low into the explanatory validity of this non-reductionist, non-predictive evolutionary framework. Kauffman (2008) presents this perspective as "lawless" in the sense that it is beyond the paradigm exemplar of neoclassicism, which derives mechanistically from physics. Since life forms cannot be predicted, this approach escapes the strictures of that reductionist frame.

The second major contribution of the findings on knowledge flows and innovation for the future concern its critical reflections on numerous inadequately scrutinised aspects of innovation theory. Accordingly, in-novation is now better specified as the key element of any evolutionary growth model. Finally, the theoretical and empirical results have shown

how relatedness and transversality are practised in the actualité and may be empirically observed by firms and policy agencies seeking or charged with enhancing business and regional innovation. This strongly suggests the validity of Kurt Lewin's observation that "there is nothing so practical as a good theory".

EUROPE AND ITS NATIONS: POLITICS, SOCIETY AND CULTURE

CULTURAL MAP
OF THE WORLD

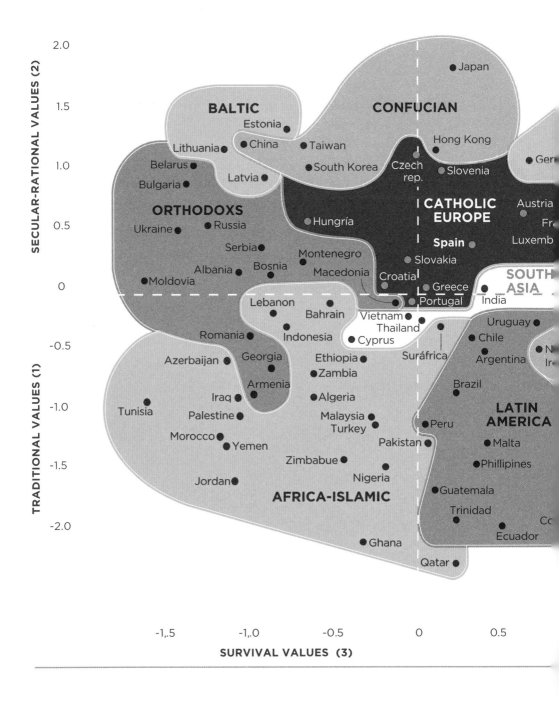

Economic and technological changes have created two basic dimensions of cross-cultural variation. The first reflects the contrast between traditional religious values and secular, rational, bureaucratic values. The second dimension contains values and beliefs that reveal a shift from an emphasis on economic and physical security to a growing preoccupation with subjective wellbeing and quality of life.
Based on data from the World Values Survey, this cultural map of the world makes it possible to situate any society on a two-dimensional plane.

Traditional values (1) underscore the importance of religion, parent-child ties, deference to authority, and traditional family values.
People who embrace these values also reject divorce, abortion,euthanasia, and suicide. These societies have high levels of patriotic pride and a nationalistic outlook.

Secular-rational values (2) are linked to modernization and secularization processes that result in greater personal autonomy, with preferences opposite to traditional values. These societies place less emphasis on religion, traditional family values,and authority.

Survival values (3) emphasize the importance of economic and physical security. They are associated with a relatively ethnocentric outlook and low levels of trust and tolerance.

Self-expression values (4) give high priority to environmental protection, gender equality, and tolerance of foreigners, gays, and lesbians. They also promote participation in decision-making in economic and political life.

As standards of living rise and the transition is made from developing nation to post-industrial knowledge society, a country tends to move diagonally from the lower left-hand corner (poverty) to the upper right-hand corner (wealth).

1.5 2.0 2.5

SELF EXPRESSION VALUES (4)

Source: World Values Survey 2010-2014

RESEARCH & DEVELOPMENT

R&D EXPENDITURE In euros per capita (2013)

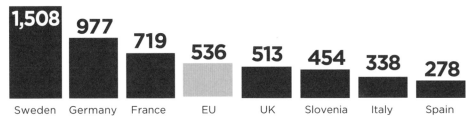

Sweden	Germany	France	EU	UK	Slovenia	Italy	Spain
1,508	977	719	536	513	454	338	278

HIGH-TECH EXPORTS In billions of euros (2014)

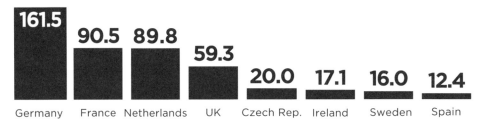

Germany	France	Netherlands	UK	Czech Rep.	Ireland	Sweden	Spain
161.5	90.5	89.8	59.3	20.0	17.1	16.0	12.4

SCIENCE AND TECHNOLOGY GRADUATES

Per 1,000 inhabitants aged 20-29 (2012)

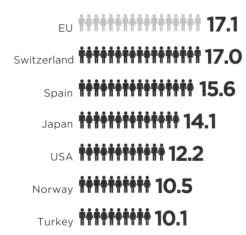

EU	17.1
Switzerland	17.0
Spain	15.6
Japan	14.1
USA	12.2
Norway	10.5
Turkey	10.1

PATENTS

High-tech patent applications to the European Patent Office per million inhabitants (2012)

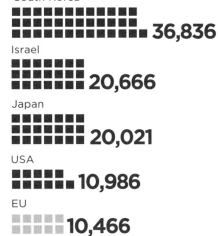

South Korea	36,836
Israel	20,666
Japan	20,021
USA	10,986
EU	10,466

Source: Eurostat

EUROPEANIST SENTIMENT

TRUST IN EUROPEAN INSTITUTIONS

Percentage of citizens that tend to trust

—— European Parliament

—— European Commission

- - - - European Central Bank

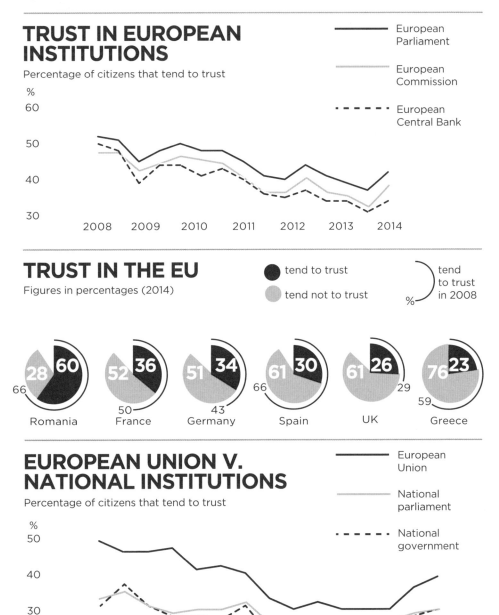

TRUST IN THE EU

Figures in percentages (2014)

● tend to trust

● tend not to trust

⟩ tend to trust in 2008

	tend to trust	tend not to trust	tend to trust in 2008
Romania	60	28	66
France	36	52	50
Germany	34	51	43
Spain	30	61	66
UK	26	61	29
Greece	23	76	59

EUROPEAN UNION V. NATIONAL INSTITUTIONS

Percentage of citizens that tend to trust

—— European Union

—— National parliament

- - - - National government

Source: Standard Eurobarometer

CHRISTOPHER BICKERTON
is University Lecturer in politics
at the department of politics and
international studies (POLIS) at
the University of Cambridge and
an Official Fellow in politics at
Queens' College, Cambridge. He
obtained his PhD from St John's
College, Oxford in 2008 and since
then has held teaching positions
at Oxford, the University of Am-
sterdam and Sciences Po, Paris.
He has published two books and
has written columns and articles
for the *Financial Times*, *New York
Times*, *Wall Street Journal*, *The
Guardian* and the *Monde Diplo-
matique*. He is the co-founder of
the political economy blog, *The
Current Moment*.

What is a member state exactly and what
does it look like? What are the factors that
have driven this shift from nation-state to
member state? Does the current crisis of the
EU signal an end to member statehood and
a return to a Europe of nation-states or is it
a confirmation of it? This chapter will argue
that member states are characterized by a
growing distance between governments and
their own societies. This growing gap be-
tween political elites and their own societies
lies behind the growth of both populism and
technocracy as powerful political phenomena
in contemporary European politics.

FROM NATION-STATES TO MEMBER STATES: EUROPEAN INTEGRATION AS STATE TRANSFORMATION

Introduction

The European Union remains a mystery to many observers. It is neither a fully-fledged European state nor is it simply a loose federation of cooperating national states. The EU is often described as coercive in its dealings with member states, and yet it has no coercive power of its own. Some think of it as a German-dominated body, and yet Germany seeks to devolve ever greater amounts of its own sovereignty to the EU. Citizens and scholars alike are often confused when they try to describe this political institution. It is often negatively defined in terms of what it is not. Historical analogies, from the antebellum United States to the Hapsburg Empire, are used to define it with limited success.

THE EU REMAINS THE WORK OF STATES AND IS NOT ITSELF A SUPRANATIONAL EUROPEAN STATE

This chapter argues that the best way to think of the EU is as a union of member states. By this, I mean that the EU is an organization dominated by its members; it remains the work of states and is not itself a supranational European state. However, its members are not typical nation-states of the late 19th century: egotistical, war-mongering, territorially greedy, jingoistic and imperialist. Rather, these are member states, whose power and authority are constituted in their relations with one another at the EU level (Bickerton 2012: 51-73). By thinking of the EU as a union of member states, we are able to explain its centrality to national political life but also its institutional weakness.

This chapter takes the Eurozone crisis as a case study of the idea that the EU is a union of member states. I argue that the failure of Syriza in its negotiations with its creditors, along with the behaviour of the Eurogroup in this matter, shed light on the nature of the EU. This

episode also raises questions about the relationship between the EU and democracy. This chapter argues that the EU does not suppress national democracy, but rather, as the European states have evolved from nation-states to member states, democratic representation at the national level has been squeezed out, leaving only populist protest and technocratic responses by national executives acting in concert at the European level.

A European Union of member states

The EU is a difficult entity to pin down for scholars and citizens alike, and so it is often defined in terms of what it is not. Many supporters of the EU lament that it is not yet a federal state, even though it has managed to accumulate considerable powers over the recent decades. Former president of the European Commission, Jose Manuel Barroso, referred to the EU as "the first non-imperial empire": one that asserted power peacefully, through its rules and regulations, and not militarily, through invasion and war. The trick here was the qualifying adjective of "non-imperial", suggesting that although the EU is not an empire, calling it so helps us understand something about it (see also, Zielonka 2006).

> CONTEMPORARY EUROPE IS CHARACTERIZED BY, IF ANYTHING, THE DISINTEGRATION OF NATIONAL IDENTITIES AND NATIONAL SENTIMENT

The EU is often defined by analogy and described as being "like" something else. It is often compared to the antebellum United States, in which individual states retained most of their sovereignty but were linked to one another through articles of confederation and then more firmly through a federal constitution (Glencross 2009). The EU has no such constitution, but many suggested the 2005 Treaty—voted down by French and Dutch voters and then resurrected four years later as the Lisbon Treaty through an impressive feat of legal tinkering—was like a constitution. It was thus called the Constitutional Treaty. When asked whether it was a constitution or just a treaty, French President Jacques Chirac cannily replied: "it is legally a treaty, but politically a constitution".

There are great difficulties in comparing the EU to the antebellum United States. The historical movement of the 1790s, which continued

into the early decades of the 19th century, was centred on nation-building. Indeed, this was the very beginning of the nationalist age that was to culminate in the First World War of 1914 to 1918. The American and French Revolutions confirmed politics as the secular basis for the state's authority, in contrast to the dynastic and religious understandings of legitimacy that had prevailed up until then (Bayly 2004). Central to the work of the Federalist authors in the United States—Madison, Hamilton and Jay—was the idea of the "American people" as the basis and the authorizing logic for the federal constitution. In his travels, a few decades later, de Tocqueville noticed how prevalent the concept of the "American people" was to political life in the United States (Tocqueville 2004).

Present day Europe is not characterized by this movement towards national consolidation or towards a pan-European nation. Those vocal nationalisms that do exist tend to assert themselves against the idea of the nation-state, as in Scotland and Catalonia. Contemporary Europe is characterized by, if anything, the disintegration of national identities and national sentiment. The steady dismantling of the United Kingdom is a case point. Thus, it is very difficult to imagine that the EU is characterized by the reappearance of this sentiment at the European level. We are simply not living in an age where loose federal unions are being forged into stronger federal states, as occurred in the US, in the course of the 19th century, or in Germany, at the end of the 19th century.

When we try to define the European Union, it is useful to look at exactly what it is. The EU is an aggregate of its institutions. These include the European Commission, the European Parliament, the Council of Ministers and the European Council. The Commission has the role of initiating proposals. The European Parliament and the Council of Ministers share the authority to decide whether or not they accept those proposals and their amendments. They often work together in secret to respond to Commission initiatives (Reh et al. 2013). The European Council has a more complicated role. It sets the general direction of the EU but is also the source of its own proposals and has become more and more involved in the day-to-day affairs of the EU (Puetter 2015). It sits atop the other institutions as it is made up of the heads of government of the member states of the EU.

The European Parliament claims to represent the European people as a whole, but this claim competes with the individual national parliaments, for whom Europe is made up of its national populations which they represent. The European Commission's power is as a bureaucracy

and as a body charged with tasks given to it by member states. The Council of Ministers is what its name describes: meetings of national government ministers that are organized along policy lines—agriculture, fisheries and others. A final institution is the European Court of Justice. This body is tasked with making judgements about whether individual cases brought before it represent breaches of European law. Both governments and citizens can bring cases to the European Court of Justice.

There is little from this institutional arrangement to suggest the formation of a single European state. Power still lies with national governments and national bureaucracies, although that power is exercised in concert with the EU's institutions. The EU is a coming together of European states more than it is a transcendence of them (Bickerton et al. 2015). The reason why it appears to us as more than that is because of the nature of the European states themselves. Rather than being nation-states that jealously guard their national interests and clash with one another along national lines, European states are member states, and their membership in the EU plays a critical role in their existence. In particular, national governments and national bureaucracies see their authority as derived from their belonging to the EU policy-making process. Their power is therefore constituted in a horizontal way through the relations they enjoy with other governments in the EU, as well as in the vertical relationship of representation between a government and its own people.

Presented in this way, we can understand an important integration paradox that has come to characterize European integration over the last thirty years. Since the signing of the Maastricht Treaty in 1992, European integration has moved forward in leaps and bounds. In addition to monetary union, the EU has also expanded into many new policy areas: foreign policy, police and border issues, justice, social policy and employment policy. However, this expansion has not come with the transfer of powers from national governments to European institutions. Over the same period, key EU institutions, like the Commission, have seen their powers reduced. We have therefore seen a form of integration without supranationalism, which can be explained by the fact that the EU is a union of member states rather than a supranational state of its own (Bickerton et al. 2015: 51-72). Member state governments are the leading agents of integration, not the traditional supranational institutions like the Commission and the Court.

The concept of the member state

The term member state is one of the most popular in European studies. Whether one looks at the legal field, sociology or the political science of European integration, member statehood is thought of as a juridical title, which is given to a nation-state when it joins the EU. Were a state to leave the EU, it would have this title revoked. What this chapter suggests is that in addition to treating it as a legal title, it makes sense also to think of member statehood as a distinctive and standalone form of state.

IT IS POSSIBLE TO IDENTIFY MEMBER
STATES FOR ITS ORGANIZATIONAL ARRANGEMENTS,
ITS POLITICAL DISCOURSE AND ITS FORMS
OF POLITICAL CONFLICT

What exactly do member states "look" like? How can one differentiate a member state from other forms of statehood? It is possible to identify member states along three lines. One is the internal organizational arrangements of member states. A second is the political discourse used by member state governments to legitimize their authority. The third is the forms of political conflict that structure member state national life. This section will look at these three in turn.

Internal organizational arrangements

The internal organizational arrangements of member states have a number of characteristics. One is the dominance of the executive. Another is the proliferation of non-majoritarian institutions to which powers are delegated by central government. A third is the lack of mediating institutions that "stand in" between the state and domestic society.

The executive dominance comes from the fact that policymaking is being undertaken less by parliaments as legislators and more by executives as negotiators. International agreements tend to empower executives in so far as they conduct the negotiations, set the terms for them, and are able to select which domestic interests they want to represent and which to leave aside (Putnam 1988). EU policymaking empowers national executives in the same way, particularly with the rise of the European Council as the dominant EU institution and its direct involvement in the ever-increasing numbers of policy areas. The flow of information is

top-down, with the executive informing parliaments of the outcomes of negotiations and presenting legislative packages not to be debated but to be voted on as finished products.

IN MANY WAYS, THE EU ITSELF HAS BECOME THE NEW FORM OF MEDIATION BETWEEN THE STATE AND SOCIETY

An extreme case of executive dominance existed during the expansion of the EU to Eastern Europe. In order to manage the negotiations with the European Commission, applicant states created powerful European offices that were often directly linked to prime ministerial cabinets. This became the core negotiating team, with the best people and resources channelled into it. Other parts of the state, both political and bureaucratic, suffered, especially national parliaments which ended up rubber stamping decisions made by their executive in union with officials from the European Commission (Bickerton 2009).

The proliferation of non-majoritarian institutions reflects the fact that member states prefer to rule through external frameworks, that is, frameworks that are external to political contestation and especially external to the political party systems. In the same way that EU institutions sit outside of political party conflict, many other key institutions of member state governance do so as well. Central banks, and thus monetary policy, are independent of political competition. This is not only true of Eurozone member states, which have delegated monetary policy to the European Central Bank, but also non-Eurozone member states. The Bank of England, for instance, is independent of the UK government, as is the Swedish Riksbank, whose independence from the Swedish Rikstag (parliament) has a clear, statutory basis. Rather than thinking of EU institutions as distinctive or unique, we can thus see them as part of a spectrum of external authorities, which national governments use as a way to exercise their own powers at a distance from national political contestation. Indeed, compared to the scope and range of non-majoritarian institutions at the domestic level, the EU is only the tip of this particular iceberg.

A third institutional feature of member statehood is the weakness of bodies that mediate between the state and civil society. The state-society relationship is traditionally conceived of as a relationship that mediated

Mario Monti in a press conference in Brussels.

through workers' and business organizations, political parties and particular frameworks, such as corporatism or pluralism (Berger 1982). The relationship is therefore normally a thick one, marked above all by the role played by political parties in "standing in" between the state and civil society. European states of recent decades have been marked by a distinct lack of mediation. In part, this comes from the disrepute of the party system, but it also has to do with a more general historical trend towards the unravelling of more complex forms of state-society relations. An extreme instance of unmediated state-society relations arose recently in Italy, where the technocratic Monti government enjoyed neither the support of the political parties nor the support of social groups in Italy (Culpepper 2014).

Of course, one can also speak of a transformation in mediation rather than an absolute decline. Indeed, in many ways, the EU itself has become the new form of mediation. State-society relations are thus mediated through institutions and bodies external to the state and society; this is the change which has taken place. A stark example of this is Greece, where the Troika of creditors have played a direct role in the everyday running of the Greek government. Relations between Greek citizens and their governments run through Frankfurt, Brussels and Washington.

Legitimizing discourses

The typical legitimizing language for the exercise of power by national governments is that of popular sovereignty and representation. This has been true at least since the emergence of the modern secular state in the late 18th century and its consolidation as a national actor in the 19th century. State power is exercised in the name of the people. This holds true across variations in political regime; the differences lie not in invoking the people's right to rule but how the identity and will of the people is determined.

The legitimizing discourses of member statehood are different. Popular sovereignty is treated more as a problem or danger to be contained than it is a source of final authority. The preferred legitimizing discourse is that of wider regional and international obligations and the more abstract language of collectively agreed rules whose validity holds regardless of political life and its multiple competing interests. Specifically, what constitutes legitimacy here is the sense of moral superiority associated with an ability to limit the national will in the absence of external coercion. Joseph Weiler (2003) has written on this particular legitimizing discourse and calls it "constitutional tolerance". In his words,

> Constitutional actors in the Member States [national executives, legislators and officials] accept the European constitutional discipline not because, as a matter of legal doctrine, as is the case in the federal state, they are subordinate to a higher sovereignty and authority attaching to norms validated by the federal people, the constitutional demos. They accept it as an *autonomous voluntary act,* an act endlessly renewed on each occasion, of subordination, in the discrete areas governed by Europe, to a norm which is the aggregate expression of other wills, other political identities, other political communities (Weiler 2003:21, italics added).

Simply speaking, we can say that whereas legitimizing discourses of the nation-state rested upon the idea of supremacy of the national will, the legitimizing discourses of the member state rest upon the idea of its subordination or submission. The idea of constraining national power through an act of self-limitation thus becomes the most important legitimizing discourse of member statehood and, therefore, of EU integration more generally. As Paul Magnette (2000) once put it, Europe, today, is all about "taming the sovereign".

Modes of political conflict

Member states are characterized by modes of political conflict that focus on contesting processes rather than outcomes. Within member states, the process of aggregating preferences has become the subject of political contestation. As a result, political life is devoted as much to challenges to governmental authority as to the enactment of specific policy programmes. If we take as an example the protests which occurred across Europe in 2011 and 2012, from "Occupy London" to the *Indignados* in Spain, we see that the concern of protestors was, in part, with the iniquities of financial capitalism and the way in which European governments had bailed out their banks. But the protestors were also driven by scepticism and disenchantment with national democracy as a process.

The political life of member states is thus based both on traditional cleavages, such as Left versus Right, and newer forms of political conflict, in which political elites are identified as a monolithic group and denounced for their self-interested behaviour and corruption. The language of *la casta* is used by Beppe Grillo, in Italy, and by Pablo Iglesias, in Spain. Indeed, the very definition of populism is to define the political field as a struggle between the virtuous people and the corrupt national elite. The prominence of populism in European politics is thus evidence of the way the political process itself—not just its outcomes—has become politicized.

Member statehood and the Greek crisis

In order to demonstrate the relevance of the member state analysis to the idea of the European Union and European integration today, this chapter takes the Greek crisis as an example. There are a number of ways in which the member state analysis helps us understand the key features of this crisis, its place within the wider European integration process and its present resolution. At the time of writing, Greece had finalized a third bail-out agreement with the EU to the tune of 86 billion Euros, to be disbursed over three years in exchange for significant and far-reaching internal reforms. This section will focus on two aspects of the Greek crisis: why Syriza failed in its negotiations with the Troika and what Yannis Varoufakis' tenure as finance minister has revealed about the Eurogroup and the nature of European monetary union more generally.

The failure of Syriza

Viewing the EU as a union of member states helps us understand Syriza's failure after winning the Greek elections in January 2015 (see also, Jones 2015). Syriza won just over 36% of the vote, leaving it short of forming a parliamentary majority on its own. It entered into a coalition with Independent Greeks, a right-wing party that was also opposed to the bail-out deal agreed to by previous Greek governments.

The incoming strategy of the Prime Minister, Alexis Tsipras, and his finance minister, Yannis Varoufakis, was to argue for change from within the single currency union. Their language was strongly pro-European, and they argued for a different policy mix for the Euro, rather than its abolition or for Grexit. Indeed, it was made very clear by both figures that Greece did not want to leave the Euro but only to change the existing terms of its deal with its creditors. This "change from within" strategy relied on the existence of real sympathy for new policies within the Eurozone, most notably some sort of debt mutualisation mechanism and debt relief for Greece—policies which signalled the formation of an embryonic fiscal union. These were policies that would have required more supranationalisation at the European level and more "burden-sharing" across borders.

What Tsipras and Varoufakis ran up against was an EU whose governing logic was not that of ever-increasing supranationalisation of macro-economic policy. Rather, the EU has for some time been moving in a "new intergovernmental" direction, with member states at the realm. In monetary policy, the focus is on rules and the importance of these rules in constraining the behaviour of national governments. This implies greater coordination between national governments but no sharing of the debt burden and no "solidarity" of the kind that Varoufakis was demanding.

Syriza also underestimated the extent to which other member state governments identified with these collectively agreed frameworks rather than with any ideological project of Left or Right (Gourevitch 2015). One might have expected Syriza to be able to rally other social democratic parties in power across Europe, most notably in Germany, France and Italy. Had there been a strong position in favour of a revised and less "austerity-focused" deal for Greece on the part of Germany's Social Democrats, then Merkel and Schäuble would have found their negotiating hand much weakened. Schäuble's strength and determination was

in some part a reflection of the absence of any challenge to his views within Germany. And yet, the SPD is in coalition with the Christian Democrats, and Sigmar Gabriel, the SPD leader, is Vice-Chancellor.

Both Italy and France, supportive of Greece at the very end when "Grexit" seemed a real possibility, did not support Greece as ideological partners. Their defence of a more socially-friendly deal for Greece was weak in comparison to their support for honouring past agreements and adhering to a rule-bound framework. In an interview, Varoufakis said that French finance minister, Michel Sapin, was personally very supportive of the Greek attempt to transform the substance of the bailout deal. Publicly, however, Sapin refused to back Varoufakis and instead urged Greece to support the conditions being offered by its creditors (Parker 2015).

The real sins of Varoufakis

One feature of the Greek crisis was the short-lived presence of the Greek finance minister, Yannis Varoufakis, within the Eurogroup. Varoufakis was tasked by Tspiras to lead negotiations with creditors, and he defended his government's position in the Eurogroup. Much ink has been spilt discussing Varoufakis, in particular his flamboyance and lack of respect for typical political and diplomatic protocol. However, if we want to explain why Varoufakis became a *persona non grata* for the Eurogroup, one has to understand how he broke many of its rules and violated its etiquette as an institution (Bickerton 2015).

In terms of the substance, there was some overlap between Varoufakis and the creditors. Many accepted, at least implicitly, that Greece's debt obligations would never be paid back in full and that some sort of debt relief was inevitable. There was also sympathy for Syriza's statements about tackling the oligarchic nature of the Greek economy. Many, indeed, saw this—as much as anything else—as the real obstacle to growth in Greece and welcomed the possibility of tackling these major figures, whose influence far outweighed their contribution to the Greek economy.

However, Varoufakis did not negotiate in the manner expected within the Eurogroup. Viewed through a member state analysis, where state-society relations are distended to the point of having closer identification between national elites at the European level than between those elites and their own domestic societies, the Eurogroup is

an institution that powerfully demonstrates this separation. Within the Eurogroup, ministers think of the discussions as being technical in nature, and there is a strong problem-solving and, therefore, consensual nature to its deliberations. Participants think of themselves as sharing a basic outlook with disagreements relegated to matters of detail. The Eurogroup is also a place where those with difficulties achieving domestic results come for support. This shared outlook prevails over the specific national affiliations of each finance minister.

In contrast to all of this, Varoufakis understood his participation in the Eurogroup as that of a Greek finance minister, bringing to the table the demands of his people. He did not leave his national identity at the door but wore it as a badge of honour. Any important issues on which he needed to compromise were brought back to Athens to form the basis of cabinet and party votes. He even began to publicize his positions before Eurogroup meetings and his interpretation of the proceedings afterwards. Varoufakis thus injected into the Eurogroup the vertical principle of direct representation that challenged the horizontal principle of elite identification, which animates the institution. He certainly also annoyed participants by patronising them, using his authority as an academic to make his case for Euro-reform. He was not at all attentive to building political coalitions, and one wonders whether he was playing a "long game" at all or instead preferred to shine brightly for a while and then disappear with a bang. This political naivety, one suspects, was not fatal, however. It was his violation of Eurogroup etiquette that made him a *persona non grata*.

Conclusion: Populism, technocracy and the future of Europe

This chapter has argued that European integration needs to be understood as a process of state transformation. National states have been transformed, and what we see in the EU is the institutional expression of these domestic level changes. It is for this reason that the EU seems so omnipresent but is also institutionally weak. The specific nature of the transformation has been labelled here as a shift from nation-states to member states. This describes a change in state-society relations, where a vertical relationship of representation and authorization, which identifies people as the basis of national power, is increasingly being replaced by a horizontal notion of state power and authority. In this

conception, participation in transnational networks of governance such as the EU are not constraints on national power but constitutive of it.

The result of this shift from nation-state to member state, and the effect on the way state power is constituted, is that political life at the national level is no longer based on a combination of democratic contestation and governmental effectiveness. Political parties have been, since the beginning of the 20th century at least, the main vehicles within European democracies for the reconciliation of the competing demands of representation and responsible government (Mair 2009). Member statehood, based as it is on a thinning of the state-society relationship to the point that mediating bodies, like parties, are increasingly marginalized, generates a kind of political life that is unable to combine representation with responsibility. Instead, the two have become uncoupled and appear as opposites that challenge one another: populism, on the one hand, and technocracy, on the other. It is the people versus the elites, rather than competing representations of the popular good and its realization through concrete sets of policies.

VIVIEN ANN SCHMIDT
is Jean Monnet Professor of
European Integration, Pro-
fessor of International Rela-
tions in the Pardee School of
Global Affairs, and Professor
of Political Science at Boston
University, where she is also
Director of BU's Center for the
Study of Europe. Some of her
recent books include *Resilient
Liberalism in Europe's Political
Economy* (co-edited, Cambridge
2013), *Democracy in Europe*
(Oxford 2006), and *The Futures
of European Capitalism* (Oxford
2002). She is currently at work
on a book on democratic legiti-
macy and the Eurozone crisis.

European integration has become an increasing
challenge to national democracies. As more
and more policy decisions are taken at the
EU level or removed to technocratic bodies,
national politics has been gradually emptied
of substance. The Eurozone crisis has made
such matters worse not only because of the
economics and politics of hard times, but also
because EU governance processes and policies
have themselves become less "democratic".
How can national democracies be reinvigorated
while rebalancing the EU's "democracy" in ways
that enable both levels to interact productively
within the new EU realities?

THE IMPACT OF EUROPEAN INTEGRATION ON NATIONAL DEMOCRACIES: DEMOCRACY AT INCREASING RISK IN THE EUROZONE CRISIS

Introduction

European integration has long had an enhancing effect on Europe's national democracies. In addition to meeting its initial commitments to peace and prosperity, the European Union has generated policies to address problems that national governments cannot resolve effectively on their own in an increasingly globalized world. However, while deepening European integration has benefited the member states of the European Union in countless ways, it has also had some unanticipated side effects on their national democracies.

> THE PROBLEM FOR NATIONAL
> DEMOCRACIES IS NOT THAT EU POLICIES HAVE
> ENCROACHED ON NATIONAL ONES, BUT THAT
> CITIZENS HAVE HAD LITTLE DIRECT SAY

As decision-making in policy area after policy area has moved up to the EU level, European integration has increasingly encroached on issues at the very heart of national sovereignty and identity. Money and monetary policy, economic organization and labor markets, borders and immigration, public services and even welfare guarantees all increasingly come under EU policies or prescriptions. The problem for national democracies is not so much that EU policies have encroached on national ones, however, but that citizens have had little direct say over these matters, let alone engagement in EU-wide political debates about the policies. The fragmented nature of European "democracy" has meant that while the policies are decided at the EU level, generally in an apolitical or technocratic manner, politics remains national. National democracies as a result have increasingly become the domain of "politics without policy" whereas the EU level appears as "policy

without politics"[1]— however "political" (or politically charged) the policies may actually be, in particular in the Eurozone crisis.

As national citizens have had less and less direct influence over the policies that affect them the most, they have expressed their concerns at the only level at which they are able: the national. Citizens have increasingly made their displeasure known through protests and the ballot box, leading to the rise of the populist extremes and the increasing turnover of sitting governments. National governments, moreover, have found themselves caught more and more between citizens' electoral expectations and the EU's collectively agreed rules and decisions.

As a result, national governments confront dual challenges: from populism at the national level and from technocracy at the EU level. But technocracy is itself a creature of the governments themselves. As member states in coordinated intergovernmental EU agreements, they have increasingly delegated implementation and oversight powers to supranational authorities, such as the EU Commission, the European Central Bank, and a proliferating number of regulatory agencies. Again, although pooling their authority to delegate responsibility may have been the best way to meet the global challenges, it has also further reduced governments' national margins of manoeuver, in particular with regard to the demands of large numbers of their own citizens.

The Eurozone crisis has made such matters worse not only because of the politics and economics of hard times, but also because of the EU's economic policies and governance processes in response to the crisis. These have only intensified the democratic challenges for citizens and their governments alike, as more and more decisions have been taken through EU level intergovernmental coordination and supranational delegation.[2] Citizens have felt their diminished influence all the more acutely, resulting in a precipitous loss of trust in both their national governments and in the EU, which has also manifested itself in even greater political volatility.

Note, however, that the impact of the EU, in particular in the Eurozone crisis, has been highly differentiated. Not only have citizens' reactions to the EU and the Eurozone crisis been very different across the member states, but national democracies have also had very different experiences of the EU and the Eurozone crisis. While some national

1 See Schmidt 2006, Ch. 1, 4.
2 Fabbrini 2013; Dehousse 2015.

democracies have been greatly undermined, others have been empowered. Greece under the latest bailout agreement is arguably the most extreme example of the hollowing out of national democracy, whereas Germany—given both its position on the Council and the role of its Constitutional Court in vetting EU legislation—has arguably been best able to ring-fence its own national democracy.

The question for the EU, then, is how can it manage to recapture the hearts and minds of all of its citizens across its member states? And how can it rebalance EU decision-making to make it more generally democratic? The question for national governments is, how can they retain enough control to satisfy the demands of national democracy without undermining the goals of European integration?

European Integration and National Democracy

European integration has, all in all, been a major boon for the EU's member state democracies. Integration has enabled the comparatively small countries of Europe to stand together as a supranational region, thereby giving them international scale and scope. It has equally enabled them to stand up to the challenges of economic globalization in an increasingly interdependent and competitive world economic system, by regionalizing their economies through a single market and a common currency. But the very integration processes that have served to enhance the substantive quality of member states' democracies, by giving them peace and prosperity at home along with extra heft as a regional power and economic authority in the international arena, have at the same time impoverished the procedural quality and political dynamics of their democracies.

European Integration and Democracy

European integration has been a democratically negotiated process among member states, as they slowly and incrementally pooled sovereignty, shared authority, and created joint control in policy area after policy area and institution after institution. The customs union was followed by the Single Market, Schengen, and European Monetary Union (EMU); the Court of Justice of the EU (ECJ) gained supremacy and direct effect; the European Central Bank (ECB) was given control over money, monetary policy, and banks most recently; and

the Commission increased its supranational powers of negotiation, regulation and oversight in areas such as international trade negotiation, financial markets, and the EMU via the European Semester for budgetary oversight.

The reduction of national democracy has been an inadvertent by-product of such increasing integration, as more and more decisions are taken at the EU level rather than the national. This has thereby emptied national democratic politics of substance without at the same time creating a fully democratic body politic at the EU level as a replacement.

The lack of citizen access to EU decision-making has only marginally been remedied by the incremental rise over time in the powers of the European Parliament (EP) as the direct voice of the people, in particular through its increasing influence via co-decision procedures with the Council and Commission and by measures for direct citizen access, such as the EU ombudsman and the citizen's initiative petition. In the case of the EP, any claims that it is the most representative of EU bodies because of its members' direct election "by the people" are weakened by the high levels of abstention in EP elections and the second order nature of such elections.[3] Moreover, in the Eurozone crisis, any such claims to representativeness are additionally weakened by the fact that the EP has had by treaty very little remit in EMU governance, although this changed somewhat over the course of the crisis.

Equally problematic are any member state leaders' claims that their indirect election to the European Council by their national citizens makes the European Council the most representative forum, and themselves the most legitimate to legislate for all EU citizens,[4] as President Sarkozy seemed to insist at the height of the Eurozone crisis when he defined a more democratic Europe as "a Europe in which its political leaders decide"[5] and Chancellor Merkel appeared to assume when she explicitly commended the new "Union Method."[6] Not least is the fact that member state leaders can only legitimately agree to impose austerity measures for the citizens who elected them, not on others—which they nevertheless did for countries in need of bailouts during the Eurozone crisis. But even if it were legitimate for member states to agree to legally binding austerity measures for everyone, delegating to their

3 Franklin, and van der Eijk 2007.
4 Schmidt 2015a.
5 In a speech in Toulon (Dec. 1, 2011).
6 In a speech at the College of Europe in Bruges (Nov. 2, 2010).

agent (i.e., the Commission) the discretionary authority to implement such rules is not similarly legitimate, given the necessarily ad hoc nature of the specific application of those rules to any given country.[7]

Additionally, assuming that the Council serves as a representative forum fails to deal with the fact that during the Eurozone crisis, it acted initially more as a bargaining arena in which one member state (Germany) exercised the greatest influence. Although academic scholarship on

THE LACK OF CITIZEN ACCESS TO DECISION-MAKING HAS BEEN PARTLY REMEDIED BY THE INCREMENTAL RISE IN THE POWERS OF THE EUROPEAN PARLIAMENT

the Council has suggested that the deliberative mode prevails over hard bargaining, even where qualified majority voting occurs, because of the focus on consensus,[8] in the Eurozone crisis, deliberation has occurred in the shadow of Germany.[9] In the months leading up to the May 2010 bailout of Greece, Germany, as the strongest economically and the most opposed to taking a decision, ensured that no decision could be taken, given the unanimity rule, until Chancellor Merkel finally agreed in order to "save the euro."[10] Germany's predominance has manifested itself not only through that country's sway in the Council decision-making process, but also in coordination with coalitional allies. It has also been evident through German leaders' ability to determine the analysis of the Eurozone crisis and set the terms for the response.

Despite the reality of a crisis that resulted from an explosion of private debt and a structure of the euro that had produced increasing divergences rather than the expected convergence between countries,[11] the crisis was framed as one of public debt rather than private—by reading off the Greek case—and diagnosed as behavioral rather than structural, from not following the rules, which was again only true for Greece (and Germany and France, in the mid 2000s). As a result, the remedies all focused on "governing by the rules and ruling by the numbers,"[12] that is, on

7 Scharpf 2013, pp. 138-9.
8 In a speech in Toulon (Dec. 1, 2011).
9 Novak 2010, Puetter 2012.
10 See Schmidt 2015a; Jacoby 2015.
11 Schelkle, 2015; Jones, 2015.
12 See, e.g., De Grauwe and Ji 2012; Enderlein et al. 2012; De Grauwe 2013; Blyth 2013.

reinforcing the rules and more strictly specifying the numbers through the various legislative packages and intergovernmental pacts (Six-Pack, Two-Pack, and Fiscal Compact), while increasing budgetary oversight through the Commission-led process known as the "European Semester." EU leaders in the European Council spent their time agreeing to restrictive rules and sanctions, rather than finding lasting solutions to the incomplete risk pool and insurance mechanism that constituted EMU and that had been put in place more by default than design.[13] What was in fact needed was greater solidarity through some form of mutualization of debt (e.g., Eurobonds) or macroeconomic stabilizers (e.g., an EU-wide unemployment fund).[14] But Germany was adamantly opposed to any such "transfer union" from the very start.

THE GERMAN CONSTITUTIONAL COURT IS THE ONLY NATIONAL COURT TO ASSERT ITS RIGHT TO VET SUCH EU DECISIONS, CASTING UNCERTAINTY ON THOSE DECISIONS

Finally, Germany's over-sized influence in the EU also stems from the features of its own national democracy, in which the Constitutional Court has played a major role in deciding what is democratically legitimate for Germany and the EU. The Court has thereby served as another power resource for German leaders, who frequently invoked the Constitutional Court to delay decisions, as they did with regard to bailing out Greece. But more importantly, the German Constitutional Court has also inserted itself repeatedly into EU matters, most notably with its hearings on the ECB's "unorthodox" monetary policies, in particular with regard to "OMT" (open monetary transactions) through which ECB President Draghi had promised to "do whatever it takes" to save the euro in July 2012, which had stopped market attacks on member state debt. Such judicial activism is in and of itself perfectly appropriate by the standards of national democracies. But it is problematic for EU governance at the very least in terms of its efficiency: What if all member states' constitutional courts were to do the same?[15] Most significant here regarding our concerns is that the German Constitutional Court

13 Schelkle 2015; Jones 2015.
14 Claessens et al. 2012.
15 Dehousse, 2011.

Members of the European Parliament voting
during a session on September 2015.

is the only national court to assert its right to vet such EU decisions, with the effect of casting uncertainty on those decisions.

Democratic Governance in the EU

The problem for the EU is that without a fully developed "government" similar to that of national democracies, EU citizens are unable to aggregate their concerns and demands in such a way as to express their will directly at the EU level. There are naturally good reasons for why this would neither be feasible nor particularly "democratic" in the EU up until today. Such reasons have been discussed and debated at length, including the lack of a European *demos*, a sense of common citizenship and identity, or even a single public sphere.[16] More recently, the scholarly conversation has shifted to seeing the potential for EU democracy more positively, as being made up of overlapping public spheres[17] and consisting of *demoi*, which would therefore be capable of constituting an EU *demoicracy*[18] or creating a "European Republic."[19] But for the moment, the EU is far from any supranational democratic reality. Importantly,

16 En particular, Weiler, 1995 and Grimm, 1997.
17 Risse 2010, 2015.
18 Nicolaïdis 2013.
19 Collignon 2004.

even were there to be any such supranational government, we would still need to consider questions of national democracy, in particular with regard to how the member states' national democracies would fare within any such supranational democracy.

Be this as it may, in the current context, we can nevertheless discuss the democratic qualities of the EU. This is because the EU does have a range of "governance" (rather than government) processes with multi-level representation and coordination that ensures that it stands up to many of the tests of democratic legitimacy even in the absence of a democracy similar to that found at the national level. Three such tests or legitimizing mechanisms are theorized in the EU studies literature.

The first test or legitimizing mechanism consists of EU policies' "output" effectiveness and performance, judged on the basis of the results of, say, the regulatory policies of the Single Market or the monetary policies of the Single Currency. The second is the EU's "input" representation of and responsiveness to citizens' political demands and concerns, which is institutionally based on member states' indirect representation of their citizens in the Council and the EP's direct representation of EU citizens. These are often theorized as allowing trade-offs in which more of the one makes up for less of the other. For example, when supranational agencies produce good policies (that is, policies that citizens believe are successful and appropriate), this is seen to make up for the fact that the citizens have not voted for those policies.[20]

The third test encompasses what I call the "throughput" quality of the EU's governance processes, judged by their efficacy, accountability, transparency, and inclusiveness. Here, there is no trade-off with input or output legitimacy: Where the quality of the throughput processes is good, they are not noticed by the average citizen, but where the quality is bad, they can skew public perceptions of input responsiveness or taint views of output results.[21] Notably, during the Eurozone crisis, questions have arisen on all sides about the quality of governance by the ECB, the Commission, and/or the Council.

Opinion is split on the throughput legitimacy of EU governance processes in the Eurozone crisis. Divisions persist, for example, on whether the ECB acted too slowly or went too far in terms of its "unorthodox" monetary policies; whether the Commission has been too flexible or not

20 Scharpf 1999; Majone 1998.
21 Schmidt 2013.

flexible enough in its application of the rules; and whether the Council has been too active or not active enough in its creation of new instruments to weather the crisis. Naturally, output legitimacy is also at issue, that is, whether the ECB's monetary policies, the Commission's oversight, and the Council's legislation have produced good enough results in the Eurozone. And here, the answer is likely to be negative, when judged by overall rates of economic growth and levels of poverty, unemployment, and inequality.[22]

WITHIN THE EU, TREATY CHANGE IS VERY DIFFICULT IF THERE IS NO CONSENSUS AMONG THE TWENTY-EIGHT MEMBER STATES

Beyond these questions of EU level output and throughput legitimacy are ones related to input legitimacy. They are situated in particular at the intersection of EU democracy with its member states' national democracies, especially in the midst of the Eurozone crisis. The increase in the Council's intergovernmental decision-making that centralized power in the hands of member state executives, however necessary at the height of the crisis, worked to the detriment of the more input legitimate co-decision making with the European Parliament. It also cut off the throughput legitimacy that comes with greater transparency in decision-making as well as with greater inclusiveness, by closing off access to pluralist processes through the EP or the Commission for citizens operating in cross-national as well as national interest groups and social movements. Moreover, the increase in supranational governance through Commission oversight of national governments' budgets in the European Semester—which the Commission vets even before national parliaments have had a chance to comment—has reduced a key component contributing to national parliaments' input legitimacy.

The most significant problem for national democracies subordinated to the EU's supranational governance system, however, is that the EU does not have the main constitutive component of national democracies' input legitimacy. National elections bring in new majorities that are able to alter the rules, or even rescind them. This is not the case in the EU, where treaty change is very difficult if there is no consensus among the twenty-eight member states, given the unanimity rule as well as the fact that some member states are required to hold national referenda.

22 But see Schmidt 2015b.

In national democratic polities, when economic prosperity plummets and policies go awry, we generally assume that citizens will elect new political leaders with mandates for policy change in the expectation that both the politics and the economics will improve. Not so in the European Union (EU), where citizen dissatisfaction with EU governance of the Eurozone crisis can do and has done little to change the policies forged at the EU level. Whether citizens express their concerns through protest or votes, including voting out national governments and voting in Eurosceptic parties on the political extremes, they have had little impact on EU level decision-making. And because EU decision-making is itself largely apolitical and technocratic, it also serves to undermine national party government, which is political and normative.

The EU's Challenges to National Politics and Democracy

The problem for national democracies is that the EU has actually unsettled the balance between the two main functions of national level political parties in their relations with their constituents. Increasingly over time, European integration has forced parties to privilege responsibility over representation, by enhancing their governing role to the detriment of their responsiveness to national electorates.[23] Responsibility without responsiveness alienates the citizens, while responsiveness to the detriment of responsibility puts national governments at odds with the EU rules and at risk of sanctions. The pressures to be responsible affect not only the sitting governments that agreed to the policies but also the opposition parties that may have campaigned against the very policies that they will be expected to implement when they gain office, even against "the will of the people." The result is a step-change in member states' commitment to responsible government, to the detriment of responsive government, leading to the "politics of constrained choice."[24] In consequence, even as national electorates clamor for more domestic input into the decisions that affect their lives, governments are forced to implement decisions that emanate from the EU, which may not be in tune with domestic perceptions of the policies that they believe would produce good and appropriate results.

23 Mair, 2013; Mair and Tomlinson, 2011.
24 Laffan, 2014.

EU Policy and Technocracy versus National Politics

To understand fully what this means, we need to consider the fragmented nature of EU multi-level democracy taken as a whole, in which politics remains primarily at the national level while policy has increasingly gone to the EU level. Put another way, the national level has increasingly become characterized by "politics without policy" as more and more policies are removed from the national arena. This has thereby emptied national politics of substance, impoverishing the national political arena and leaving the way open to populist contestation. At this same time, the EU level consists of "policy without politics." Member state leaders in the Council tend to eschew the language of the left or the right when speaking of their national interests, the EU Commission uses the language of technocracy, and the EP, if not left out of the game entirely, uses the language of the public interest.[25] This makes for depoliticized EU policy debates that use primarily technical arguments that do not resonate with European citizens, who are used to the left/right divides of national debates, often worry about EU policies on left/right grounds, and expect normative arguments that resonate with national values and political concerns.

Such apolitical or technocratic language and discourse enable member state leaders to cast their nationally focused discussions of EU policies in whatever way they deem appropriate for their domestic political audiences.[26] The fact that member state leaders' references to the EU often take the form of blame-shifting ("the EU made me do it") or credit-taking (without mentioning the role of the EU) only increases problems with regard to public perceptions of the EU. And it feeds into populist discourse about the EU being responsible for all national problems, together with the national politicians who go along with EU demands.

Yet, and here is the rub, although the EU-level discourse may appear apolitical and technocratic, as "policy without politics," the actual content of the policies is certainly political. The economic policies, in particular in response to the Eurozone crisis, although cast as TINA—there is no alternative—are in fact conservative, following ordoliberal principles focused on the need for sound money and stable finance in the macroeconomic sphere and neoliberal programs focused on structural reform of national labor and welfare systems. Moreover, while

25 Schmidt 2006: 21–29.
26 Schmidt, 2006; J-C Barbier, 2008.

the policies are in this sense political, neoliberalism itself, in its more extreme forms, can be seen as anti-political or even anti-democratic— with technocratic rule assumed better able to solve problems through non-majoritarian institutions run by experts than political rule, populated by "rent-seekers".[27] Notably, whether or not policymakers buy into the anti-political philosophy of neoliberalism when taken to its extremes, they carry it out when they impose policies decided in Brussels on national constituencies. EU technocratic considerations often seem to take precedence over citizens' normative concerns and to trump their political concerns because they cannot change the policies through national politics. This is when responsible politics replaces responsive politics, and when the politics of constrained choice means that politicians implement policies that national parties and parliaments do not generate or debate and that the public may oppose.[28]

One important contributing element to the crisis of mainstream national party politics has come from this increasing predominance of technocracy to the detriment of national party politics. As more and more seemingly depoliticized EU level technocratic decisions have become national policy, without real debate or significant involvement of national parliaments, national party politics and indeed national democracy has weakened. Definitions of democracy based on party politics assume that political parties will provide both political mediation—by aggregating and articulating competing conceptions of the common good—and a procedural framework expressive of the constitutive values of democracy, including the principles of parliamentary deliberation, the rules of decision-making, and the recognition of the legitimacy of opposition.[29] EU level technocracy, by sidelining both national mediation and deliberation, thereby weakens national party democracy.

An even greater concern is that ever-increasing technocracy plus ever-weakening mainstream party politics have together fuelled the rise of populism. Populists' main target is mainstream party politics, which they accuse of being run by self-serving and corrupt elites that have no interest in "the people." The irony is that technocracy also has as its target mainstream party politics, seen as inefficient and rent seeking (read corrupt). Technocracy and populism are very different things. But the danger of

27 Gamble 2013; Schmidt and Woll 2013.
28 Laffan, 2015.
29 Bickerton e Invernizzi Accetti, 2015.

technocracy is that too much of it undermines mainstream, party-based representative politics while increasing support for the populists.[30] And too much populism can lead to the destabilization of democracy.

Europe's Growing Political Volatility and Euroscepticism

The end result is the increasing political volatility that comes from citizens' sense that their preferences—whether expressed through the ballot box, social concertation processes, or social activism—don't count.[31] Citizens have been punishing their national politicians with growing frequency and intensity, resulting in the increasing turnover of sitting governments[32]. Political volatility has become the rule not only in the periphery but also in the core—in particular since the Eurozone crisis. France is a case in point—President Sarkozy was only the second president in the Fifth Republic not to have won a second term; President Hollande has had the lowest popularity rating of any president of the Fifth Republic (down to 12 percent in November 2014—although back up to a still very low 20% by April 2015). Governments are generally more fragile and often on a knife's edge with regard to their majorities, while mainstream parties have been having more and more difficulty forming a government—as was the case of the Italian elections of February 2013. Even more problematic for the EU is the possibility that more anti-democratic or "illiberal" governments will also emerge, as in Hungary. There are worrying signs even short of this, however, with the rise of far right extremist parties, such as the neo-Nazi party, Golden Dawn, in Greece, with 9% of the vote in the June 2012 elections, and still above 7% in the September 2015 election.

Increasing Euroscepticism or even anti-European—and not just anti-euro—feeling is part and parcel of the political volatility that only intensified with the continuing Eurozone crisis. The "sleeping giant" of EU-related party divisions and Euroscepticism, long predicted by analysts, has finally awakened.[33] We can see this not just in the growing divisions over the EU within mainstream parties but even more significantly in the

30 Bickerton and Invernizzi Accetti 2015.
31 Mair, 2013.
32 Bosco et al., 2012.
33 Franklin and Van der Eijk 2007.

rise of extremist parties. These include not only hard right extremes but also the less extreme populists on the right (e.g., the National Front in France, Geert Wilders' party in the Netherlands), on the left (e.g., Syriza in Greece, Podemos in Spain), and in what we could call the less easily classified "radical center" (e.g., the Five Star Movement in Italy, the AfD in Germany, and even UKIP in the UK). Notably, such parties can be found not only in the countries hardest hit by the crisis, in Southern and Eastern Europe, but also in those largely unaffected by the crisis economically, mainly in Northern Europe. This includes Scandinavia[34]—with the True Finns' breakthrough in the 2011 Finnish elections, the Sweden Democrats' in the September 2014 elections, and the Danish Peoples Party's historic gain in the June 2015 election, becoming the second largest party in the country, and precipitating the collapse of the center-left government. Even Germany, which had seemed vaccinated against the extreme right, saw the meteoric rise of the AfD (Alternative for Germany) in 2014, along with an anti-immigrant extremist movement, Pegida.

The results of the European Parliament elections were also a sign of the rise of Euroscepticism, in particular with the victories of Marine Le Pen's FN in France and Nigel Farage's UKIP in the UK—although Prime Minister Renzi's massive 40% victory for the social democrats of the Democratic Party (PD) in the Italian contest (a first in the postwar history of Italy) suggests that there is hope for centrist parties whose leaders promise to make national views heard at the EU level as well as to make national democracy work better.

Importantly, although public disenchantment with the EU in any form is mainly seen in the rise of extremist and populist parties, especially on the radical right,[35] it can also be found in the polarization of views across national European public spheres, in particular between Northern and Southern Europe.[36] Such polarization is also evident in the growing differentiation in citizens' attitudes between a more cosmopolitan open idea of Europe and a more xenophobic closed view,[37] as well as in public debates that have become increasingly politicized around EU and Euro issues. This has affected both Eurozone and non-Eurozone countries, largely pitting the South against the North, with an increase in debates focused

34 aggart, and Szczerbiak 2013; Usherwood, and Startin 2013.
35 Gómez-Reino and Lamazares 2013.
36 Kriesi and Grande, 2015.
37 Kriesi et al., 2008.

on questions of national sovereignty, whether against "Northern" impositions of austerity by publics in the South, or against further supra-national institutionalization and loan bail-outs by publics in the North—and this despite the fact that the arguments of political elites engaged in crisis management have focused primarily on economic and political efficiency.[38]

SURVEYS AND POLLS DOCUMENT
A PUBLIC DISENCHANTMENT WITH THE EU
AND NATIONAL GOVERNMENTS

Surveys and polls document quite clearly this public disenchantment with the EU as well as with national governments.[39] Eurobarometer polls demonstrate the massive loss of trust in both national governments and the EU over time, in particular with the Eurozone crisis. Trust in the EU dropped from a high of 57% in spring 2007 to a low of 31% in spring 2012, which continued unchanged in 2013 and spring 2014, while trust in national governments dropped from a high of 43% in spring 2007 to 24% in Fall 2011 and to an even lower 23% in fall 2013.[40] Such negative views of the EU are evident also in the loss of support for the European project, with the positive image of the EU down from 52% in 2007 to 30% in 2012, while negative images went up from 15% in 2007 to 29% in 2012—neck and neck with the positive responses.[41]

Only in late 2014 was there an uptick in public views, with trust in the EU jumping 6 points, to 37% in fall 2014, and trust in national governments up 6 points as well, to 29% in fall 2014.[42] This may be the result of a sense that the EU is finally turning the corner economically, that politics does matter, with the greater politicization of the debates in the European Council among political leaders around flexibility and in the EP with the elections, or that the policies may change, given the ECB announcement of quantitative easing and anticipation of the arrival of a new Commission promising investment and growth. That said, it could just be a blip in the opinion polls.

Moreover, although support remains strong for retaining the Euro, including 69% in Greece, 67% in Spain, 66% in Germany, 64% in Italy, and 63% in France, this suggests only that citizens do not see exit from

38 Kriesi et al., 2012; Kriesi, 2014.
39 Hobolt 2015.
40 Eurobarometer EB 8241 Hobolt y Wratil, 2015.
41 Eurobarometer EB 78, Dec. 2012.
42 Eurobarometer EB 82, 2015.

the Euro as an option, not that they are happy with the policies related to it.[43] Much the contrary, a September 2013 Gallup Opinion Poll showed that a majority of European citizens (51% of respondents) did not think that austerity was working, by contrast with a minority of 34% who thought it was working but takes time, and a very small percentage of 5% who thought it was working.[44] So how do we explain continued support? There is evidence to suggest that even as citizens continue to support the euro, their reasons have increasingly less to do with the euro's link to identity and increasingly more to do with their self-interest. A utility-based logic, rather than an identity-based one, is most likely to explain why, despite the crisis, support has remained strong—even though the public may be increasingly unhappy about the euro's effects.[45]

Meanwhile, the unions find that all they can do is agree to concessions while gaining nothing in return, as in the Spanish pension agreement and the Irish Croke Park deal. At the same time, all that the most social movements like the Spanish *indignados* have managed to do is to mobilize members for protests and demonstrations that get them nothing other than, sometimes, news coverage[46]—although in certain instances this has led to the creation of new political parties, most notably Podemos and Syriza. Repression of such movements is also an issue, however. The Council of Europe (2013) criticized EU member state governments for sidestepping regular channels of participation and social dialogue on the pretext of national financial emergency, with harsh responses against demonstrators and infringements of freedom of expression and peaceful assembly, as well as reductions in media freedom, in particular in public outlets.

The Rise of the Populist Extremes in Europe

Complacency would be a mistake in the face of the rise of the populist extremes. Extremist parties don't simply go away when times get better—as the experience of the boom years of the early and mid 2000s demonstrate. Once populism takes hold, it is not easy to dislodge. The extreme right populist parties that thrived in the 2000s on identity politics focused on anti-immigrant issues and the EU have simply added

43 Pew Survey, May 2013.
44 Gallup poll, Sept. 2013 http://www.scribd.com/doc/172138343/Gallup-Debating-Europe-Poll-Austerity-Policies.
45 Hobolt and Wratil 2015.
46 Armingeon and Baccaro 2013.

skepticism about the Euro to its list of complaints. Moreover, with the fall 2015 crisis resulting from the massive flows of refugees and immigrants from North Africa and the Middle East, the populist parties on the extreme right, in particular, have continued to thrive on an issue that they have long exploited to build support.

Populism should not be seen as a totally negative phenomenon, however, since it can have certain positive effects, such as giving voice to underrepresented groups, mobilizing and representing excluded sections of society, and increasing democratic accountability by raising issues ignored or pushed aside by the mainstream parties.[47] The extremes on the left in particular, by mobilizing on the basis of social justice and human rights as well as against the inequalities caused by the increasing predominance of financial capitalism and its accompanying booms and busts, or by the lack of progressive taxation, can serve as a positive pull on mainstream parties, on the right as much as the left. However, there are many fewer extreme left parties with a significant popular following (with the exception of Greece and Spain) than extreme right parties. And these are the parties that appear to have exerted the most influence in political debates so far, by pulling center right mainstream parties closer to their positions, especially with regard to opposition to immigration and freedom of movement or minority rights. On the left, moreover, the rise of left-leaning extremism has put center left parties in a quandary—to move left, thereby challenging EU level agreements, or to resist any leftward move, thereby weakening governing majorities or losing support from part of their traditional electorate. In addition, the potential victory of one of the populist anti-EU parties in national elections in the next few years could be highly problematic not only for the country in question—especially if it were a coalition with an extreme right party that would seek to implement its discriminatory or anti-EU views—but also for the EU, given decision rules that give individual member states veto power over treaties.

The only possible signs of light with regard to populist parties have been Greece's Syriza and Spain's Podemos, which look set to become those countries' new center-left parties in place of the moribund Greek Socialist party PASOK and the Spanish Socialist Workers' Party (PSOE). What has made these new parties credible to large portions of the electorate is not only that they have engaged openly with difficult questions about the distribution costs of fiscal consolidation. It is also the fact

47 Mudde and Kaltwasser 2012.

that their initial exclusion from power has put them in a good position to deliver a radical critique of the rent-seeking behavior of mainstream party, state and technocratic elites. Rather than worrying that these new parties may prove intractable, we should recognize that they could actually be the ones to bring real renewal to their countries' politics as well as to generate citizen-friendly structural reforms focused on reducing corruption, improving tax collection, and promoting social justice.

POPULISM CAN HAVE CERTAIN POSITIVE EFFECTS: GIVING VOICE TO UNDERREPRESENTED GROUPS, MOBILIZING EXCLUDED SECTIONS OF SOCIETY, AND INCREASING DEMOCRATIC ACCOUNTABILITY

With the electoral victories of Syriza to national office and Podemos to local office (most notably to the office of mayor of Madrid), these parties' ability to deliver on their promises will be put to the test. For the moment, however, it is too early to say what effect they will have, although the protracted negotiations of Syriza with the EU on a new debt package suggest that the government tried, and failed, to change both the Eurozone policy narrative and the agenda. This brings us back to the relations of power within the EU and, in this case, the Council of Eurozone Ministers, where Germany—with coalitional allies, in this case Central and Eastern European countries, such as the Baltic states and Slovakia, in addition to Finland and the Netherlands—again dominated.

The "Greek tragedy" that unfolded over the course of the spring and summer of 2015 resulted from Syriza having misjudged the "game" of hardball that was being played, in particular by German Finance Minister Schäuble, who turned out to be the "master gambler."[48] That said, Greek Prime Minister Tsipras also gambled, with a confusing referendum at home in which he campaigned for a "no" vote in order to strengthen his hand in Brussels, but got a "yes" vote (against austerity but in favor of remaining in the euro), and came back to the table with a weakened hand and a country in worse economic shape. The Greek government had not expected the other member states, in particular in Southern Europe, to stand with the other finance ministers for "responsibility" to follow EU rules over responsiveness to Greek citizens' expressed democratic will. But this was arguably naïve, since the Greek government was not

48 Sauerbrey, 2015.

simply asking EU member states to take on board another member state's democratic vote to end its adjustment program. It was asking Eurozone finance ministers to suspend the EU rules on austerity and structural reform, agreed by all, which those very ministers had been applying in their own countries. It was not just the Irish and the Portuguese, who had recently exited adjustment programs, who refused to let Greece off the hook. It was even the Italians and the French, who had been clamoring for increased flexibility in the application of the rules, but who were equally engaged in pushing reforms in their own countries. To let Greece off the hook would be to open up debate in other member states on past and present reform programs under EU rules. Moreover, it could have fueled electoral support for the populist extremes, which would use any Greek exception to argue for an end to EU-related programs in their own country—in particular for Spain, where Podemos had become a serious threat to the Conservative government of Prime Minister Rajoy. Better to envision Grexit—at least for German Finance Minister Schäuble, who in response to Greek Prime Minister Tsipras' claim that he had a democratic mandate to demand change in Europe, stated: "I have also been elected."[49]

The main question for Syriza will be whether it manages to become a credible political party able to deliver policies while keeping its promises, thereby fraying the difficult path between being responsible by credibly implementing the bailout agreement and being responsive to the concerns of its citizens. In other words, will Syriza be able to bring much needed reforms to the country in the domain of anti-corruption efforts, strengthen state administrative capacity, collect taxes, and pull Greece out its economic depression despite the continued austerity demanded by the Eurozone leaders and consecrated by the bailout package that they signed? The new elections in September 2015 that brought back to power a Syriza now stripped of some of its most radical elements has at least given Prime Minister Tsipras a mandate to implement the program—something he did not have when he was elected in February 2015 with promises to end the austerity program.

With the exception of Greece, however, to see populism as potentially returning party politics to its proper place in the EU is the optimistic view. The pessimistic view is that the decline of traditional party politics, already evident beginning in the 1990s, continues apace, and with it the growing political volatility related to the increasing mediatization of

49 *Financial Times*, June 15, 2015.

politics that enables populist parties to thrive.[50] And at the EU level, the pessimistic view is that gridlock takes hold, with no new consensus on how to reform and with continued differences in preferences between core and periphery. Moreover, if the extremes on the Eurosceptic right come into coalition governments in one or more member states, all bets are off in terms of forward movement in EU and Eurozone governance, with deleterious effects all around.

Conclusion: What Future for Europe and National Democracies?

Over time, citizens have come to perceive the EU as more and more remote (read technocratic) and national governments as less and less responsive to their concerns, in particular in the midst of the Eurozone crisis. This has translated not only into a growing loss of trust in the EU and national governments but also to ever more volatile national politics, with the growth of populism. Mainstream parties and party politics have been weakening, and incumbent governments have increasingly been voted out of office as extremist parties with anti-euro and anti-EU messages have gained attention, votes, and even seats in both national parliaments and the EP. What is more, the loss of trust is also increasingly found between countries, including especially Northern versus Southern Europe with the Eurozone crisis, and then Central and Eastern Europe with the North against the South in the latest Greek crisis—although this mix has shifted with the current migrant crisis, which has seemingly pitted the CEECs and the UK against the rest.

This said, the EU has not affected all national democracies in the same ways. While some countries have largely maintained or even enhanced their democratic powers and practices, others have seen their democratic powers diminished, their democratic practices hollowed out—in particular in countries subject to adjustment programs associated with bailouts. The differences are most pronounced between Germany and Greece. Germany has been able to ring-fence its national democracy while promoting its preferences for the Eurozone rules, while its more active Constitutional Court has also time and again vetted EU legislation when concerned to safeguard German democratic standards. In contrast, Greek governments have seemingly exchanged democratic autonomy for economic solvency, as successive governments have become more responsible for policy while

50 Kriesi 2014.

giving up on responsiveness to citizens' needs and demands, culminating in the agreement of the extreme left party, Syriza, to do the same.

The question for the EU today is therefore how to reinvigorate national democracy across Europe while rebalancing the EU's "democracy" in ways that enable both EU and national levels to interact productively within the new EU realities. For this, mainstream party politics at both national and EU levels require strengthening and rebooting in order to confront two very different enemies: technocracy and populism.

IF THE EXTREMES ON THE EUROSCEPTIC RIGHT COME INTO COALITION GOVERNMENTS IN ONE OR MORE MEMBER STATES, ALL BETS ARE OFF REGARDING FORWARD MOVEMENT IN EU GOVERNANCE

The EU myth has long been that it does best during moments of crisis, when it engineers great leaps forward into deeper forms of integration that solve the existential problems that beset it at the moment. This time may be different (if the myth was ever true).[51] In the Eurozone crisis, rather than resolving the crisis with good (output legitimate) results, the EU may have prolonged it through rules-based governance processes and policies focused on austerity and structural reform. This has also created serious problems for national input legitimacy, by leaving national governments more torn than ever between their responsibility to honor EU agreements and their responsiveness to citizens, which only further feeds citizen disaffection. Such technocratic fixes—which in the Eurozone crisis have meant doubling down on the (throughput) rules—have only fueled the rise of populism, to the detriment of mainstream national politics and democracy.

So what can be done? At the very least, the EU needs a reset in terms of policies and processes—arguably with more responsibility for policies to be decentralized to the national level in order to ensure greater responsiveness to citizens while at the same time ensuring continued EU level coordination. But for this, as for the many other initiatives that are required, the EU would first need leaders with a new vision and a new narrative about what the EU is, what it should be doing, and where it should be going. For the moment, such leaders are lacking.

51 See Matthijs and Parsons 2015.

NIEVES PÉREZ-SOLÓRZANO BORRAGÁN is a professor in European Politics at the University of Bristol. She has previously worked at the universities of Exeter and East Anglia. She holds a BA in History and Geography from the University of Salamanca, an MA from the College of Europe (Bruges) and a PhD from the University of Exeter. Her research examines the involvement of civil society in EU governance. She specialises in the ethical dimension of lobbying regulation and the regulation of conflict of interests in the EU. She co-edits with Professor Michelle Cini one of the leading textbooks in EU Politics.

Democracy promotion and support for civil society have been key defining elements of the enlargement policy since the Eastern Enlargement. A working democracy is a political requirement to join the EU, and a vibrant civil society is perceived as evidence of democracy and good governance at work, because it allows citizens to freely associate and engage in civic action. This chapter analyses the EU's transformative role through the lens of the civil society promotion strategy in candidate countries launched by its enlargement policy, and to studies the wider debate about democracy in the EU and the standing of its enlargement policy after the crisis.

CIVIL SOCIETY AND EU ENLARGEMENT

Introduction

The European Union's enlargement policy has traditionally been described as the EU's most successful foreign policy because it has managed to trigger the expansion of the democratic ideal across the European continent. The EU's ability to peacefully spread these ideals derives from the political conditionality that defines the accession of any country to the EU, which requires any candidate[1] to converge towards the EU's principles of democracy, open market and protection of human rights. The extent of the EU's transformative effect became obvious with the so-called Eastern enlargement in 2004-2007 when twelve countries (out of which 10 were new democracies)[2] joined the EU.

A VIBRANT CIVIL SOCIETY IS PERCEIVED AS EVIDENCE OF DEMOCRACY AND GOOD GOVERNANCE

Democracy promotion and support for civil society have been key defining elements of the enlargement policy since the Eastern enlargement. A working democracy is a political requirement to join the European Union and a vibrant civil society is perceived as evidence of democracy and good governance at work, because it allows citizens to freely associate and engage in civic action, whether to shape government policy or to voice the concerns of certain sections of society. This

1 A candidate country is a country negotiating accession to the European Union. This status is granted by the European Council on the basis of a recommendation by the European Commission. Candidate country status does not give an automatic right to join the EU.
2 These are Cyprus, Czech Republic, Estonia, Hungary, Latvia, Lithuania, Malta, Poland, Slovakia, Slovenia, Romania and Bulgaria.

concern for civil society promotion also responds to two challenges affecting the European Union. Firstly, the involvement of civil society actors in the governance of the Union has been presented not just as a mechanism to ensure good governance, but also as an instrument to engage citizens and thus address the Union's perceived democratic deficit and detachment from the lives of average Europeans. Secondly, the EU's territorial expansion has become contested amongst EU citizens. A recent Eurobarometer survey shows that a higher percentage of respondents within the EU is now against further enlargement (49%) than those supporting enlargement (37%) (Eurobarometer, 2014:143). Therefore, the EU has involved civil society to promote public debate about the enlargement process and thus remedy increasing contestation both in the EU and in the candidate countries.

THE EU HAS INVOLVED CIVIL SOCIETY TO PROMOTE PUBLIC DEBATE ABOUT THE ENLARGEMENT PROCESS

This chapter analyses the European Union's transformative role through the lens of the civil society promotion strategy in candidate countries launched by its enlargement policy, and places this analysis in the wider debate about democracy in the EU, as well as the standing of its enlargement policy in the aftermath of the financial crisis. This is a salient topic for three reasons: firstly, because it allows us to investigate the EU's ability to trigger change beyond its borders in order to achieve a particular model of democracy, and to identify the mechanisms through which this change is promoted and supported. This speaks to the wider academic debate about the EU's normative power, that is, the Union's ability to project its core values through mechanisms of reward (EU membership), support (financial assistance) or punishment (delayed membership or suspension of membership negotiations). Secondly, because it allows us to discuss aspects of the EU's attempts to address its democratic deficit through civil society promotion and citizen participation, thus drawing on the wider debate about democracy and legitimacy in Europe at a time when European integration has become widely contested. Thirdly, the status of enlargement policy within the EU and its resonance across Europe has fundamentally changed, due to three factors: the effects of the EU's redefinition of enlargement as a policy tool, the challenges derived from the absorption

of new members into the Union, and the effects of the 2008 financial crisis. Enlargement is no longer a top policy priority for the EU, but has become subsumed into the wider European Neighbourhood Policy. This fact allows for a reflection on how the EU's policy priorities shift in light of more immediate challenges, such as the economic crisis in the Euro zone, the refugee crisis or the strained EU-Russia relations.

This article starts by summarising the key characteristics of the EU's enlargement policy with a focus on conditionality as an instrument to promote domestic change, and on the capacity-building mechanisms to support such change, as evidence of the EU's transformative-normative power. The second part of the article discusses why civil society promotion has become a concern for the European Union in general, and in the context of enlargement in particular. The third section reviews the European Union's promotion of civil society in candidate countries and its effects on civil society both at the national and European levels. The final section summarises key findings, and places the analysis of enlargement and civil society in the current context of contestation and defiance towards the European integration, as well as of the key challenges facing the Union.

The European Union's Enlargement Policy

The European Union has been involved in several rounds of territorial expansion[3] that have seen the Union expand from the original six member states to its current twenty-eight. The process of enlargement has transformed the European Union by making it more diverse; it has had far-reaching implications for the shape and definition of Europe, and for the institutional set-up and the major policies of the Union. This section summarises the key characteristics of EU enlargement as a process and a policy by focusing specifically on the use of conditionality as an

3 The Northern enlargement in 1973 included Denmark, Ireland and the UK. The Mediterranean enlargement had two phases: in 1981 Greece became a member while Portugal and Spain joined in 1986. The EFTA enlargement in 1995 included three previous members of the European Free Trade Agreement, namely Austria, Finland and Sweden. The Eastern enlargement took place in two phases: Cyprus, Czech Republic, Estonia, Hungary, Latvia, Lithuania, Malta, Poland, Slovakia and Slovenia joined the EU in 2004; and Bulgaria and Romania joined in 2007. The Balkan enlargement started in 2013 with the accession of Croatia to the EU.

instrument to promote change in candidate countries. It also focuses on capacity building as a mechanism to strengthen domestic structures in the candidate countries, including civil society organisations. This section of the chapter provides a necessary background to understand what EU enlargement tells us about European integration in general, but also to introduce the relevance of civil society as a concern for the EU, which will be discussed in more detail in section two.

EU enlargement is best understood as both a process and a policy (see Juncos and Pérez-Solórzano 2015). As a policy, enlargement refers to the principles, goals, and instruments defined by the EU with the aim of incorporating new member states; it is also part of the Union's wider European Neighbourhood Policy. In this typical intergovernmental policy under which member states retain the monopoly over decision-making, the European Commission plays a delegated role monitoring the suitability to join the EU of each country, and acting as a key point of contact. A detailed set of chapters, each of which covers a policy area of the acquis, frames the accession negotiations between the Commission in representation of the EU and each candidate country. Once all aspects of accession have been negotiated, the accession treaty must be approved by the European Parliament and needs to be ratified by each member state, as well as by the candidate country in accordance with their respective constitutional requirements. In most cases, candidate countries have held a referendum prior to joining the EU.

As a process, EU enlargement involves the gradual and incremental adaptation of the countries wishing to join the EU to its membership criteria. In the academic literature, this process is traditionally called Europeanisation: a one-way and asymmetric process through which domestic actors adopt EU norms and values, and institutional and policy changes take place. The European Union acts as a normative actor embarked in the diffusion of democratic norms within its immediate neighbourhood (Sedelmeier and Schimmelfennig 2005). This is not a static process; domestic actors are empowered or weakened by European integration, and domestic environments will present different degrees of resistance to EU-driven policy and institutional change while new identities will develop. This process became more complicated after the end of the Cold War, when the Union had to respond to the accession applications of the newly democratizing countries from Central and Eastern Europe (CEE). With time, the EU's membership requirements have been expanded, and the number and diversity of countries wanting

to join the Union have increased. Originally, Article 237 of the Rome Treaty only required the applicant country Treaty to be a "European state".[4] The 1993 Copenhagen European Council adopted a set of more specific political and economic conditions with which countries willing to become EU members had to comply. According to the so-called "Copenhagen criteria", applicant countries must have stable institutions guaranteeing democracy, the rule of law, respect for human rights and the protection of minorities, a functioning market economy capable of coping with the competitive pressures and market forces within the Union, and the ability to take on the obligations of membership, including adherence to the aims of political, economic, and monetary union. Applicants also had to adopt the *acquis communautaire*.[5]

EU ENLARGEMENT INVOLVES THE GRADUAL AND INCREMENTAL ADAPTATION UNDERTAKEN BY CANDIDATE COUNTRIES IN ORDER TO MEET ITS MEMBERSHIP CRITERIA

The key principle driving EU enlargement has been that of political conditionality, in other words, applicant states must meet certain conditions (i.e., the Copenhagen criteria as outlined above) before they can become EU member states. The identification of this set of criteria led to the establishment of a complex monitoring mechanism managed by what at the time was the Commission's Enlargement Directorate-General (DG Enlargement),[6] which would act as a "gatekeeper", deciding when countries have fulfilled these criteria and whether they are ready to move to the next stage (Grabbe 2001:1020). This monitoring process takes place following the benchmarks set by the Commission in different documents—in the case of the Western Balkans, the stabilization

4 For example, Morocco applied for EU membership in 1987, but its application was turned down because it was not considered to be a European country. By contrast, Turkey, which had applied for membership in the same year as Morocco, was officially recognized as a candidate country by the Helsinki European Council in December 1999, despite the fact that Turkey's European identity had been questioned by some member states.

5 This is a French term that refers literally to the Community patrimony. It is the cumulative body of the objectives, substantive rules, policies, and, in particular, the primary and secondary legislation and case law—all of which form part of the legal order of the EU. It includes the content of the treaties, legislation, judgements by the Court of Justice of the European Union, and international agreements. All member states are bound to comply with the *acquis communautaire*.

6 Now renamed the DG Neighbourhood and Enlargement Negotiations (NEAR)

and association agreements (SAAs) and the European partnership agreements (EPAs), and the Europe agreements in the case of the Eastern enlargement. Compliance is also monitored in the annual Progress reports produced by the Commission, which presents an assessment of what each candidate and potential candidate has achieved over the last year. This monitoring means that the enlargement process follows a merit-based approach (Vachudova 2005:112–13). But is also reflects the ability of the European Union to exercise pressure over the candidate countries to implement reforms to ensure compliance with the EU's norms in return for EU membership, market access, financial and technical assistance and international recognition for their progress towards democracy. This is not a linear process, however, and when candidate countries fail to meet their commitments, they face either delayed accession (as in the case of Bulgaria or Romania due to problems with corruption and judicial independence) or a halt in the negotiations, as in the case of Turkey over the Cyprus issue. In words of Schimmelfennig and Sedelmeier (2004:664), the effectiveness of EU conditionality depends on the "credibility of the threats and rewards". Conditionality is being increasingly challenged as the credibility of the main reward, which is EU membership, is becoming less definite for candidate countries. As will be discussed in more detail below, the difficulties derived from the absorption of new member states after the Eastern enlargement have provoked a limited enthusiasm for further enlargement within the EU.

The "enlargement fatigue" is being mirrored in the candidate countries by an "accession fatigue". In other words, without the tangible promise of membership, political elites do not engage in the transposition and implementation of EU-driven reforms but rather "produce rhetoric statements of intent that are not followed through in any substantive way" (O'Brennan 2013:42). Bridging the gap between rhetoric and implementation is a key challenge. The EU has become increasingly aware of the need to rigorously apply conditionality and of the difficulties and weaknesses displayed by candidate countries in meeting the accession criteria. Thus, these criteria have been extensively defined by the EU to include conditions "partially designed to address transformation problems and weaknesses of the candidates" (Dimitrova 2002:175). In practice, this has translated into the development over time of an "administrative *acquis*", that is, a set of institutions and administrative structures needed to successfully implement

TV debate on TF1 channel during the French referendum
on European Constitution, on 29 May 2005.

the legal acquis before accession.[7] To address this gap between actual
candidate countries' ability and requirements of EU membership, the
EU has actively engaged in capacity building initiatives to support both
public administrations and civil society actors. Capacity building has
been widely used as a policy instrument by international organisations
since the 1990s in order to enable domestic systemic change, to reduce
poverty and to promote sustainable development (Black 2003). As a
policy tool, it has some specific characteristics, such as being highly
technical, lacking direct pressure mechanisms and assuming that those
being targeted do not have sufficient resources, skills and information
(Papadimitriou and Stensaker: 3). While intended to create long-term

7 The 1995 Madrid European Council stressed that it is not enough that the candidate mem-
 ber states transpose European legislation into national laws, they need also to ensure the
 administrative and judicial infrastructure to implement the *acquis communautaire*. The ad-
 ministrative capacity condition for accession means that a candidate country must bring
 its institutions, management capacity and administrative and judicial systems to Union
 standards with a view to implementing the acquis effectively in good time before accession.
 The administrative acquis (also termed "institutional and administrative *acquis*" since 1997)
 (European Commission (1997) has been characterized by a lack of clarity regarding its spe-
 cific implications and measurement criteria. It is also marked by the need to develop new
 horizontal instruments to reinforce the institutional capacities of the candidate countries,
 given the absence of specific legal or institutional templates that would allow for tighter
 top-down enforcement.

effects, capacity building does not necessarily provoke an automatic change in regulation, standards or policy content. The policy discourse surrounding capacity building is strongly aspirational in terms of its language of inclusiveness and cooperation and democracy, but the actual practice is more results-oriented and heavily influenced by the donor's or the international organisation's priorities. (Black 2003:117). As will be discussed below, some of these characteristics and discrepancies feature in the EU's capacity building initiatives for enlargement and civil society promotion.

THE EU IS ABLE TO DIFFUSE ITS NORMS OF DEMOCRACY WITHOUT THE USE OF COERCIVE MILITARY POWER; IT HAS BUT TO WIELD THE CARROT OF EU MEMBERSHIP

In the context of enlargement, the EU's main capacity building initiatives take the form of financial assistance through the Instrument for Pre-accession Assistance (IPA) and the Technical Assistance and Information Exchange instrument of the European Commission (TAIEX). Typically, these instruments incorporate mechanisms to educate, socialise and transfer expertise in order to help countries in the application and enforcement of EU legislation, as well as enabling the distribution of EU best practices. For example, TAIEX incorporates the use of workshops, expert visits and twinning initiatives. In the case of IPA, its current programme running until 2020 incorporates performance indicators aimed to assess whether the expected results have been achieved (European Commission 2015a). In this manner, the EU has been able to exercise a substantial influence over the socio-economic and political systems of the countries of CEE, as the attractiveness of membership has allowed the Union "to pursue broader political goals through its enlargement policy" (Sedelmeier 2011). This offers an excellent illustration of the EU's role as a normative soft power: it is able to diffuse its norms of democracy, open market and defence of human rights by submitting them to membership, but also making explicit requirements about what kind of institutions or actors may be best placed to implement such norms (Manners 2002). Unlike traditional powers, the EU is able to do so without the use of coercive military power; it has but to wield the carrot of EU membership.

The queue of countries wishing to join the Union reveals that membership continues to be a very attractive option for countries surrounding

the EU.[8] However, a number of problems are challenging the ability of the EU to exercise influence in its neighbouring countries, and call into question the relevance of enlargement as a policy. Firstly, the Eurozone crisis, especially the situation in Greece, as well as the absence of a substantive believe in the likelihood of EU membership, is affecting the perception amongst the candidate countries of the EU as an anchor of economic prosperity and as a driver of reform. This accession fatigue is accompanied by a remarkably diminished support to EU membership in the candidate countries. For example, while Macedonian citizens are still pro-EU membership (56% approved of EU membership), support for membership has continued to decline in Turkey, where only 38% considered accession to the EU a "good thing" (Eurobarometer, 2013:67-8). Secondly, the refugee crisis highlights the Union's limits to act purposefully and in unison in the face of the plight of refugees seeking asylum in the member states and, critically, it highlights the divisions between old and new member states. Thirdly, the so-called enlargement fatigue has been felt since 2004. It refers to a general post-accession reticence within the EU towards further widening, in benefit of a greater focus on deepening integration across member states. This is reflected in the steadily decline in support for EU enlargement amongst EU citizens, with a slight majority against further enlargement (49%) versus those supporting enlargement (37%) (Eurobarometer, 2014:143). It is also reflected in the increasing support to populist Eurosceptic parties in the majority of EU member states (as illustrated by the results of the 2014 European elections), who see enlargement as a source of insecurity, further pressure on migration and of crippled welfare systems across the EU. Fourthly, this gives context to the new Commission's approach to enlargement under President Jean-Claude Juncker. In his opening speech to the European Parliament in July 2014, President Juncker stated that "the EU needs to take a break from enlargement" and that "no further enlargement will take place over the next five years" (Juncker 2014:11). For the countries wishing to join the EU, these developments call into

8 Accession negotiations were opened with Turkey in 2005, Montenegro in 2012, and Serbia in 2013. FYR Macedonia and Albania are also candidate countries, although no date has been set for the start of accession negotiations. Bosnia and Herzegovina and Kosovo have the status of "potential candidate countries". Furthermore, Ukraine, Moldova, and Georgia have repeatedly expressed their desire to become members of the EU one day

question the EU's long-standing commitment to enlargement. Fifthly, Russia's annexation of Crimea and the civil war in Ukraine have strained EU-Russia relations, as evidenced by the EU's imposition of economic sanctions on Russia, and the latter's retaliation by limiting food imports from the EU member states. In the medium term, and despite Angela Merkel's warning that Moscow cannot veto EU expansion. The EU's approach to enlargement in the Balkans and to its Eastern neighbours will be shaped by an increasingly belligerent Russian Federation that regards Serbia, Moldova and Georgia as part of its sphere of influence. Finally, and critical to the role of conditionality as a defining principle, we are witnessing democratic backsliding in some new member states such as Hungary. While conditionality worked as a principle to shape the meritocratic accession of countries from Central and Eastern Europe, once in the EU not all of them have maintained such standards; conditionality has thus ceased to have any real teeth to redress the situation. The case of Hungary's new constitutional challenge to key fundamental rights and the way in which the Fidesz government is dealing with the refugee crisis are two illustrative examples of how EU membership does not necessarily lock in democracy in former communist countries. The EU has been unable to tackle this democratic backsliding and, crucially, has refrained from applying Article 7 TEU that allows the Council to withdraw certain membership rights for serious and persistent breaches of democratic principles (Sedelmeier 2014:106). In words of Juncos and Whitman (2015:213): "Ten years after the 'big bang' enlargement to Central and Eastern Europe, there are significant lessons learned as to the challenges faced by EU conditionality to promote deeper political and economic domestic reforms." Given that the EU considers civil society a building block of democracy, it is not surprising that the Union has turned its attention to promoting its development and policy engagement, both in EU governance mechanisms and in the context of enlargement. The next section unpacks why civil society promotion is a general concern for the EU, and specifically a dimension of the EU's enlargement strategy.

Civil Society Promotion as Concern for the European Union

Civil society is a contested concept that has a long tradition in the history of political thought. In this chapter, civil society is understood as a

mediating sphere of society, distinct and independent from the market and the state, which is populated by more or less organised groups that claim to represent, speak for and participate in policy-making on behalf of diverse constituencies. Civil society is typically regarded as a crucial building block of democracy, because it is the space between the public and private spheres where civic action takes place (Grugel 2002:93, Kaldor 2003, Putnam 1993). This enthusiasm for civil society (particularly since the 1990s) amongst governments and international organisations can be explained by three interrelated phenomena, namely, the perceived

CIVIL SOCIETY IS THE SPACE BETWEEN THE PUBLIC AND PRIVATE SPHERES WHERE CIVIC ACTION TAKES PLACE

failure of traditional forms of political representation, such as political parties; the demise of communism; and the need to democratise international organisations, such as the European Union. In practice, the outcome of this enthusiasm was reflected in the expansion of programmes for civil society promotion in developing countries since the 1980s, used as an instrument to strengthen transition to democracy after the fall of the Berlin Wall. In this context, strengthening civil society was viewed as an end in itself, as well as a means of furthering the other elements (such as human rights and free and fair elections) within the democracy promotion agenda (Ishkanian 2007:3). The European Union echoes this enthusiasm for civil society in its enlargement policy by affirming that "when it comes to democratic governance and the rule of law and fundamental rights, including freedom of expression and association and minority rights, [civil society] can create demand for enhanced transparency, accountability and effectiveness from public institutions and facilitate a greater focus on the needs of citizens in policy-making" (European Commission 2013:1)

In the academic debate, the revival of civil society after the revolutions in Central and Eastern Europe gave voice to more critical views that challenged the benign understanding of the term (Kopecky and Mudde 2003) and highlighted the dangers of an active civil society, not necessarily supporting ideas and goals of democracy, freedom and the rule of law (Berman 1997). Empirical studies showed evidence of how the civic space opened up by democratisation processes had been filled not only by liberal and benign civil society actors, but also by actors, who are ideologically radical, populist, intolerant and often involved in

The President and the Prime Minister of Croatia at their
arrival to sign the EU Accession Treaty, on 9 October 2011.

contentious state politics (Glenn 2001:31). Bringing the "dark side of
civil society" to the fore, Kostovicova (2006:21, 25-26) uses the example
of post-Milosevic Serbia as evidence of how civil society is weakened
by the processes of democratisation and nation building. Similarly, the
analysis of this situation where an international donor intervenes in
domestic promotion of civil society has given rise to critical voices.
These opinions draw attention on how external actors, such as the EU,
promote a specific type of civil society group, which is constrained,
dependent on, and co-opted by the priorities of international donors
(Gershman and Allen 2006; Fagan, A. 2005). Mindful of this, the Eu-
ropean Union has been more forthcoming recently about the fact that
outside influence is not sufficient to strengthen civil society, while warn-
ing that "external donors may over influence civil society activities. Or-
ganisations that are excessively dependent on international or domestic
public funding can in some instances hardly be considered genuine civil
society and risk de-legitimising their activities in the eyes of the public"
(European Commission 2013:3).

For the European Union, civil society promotion is a priority, firstly
as a policy mechanism to address its perceived democratic deficit, and
secondly as an instrument for democracy promotion in its enlargement
strategy. These two concerns are tightly interlinked and reflect two of
the wider phenomena identified above, namely, the need to democratise

international organisations due to their detachment from individual citizens, and the legacy of communism in the form of weak civil societies across Central and Eastern Europe. As will be argued below, the European Union's internal discourse on it as a remedy to its own democratic shortcomings has influenced how the Union has conceptualised civil society and designed mechanisms for its promotion in candidate countries. Equally, civil society has influenced the policy instruments designed by the EU to challenge the increasing contestation of enlargement and legitimise the accession of new member states amongst the citizens of the EU, and those of the candidate countries.

Civil Society and the EU's Democratic Deficit

The EU's democratic deficit typically refers to the conceptualisation of the Union as an elitist, international organisation where decisions are reached by unelected policy experts who are not accountable to elected representatives, while laws are passed with little transparency and publicity. The public questioning of the EU's democratic credentials was already evident in the 1990s with the difficult ratification of the Maastricht Treaty in France and Denmark.[9] Over the years, European citizens have expressed their discontent with the European Union through their negative votes in several Europe-wide referenda, but also by increasingly supporting Eurosceptic parties, both in domestic and European elections. Initially, the EU tried to address this challenge by enhancing the powers of the European Parliament and thus strengthening the representative dimension of democracy in the Union. Such an approach proved insufficient, given that the European Parliament lacks the power of legislative initiative, does not have the same influence as legislatures in the member states, and participation in European elections is markedly lower than in national elections. The 2001 *White Paper on European Governance*, which was designed "to open up policy-making to make it more inclusive and accountable" (European Commission 2001: 5), develops a further two-pronged legitimatisation strategy that expands beyond the representative democracy realm, by focusing on enhanced citizen participation via civil society organisations, and a

9 French citizens ratified the Treaty with a minimal majority of 51% and the Danes were made to vote in two subsequent referenda to finally ratify the Treaty.

more active communication with the general public on European issues. Each dimension is discussed in turn below, as more civil society participation and better communication with citizens are strategies that have been transferred to the EU's enlargement policy.

The White Paper consolidates the role of civil society organisations as "giving voice to the concerns of citizens and delivering services that meet people's needs" (Commission of the European Communities 2001:11); and it regards participation as "a chance to get citizens more actively involved in achieving the Union's objectives and to offer them a structured channel for feedback, criticism and protest" (Commission of the European Communities 2001:12). Participation as a democratic principle which defined governance in the EU was incorporated in the Lisbon Treaty.[10] This fact constitutionalises the Union's attempt to strengthen its legitimacy by incorporating civil society participation and direct citizen engagement with its day-to-day functioning. The second aspect of the EU's legitimating strategy consists in a better communication and dialogue with citizens. It speaks to another dimension of democracy, deliberation and its promise to deliver better informed citizens who ideally are more supportive of the integration process. The European Commission developed a number of initiatives which follwed in the footsteps of the White Paper and which were a reaction to the non-ratification of the Constitutional Treaty, and to the public contestation towards the European integration evidenced in the referenda for the ratification of the Lisbon Treaty. These initiatives aimed at "listening better", "explaining better" and "going local" in the context of the *Plan D for Democracy, Dialogue and Debate and the White Paper on Communication Strategy and Democracy*. The Plan D intended to reinvigorate European democracy and help the emergence of a European public sphere, where citizens are given the information and the tools

10 Article 11 TEU establishes that: 1. The institutions shall, by appropriate means, give citizens and representative associations the opportunity to make known and publicly exchange their views in all areas of Union action; 2. The institutions shall maintain an open, transparent and regular dialogue with representative associations and civil society; 3. The European Commission shall carry out broad consultations with parties concerned in order to ensure that the Union's actions are coherent and transparent; 4. Not less than one million citizens who are nationals of a significant number of Member States may take the initiative of inviting the European Commission, within the framework of its powers, to submit any appropriate proposal on matters where citizens consider that a legal act of the Union is required for the purpose of implementing the Treaties.

to actively participate in the decision making process and gain owner-ship of the European project (European Commission 2005a). In other words, a wider and more inclusive public debate would help build a new consensus on the future direction of the Union. These initiatives

> THE WHITE PAPER WAS DESIGNED "TO
> OPEN UP POLICY-MAKING TO MAKE IT MORE
> INCLUSIVE AND ACCOUNTABLE"

are continued today through the Citizen's Dialogues, which give people across Europe a chance to talk directly with members of the European Commission and of the Europe for Citizens Programme, which includes amongst its priorities debating the future of Europe to deepen further into the discussion on the future of Europe and what kind of Europe do citizens want (European Commission 2015b).

Drawing on the lessons learnt from its domestic approach to civil society, the EU actively tries to address the weakness of civil society in the candidate countries, while at the same time improving the direct di-alogue with citizens in order to enhance public support for enlargement.

The Challenge of a Weak Civil Society in the Candidate Countries

The promotion and support for civil society organisations (CSOs) has been at the core of the EU's enlargement strategy since the 1990s. Such an approach was not evident or really necessary in earlier rounds of en-largement, because civil society was not yet a concern for the European Union as a legitimising mechanism, the accession of new member states was not contested, and the countries joining the EU before 2004 were not regarded as requiring support in this respect. However, with the fall of the Berlin Wall and the move towards regime change in the countries previously under the Soviet sphere of influence, political scientists and international organisations found themselves having to account for how the so-called democratisation process had taken place, and also seeking to identify evidence of democratic practice in these new democracies. The early literature on democratisation in post-communist Europe defined civ-il society as a vibrant force energised by the popular support for the 1989 revolutions (see Cohen and Arato 1992). The relative success in the democ-ratisation process of countries such as Poland, Hungary or the former

Czechoslovakia, where civil society had stronger roots, provided validating empirical evidence. The comparative reading of accounts on the successful civil society experience in post-authoritarian regimes such as those in Mediterranean Europe and Latin America, and the typical post-Cold War language of a common wave of democratisation provided ample evidence to foreshadow similar dynamics in post-communist Europe.[11]

WITH THE FALL OF THE BERLIN WALL
THE DEMOCRATISATION PROCESS UNDERTAKEN
HAD TO BE ACCOUNTED FOR HOW

These optimistic accounts were soon followed by more cautious evaluations of civil society dynamism in the new democracies. In fact, the actual evidence pointed towards a relatively weak civil society (compared not just with that of established democracies, but also and most importantly with that of post-authoritarian regimes) and an inadequate associational life (Howard 2003, Bernhard 1996, Ost 1993). The defining features of this weak civil society are low levels of organisational membership, low levels of participation in associational life, low levels of trust in organised civil society organisations and limited de facto consultative procedures. The factors explaining the apparent paradox of weak civil societies in the region are to be found in the communist legacy and the mismatch between a disenchanting citizens' experience of post-communist democracies and their high expectations (Howard 2003, Pérez-Solórzano Borragán 2006:135). A different interpretation of this absence of a vibrant civil society points towards the impact of globalisation, which prevents the societal sphere in post-communist Europe from developing in a vacuum, to a certain extent. Thus the new democracies of Central and Eastern Europe are converging towards, or being infected by, the pathology of citizen demobilisation that affects established democracies.

Faced with such weak civil society, the EU's focus on strengthening its structures in candidate countries does not come as a surprise. Additionally, to ensure that civil society from the new member states actively participates in the consultation mechanisms that have emerged at the European level, the European Union has been active in supporting the Europeanisation of civil society organisations in the candidate countries. The EU's key initiatives and instruments are discussed in the next section.

11 For a critique of this view see Collier and Levitsky 1997.

Enlargement and Public Contestation

As discussed earlier, the European Union faces the challenge of the increasing public contestation towards further territorial expansion of the Union. While citizens' support for EU enlargement might not have been an issue previously, the Eastern and Balkan rounds forced the European Union to seek mechanisms to address increasing public reluctance and declining support for further enlargement in the member states. The accession of new member states has become a politicised issue both in the EU and in the candidate countries. Within the EU the accession of new member states has given rise to expectations, as well as to fears regarding mass migration and concerns about the accession of countries such as Turkey, which is regarded as being less European and geopolitically more problematic than other candidate countries. In the new member states, the costs of adapting to EU membership, coupled with general public misunderstanding of the process of accession to the EU did not match the initial public expectation of a prosperous return to Europe. Enlargement fatigue and disillusionment with the European Union explain the EU's attempt "to dispel misapprehensions about the enlargement process" (European Commission 2000). The next section discusses the EU's civil society promotion strategy and the attempts to address the challenges of a weak civil society in candidate countries and of contestation.

EU Enlargement and Civil Society Promotion. An Assessment

The EU supports civil society in candidate countries during the pre-accession period. In supporting the development of a vibrant civil society, the Union conceives of these organisations as actors who will help candidate countries to meet political conditionality demands such as human dignity, freedom, equality, the rule of law and respect for human rights. At the same time, the involvement of civil society in the pre-accession process is regarded as a means "to deepen citizens'" understanding of the reforms a country needs to complete in order to qualify for EU membership. This can help ensure EU accession is not just a government exercise and stimulate a balanced public debate, which is crucial to achieving a well-informed decision on EU membership at the end of the pre-accession process" (European Commission 2013:1). In this context,

the EU's civil society promotion strategy has two main goals: achieving an environment that is conducive to civil society activities and building the capacity of CSOs to be effective and accountable, independent actors. In addition to this domestic agenda, the European Union is also committed to ensure that civil society organisations in the candidate countries are able to aggregate key societal interests and channel them to decision-makers at the EU level, in order to facilitate the involvement of civil society actors in the EU consultative mechanisms,[12] such as the European Economic and Social Committee, the European Commission's consultations or the European Social Dialogue:

> Social partners play an important role in promoting the right to association and should therefore also be supported to improve their action. The perspective of social partners and professional and business associations also needs to be reflected in the Commission's work, and partnerships between these organisations, particularly from disadvantaged regions, and their counterparts in the EU should be strengthened (European Commission 2013:3).

The increasing contestation of enlargement policy is being addressed by the European Union through dialogue mechanisms that mirror the instruments deployed, in order to address its democratic deficit (see earlier discussion). To improve citizens' knowledge about EU enlargement, the European Commission has developed a so-called civil society dialogue[13] "to generate a dialogue with Europe's citizens and to ensure broad support for the enlargement process both within the EU member states and the candidate countries" (DG Enlargement 2002:18). With this strategy the European Commission expected to generate dialogue

12 This commitment to enhancing the participative capacity of civil society at the European level is present in the European Union's rhetoric since 2008 (see Commission of the European Communities 2008).

13 The civil society dialogue is further developed in the 2005 Communication "Civil Society Dialogue between the EU and Candidate Countries". In this document, the dialogue with civil society is framed as an overarching communication instrument with a very wide remit in terms of objectives, areas of concern, actors involved and territory as the initiative is extended to Croatia. The 2006 Communication "The Western Balkans on the Road to the EU: Consolidating Stability and Raising Prosperity" expands the civil society dialogue to include all the countries of the Western Balkans, with an additional focus on enhancing dialogue between Western Balkan societies. The European Commission's 2008 "New Civil Society Dialogue Programme" re-labels the civil society dialogue as the "People 2 People – P2P Programme".

with public opinion in the candidate countries and in what then was the EU-15 to "help ensure that the negotiations are concluded with public support and the resulting Treaties of Accession are signed and ratified on the basis of well-informed and realistic public expectations" (European Commission 2000b:1). Civil society dialogue is concerned with the top-down engineering of a public sphere that is debating enlargement, where the exchange of information and opinions would result not just

TO IMPROVE CITIZENS' KNOWLEDGE ABOUT EU ENLARGEMENT, THE EUROPEAN COMMISSION HAS DEVELOPED A SO-CALLED CIVIL SOCIETY DIALOGUE

in better-informed citizens, but ones supportive of the enlargement process. Also, the civil society dialogue would "support the further development of a lively and vibrant civil society in the candidate countries, which is key to the consolidation of human rights and democracy, in line with the political criteria for accession"(European Commission 2005b:3). Thus civil society appears to be conceived of as a party in the dialogue, a facilitator of citizen engagement and an outcome of the process. As Commissioner Rhen (2008) put it at the time: "Communicating the success story of enlargement is a common challenge for us all. As civil society representatives, you are the bridge between the EU institutions, national authorities and citizens. You can raise awareness of the successes and challenges of EU enlargement. You can strengthen confidence between citizens in the EU and the aspirant members".

The European Union has two sets of instruments, namely, political and financial, to implement its civil society strategy. Regarding political support, the European Union commits to encourage enlargement countries to make legislation more conducive for civil society and to promote the involvement of civil society in the pre-accession process. There is crucial rhetoric support derived from the regular reviews of the state of civil society in each candidate country's annual Progression report. Regarding financial support, while funding is available through the Instrument for Pre-accession Assistance (IPA) the main instrument is the Civil Society Facility (CSF[14]), created in 2008 by the European Commission to

14 For the period 2011-12 the CSF had a budget of EUR 40 million.

provide financial support for the development of civil society. The CSF incorporates three strategies that reflect both domestic and transnational initiatives, namely: support for national and local civic initiatives and capacity-building to strengthen the role of civil society in the candidate countries; support for partnerships between civil society organisations in the candidate countries and from EU Member States to develop networks and promote transfer of knowledge and experience; and a "People 2 People" programme supporting visits to EU institutions and exchange of experience, know-how and good practice between local civil society, the EU and civil society in Member States (European Commission 2015c).

Over the years, the European Union has become more prescriptive in terms of the monitoring and evaluation of its initiatives in the candidate countries. This strategy, more oriented to results, responds to the EU's focus on addressing the candidate countries' implementation deficits and ensuring funding invested in truly addressing the Union's priorities regarding civil society development. For this purpose the European Commission, in consultation with stakeholders, has developed a monitoring and evaluation framework that involves a clear set of objectives, results and indicators (European Commission 2013:6-11). For example, when assessing whether the objective of achieving a more conducive environment for the activities of civil society organisations the following results will be expected:

> All individuals and legal entities can express themselves freely, assemble peacefully and establish, join and participate in non-formal and/or registered organisations
> The policies and legal environment stimulate and facilitate volunteering and employment in CSOs;
> National and/or local authorities have enabling policies and rules for grassroots organisations.
> (European Commission 2013:6-7)

However, the European Union has not developed a systematic review of its civil society promotion strategies in the context of enlargement. The official evidence of whether the goals outlined above have been met is fragmented and can be drawn mainly from the European Commission's Progress reports on each candidate country,[15] and from its own Strategy papers on enlargement. This evidence reveals that in the most

15 These reports are publicly available online at http://ec.europa.eu/enlargement/countries/strategy-and-progress-report/index_en.htm

A group of visitors observes a plenary session of the European Parliament.

recent Commission's Strategy Paper on enlargement of 2014, the need to do more to support civil society is recognised (European Commission 2014:2). In this same document, the limits to civil society development in Serbia and Bosnia Herzegovina are acknowledged, while in the case of Turkey there is specific mention to how "several pieces of legislation proposed by the ruling majority, including on fundamental issues for the Turkish democracy, were adopted without proper parliamentary debate or adequate consultation of stakeholders and civil society" (European Commission 2014:46). The political science literature has been more forthcoming by providing country-study and sectoral analysis of the state of civil society in candidate countries during the pre- and post-accession periods. A review of this literature shows that the achievements derived from these initiatives remain modest and that there is evidence of variation across countries, as the EU's influence has had a differentiated impact on diverse national environments. Moreover, there is evidence that in certain circumstances the EU's intervention may have perpetuated the weakness of civil society through financial dependencies and the demanding criteria established by EU institutions in order to engage civil society organisations in regular consultation. The selected examples below offer an illustration of the EU's impact on civil society development in the candidate countries, the EU's impact on the ability of civil society groups from candidate countries to participate

in consultations at the European Union level, and the "People 2 People" initiative in addressing public contestation.

The EU's Domestic Influence

Firstly, looking at the creation of better domestic environment for civil society development, the evidence points towards a slow and gradual change. For example, the European Economic and Social Committee has been active in trying to help civil society organisations operate efficiently at the national level, providing know-how and supporting their participation in European activities (see Pérez-Solórzano Borragán and Smismans 2008). Such initiatives include the organisation of training seminars, fact-finding missions to the candidate countries, hearings with civil society and discussions with European Commission delegations. The EESC also sought to build adequate administrative capacity to promote and enhance stakeholder participation in policy making in the new member states. It equally encouraged the creation of national economic

> THE EU HAS BECOME A REFERENCE TO IMPROVE CONSULTATION STRUCTURES, BUT CIVIL SOCIETY ORGANISATIONS ARE STILL CONSTRAINED BY THEIR DOMESTIC ENVIRONMENTS

and social committees. Whether the EESC initiatives had any impact at the national level remains difficult to assess. A 2002 study undertaken on behalf of the Committee shows that the national economic and social committees promoted by the Committee often operate informally, rather than as strongly institutionalised advisory bodies for their government, and questions remain as to their representativeness (Drauss 2002:169).

On the other hand, the EU has become a discursive reference to seek legitimacy and improved consultation structures, as well as to justify organizational change, but civil society organisations are still constrained by their domestic environments, the dominance of national level identities and a lack of sufficient resources to engage in transnational activities. For example, in the case of the Czech Republic, Forest's study (Forest 2006) is a clear illustration of how the EU's support has contributed to a re-conceptualisation of gender concerns by women's organisations. The transfer of new concepts, such as equal opportunities

and gender mainstreaming, coupled with capacity building, training and monitoring, has shaped women's organisation mobilisation repertoires. The EU's influence prompted the creation of new mediating institutions such as the Council for Equal Opportunities, a new domestic opportunity structure that formalises the relationship between the state and civil society organisations and thus establishing formal relationships between non-governmental organisations (NGOs) and the state. Both sets of actors are empowered by this development: by engaging in the Council, women's organisations gain in recognition and can expect long-term influence on policy-making. The state has enhanced its deliberative stand while limiting public protest and moving gender issues out of the political debate (Forest 2006).

Continuing with the example of the Eastern enlargement, despite the EU's expectation of stakeholder involvement in national consultations, the pre-accession strategy did not empower sectoral organisations. A 2003 survey of business interests[16] shows communication between national governments and the business sector on enlargement-related issues was limited during the accession process. Only 4.9% of the companies surveyed were regularly consulted; 68.5% only received general information about the accession process through the media and felt that they did not influence their government's negotiating position at all. This limited consultation on EU accession caused concern amongst business umbrella organisations based in Brussels who called on "the political leaders and the Commission to introduce new awareness programmes and to consult much more with the business community in the accession countries on economic issues" (Eurochambres 2003).

A comparative study of environmental actors in Hungary, Poland and Romania shows that civil society organisations were too weak and often unwilling to exploit the opportunities offered by EU accession. Moreover, civil society organisations were reluctant to collaborate with state actors and saw themselves more as watchdogs scrutinising the government's implementation of environmental regulations. In addition, the availability and distribution of resources favoured those civil society organisations that were already better established and re-sourced (Börzel and Buzogány 2010:158-182). In her comparative survey

16 The CAPE surveys were undertaken by EUROCHAMBRES between 2001 and 2003 and involved 1658 companies from Bulgaria, the Czech Republic, Estonia, Hungary, Latvia, Lithuania, Poland, Romania, Slovakia and Slovenia

of environmental NGOs in the Czech Republic, Hungary, Poland and Slovakia, Carmin found more evidence of how the pre-accession experience helped the development of two clusters of NGOs: "The first cluster consists of a small cadre of highly professionalized and internationalized organizations that engage in policymaking in the international and national arenas. The second cluster of NGOs tends to sponsor activities and take action on behalf of their members and provide environmental and government support services at the local level [...] NGOs in the latter group often are overlooked by agencies, governments and foundations, even though they make important contributions to environmental governance (Carmin 2010:183). In the case of environmental NGOs in Bosnia-Herzegovina and Serbia, Fagan identifies an increasing professionalization of NGOs as result of EU intervention. In practice this translates into limited policy-making access to "less contentious policy areas where they are encouraged to deliver expertise and assistance rather than to act as advocates for community interests or to express political opposition to contentious developments" (Fagan 2010:203).

In sum, the evidence to date regarding domestic influence points towards a Europeanisation of the discourses of some civil society organisations; the differentiated impact of the EU has empowered and weakened certain actors, while new dependencies have been established due to the structural weakness of both civil society and state mechanisms for consultation.

The EU's Influence on the European Dimension

Regarding the European dimension of civil society development, recent research shows that the participation of civil society organisations in the EU's consultation procedures post-accession is less dynamic and evident than that of similar organisations in older member states. While the domestic weakness of civil society in candidate countries may offer some evidence explaining the difficulty to mobilise at the EU level, the consultation conditions are also an additional hurdle to negotiate in terms of resources, capacity, expertise and internal good governance (Quitkatt 2011, Pérez-Solórzano Borragán and Smismans 2012, Kohler-Koch and Quittkat 2013). Recent data shows that, compared to other member states, engagement in Commission consultations is scarce and has no clear pattern regarding the choice of policy area. Specifically, between

2003 and 2006, the input of civil society groups from new member states to Commission impact assessment consultations accounted for 6.14% of the total opinions submitted. In other words, the total of opinions submitted by the eight new democracies (not including Romania and Bulgaria) is less than half the total opinions submitted by German or French groups, and it amounts to almost the same amount of opinions submitted by Finnish or Belgian groups (see Obradovic and Alonso Vizcaino 2007).

RESEARCH UNDERTAKEN ON THE EUROPEAN ECONOMIC AND SOCIAL COMMITTEE SHOWS THAT REPRESENTATIVES OF CIVIL SOCIETY FROM THE NEWER MEMBER STATES ARE LESS ACTIVE

Similarly, research undertaken on the European Economic and Social Committee—the European Union's institution for the representation of civil society in the aftermath of the Eastern enlargement—shows that representatives of civil society from the newer member states are less active (see Pérez-Solórzano Borragán and Smismans 2008). The question is if, to some extent, the under-representation is due to a lack of interest or a felt need on behalf of these new representatives to first go through a longer learning process before taking up such functions, or, rather, if current procedures and established practices tend to disadvantage new members. There seems to be a willingness from some representatives from the newer member states to be more actively involved, although some have complained that current procedural practice tends to privilege "experienced" old member state representatives to their exclusion. A number of representatives from new member states have complained about the absence of interpreters during meetings, for example: "Excuses justifying the lack of interpretation because of the large number of new members and languages cannot be put forward in perpetuity. Since highly specialised vocabulary and terminology is used during the discussion of opinions, it is not simply a question of knowledge of languages but an important problem that requires rapid and effective resolution" (Mendza-Drozd et al. 2004).

The EU's Influence on Addressing Contestation

The fact that enlargement is still a contested policy goes some way to show the limited effect of the European Union's People 2 People programme (formerly known as civil society dialogue) in addressing

contestation. In the absence of a systematic review of the outcomes derived from this programme, what follows is a critique towards it, based on its objectives. What I argue, instead, is the deficient instruments to achieve them. The People 2 People programme aims not only to generate public spheres across different levels, but also to address

THE POLICY TOOLS ADDRESS ALL CIVIL SOCIETY ACTORS: INSTITUTIONS, ORGANISATIONS AND THE MEDIA

the deficiencies of domestic civil societies. Policy tools should not only be heterogeneous, but also aimed at different outcomes. Hence, the measures can be divided into four categories:[17]

1. Support for local, civil-society initiatives and capacity building, in order to reinforce the role of civil society.
2. Programmes to bring journalists, young politicians, trade union leaders and teachers into contact with EU institutions and thus raise awareness about the EU and its enlargement process.
3. Support for building partnerships and developing networks between the civil society organisations, businesses, trade unions and other social partners and professional organisations in the beneficiary countries, and their counterparts in the EU, so as to promote transfers of knowledge and experience.
4. Involving the media in awareness raising to improve citizens information.

A detailed evaluation of these measures allows some initial conclusions about the potential that the civil society dialogue met the general aspiration of creating a transnational, European, deliberative and public sphere that is supportive of enlargement. In general terms, the policy tools address all the relevant actors operating in the public sphere, namely institutions, civil society organisations and the media. Looking in more detail at the actual initiatives to generate a transnational debate (particularly in the case of Turkey), it is interesting to see that the Commission is relying on mechanisms to increase awareness about

17 What follows draws on the Communication from the Commission to the Council and the European Parliament, Recommendation of the European Commission on Turkey's progress towards accession; the 2005 Communication "Civil Society Dialogue between the EU and Candidate Countries"; and the 2006 Communication "The Western Balkans on the Road to the EU: Consolidating Stability and Raising Prosperity".

Turkey in the EU member states, but none of these address the creation of deliberative forums for discussion. Rather, the initiatives refer to mobility programmes, scholarships, media development, financial support to NGO development, exchanges between professional organisations, and school links and public relations activities sponsored by the Turkish government (European Commission 2005b:5-8). These mechanisms could potentially address the perceived information gap and thus help to develop better informed citizens, both in Turkey and in the EU, who become more supportive of enlargement. It is not obvious that these mechanisms would either change perceptions—as there is no control on how messages may be understood by citizens—or help bring citizens in Turkey and in the EU to a deeper understanding of each other and the enlargement process, which would unite them in the support of this common project, thus legitimating it.

The networking activities involving civil society organisations from the candidate countries and their counterparts in the member states are geared towards providing socialisation mechanisms. In this way, knowledge transfer can take place and the civil society organisations for the candidate countries can learn how to operate in a pluralistic environment, and learn from the best practice of their EU counterparts. In other words, these initiatives would allow for the socialisation of the professional elites and strengthen the capacity building of civil society organisations in the candidate countries through the sharing of best practice. The policy tools deployed by the Commission point towards deliberation amongst elites. This reproduces the systemic fragmentation that has traditionally limited emergence of a truly pan-European public sphere. Here some kind of aggregating mechanism would be required. The expectation would be that civil society organisations are able to act as a discursive interface among the EU, the citizens of the member states and the candidate countries by monitoring policy-making, and to bring citizens' concerns into EU deliberations. To this day, the People 2 People programme does not provide any kind of feedback or reflexive mechanisms that would facilitate the fulfilment of civil society organisations' potential to help dynamise a public sphere on enlargement. Furthermore, a question still to be addressed is whether civil society organisations in the candidate countries actually posses the capabilities and expertise to aggregate the interest of their constituencies and subsequently channel their concerns to the European level. The answer to this question is "no". The number of capacity-building mechanisms that

the civil society dialogue deploys suggests that civil society organisations in the candidate countries are far from ready to perform the dual conveyor belt function (i.e. aggregating the wider interest and channelling it to the decision-makers). The civil society dialogue's aspirations are not matched by the capacity and expertise of civil society organisations in the candidate countries. There is a clear mismatch between policy aspirations and policy tools that needs to be remedied.

Conclusion

Enlargement policy and civil society promotion are tightly interlinked. While further territorial enlargement has taken a back seat in the current European Union's priority list, the support for democracy in general, and civil society in particular are still significant priorities for the Union, particularly in light of the observed democratic backsliding in new member states such as Hungary or Romania, and of the increasing contestation of European integration as the increasing support for Eurosceptic parties shows.

This chapter has shown how the EU's concept of civil society is deeply rooted in a maximalist understanding of democracy where civic groups, associations, NGOs or trade unions play a fundamental role in ensuring good governance. Moreover, in the specific context of the enlargement policy, they help to address the deficiencies in the implementation of the accession criteria. The European Union acts as a typical international donor who promotes a particular type of civil society and who expects its civil society promotion strategies to trigger domestic change. As this contribution has revealed, the marriage between EU enlargement and civil society promotion is not always a smooth one and the EU has had a limited transformative role. At the domestic level, there is limited evidence to show that the EU's civil society promotion strategy has helped remedy the weaknesses of civil society in new member states, in the Balkan candidate countries and in Turkey. More needs to be done to address funding dependencies and support more grass roots, issue-based groups whose role may not be to implement EU programmes, but to aggregate the interests of diverse sections of society. The EU has been partially successful in providing domestic civil societies with legitimating discourses to try and enhance their participation (when sought) in policy-making when faced with reluctant and often inadequate state

structures. At the European level, while the EU provides opportunity structures for participation in policy making, the evidence points towards a less participatory dynamism amongst civil society actors from the new member states, who struggle to meet the EU's participatory requirements of expertise and organisational good governance against a background of structural weakness. This state of affairs challenges the EU's own ability to lock in democracy in the new member states as

THE EU ACTS AS A TYPICAL DONOR WHO PROMOTES A PARTICULAR TYPE OF CIVIL SOCIETY AND EXPECTS ITS STRATEGIES TO TRIGGER DOMESTIC CHANGE

conditionality no longer applies and the threat of membership suspension on the grounds of not meeting the EU's maximalist understanding of democracy is not yet credible. But it also defies the EU's own attempt to address its democratic deficit by enhancing civil society participation in EU governance, as that civil society active at the EU level does not necessarily mirror the Union's own diversity.

Finally, contestation of EU enlargement is increasing and the European Union is having to address more immediate challenges, such as the aftermath of the Euro zone crisis, the lack of robust united action to address the refugee crisis, and the difficult relations with Russia. However, these difficulties ought not to divert the EU's attention from its civil society promotion strategy in candidate countries in particular, and its Eastern Neighbourhood in general. The European Union needs in these countries dynamic, independent civil society organisations that are able to exercise checks and balances on national governments, especially if they deviate from the principles of democracy, rule of law and protection of individual rights.

KEES VAN KERSBERGEN
Kees van Kersbergen holds
a PhD in Social and Political
Sciences (European University
Institute, Florence, Italy, cum
laude). He is professor of Com-
parative Politics at Aarhus Uni-
versity. He has published widely
in the area of welfare state stud-
ies in refereed journals and with
major university presses. His
latest book is *Comparative Wel-
fare State Politics: Development,
Opportunities, and Reform* (2014,
with Barbara Vis).

This chapter discusses the strengths and
weaknesses of European welfare states,
which protect citizens in hard economic
times. In many countries, governments tend
to respond with austerity policies that not
only undermine the protective function of the
welfare state, but also weaken its economic,
social and political support base. Increasing
inequality is one of the observable conse-
quences, which is associated with bad social
and political outcomes in terms of health,
social mobility, social and political trust, polit-
ical representation and participation.

THE WELFARE STATE IN EUROPE

Introduction

Allow me to start this chapter by saying that there is no such thing as the European welfare state. Nevertheless, the welfare state is seen as something thoroughly European in origin, in character and even in terms of identity.

The welfare state is European *in origin* because its birth is commonly dated to late 19th century Germany. Around 1850, most industrializing capitalist countries already had some version of a modern poor law and had started to introduce labour protection measures (Polanyi [1944] 1957). The Prussian state, moreover, had already started to experiment with social insurance or health funds (see Hennock 2007) in the 1840s. But it was in imperial Germany that Bismarck first introduced mandatory social insurances on a grand scale (Kuhnle and Sander 2010), including sickness insurance in 1883, an industrial accident scheme in 1884 and old age and invalidity insurance in 1889. Other European countries followed, some early on (Austria) while others comparatively late (the Netherlands).

> THERE IS NO SUCH THING AS
> THE EUROPEAN WELFARE STATE.
> NEVERTHELESS, IT IS EUROPEAN IN ORIGIN,
> CHARACTER AND IDENTITY.

The welfare state is European *in character*, because the wide-ranging, interconnected social policies that make up the welfare state reflect the historical European experience of social misery, turmoil, protest, political conflict and war, on the one hand, and reconciliation, cooperation, stability, order, harmony and peace, on the other. The welfare state came to embody a unique answer to the question of how to build and maintain a relatively cohesive economic, social, political and cultural order.

Bismarckian social insurances, after all, were not merely pioneered to deal with the social risks of industrial society and to improve workers' living conditions, but they were principally launched to serve the political goals of state- and nation-building and social order. The very term "welfare state" was popularized, if not invented, by the Archbishop of York, William Temple, who used it in 1941 to contrast this ideal state with the Nazi "warfare state".

In terms of identity, the welfare state has established itself as an idea and an ideal that Europeans share, a political and social accomplishment highly valued by European publics and an institution to which people attach their (national) identity. This is perhaps more true for the Scandinavian realm than for other areas, and it also holds more weight for some of the welfare state's programmes than for others. Yet, even in the United Kingdom, where the public entrenchment of the welfare state is arguably much weaker than in Scandinavia, the National Health Service (NHS) is considered to be one of the best in the world and, more importantly, an institution that makes people proud to be British. Tellingly, the NHS beat the Armed Forces, the Royal Family and the BBC in a popularity contest (Ipsos MORI 2014; Quigley 2014).

In the broader European Union context, the catchphrase "European Social Model" has come to refer to something that is uniquely European to the extent that this model is capable of promoting positive-sum solutions to what elsewhere (e.g., in the allegedly not-so-social American model) are considered to be unavoidable trade-offs between sustainable economic growth, on the one hand, and social justice and social cohesion, on the other. Because of its effectiveness, the European Commission champions the developed welfare state as an example to mimic for other countries and at the supranational European level. In the words of former President of the European Commission Barroso:

> Yes, we need to reform our economies and modernise our social protection systems. But an effective social protection system that helps those in need is not an obstacle to prosperity. It is indeed an indispensable element of it. Indeed, it is precisely those European countries with the most effective social protection systems and with the most developed social partnerships, that are among the most successful and competitive economies in the world (Barroso 2012).

The welfare state in Europe represents a huge accomplishment; thriving economies, livable and trustful societies and efficient polities are almost unthinkable without it. Yet, at the same time, the welfare state

is under siege as it faces a number of demographic, economic, financial and political challenges.

I will proceed in this chapter by first shortly portraying three views that often pop up in debates on the welfare state and that are meant to challenge its very *raison d"être*. They contain important truths, but only tell part of the story. Next, I discuss what the welfare state does and argue that it is primarily about providing protection against social risks and much less about redistributing income. I then describe how welfare states in Europe differ enormously in how well they protect their populations and in how they address income inequality. Welfare states are not static, and in the last two decades or so, many have reoriented their social protection systems towards labour market activation and social investments so as to deal with the challenges of new social risks and ageing. This has been a pan-European and—in an economic and social sense—a relatively advantageous development, but one which the financial crisis and the economic recession that followed it are now seriously jeopardizing. The formidable task welfare states are facing is to find yet again new ways to continue to provide social protection while promoting sustainable economic growth (see Begg et al. 2015).

Three half-truths about the welfare state

Three beliefs often pop up when people talk about the welfare state. One view frequently heard is that it is a very expensive, inefficient human invention that we, at best, can just about afford, but that most likely is depleting our resources and is, in any case, unmaintainable in the long run. The welfare state is making us all worse off because of the prohibitively high level of contributions and taxes it requires. In other words, although the welfare state might perhaps be valued as in some way useful from some social point of view, overall it is primarily an economic burden. Indeed, the welfare state obviously requires large financial resources to function and has built-in economic disincentives, but this is only one side of it. The other part is that the welfare state— on the demand-side via consumption smoothing—greatly contributes to macroeconomic stability and—on the supply-side through investments in human capital (e.g., education and training) and social services—stimulates economic development. Recent research even finds that welfare state generosity does not create work disincentives; on

the contrary, it increases employment commitment (Van der Wel and Halvorsen 2015).

The second belief recurrently voiced is that the welfare state is in crisis or is itself causing a crisis in the economy or in politics. The intriguing observation to make here is that the welfare state has almost always been considered to be in crisis or to be causing one. In 1975, the trilateral commission (Crozier et al. 1975) published a report on the worldwide overload and ungovernability crisis of democracy. This was allegedly caused, among other things, by the continuously rising expectations and demands of citizens on the welfare state. The oil crises of the 1970s were argued to have led to a fiscal and legitimacy crisis of the welfare state. Some predicted that the welfare state caused economic collapse because its redistributive policies undermined the profitability of capital and hence impeded investment. Others highlighted that the expansionary spending of the welfare state was crowding out private investment.

SOME PEOPLE CONSIDER
THE WELFARE STATE A KIND OF ROBIN HOOD
INSTITUTION THAT STEALS FROM THE RICH
AND GIVES TO THE POOR

More recently, predictions of crisis and collapse are coming from analyses that highlight the negative impact on the welfare state of increasing interdependence, internationalization and globalization. Social systems are believed to be in need of dismantling for reasons of international competitiveness. Governments are caught in a "race to the bottom". On top of this, intensified European integration is argued to favour "social tourism" and "social dumping", phenomena that are undermining national welfare states, and European solutions still lag behind. In spite of these alarming stories, however, the welfare state not only clearly survived several crises (Starke et al. 2013), but has continued to function. In fact, it has performed its functions of social protection surprisingly well given the extreme challenges it has been facing (see Van Kersbergen and Vis 2014: chapters 5 and 10).

The final idea that frequently crops up is that the welfare state is fundamentally a kind of "Robin Hood" institution that steals from the rich and gives to the poor. This perspective obviously arouses strong sentiments as some worship Robin Hood and his Merry Men as heroes of the poor, while others see him and his helpers as villains who should

be detained and rendered harmless. The Robin Hood metaphor, in a sense, is invoked to underpin the two other views: the welfare state as a millstone around the neck of the economy and the welfare state in crisis and as the cause of crises. Although such ideas obviously capture parts of the reality of welfare states in Europe, they merely tell part of the story and, hence, show an incomplete truth.

Robin Hood versus the Piggy Bank

So, what is the whole story about the welfare state? What is the welfare state and what does it do? Let me focus on the Robin Hood issue. Is the welfare state really a kind of Robin Hood institution that steals from the rich and gives to the poor? The first thing to note here is that although income redistribution is an aspect of many social policy programmes that make up the welfare state, especially those tailored to fight poverty, it is not the reason why the welfare state exists. The welfare state is a collection of institutionalized policies and entitlements as social rights, which in various ways offer protection for all who might experience economic and social hardship. The welfare state is, therefore, foremost about the pooling and redistribution of social risks, particularly the risk of income loss, and not (necessarily) about income redistribution. The metaphor best depicting this essential function of the welfare state, as Barr (2001) has so imaginatively suggested, is the piggy bank: a device to help people insure against social risks and to assist people in redistributing resources over the life cycle. Importantly, welfare states differ enormously in how well their piggy banks protect citizens against social (labour market and life cycle) risks and how much their Robin Hoods redistribute income.

The second thing to stress in this context is that there is no such thing as the welfare state. Welfare states differ quite dramatically in the size of the budgets devoted to social protection and redistribution, with net social spending (2011, after taxes, tax breaks and social benefits are taken into account) ranging from a low 14.2% of Gross Domestic Product (GDP) in Estonia to a high 31.3% of GDP in France (OECD 2013). Moreover, welfare states not only contrast sharply in cash, they also diverge distinctly in kind: they are qualitatively very different in how they organize and finance their systems of social protection and how they design and how they spend their social budgets. These differences, most

importantly, have huge consequences for the functioning of the labour market, for the organization of people's working and family life and for the level of social protection and income equality societies foster and people enjoy.

In many welfare states, Robin Hood plays a less prominent role than the piggy bank for the straightforward reason that the systems are simply not designed to redistribute income (even though they all do to some extent). In fact, in the conservative and southern welfare states (see below) income redistribution was a secondary goal and occurs as a side-effect if it enters social policy at all. Only in the social democratic universalist welfare states does Robin Hood redistribute large sums of money, not only to the poor, but also, most strikingly, to the middle class. What welfare states do is to offer protection against social risks (old age, unemployment, disability, etc.) and provide income maintenance. Most income redistribution is actually horizontal, that is, intrapersonal over the life course and within income groups, and much less from the rich to the poor. Only in the lean liberal welfare states is Robin Hood supposed to play the superhero of the poor because here many of the social provisions exclusively cater to the poor. However, recent research (Levell et al. 2015) shows that even in the liberal welfare states (e.g., the United Kingdom), more than half of income redistribution is of the intrapersonal kind and over the life-course: people put money in the piggy bank during their active working life and smash it when they are in need later in life.

Different kinds of welfare states in Europe

The kind and quality of social rights that the welfare state guarantees entail one dimension that has to be taken into account to understand the extent to which individuals and families can uphold a decent life in case of sickness, unemployment or old age, independent of their per-formance on the labour market. How strict are the eligibility rules for a benefit? How long should one have contributed to a scheme before one is entitled to a transfer or service? Does a social benefit depend on one's former income and does qualification depend on a means test? This quality of benefits and services is high if it is relatively easy to qualify for them, for example, when the required contribution period is short and when there are no means tests. Similarly, a social right is of high

quality when a benefit's replacement rate is high (how much of a wage or salary is replaced by a benefit) and its duration is long.

The other dimension that one needs to look at to evaluate the quality of social protection is to what extent the welfare state alters, reproduces or even reinforces social and economic stratification. As Esping-Andersen (1990, 55) has famously argued, welfare states "are key institutions in the structuring of class and the social order", and depending on their institutional set-up, they have widely divergent effects on social structure. Welfare states "may be equally large or comprehensive, but with entirely different effects on social structure", and they come in different shapes: "One may cultivate hierarchy and status, another dualisms, and a third universalism. Each case will produce its own unique fabric of social solidarity" (58). Esping-Andersen distinguished three types of welfare states: liberal, social democratic and conservative.

ESPING-ANDERSEN DISTINGUISHED THREE TYPES OF WELFARE STATES: LIBERAL, SOCIAL DEMOCRATIC AND CONSERVATIVE

The liberal welfare state is market-oriented, and public provisions for income maintenance and relief mainly cater to the poor. Most people in countries such as Australia, the United States and the United Kingdom (with the notable exception of health care) are able to find social protection in the private market. Low and flat rate tax-financed benefits characterize the system, and access to benefits is restrictive because benefits are means-tested. Private social insurance is encouraged via tax exemptions and allowances, which favour the middle class and the rich. The liberal welfare state is also service-lean, and transfers are modest to mean. The inequalities generated in the private market are not countered in this system, and those who can afford it are well-protected, whereas others come to depend on means tested assistance. This model came under political pressure early on (Reagan, Thatcher), and austerity politics became the dominant response to many of the challenges the welfare state faces.

The social democratic welfare state grounds social rights in citizenship or residence and, hence, to a substantial extent, does away with status differentials. This model, as found in the Nordic countries, is generally also tax-financed, but access to social provisions is much

more open, and benefits and services are more generous than in the liberal model. The model provides social services for all without strict qualifying conditions. The role of the market in service and benefit provision is played down. Several of the Nordic countries went through performance crises in the 1990s, but managed to recover from this by essentially maintaining their path of development, stressing maximum labour force participation, flexible but protected labour markets and social investment.

WELFARE STATE MODELS DIFFER SUBSTANTIALLY IN HOW MUCH THEY ARE COMMITTED TO SPEND

The conservative or corporatist welfare state model features Bismarckian social insurance programmes that are differentiated and segmented along occupational and status distinctions. In addition, in countries such as Germany and Austria, state employees (civil servants) receive privileged treatment in social insurance, particularly pensions. In this model, people, particularly men, qualify for a provision or benefit to the extent that they have contributed to a social scheme. Employment record is decisive for acquiring social rights. Employees pay contributions to social insurance funds and receive benefits that are earnings-related and depend on contribution period. This model is typically social service-lean and transfer-heavy.

These features of the conservative system imply that the existing stratification system and income inequality are largely left untouched and, in fact, tend to magnify rather than moderate existing differences in status and income. The employed, especially those working for the state, are well-protected insiders, whereas those without a strong attachment to the labour market are outsiders whose social protection depends on their family. The model came under strain in the 1980s and 1990s because many of its qualities (early exit schemes, passivity of benefits, dualism in protection, gender bias) precluded the necessary growth of labour market participation, especially of women.

Some argue that there is a specifically southern or Mediterranean fourth model found in Italy, Spain, Portugal and Greece. The model shares many features of the conservative one, but is characterized by much more fragmented and particularistic social insurances, a rather one-sided stress on pensions (although less so in Spain), a very pronounced

insider-outsider and gendered structure of the labour market, an even more pronounced role of the (extended) family in the state-market-family mix of social protection, an under-developed social assistance system and clientelism in the allocation of benefits and jobs in the public sector. This model came under pressure because of problems of low (formal) labour force participation, wide social protection gaps, a weak state and, hence, suboptimal tax capacity (the quintessential example would be Greece, see Petmesidou and Guillén 2015).

These welfare state models, in short, differ substantially in how much they are committed to spend, but what matters most for social outcomes, such as social protection and inequality, is on what specific social purposes that money is spent, how the programmes are organized, taxed and financed and how transfer- or service-oriented they are.

The generosity of welfare states

One way of gauging the relative quality of what the welfare state does and how well it does this is by looking at the welfare state's generosity. Generosity depends on the replacement rates of key social benefits, the duration of such benefits, the kinds of demands people have to meet in order to qualify for a benefit, the number of waiting days included in the rules and how many people are covered by the social scheme. Generosity captures the extent to which social services and benefits have been institutionalized as social rights that allow people to "maintain a livelihood without reliance on the market" (Esping-Andersen 1990, 22).

In chart 1, countries are ranked (high to low) according to their generosity index in 1980. The higher the score on this index, the more generous the systems are. As can be seen from the table, in 1980, the Swedish social democratic welfare state was the most generous and the Australian liberal welfare state was the most tight-fisted. One can also quite easily recognize Esping-Andersen's classification of welfare states. In 1980, the most generous welfare states were the social democratic countries (except Finland), closely followed by the conservative countries. Most liberal welfare states (Canada, New Zealand, the United States and Australia) are found at the bottom of chart 1. In 1980, Italy's welfare state looked more like a liberal than a conservative European welfare model, whereas the liberal United Kingdom was closer to Austria and Germany than to any of the liberal welfare states.

Chart 1 also shows that in terms of generosity, the neat picture of the three worlds of welfare states has become somewhat blurred in 2010. The liberal welfare states have remained quite clearly distinctive in the relatively humble levels of bigheartedness of their welfare states. Interestingly, the United Kingdom seems to have become much more of a liberal welfare state than it used to be, dropping from place 9 in 1980 to 12 in 2010. Some of the social democratic states have become much less generous too. Sweden, the world's generosity champion in 1980, fell 5 places and ended at rank 6 in 2010, while Denmark descended from

THE GENEROSITY OF WELFARE STATES, 1980 AND 2010

Countries are ranked (high to low) according to their generosity score in 1980.
Figures in brackets refer to the country's ranking **(1980/2010)**

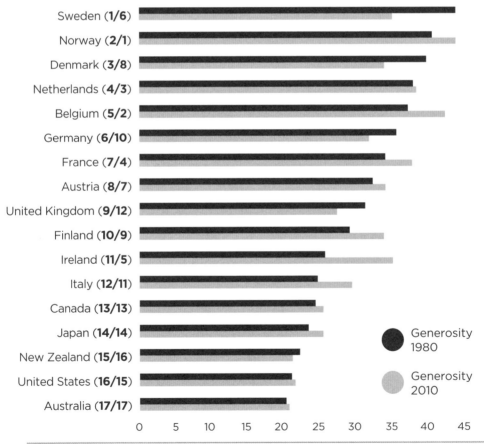

Source: Scruggs et al., 2014

Chart 1

place 3 to 8. Three continental European countries (Belgium, the Netherlands and France) have surpassed the social democratic welfare states (except Norway) in generosity in 2010. The biggest change is found in Ireland, where the welfare state generosity index jumps from 25.8 to 35.3, locating this country at place 5, also above Sweden and Denmark. Even though the precise ranking of welfare states and the composition of the models have changed, it is obvious that there are still clear differences in the quality of welfare states as measured by the generosity index.

The welfare state and income redistribution

The generosity index cannot inform us precisely about the redistributive features of the welfare states, but it seems reasonable to suspect that the more generous systems are also more egalitarian. And, indeed, there is a reasonably strong negative correlation between how generous welfare states are and how much inequality they produce (Jensen and Van Kersbergen 2016). The OECD (2014) has published interesting data on how welfare states redistribute and which income groups profit relatively most from social benefits. It turns out that welfare states differ enormously in which income groups they most privilege. The southern European welfare states transfer a much higher proportion of social benefits to the highest income group than to the lowest one. Portugal leads this group of southern European countries, where the lowest income group receives clearly less than what the top receives: 11% of all cash benefits goes to the bottom 20% earners, whereas 40% goes to the top 20%. Portugal also has one of the highest levels of inequality.

There are two important causes for this phenomenon. First, most transfers in these countries are simply not meant to help the poor exclusively, but rather are to cover the social risks of all social strata. Second, benefits for the retired, disabled and unemployed are often linked to contribution period and are earnings-related, so that relatively more goes to the well-off than to the poor. This is especially true for pensions, and the southern—and some of the continental European—countries are typically pension states: Italy, Greece and Portugal, but also France, roughly spend between 13% and 16% of GDP to pensions, two to three times as much as the social democratic, liberal and some of the conservative welfare states (Switzerland and the Netherlands), which typically spend between 3.6% and 7.4% of GDP on pensions. This

means that income redistribution in the pension-heavy welfare states is not from the rich to the poor, but primarily from one period in life to another. In other words, inequalities produced during working life are directly reproduced, rather than moderated, in retirement.

This redistributive pattern contrasts sharply with the liberal and social democratic welfare states, in which the bottom group receives relatively more than the top. Australia, for instance, clearly targets the poor as over 42% of total benefits goes to the bottom and only 3.8% goes to the top. However, given that Australia's level of inequality is close to that of Portugal, it is also clear that there is no one-on-one relationship between the allocation of public benefits to different income groups and inequality. The main reason is that the relatively high level of transfers to the bottom income group can be an effect of two different things: either a high level of overall spending, as in the Nordic countries, or targeting through means testing (i.e., offering usually minimum benefits exclusively to those who have no other means), as is the case in the Anglo-Saxon countries.

Another thing to take into account is that much of the effect of the welfare state on inequality depends on how social benefits and services are financed and allocated. The universalist and comprehensive tax-financed systems that are characteristic of the social democratic model turn out to be much more redistributive than the targeted systems, even if there is no progressivity in taxation (see Rothstein 1998). In a way, this is counterintuitive because these welfare states are very generous to the middle class and do not target the poor. In fact, higher income groups disproportionally profit from social services, especially health care and education. Hence, one would expect a fully means-tested system, in which a disproportional proportion of benefits goes to the poor, to be much more redistributive. However, means-tested systems tend to be tight-fisted, whereas social democratic universalist systems distribute much larger sums of money, and as a result, the latter come out as much more redistributive than the more targeted and means-tested ones, a phenomenon called the paradox of redistribution (Korpi and Palme 1998).

The redistributive effect of the welfare state can be directly measured by the percentage difference through transfers and taxes between inequality in market income and inequality of disposable income. Income redistribution is the outcome of public spending on cash benefits, how much the tax-benefit system targets the poor and the progressivity of

the tax system. Adema et al. (2014) have shown that all welfare states redistribute and lower inequality, at least to some extent, but that the cross-national differences in the welfare states' redistributive effects are large, varying from a decline in inequality of 20% to 30% in the liberal welfare states to 45% to 47% in Ireland, Slovenia, Finland, Bel-

THE EFFECT OF THE WELFARE STATE ON INEQUALITY DEPENDS ON HOW SOCIAL BENEFITS AND SERVICES ARE FINANCED AND ALLOCATED

gium and Hungary. Interestingly enough, the countries with the lowest income inequality, namely the social democratic welfare states of Sweden, Norway, Finland and Denmark, are not among the countries with the top redistributive tax-benefit systems. This, first of all, reflects the fact that these countries have relatively equal market income distributions in the first place. In addition, the picture is somewhat distorted because the redistributive impact of the Nordic countries' extensive social services financed via taxation are not taken into account (Adema et al. 2014, 19).

Welfare state adaptation and social investment

Welfare states and welfare state models are not static institutions; on the contrary, they are continuously updated and adapted to constantly changing social, economic and political circumstances, including shocks, such as the financial crisis and the economic recession that followed in its wake. As documented in more detail elsewhere (Van Kersbergen and Hemerijck 2012; see extensively Hemerijck 2013), all welfare state models have undergone significant changes in the main areas relevant to social policies.

In macroeconomic policy, countries have converged around a policy framework centred on economic stability, hard currencies, low inflation, sound budgets and debt reduction. The introduction of Economic and Monetary Union turned monetary policy into a fixed parameter for policy reform in other fields. Most countries have also responded to internationalization with wage restraint, usually backed by broad social pacts between employers, unions and the government. Everywhere,

there has been a reorientation of labour market policy towards activation with a view to maximize labour market participation. All welfare states have increased work incentives, although not all have managed to the same extent to accompany this stick with the carrot of human capital investment.

Another general trend has been labour market deregulation, particularly decreasing job protection, in order to make labour markets more flexible and to create opportunities for labour market outsiders. There are, however, large differences between countries in that only some (e.g., Denmark and the Netherlands) complemented the flexibilization of labour markets with measures that extend social protection to vulnerable groups, establishing systems of "flexicurity". More generally, the trend in social insurance has been to focus more on labour market (re-)integration than on income maintenance. Retrenchment of unemployment protection has been part of the flexibility venture almost everywhere, although minimum income schemes have been introduced or improved in a number of countries where these were lacking.

WELFARE STATES ARE CONTINUOUSLY UPDATED AND ADAPTED TO CONSTANTLY CHANGING CIRCUMSTANCES, INCLUDING THE FINANCIAL CRISIS AND THE ECONOMIC RECESSION

Everywhere, reforms have been introduced to make pension systems sustainable under conditions of low or declining fertility and increasing life expectancy (see European Commission 2015). Measures include increasing the retirement age, limiting early exit, introducing occupational and private pillars on top of the public schemes and redefining the actuarial links between contributions and benefits. Many countries have also increased their efforts to assist people in their attempts to reconcile work and family, for example, by extending child care and pre-school facilities and other services as well as parental leave provisions.

In Europe, policy reforms in welfare states of various kinds have often taken inspiration from the idea of social investment. The basic conviction is that social policies should not just passively compensate for social mishap, but should more proactively be used to prevent labour market inactivity, to adopt a life course perspective (e.g., life-long learning) and to promote human capital so as to stimulate both equality and economic growth. Increasing the capacity of individuals

over the life course to remain in employment not only provides a high level of social security, but also greatly enhances the long-term financial sustainability of the welfare state. It is in this sense that the term "investment" must be taken quite literally: an investment in human capital will yield great returns in terms of money saved on passive benefits and money earned from taxes and contributions. Investments in children are particularly promising, because they help smooth inequalities in (cognitive) abilities and health and prevent an accumulation of disadvantages over the life course, which would otherwise increase demands on passive welfare (Kvist 2015). The social investment strategy hence aims at developing policies that "help to simultaneously widen the tax-base, increase fertility, fight poverty and inequality, or improve the financial sustainability of certain key programmes such as pension schemes" (Morel et al. 2009, 10). The European Commission has promoted social investment as the key policy framework to guide member states in their social policy reforms (European Commission 2013) and to reach the goals of the Europe 2020 strategy for smart, sustainable and inclusive growth.

The impact of crisis and recession

Before the financial crisis hit, social investment was rapidly becoming the foundation of a new policy paradigm in most if not all welfare states as well as at the European Union level. One ingredient of the social investment strategy, namely employment and activation policies, was adopted everywhere and has helped to increase labour force participation, especially among women and older men. The economic recession, however, has greatly amplified the financial pressure on the welfare state, both by multiplying the number of people on benefits and by decreasing the financial contributions for social policy. Virtually everywhere this has led governments to increase their austerity policy efforts and to retrench on social entitlements so as to help rebalance the public budget. Even though in discourse the social investment agenda still seems intact, particularly at the European level, it has also become increasingly clear that social investment policies are particularly vulnerable to cuts in the short run, precisely because social investments yield returns only in the longer run, while cost containment is a necessity now.

Let me take as an example the social democratic welfare states, in which the social investment path has been followed far longer than anywhere else and where it has become an intrinsic component of the welfare state paradigm. If one, for example, compares public expenditures, one finds that the social democratic welfare states spend 3-4% of GDP more than the conservative, liberal and southern European welfare states on key social investment programmes (education, family benefits and active labour market programmes). The effects are evident in the use of public services, where the social democratic welfare states stand out in the large number of children they enrol in pre-education and children and adults in education (schools, training institutions, etc.). The public provision of childcare, education, work-life reconciliation initiatives and active employment policies not only provide people with the skills to work, but they also free up time to participate in the labour market and generate jobs. As a result, labour market participation rates of men and women are highest in the social democratic welfare states. Finally, as is well known, income inequality and poverty rates are lowest in the social democratic countries.

Recent trends, however, seem to indicate a change of direction even in the social democratic social investment approach, namely a move away from universalism and inclusive social investment, with rising selectivity in social policy as an effect of tighter eligibility criteria, more targeting and privatization. Similarly, focusing on outcomes, there are signs of rising inequality and poverty as an effect of direct retrenchment and policy drift, that is, not updating social policies to new needs (see Van Kersbergen and Kraft 2016). The point to stress here is that if the social democratic welfare states are finding it already increasingly difficult to uphold their allegiance to the social investment oriented welfare state, then it is highly likely that other types of welfare states will find it close to impossible to remain committed to the social investment path they had started to follow before the financial crisis.

The financial meltdown of 2008 and the subsequent recession caused all welfare states to experience similar problems, including rising unemployment, reduced credibility of the banking sector, falling exports and rising budget deficits. Because of the problem similarity, governments initially responded in roughly similar ways. The immediate response was to massively support the financial sector and to protect demand by continuing existing social policies and introducing temporary measures to stimulate demand. But bailing out banks, recapitalizing them

and a host of other measures to save the financial sector added up to a very high bill. And on top of that came rising social expenditures and decreasing taxes and contributions, which put public budgets under extreme financial pressure.

Interestingly enough, the financial crisis of 2008 and the Great Recession that followed in its wake, for obvious reasons, were not blamed on the welfare state, at least not initially. In fact, the welfare state was celebrated for how it cushioned the harmful effects of the crisis as its automatic stabilizers did exactly what they were meant to do: automatically stabilize demand and protect people from hardship. But then something happened, which Mark Blyth (2013) has labelled "the greatest bait and switch in modern history": although the fiscal crisis in European welfare states (except Greece) was a consequence of the

THE RECESSION CAUSED ALL WELFARE STATES TO EXPERIENCE RISING UNEMPLOYMENT, REDUCED CREDIBILITY OF THE BANKING SECTOR, FALLING EXPORTS AND RISING BUDGET DEFICITS

financial crisis, it became progressively portrayed as its cause. Because states took responsibility for the massive private debt that banks had caused by socializing it as public debt, the banking crisis was turned into a sovereign debt crisis, as if it had been the welfare states, rather than the banks, which had caused the predicament. Thus, the problem became reformulated as one of excessive (welfare) state spending and public debt, which had to be battled by a severe politics of austerity in order to solve the financial crisis and stimulate the economy.

As a result, the political conviction everywhere became that the costly initial response to the crisis and the recession was not sustainable in the long run because it was causing deficit spending to rise dramatically. This ushered in a period of austerity with a view to restore balanced budgets and contain public debt. Governments realized, or in some cases were reminded by the financial markets, that deficit spending had reached its limits. Consequently, the politics of reform increasingly came to revolve around the question of who was to pay for what, when and how. In other words, the outcome of these political struggles determines who will carry the heavy burden of financial and economic recovery. The crucial political choice virtually everywhere seems to be founded on the conviction that a swift return to a balanced budget is

the only sensible route to economic recovery and that drastic retrench-
ment is the only means to achieve that goal. Governments have already
agreed on significant public spending cuts, which add up to drastic
reforms that particularly hurt social investment policies and induce
new distributional conflicts, although more so in some countries than
in others.

Conclusion

Let me highlight two issues by way of a conclusion. On the one hand,
there has not been a major onslaught against the welfare state in the
immediate wake of the financial crisis. On the other hand, there have
been increasingly drastic spending cuts that seem to undermine the
social investment path that welfare states had chosen to follow. During
the last twenty 20 years or so, welfare states have been continually
adjusting to new economic and social demands, and governments have
pursued, albeit with considerable variation, apparently well-adapted
and innovative social policies, such as social investment. But under
increasing stress, especially in the wake of large budget deficits and
pressures from financial markets, it is not evident that core social pro-
grams can be protected through reform; they may become victims of
the pending distributional battles or of further policy drift.

Welfare states have been remarkably flexible and capable in their
adjustment to their permanently changing environments. Their core
social arrangements remain highly popular so that any attempt at a
radical overhaul continues to meet public resistance. Yet, severe budget-
ary problems, the unpredictable but threatening responses of financial
markets and the real economic consequences of the financial crisis not
only pressure for further reform, but possibly undermine the political
capacity to implement those reforms needed to guarantee the contin-
ued protection of people against social risks that the welfare state has
so far offered.

ROBIN SHIELDS is Senior Lecturer at the University of Bath, where he is also Director of the Doctor of Business Administration in Higher Education Management. He holds a PhD from University of California. His analysis of global international student flows received the George Bereday Award for the most outstanding article in Comparative Education Review in 2013. Robin has also acted as Principal Investigator on research funded by the Higher Education Academy, Leadership Foundation for Higher Education, and the Dutch Ministry of Foreign Affairs.

This chapter examines policy initiatives that aim to coordinate and integrate higher education in Europe, focusing on the issue of international student mobility. From an inter-regional perspective, a key priority has been to build and maintain the preeminence of European higher education in relation to North America and East Asia. Intra-regional priorities center primarily on efforts to support the European Economic Area. These dynamics are examined through three policy initiatives: the Erasmus+ student mobility programme, the Erasmus Mundus post-graduate mobility programme, and the European Higher Education Area.

FROM THE "IMAGINED" TO THE "POST-BUREAUCRATIC" REGION: THE SEARCH FOR EUROPE IN HIGHER EDUCATION POLICY

This chapter examines how international student mobility in higher education is used to construct Europe—both geographically and ideologically. It does so by analysing three distinct but interrelated policy initiatives: the Erasmus student mobility programme, the Erasmus Mundus postgraduate mobility programme and the European Higher Education Area. My argument is that the search for Europe has been a key concern and goal of international mobility in higher education. However, that search has entailed two parallel changes in recent years. The first change has involved a shift from Europe as a shared imaginary—akin to what Anderson (1983) calls an "imagined community" in his analysis of the formation of nation-states—to a collective resembling what Heckshcher (1994) calls the "post-bureaucratic organization", characterized by flexibility, self-organization and continuous internal dialog.

THE SEARCH FOR EUROPE HAS BEEN A KEY CONCERN AND GOAL OF INTERNATIONAL MOBILITY IN HIGHER EDUCATION

The second shift has involved an increasing emphasis on the relationship of Europe with the rest of the world since the construction of Europe is defined by the interaction between the European and non-European. Drawing upon data of international student mobility flows, I show that the benefits of international student mobility have come primarily from inter-regional flows, although both inter- and intra-regional mobility have experienced rapid growth.

The paper begins by introducing and analysing the Erasmus student mobility programme, the Erasmus Mundus programme and the European Higher Education programme. It then presents a brief analysis of trends in international student flows and compares the programmes to show how they provide evidence of changes in the construction of Europe through higher education policy. The paper concludes by linking

these changes to the changing nature of the search for Europe, both in higher education policy and in a more general sense.

Erasmus and Erasmus+

The Erasmus student mobility programme represents the longest-standing higher education policy at the European level. Since its inception in 1987, more than 3 million students and 350,000 higher education staff have taken part in mobility funded by the programme (European Commission 2014a). During the same time, it has expanded from 11 to 33 participating countries, and its budget has increased from €13 to €550 million (European Commission 2014b). This sustained growth leads Papatsiba (2006, 98) to declare Erasmus as the "single most successful component of EU policy". This view was reflected in the renewal of the programme, from 2014 to 2020 as Erasmus+, extending the Erasmus "brand" to include all programmes on education, training, youth and sport.

ERASMUS SERVES TO DEVELOP A
WORK FORCE THAT HAS EXPERIENCE WORK-
ING ACROSS NATIONAL BORDERS

At its core, the Erasmus programme supports student exchanges between European universities, particularly by offering student grants to support international mobility within Europe. Under the Erasmus programme, European universities can form partnerships (bilateral agreements), through which their students undertake exchanges of one or two semesters of study. Because credit systems can vary between countries, students learning while on exchange are measured by the European Credit Transfer and Accumulation System (ECTS), with ECTS credits converted to those used by the home institution upon return. Erasmus mobility is thus often referred to as "exchange mobility" or "within cycle mobility", in contrast to "degree mobility", in which a full academic degree is obtained abroad.

Since its inception, the Erasmus programme has seamlessly and simultaneously integrated both sociocultural and economic goals. As motivations for the initiation of Erasmus in 1987, the Council of Ministers (1987) referenced both "a view to consolidating the concept of a

People's Europe" and "an adequate pool of manpower with first-hand experience of economic and social aspects of other Member States". In respect to its sociocultural aspects, much research has identified the use of Erasmus as a means of producing and fostering European identity through the production of "self-identifying European citizens" who will support European integration in the future (Mitchell 2012, 494). However, evidence to date is very mixed on its success in accomplishing these goals, with studies reporting differing results on whether or not participation in Erasmus increases a sense of European identity (e.g., Siglas 2010; Mitchell 2012).

In addition to its social and cultural goals, the objective of European economic integration—and specifically the growth of a mobile and fully-integrated European workforce—is not far beneath the surface. From this perspective, Erasmus serves to develop a workforce that has experience working across national borders within Europe, familiarity with multiple European cultures and, possibly, competence in multiple European languages. Concerning workforce development, evidence is more limited, although the work of Parey and Waldinger (2010) suggests that participation in the Erasmus programme increases future mobility in the labour market.

The intertwined and inseparable processes of identity formation and economic integration closely resemble the process of nation-state formation described by Anderson (1983) in *Imagined Communities*. According to Anderson (1983), nation-states are "imagined communities" in the sense that their members "will never know most of their fellow-members, meet them or even hear of them, yet in the minds of each lives the image of their communion" (6). While acknowledging the limitations of direct analogies between the construction of Europe and the nation-state (Decker 2002; Siglas 2010), the concept of the imagined community applies very well to the rationales articulated in the Erasmus programme. Much as the advent of mass education systems was integral to producing the imagined community of the nation-state, the Erasmus programme aims to produce an imagined European identity that would facilitate economic and social integration. The ideological appeal of higher education—particularly its foundation in the search for universal knowledge—makes it an ideal medium for constructing identities that claim an equal or superior status to nationality.

With respect to the construction of Europe through higher education policy, three key features of the Erasmus programme are (i) a focus on

constructing Europe primarily in an intra-regional sense, by stimulating and fostering a sense of European identity among European youth; (ii) the prominence and importance of a common European identity through a shared imaginary; and (iii) strong institutional support, for example, from the European Commission, which commits to the ongoing funding of Erasmus mobility without the expectation of developing self-funding or market-based funding in the future. As discussed below, these three key features of the Erasmus programme are a useful reference point to analyse subsequent changes in policy on mobility. The long history and widely acknowledged success of the Erasmus programme provided a strong foundation for European higher education policy-making in other areas, especially inter-regional mobility.

Erasmus Mundus

Unlike the Erasmus programme, the Erasmus Mundus programme focuses on mobility between European and non-European countries. More specifically, it funds and facilitates the establishment of Erasmus Mundus Joint Masters Degrees (EMJMDs), which are designed and delivered by a consortia of three or more European universities. These masters programmes are supported by student scholarships (typically 13 to 20 per EMJMD) and funding for visiting lecturers and scholars. The scholarships support the mobility of students from non-European countries, with a large share of funds earmarked for students from "partner countries" (i.e., those that receive funding from EU development programmes).

By guaranteeing a supply of fully-funded, well-prepared, post-graduate students, the Erasmus Mundus programme essentially "primes the pump" for the EMJMDs, which will offer the potential of recruiting larger numbers of self-funded students in the future. The programme was launched in 2004, renewed in 2009, and is now a partner of the larger Erasmus+ programme for education, youth, training and sport from 2014 to 2020. As of 2013, 285 joint degree programmes had been funded by the Erasmus Mundus programme, with 180 on offer in the 2014/15 academic year (European Commission 2014a). In addition, some 13,957 scholarships have been funded by the programme since 2004, with India (1,519), China (1,339) and Brazil (578) comprising the largest sending countries (European Commission 2013).

Rather than constructing Europe through internal mobility, Erasmus Mundus clearly focuses on the relationship between Europe and the world. Thus, instead of a shared imaginary, engagement with third countries (i.e., inter-regionalism) provides a mirror in which the vision of Europe is reflected. European-ness is defined less by interaction within Europe than by how Europe engages with the rest of the world. Although intra-regional integration is promoted through EMJMDPs and the cross-national collaboration they entail, this internal cooperation is no longer an end in itself but instead becomes a means to improve the attractiveness of European higher education from an external perspective. In emphasizing the need to attract students from around the world, the Erasmus Mundus programme introduces an interest in promoting the success of European higher education in a globally competitive environment.

The European Higher Education Area

The European Higher Education Area (EHEA) is an initiative of 47 higher education ministries, which aims to reform national higher education systems to improve the comparability and compatibility of degrees. It was launched with the Bologna Declaration in 1999, in which 29 European countries started a decade-long process of ministerial conferences that focused on the mutual recognition of degrees and credit transfers. The Bologna Process culminated in the formation of the EHEA in 2010, by which time the initiative had expanded to include 47 countries, reaching well outside the borders of the EU to include Turkey, Kazakhstan and Azerbaijan.

While the EHEA entails a set of broad changes that increases the comparability and compatibility of higher education institutions, Papatsiba notes that "the promotion of mobility is clearly the most concrete, easily interpreted and uncontroversial aim" of the EHEA. Mobility is considered on two respects: first, maintaining and developing Europe as a destination for students from outside the EHEA (inter-regional mobility), particularly in relation to competing destinations such as North America, Australia and, increasingly, East Asia (Teichler 2012; Croché 2009); and second, furthering the longstanding goal of internal mobility first promoted by Erasmus in 1987. However, rather than funding such mobility directly, the EHEA promotes mobility by lowering barriers and

increasing compatibility. It proposes a three-cycle degree system (i.e., Bachelors, Masters and Doctoral degrees) with common credit systems and degree lengths. The rationale is that these commonalities should promote mobility both within cycles (e.g., studying abroad or transferring in the middle of a degree) and between cycles (e.g., completing bachelors and masters degrees in different countries).

Unlike the Erasmus student mobility and Erasmus Mundus programmes, the European Higher Education Area is not an initiative of the European Commission, although the Commission has been directly involved and supportive since its inception (Keeling 2006). Instead, it is coordinated by a rotating secretariat and executive chair, with implementation of and adherence to the work programme largely delegated to the higher education ministries of its members. As Papatsiba (2006) notes, the EHEA is not a binding agreement and therefore relies on the shared self-interests of its members to provide impetus for the reforms entailed.

EHEA AIMS TO REFORM NATIONAL HIGHER EDUCATION SYSTEMS TO IMPROVE THE COMPARABILITY AND COMPATIBILITY OF DEGREES

Research on the EHEA has noted its similarities to the project of European Economic Integration (i.e., the European Economic Community and the Eurozone), with a common currency (ECTS) and free movement of people (Wachter 2004). However, the ways in which the EHEA differs from other initiatives in European integration is of equal interest, particularly in understanding its methods for the construction of Europe. For example, the organizational model of the EHEA is notably different from that of the European Union. While the latter has been driven by a relatively strong institution (the European Commission), to which powers are delegated from member states, the organization of the EHEA is far more flexible and ambiguous. Unlike the European Commission—which has substantial purview over its members' policies through its policy directives and regulations—the EHEA works only by establishing agreement on and commitment to harmonization principles (i.e., recognition of ECTS, agreement on the three-cycle system of bachelors, masters and doctoral degrees and corresponding numbers of credits), which are implemented by members.

Jayasuriya (2008) and Robertson (2010) use the label "Regulatory Regionalism" to describe the flexible and largely non-institutionalised

model of governance employed by the EHEA. In Jayasuriya's words, this approach relies

> more on the active participation of national agencies in the practices of regulation than on formal international treaties or international organisations for their enforcement [...] a decisive characteristic of these new modes of governance [...] is the reliance on the national application or ownership of internationally formulated standards (Jayasuriya 2008, 22).

Rather than scaling up traditional functions of the nation-state (i.e., higher education policy) to the regional level, regulatory regionalism embeds regional objectives within national policy-making. Key to this form of governance are what Jayasuriya (2010) terms accountability communities, which are processes and forms of interaction that ensure national compliance and adherence to regional priorities.

This approach to regional organization also resembles what Heckscher (1994) calls the post-bureaucratic type, in which authority and control are not exercised by central hierarchies but rather operate through ongoing dialog, network structures and systemic patterns of preference and behaviour. Features of the EHEA, such as the ongoing ministerial conferences (ongoing dialog), nationally-led implementation (non-hierarchical structures) and an open and flexible approach to membership (extending well outside most geographic definitions of Europe), suggest that a form of organization that in many ways resembles Heckscher's "ideal type" is emerging in the realm of higher education policy. Mutual self-interest—rather than binding agreements or powers scaled "up" to the regional institution—drives the process forward and ensures the cohesiveness of the region. Some evidence of the ability of this form of organization to coordinate regionalization is provided in trends in international student flows.

Policy and Trends in European Student Mobility

The changes discussed above have taken place in the context of unprecedented growth in international student mobility. In 1999 (the first year for which data are available), approximately 1.4 million students undertook degree level studies outside their home country; by 2012, this number had increased to over 3.5 million students.

A key objective of both Erasmus Mundus and the EHEA is increasing the "attractiveness" of European higher education, which is often

operationalized through its choice as a destination for international study (Croché 2009; Wächter 2004). Chart 1 displays growth in inter-regional international students in the EHEA and to Erasmus programme countries, using 1999 as a baseline, with global growth indicated as a reference. Inter-regional students include only those whose country of origin (i.e., the country of prior residence or study) is outside EHEA or Erasmus programme countries. These data—collected by a collaboration between UNESCO Institute for Statistics, OECD and Eurostat and reported by UNESCO—measure degree mobile students, that is, those who go abroad to complete a whole degree-level qualification. Thus, students on short-term exchange programmes, including Erasmus student mobility, would not be counted (although those on EMJMDPs would be included).

Trends show that inter-regional mobility grew steadily between 1999 and 2012. Additionally, the growth of inter-regional mobility to the EHEA outpaced global growth in international student numbers, which

INTER-REGIONAL STUDENT MOBILITY GROWTH In percentages

Chart 1. Trends in inter-regional degree mobile international students, 1999-2012. Data from 1999 are used as a baseline (100%). Degree mobile students include only those who undertake a full degree abroad, and do not include exchange students. Data show that student-flows from other regions to the EHEA have outpaced global growth in international student mobility.

was very strong itself. Thus, in inter-regional terms, the EHEA can be considered a fairly effective initiative insofar as its formation has been associated with very high growth in inter-regional student flows, a key measure of the "attractiveness" it seeks.

Both figures highlight the phenomenal growth in mobility, both in Europe and globally. Thus, even the programmes and regions that have experienced lower growth in relative terms have experienced strong growth in absolute terms. This growth is also evident in the Erasmus programme, which relies heavily on grants funded by the European Commission rather than more market-based (self-funded) mobility. Erasmus mobility has nearly doubled since 1999. However, these trends suggest that the primary benefits of international student mobility have been in inter- rather than intra-regional terms. While the EHEA is also supportive of intra-regional integration by encouraging a flexible and mobile European workforce (Papatsiba, 2006), evidence suggests that

INTRA-REGIONAL STUDENT MOBILITY GROWTH In percentages

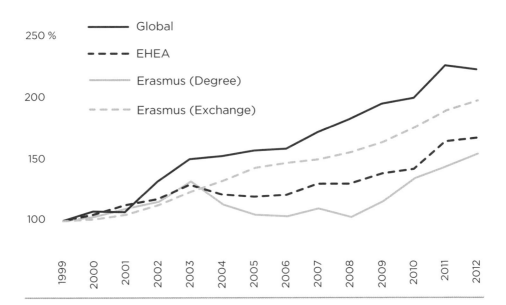

Chart 2. Trends in intra-regional mobility. Degree mobile students are those undertaking a full degree abroad (either in Erasmus programme countries or the larger set of EHEA countries). Erasmus exchange students are those undertaking short-term mobility (within a degree programme) through the Erasmus programme. All types of mobility have increased, although at a slower pace than global international student mobility.

growth in this area has been more limited than the development of the EHEA as a destination for students from other regions of the world. In this respect, the EHEA has outpaced the global growth in international student mobility.

The analysis provided above shows that, in most senses, inter-regional growth has outpaced intra-regional growth, and development of the EHEA as a destination for inter-regional students is the only area in which European student mobility has outpaced global mobility growth. However, it is important to use caution when applying this evidence to the interpretation of higher education policies on mobility. The data alone are not sufficient to establish cause and effect, but rather provide an indication of the trends that have accompanied policy implementation.

Analysis: Change and Continuity in European Higher Education Policy

In order to best interpret how higher education and international mobility are used in the search for Europe, it is helpful to first identify the points of difference and commonality in the policies discussed above. First, these three initiatives share a point of commonality in that they do not seek complete integration of higher education, implicitly acknowledging this would "neither be desirable nor achievable" (Paptsiba 2006, 96). Instead, they are all premised on the duality of national independence and European integration. In other words, the European dimension does not erode or supersede the authority of the nation-state, but rather works through it. In Hartman's words, regionalism in higher education "penetrates borders without dissolving them" (Hartman 2008, 209), and the primacy of the nation is maintained in the construction of the region.

Second, it is important to note that all the initiatives discussed above remain active contemporaneously. Rather than new initiatives superseding their predecessors, the programmes are largely complementary in nature and provide a structure of mutual legitimation and reinforcement. For example, the Erasmus student mobility programme first established a systems of credit transfers (ECTS) that would later become the basis for the EHEA. Similarly, a key goal of the Erasmus Mundus programme is to "increase the quality and the attractiveness of the European Higher Education Area" (European Commission 2015, 93). However, although the three initiatives discussed above coexist and

reinforce one another, they also evince a shifting emphasis in how Europe is understood. Concerns that were not considered relevant at the inception of Erasmus (global competition and self-sustained funding) become central in the Erasmus Mundus programme and the European Higher Education Area.[1]

Third, the three policy initiatives demonstrate shifts in the model of support and involvement from European institutions. Erasmus student mobility has been initiated, coordinated and funded by institutions of the European Union (i.e., the European Commission), with implementation delegated to the national level and universities. Thus, the European institution plays a strong, central role in the ongoing operation and funding of the programme, very similar to that of national governments in welfare states. There is no expectation that the programme would function without direct and continuing institutional support. However,

THE CHANGES REFLECT REDUCED RELIANCE ON INSTITUTIONS AND MORE CONCERN OVER THE ROLE OF EUROPE WORLDWIDE, AND NOT ONLY FOR ITS OWN INTERESTS

in the Erasmus Mundus programme, the role of European institutions is much more limited: instead of ongoing funding for programmes, the European Commission "primes the pump" by guaranteeing a supply of internationally mobile students through the scholarship programme. The supply-side focus of Erasmus Mundus contrasts quite starkly with the institutionally-led model of Erasmus European mobility, although the two operate through very similar mechanisms (i.e., scholarships for mobility). With the EHEA, the role of European institutions is further reduced: rather than a central actor that coordinates regional integration, the European Commission becomes a member in a larger process—ironically holding a status that is nominally equal to its own member states.

Fourth, policymaking in relation to mobility displays a clear shift from an intra-regional to an inter-regional focus. The Erasmus student mobility initiative displays virtually no concern for Europe in an

1 It is interesting to note that more recent policy documents on the Erasmus programme speak favourably of "Zero Grant" students—those who were unable to obtain a grant for their mobility and so use their own funds instead. This also indicates a shift towards a self-funding mechanisms within the Erasmus programme.

inter-regional perspective; instead, the focus is entirely on fostering and mobilizing mobility within the region. However, the inter-regional focus of Erasmus Mundus and the EHEA is very clearly on the relationship between Europe and other regions of the world, and it is closely connected to the "attractiveness" of European Higher Education, that is, its ability to attract students from other parts of the world.

Cross-cutting analysis of the initiatives and trends discussed above thus reveals both continuity and change. It is important to keep in mind that there have been few radical disjunctures or reversals in mobility-related policies. However, it is equally important to note that where change has occurred, it has consistently been in the direction of programmes that rely less on formal institutions, are more market-oriented and are more concerned with Europe in the world rather than Europe in itself. These models of regional coordination and governance could hold important implications for the wider search for Europe.

Higher Education Policy and the Search for Europe

The search for Europe, as it has unfolded in the domain of higher education policy, raises interesting questions about the changing ways in which Europe as a region is constructed and defined. Specifically, the shift from institutionally-led to self-organizing forms of regional integration and governance raises the question of whether Europe in a larger sense relies upon institutions and a shared identity that underpins them. Conversely, is it possible to have "Europe" without European institutions and a European identity?

To date, Europe integration has adopted many of the tradition symbols of the nation: flag, currency and—through programmes such as Erasmus—an "imagined community" or shared identity. However, widespread social and economic changes call into question the durability and necessity of these symbols as a basis for regional integration. In many areas of social and economic life, forms of organization that have traditionally been institutionally-led are coordinated through more flexible and self-organizing approaches. Just as decentralized systems such as Bitcoin hint at the possibility of currency without institutional management, the recent trends in higher education policy discussed above suggest that more self-organizing approaches to regionalism may be possible. This approach relies upon common self-interests among

regional members and non-hierarchical approaches to implementation, rather an institutional bureaucracy.

The current model of regional integration in Europe—that is, a strong regional institution underpinned by a shared imaginary—may undergo profound transformation, becoming less institutionally-based and less reliant on a shared identity. This is not due to a shortcoming or failure of the particular institutions and approaches of European integration, but rather because the models on which this approach is based are themselves undergoing profound transformation. Changes in higher education policy with respect to international student mobility suggest that such a transformation does not take place in the form of a radical disjuncture, but rather through a gradual shift in which institutionally-led models coexist with a shift towards forms of organization that more resemble the post-bureaucratic type.

Furthermore, changes in the construction of Europe through student mobility establish the region less through its internal constitution than through its interface to and engagement with other regions (i.e., inter-regional dynamics). Europe is defined much less through its internal identity than through its encounter with the non-European, which in many senses becomes a mirror in which the region appears. These changes suggest a future in which some cornerstones of regional organization to date—identity and institutions—will become less necessary and foundational to the construction of the region, bringing new complexity and possibilities to the search for Europe.

BICHARA KHADER is Professor Emeritus at the Catholic University of Louvain and Founder of the Study and Research Centre on the Contemporary Arab World. He has been a member of the Group of High Experts on European Foreign Policy and Common Security (European Commission) and Member of the Group of Wisemen on cultural dialogue in the Mediterranean (European Presidency). Currently he is a visiting professor at various Arab and European universities. He has published almost 30 books on the Arab World, the Euro-Arab, Euro-Mediterranean and the Euro-Palestinian relations.

Some 25 million Muslims live in the 28 Member States of the EU. The vast majority of them came seeking work and were needed for sectors referred to as "difficult, dirty and dangerous". In the 80's, they started to be perceived not as immigrants, but as "Muslims", eventually threatening the social fabric of European societies. The terrorist attacks by tiny groups of Islamist fanatics and the radicalisation of thousands of native Muslim Europeans added fuel to the surging anti-Muslim sentiment in Europe. Unless there is a simultaneous effort by immigrants to better integrate in European societies and by the latter to show openness, tensions may become worrisome.

MUSLIMS IN EUROPE: THE CONSTRUCTION OF A "PROBLEM"

The presence of some 25 million Muslims in the 28 countries of the European Union is currently sparking debate, controversy, fear and even hatred. Never before have we witnessed such a climate of mutual suspicion between Muslims and mainstream European societies. Public opinion surveys in Europe show increasing fear and opposition to European Muslims, who are perceived as a threat to national identity, domestic security and the social fabric. Muslims, on the other hand, are convinced that the majority of Europeans reject their presence and vilify and caricaturise their religion.

**SURVEYS SHOW INCREASING
FEAR TOWARDS EUROPEAN MUSLIMS,
WHO BELIEVE THAT EUROPEANS
CARICATURISE THEIR RELIGION**

Such a misunderstanding is worrisome as it fuels dangerous Islamophobia, on the one hand, and radicalisation, on the other. European states are alarmed by these developments since they place harmonious cohabitation in jeopardy. Consequently, they have taken measures and enacted laws to combat extremist forces, curb radicalisation and improve Muslims' integration into the receiving countries.

However the situation is not simple. How could Europe encourage Muslim integration into secular states? Are radicalisation and extremism linked to economic marginalisation? Are they a product of a narrative that divides the world into two camps: us and them? Is extremism is only faith-based? If so, why did an extremist Norwegian kill, in 2011, dozens of his compatriots who were not Muslims? European states continue to grapple with these thorny questions without being able to devise a coherent response.

My arguments are that Muslims are settling permanently in Europe, that the vast majority want to live in peace, that European integration

policies have been erratic and inconsistent and that only a tiny minority of Muslims are engaged in radical activities. I also argue that in addition to faith-based radicalisation (religiously-motivated groups or individuals), there is an identity-based extremism (far-right parties), which is no less dangerous, and Europe should confront both problems by drying up the ideological sources of extremism. Finally, I make the point that Islamist radicalism in Europe remains marginal. This radicalism is not the result of failed integration, but rather local-global connections, which are linked to identity rupture and the exposure of young European Muslims to the unbearable images of destruction and violence in many Muslim countries, mainly those in the Middle East. Whether this violence is the result of Western intervention, such as the invasion of Iraq and the Israeli offensives in Gaza, or the result of the assault of Muslim regimes on their own populations, such as in Iraq or Syria, is irrelevant.

The Muslim population in the EU is mainly linked to migration dynamics

The presence of Muslims in Europe is not a new phenomenon. Starting in 711, Muslims conquered large swathes of Northern Mediterranean shores and set up Caliphates and Emirates mainly in the Iberian Peninsula for more than seven centuries. The fall of the last Emirate of Granada, in 1492, marked the end of Muslim political rule in Spain. Later, the Inquisition led to the very expulsion of Muslims, Sefardi Jews and converted Spaniards.

Almost concomitantly, in the Eastern Mediterranean, Islamised Ottomans defeated the Greeks, ejected them from Anatolia, took Constantinople (1453), which later became Istanbul, and conquered the Balkan region. Balkan States achieved their independence in the 19th century, before the dismantlement of the Ottoman Empire in the aftermath of the First World War. Muslim Bosnians, Albanians and Kosovars have not been expelled, and nowadays, they constitute Europe's indigenous Muslim population.

This article specifically tackles the issue of Muslims who immigrated to Europe after the Second World War and who now represent the bulk of the European Union's Muslims. Indeed, as European states started their reconstruction at the end of the war, they resorted to their ex-colonies to offset labour shortages. Hundreds of thousands of North Africans, most of them Berbers from traditionally rural areas of the

Rif Mountains, immigrated to France. Indonesians and Surinamese went to Holland, and Indians, Pakistanis and Bangladeshis entered the United Kingdom. The case of Germany is more specific since it has been the main destination of Turkish and Kurdish labour immigrants, although Turkey was not a German colony, but simply an ally in the First World War.

Obviously, not all labour migrants in the 1950s were Muslims, but given that the immediate belt surrounding Europe consists of Northern African and Middle Eastern Muslim countries, most of which have been colonised by European countries, it is no wonder that the majority of foreign labour migrants in Europe are Muslims. Those migrants left their countries in the 1950s and 1960s in search of work, social advantages and higher wages. The vast majority of these first generation migrants were young. They did not intend to settle permanently but hoped to accumulate sufficient savings, which would allow them to build a house, open a shop, buy a taxi, etc. and prepare a winning return to their home country. Since their stay was seen as temporary, these migrants, whether single or married, sent home almost 80% of their salaries to their families as remittances.

On the whole, these migrants contributed to the economic boom of many European states as they built roads and railroads, worked in the coal mines, cleaned streets and offices and, on the whole, did the jobs that Europeans were reluctant to do. Until 1970, there was neither a migration "problem" nor, a fortiori, a Muslim "problem" in Western Europe. Migrants were largely invisible in public places. They had no specific demands related to their religion as they did not intend to settle permanently, and they did not suffer from discrimination or prejudice as they were contributing to the well-being of European societies. There was no Islamophobia, although class racism did exist. In summary, migration was seen as a gift, not as a burden and even less as a threat.

In the early 1970s, the European economic boom came to a halt. The oil crisis of 1973 was the "straw that broke the camel's back", as the Arabs say. From that year on, European states enacted laws restricting regular migration but, at the same time, relaxing restrictions of family reunification. Immigrants hurried to bring over their families. These measures produced significant quantitative and qualitative effects. Statistically, the sheer size of the migrant population increased considerably in the 1970s and the 1980s. Economically, the number of workers among migrants dwindled drastically. Sociologically, there has been a

process of feminisation of the migration stocks while the presence of children inaugurated the second-generation phase.

All of these transformations produced unforeseen effects. First, the arrival of families from rural areas changed the immigrants' attitudes towards religious and cultural values. While temporary workers accepted "basement mosques" (*les mosquées des caves*) as a temporary solution to their prayer needs, the sedentarised immigrants asked for mosques and minarets. Secondly, the visibility of migrants in public space increased (veiled women, children going to school, etc.) Thirdly, immigrant families congregated in certain areas where they could find informal support structures and social networks. Families could thus keep in constant contact with their home countries by phone, internet or travel.

THE EU FACES A DAUNTING CHALLENGE, SINCE DEFENSIVE AND PROTECTIVE POLICIES IN THE MEDITERRANEAN DID NOT SUCCEED IN DETERRING ASYLUM SEEKERS, REFUGEES AND MIGRANTS

Finally, in the last three decades, marriage immigration peaked as the first and second-generation youth entered the marriage market. To take just two examples from Holland, between 1995 and 2003, Turkish marriage immigration peaked at 4.000 per year while Moroccan marriage immigration hit a record of 3.000 per year. Marriage immigration ensured continued, high fertility among the immigrant population as many second-generation immigrants prefer to marry spouses from their parents' home countries, who are young, traditional and virgin, rather than marrying a fellow second-generation immigrant like themselves. Obviously, marriage immigration has maintained the migration dynamic intact.

This significantly differentiates Muslim immigration to Europe with the Muslim expatriation in the USA on two grounds. First, Muslim migrants in Europe are, at most, a two to four hour flight from their home countries, while the distance between the USA and their home countries gives little choice but to integrate into the American "melting pot". Secondly, as Robert Leiken argues, "unlike the American Muslims who are geographically diffuse, ethnically fragmented and generally well-off, Europe's Muslims gather in bleak enclaves with their compatriots". Finally, the rate of mixed marriages in the USA is higher than in Europe.

This differentiation explains, to a certain extent, why Islam and Muslims in the United States are not a major concern while in Europe, at least since the 1980s, migration has become an issue, mainly because two-thirds of the migrants are Muslims. Indeed, everything related to Islam in Europe became a cause of anxiety: the mushrooming of mosques, women's veils and new religious fervour. It is in this context that far-right parties emerged and started to garner support in presenting migration as a threat. In reaction, Western European states began erecting new defences against the much mediatised threat of mass immigration by strengthening direct immigration control through severe visa regimes, internal surveillance and outsourcing border control on the external borders of the EU.

But all *cordons sanitaires* put in place could not stop or even slow the flow of irregular migration from southern countries. The long land border and coastlines of many European states hindered the effective policing of frontiers. In many cases, land and maritime controls only served to displace the routes of migration, making the travel longer and riskier and making traffickers richer as they showed their ability to adapt to the new regulations. Southern European countries were particularly exposed to irregular migration. At the beginning, Spain, Italy, Greece and Malta were transit countries and "stepping stones" for other destinations. But later, in the 1990s, they became countries of final destination for waves of irregular migrants.

Thousands of these irregular migrants lost their lives in an attempt to reach the perceived "European Eldorado". But hundred of thousands made it. They lived in precarious situations, as illegals, irregulars or *indocumentados*, but over the years, they have been legalised, in what Spain has called *regularizacion*, and Italy, *sanatoria*. In this respect, the case of Spain is emblematic as the number of *asentados* Moroccans, to take just one example, jumped from 50.000 in 1992 to 750.000 in 2015, which is a multiplication by 15. The same happened in Italy. The so-called "fortress of Europe" proved to be an exercise in fantasy. Undoubtedly, restrictive visa regimes affected legal migration but triggered irregular migration. Externalised control of migration and detention camps have not discouraged migrants. It is, therefore, not surprising that today, there are more than one million Muslims in Spain and a similar figure in Italy.

The problem has become more acute recently with the substantial increase of asylum seekers from impoverished or devastated countries

in the South, like Syria, Iraq, Afghanistan, Eritrea and even the Gaza Strip. While the Mediterranean is being transformed into a cemetery of drowned dreams, European countries are bickering about the cost-sharing of land borders and coastline policing and about distributing asylum seekers among European states.

Let us recognise that the challenge is daunting since defensive and protective policies in the Mediterranean did not succeed in deterring asylum seekers, refugees and migrants. European leaders found themselves caught between alarmed rejectionists, who invoke financial costs, security risks and social challenges and who ask for more muscular policies to stem the flow of mass immigration, and vocal refugee advocates, who posit the problem in terms of human dignity and the necessity to protect, recalling the example of Jordan and Lebanon, which are hosts to more than a million Syrian refugees each.

There is no doubt that the situation is difficult to manage. On the one hand, in face of the magnitude of the human tragedy, Europe cannot remain blind, deaf and with its arms crossed. On the other, it cannot leave its doors wide open to the misery of the world. This historical review clearly shows that through natural increase and new migration flows, in all their forms, the Muslim population is increasing rapidly in the European Union to the bewilderment of European states, caught off guard by the sheer numbers of refugees and asylum seekers. One can easily bet that the anxieties which surround the migration issue will not vanish as long as neighbouring Muslim countries remain feverish and destabilised and as long as European Islam is constructed as a problem.

Who are the Muslims in Europe?

Muslims in Europe fall into six categories:
1) Indigenous Muslims who have lived in Europe for many centuries, mainly in Bosnia, Albania and Kosovo, where Islam is a foundational element of their history, but also in Romania and Bulgaria, where they are a native minority, and Poland and Crimea, which is home to an old Tatar Muslim population.
2) Students and businessmen who come from Muslim countries. In France alone, there are some 70.000 North African students, and London is the capital of Arab and Muslim businessmen.

3) Muslims who entered initially without restriction, such as the Commonwealth citizens in Great Britain, Algerians in France or Surinamese and Indonesians in Holland.
4) Muslims who came to Western Europe, in the 1950s and the 1960s, as labour migrants.
5) European Muslims who are born in Europe to migrant parents.
6) And, finally, asylum seekers and refugees, whose numbers have substantially increased in the last three years. From January to August 2015, 235.000 refugees poured into Europe, the majority of them from neighbouring Muslim countries.

We don't include in these categories the 30 million Muslims of the Russian Federation, which includes many Muslim countries. In this ar-

EUROPEANS GREATLY OVERESTIMATE THE SHARE OF MUSLIMS IN THE TOTAL POPULATION: THE FRENCH ESTIMATED IT AT 31% IN FRANCE , WHILE IT DOES NOT EXCEED 6%

ticle, we shall deal only with Muslims of migrant origin in the European Union. They fall into three categories: a) those who are registered as foreigners; (b) those who acquired the nationality of the country where they live and work; and, finally, (c) those who are native European,

On the whole, I estimate that there are some 23 million Muslims living in the 28 European states, three-quarters of whom are already European citizens by naturalisation or birth. To these numbers, we may add some 2 million Muslims who migrated illegally and have not yet been officially legalised. This makes a total of 25 million Muslims, some 5% of the total European population.

These numbers are not threatening. And yet there is a widespread sentiment that Europe is being invaded by a growing Muslim population that cannot or will not be assimilated and that dreams, as blogger Agnon de Albatros argues, of "implementing Shari'a law in Europe and making this infidel continent part of the domain of Islam" (www.albatros.org). Thus, the Muslim demographic is becoming a central theme of many books, in which Muslims are perceived as posing "the most acute problems on account of their religion and their numbers" (Christopher Galdwell). Right wing parties are not saying anything else. "Against the Islamisation of Europe" was the slogan chanted by the Pegida German protesters in Dresden, in 2015.

Is there a reason for concern? For many Europeans, the answer is yes, not only because of the increasing number of Muslims in Europe, but also because Europeans greatly overestimate the share of Muslims in the total population. A 2014 poll from the Social Research Institute found that French respondents estimated the percentage of Muslims in France at 31%, while the real percentage does not exceed 6%. Germans gave the percentage at 19% in spite of the actual 4%.

Some demographers are not less anxious. They recognise that the total Muslim population is projected to jump from 25 to 35 million between 2015 and 2035. They invoke both internal and external factors. Among the internal factors, they pinpoint the higher fertility rates among Muslim Women and the fact that Muslim population is younger: people under the age of 30 represent 50% of the Muslim population in 2015, compared with about 33% in the non-Muslim European population. They also argue that Muslim women marry in larger numbers and at younger age and divorce less than their non-Muslim counterparts.

To these internal factors, one must add net migration influx. In spite of its economic crisis, the EU remains a migration magnet for Arabs, Sub-Saharan Africans, Asians, etc. Recent events in the Mediterranean, in 2015, clearly indicate that both "push" and "pull" factors are still at play. As a matter of fact, current migration pressures are not caused exclusively by external push factors, such as poverty, conflict and repression. The current focus on push factors diverts attention away from significant pull factors, such as the very fact that the European countries are already hosts to significant immigrant or immigrant-origin populations, opening new channels for migration. As Esther Ben David puts it, "the more people emigrate from a certain town or village, the more likely it becomes that their neighbours [...] will follow in their path".

To this reality, one has to add travel accessibility, expanding international networks and the fact that there is still demand at the upper end of the labour market for highly qualified professionals, and at the lower end, there is demand for workers in unregulated sectors of the economy, which depend on a cheap and exploitable workforce to remain competitive. Clearly, migration pressures from Muslim and non Muslim countries will not diminish any time soon. Yet, in spite of the projected increase in Muslim demographics in the EU, in no European country will the Muslim population exceed 10% of the total population by 2035, with the exception of France and Belgium.

European integration policies and the segregation realities

From the very beginning of labour migration, in the 1950s and 1960s, European states have adopted different policies with respect to managing their immigrants and integrating them. Some countries, like Germany, did little in the first decade to facilitate the integration of its migrants. It viewed them as temporary "guest workers" (*geist arbeiter*). The United Kingdom and the Netherlands embraced the notion of multiculturalism, by which the governments sought to maintain distinct cultural identities and customs. France, by contrast, professed a policy of assimilation by imposing its model of secularism.

> THE SOCIAL UNREST WAS ALMOST CONCOMITANT
> WITH THE TERRORIST ATTACKS IN MADRID AND
> IN LONDON, SERVING AS EYE-OPENERS AND QUES-
> TIONING OLD INTEGRATION MODELS

Whatever the model, the immigrants, as I said earlier, gathered in ethnic neighbourhoods, called *banlieues*, in France, and suburbs, in England. After the economic downturn of the 1970s, and the closure of mines and factories, immigrants became the first to bear the brunt of the crisis. Unemployment skyrocketed, leading to widespread riots in the United Kingdom and in France (*la révolte des banlieues*, in 2005 and 2007). Although a large number of the rioters appeared to be Muslims, most observers agree that urban segregation and the lack of opportunity and upward social mobility were key factors behind the unrest. The social unrest was almost concomitant with the deadly terrorist attacks in Madrid, in 2004, and in London, in 2005. France had already suffered similar terrorist attacks in 1997. Holland and Denmark were not spared, with the assassination of filmmakers and cartoonists.

These tragic events served as eye-openers. Old integration models came under attack. Multiculturalism in the UK and in Holland has been questioned, and gradually, the policy has been abandoned, and governments have stepped up their efforts to better integrate their Muslim communities. Germany relaxed its naturalisation policy and allowed Turks and Kurds to acquire German nationality. Only France stuck to its secular model.

Undoubtedly, in the last 15 years, the issue of migration and integration policies has dominated the political and intellectual debate, with

two questions gaining particular momentum: Are European Muslims discriminated and segregated? And, if so, should the European states be held responsible? The answer obviously varies according to ideological affiliations and political stands, but let's stick to the facts. As the bulk of Muslims are labour immigrants or native-born of immigrant origin, they are poorer than the national average, and they often live in segregated neighbourhoods. However, it is also true that poverty is often linked to poor parental control, dropping out of school and the lack of opportunities. In addition, there was an alarming development in the 1980s. The migrants, whose problems were seen as a consequence of their socio-economic status during the preceding decades, started to be perceived as culturally different.

The apparent failure to integrate has been viewed in cultural terms, that is, as failure to adapt to European culture and to adopt European norms, values and styles. In other words, Muslims do not integrate because they are Muslims, and Islam is perceived as incompatible with Western culture and values. Thus, it is no surprise that Islam has been constructed as a problem.This shift in perception is synchronic with the advent, since 1979, of the so-called Islamic revival. Indeed, in the 1960s and 1970s, the "other" was a labour migrant from Turkey, Morocco, Algeria or Pakistan, etc.; however, in the 1980s, these migrants became trapped in one communitarian cage: Islam.

However, there is no one Muslim community in Europe; this is a fantasy. Muslims come from different countries, live in different countries and speak different languages. They are immensely divided in their faith, in their ethnicity and also in their relation to religious practice and to the role religion plays in their lives. It is therefore erroneous to remove the migrant from his own condition. A migrant born to Algerian migrant parents with French nationality is first of all French. So why should we encage him in a Muslim community supposedly closed and fixed forever? Speaking constantly of Muslim community means that Islam eclipses the individual Muslim as the presumed actor of social and political change. In other words, as Sami Zemni, from the University of Gent, argues very aptly, "It is not Muslims who produce history, but Islam that conditions the behaviour and identity of Muslims. [...] In the end a Muslim is an automatom, endlessly perpetuating the religious prescriptions of Islam". Such a postulate is both erroneous and dangerous, not only because Islam assumes the role of an internal enemy in a societal cold war between European societies and their Muslims, but also

Two young Muslim women in Berlin.

because the integration issue is disconnected from the socio-economic context and becomes the sole responsibility of Muslims.

Happily enough, many Muslims are fighting their way into European societies and gradually integrating their norms. Many success stories of Muslims in all sectors, from economy to culture, provide ample proof that there is no Muslim fatality. Muslims with higher education and higher wages—like the 300.000 Arabs of the Middle East residing in London or the Lebanese expatriates in Paris—do not live in segregated communities and are well integrated in society. Unfortunately, the bulk of Muslims in Europe are labour migrants or sons of labour migrants who are badly equipped to better integrate into European societies, not because of Islam, but because of their socio-economic condition.

Should we, therefore, incriminate official policies for the lack of integration? I believe so, to a certain extent. There have been shortcomings and even failures in France and elsewhere. Urban policies have been inadequate. Employment incentives have been limited and job discrimination insufficiently addressed. All of these shortcomings are now under review, and measures are being taken, unfortunately, up until now, with scarce results.

Muslim youth of Europe, radicalisation and violence

European states recognise that the vast majority of Muslims in Europe do not engage in violence or terrorist activities, but, at the same time, they admit the existence of small cells or "lone wolves", which are considered to be radical Islamists, prone to violence and with links to Al-Qaeda or ISIS (the Islamic State). Personally, I don't share the theory of the lone wolves because behind each terrorist, there are groups which provide logistics, ammunition and training. But thorny questions have to be raised: How does a native European Muslim become radicalised? Why?

> THE ASSERTION THAT ISLAM IS THE RELIGION
> OF THE SWORD, AND THAT OTHER RELIGIONS,
> SUCH AS CHRISTIANITY, JUDAISM OR EVEN BUDDISM,
> ARE RELIGIONS OF PEACE IS GROSSLY MISLEADING

The radicalisation of some home-grown Muslim youth can take place in radical mosques, in prison, during long stays in Muslim countries or through the internet. The 2004 Madrid bombing, which killed 192 people, was carried out by North Africans, mostly Moroccans, who were residents in Spain, but some, reportedly, had links with a Moroccan terrorist group affiliated with Al-Qaeda. Three of the four perpetrators of the 2005 London attacks were home-grown, second-generation British Muslims trained in Pakistan. Merah, the French terrorist who killed three soldiers and three Jewish youth in Toulouse, and those who assassinated Charlie Hebdo's cartoonists and Jewish shoppers were second-generation French Muslims of Algerian descent. Moreover, some young Muslim jihadists who join ISIS in Syria and Iraq are born and educated in European countries, and many of them are even European Muslim converts.

Why, then, does a tiny minority of Muslim European youth engage in violence? Answers tend to differ significantly. One school of thought adopts a culturalist view, which links terrorism, jihadism and extremism to the Islamic religion itself. For its proponents, violence is consubstantial to Islam since most of the modern conflicts are taking place in Muslim countries and since the majority of terrorist groups are Muslims, such as al-Qaeda, ISIS, Boko Haram, Somali Al-Shabab, etc.

A second school of thought, considered to be realist, asserts that the failure of European governments to fully integrate Muslim communities

leaves some European Muslims more vulnerable to jihadist ideologies. Some young people feel so left behind and alienated that they turn to Islam as a badge of cultural identity. In a recent interview, Salman Rushdie explained the following: "Give a Kalachnikov and a black uniform to an unemployed youth, who is vulnerable and disadvantaged, and you confer to him a power" (Le Vif Express, 14-20, August 2015).

Clearly, these arguments are not convincing. The assertion that Islam is the religion of the sword (*religion de l'épée*), and, by contrast, that other religions, such as Christianity, Judaism or even Buddism, are religions of peace (*religions de la paix*) is grossly misleading and historically erroneous. For centuries, religious wars split European countries apart. Nowadays, Buddhist monks organise mass killings and deportations of Muslims in Myanmar, and Jewish extremists colonise Palestine and abuse secular Jews in the name of God.

But neither is the other argument totally credible. First, there are millions of immigrants who suffer from segregation, discrimination and lack of opportunities but who do not engage in terrorist activities. Secondly, some terrorist attacks, like those carried out in the US in 2001, were perpetrated by well-educated and economically comfortable individuals. And thirdly, among those who join ISIS in Syria and Iraq, one can find entire families or even converts.

In my humble opinion, four factors might help fully grasp the gradual process of radicalisation. The first is identity-based radicalisation. For many young Muslims of migrant origin, whether left behind or fully integrated, there is a widespread feeling that they are not fully accepted as fellow citizens. After three generations, a French citizen of Algerian descent is still perceived as an Algerian and a Muslim. He may never have visited Algeria, and he may be a non-believer, but he is still perceived as an alien. Clearly, some Muslim youth feel torn apart between a country of origin they don't know and their home countries (France, Belgium or Germany) that turn their back on them. It is no small wonder that some youth curse the country in which they are born and raised.

The second factor is socio-economic based radicalisation. This form of radicalisation is related to the socio-economic grievances harboured by second and third-generation Muslims. Undoubtedly, the lack of opportunities is linked to objective failures like poor education and training. Others are linked to job discrimination. For example, a friend of mine, a young Algerian Muslim and an excellent engineer, sent an application for a job vacancy and signed the letter with his true name. He received

an answer that the job was no longer vacant. He sent the same letter with some slight modifications, including his westernised name, and he was summoned for an interview. This happens frequently and feeds the sentiment that university studies are not necessarily a ladder of social mobility in the case of many Muslims. In the long run, this may sow the seeds of hatred.

THE MINORITY MUSLIM YOUTH RADICALISATION IN EUROPE HAS MORE TO DO WITH TODAY'S GLOBAL-LOCAL CONNECTIONS RATHER THAN WITH FAILED INTEGRATION

The third factor is the search for a mission. In many cases, we saw terrorists who became suddenly, fervently self-radicalised and fanatically religious, breaking off from their families and friends and embodying what Oliver Roy called a "generation rupture". These self-radicalised youth pursue a fantasy of heroism, which I called the passage from "zero to hero", or, the passage from anonymity to celebrity. "We have avenged the Prophet Muhammad", shouted the killers of the Charlie-Hebdo cartoonists, in January 2015.

This self-radicalisation is partly due to persistent, socio-economic challenges, but also to the exposure to social media and to satellite television, some of which is generously financed. It is no secret that some petrodollar-financed satellite channels propagate a literalist reading of the Koranic texts, indirectly contributing to the forging of a radical mindset that is prone to see the world with binary logic: Islam versus the Other, Good versus Evil. Such logic leads to fanaticism and the rejection of negotiation, dialogue or compromise. Here lies the difference between a religious radical terrorist who doesn't negotiate and a nationalist terrorist who does.

The fourth factor is geopolitical based radicalisation. This relates to the constant exposure that young European Muslims have of the sufferings inflicted by the West and its regional allies on fellow Muslims in many parts of the Arab and Muslim worlds. It is not fortuitous that Al-Qaeda and later ISIS increased their activities in Iraq after the American invasion in 2003. The three Israeli offensives in Gaza (2007, 2012 and 2014) produced dramatic resentment among Muslims against Israel and its western allies, mainly the Americans, who were accused of having double-standards for standing by Israel, in spite of

its continuous breaches of international law and violations of human rights. But the belief that those terrorists who orchestrated the horrific attacks in Madrid, London and elsewhere were avenging the suffering of the Palestinians is wrong and misleading. Palestine has been more of a justification than a source of radicalisation for some young European, radical Muslims.

All of these forms of radicalisation may converge or not. We have seen cases of native European converts engaging in terrorist activities. The September 11th terrorists were highly skilled and affluent. Many terrorists are not religious but suddenly become fanatically religious in a sort of informal religious radicalisation. We have also seen cases of radicalisation in countries, such as Holland, which have done much to accommodate Muslim immigrants (affirmative action hiring policy, free language courses, etc.) As a matter of fact, Mohamed Bouyeri, who murdered the filmmaker Theo Van Gogh, was born in Holland and was collecting unemployment benefits.

These facts do not totally invalidate the relationship between failed integration and radicalisation. But what seems unquestionable is that the minority Muslim youth radicalisation in Europe has more to do, as Anna Triandafyllidou argues, "with today's global-local connections rather than with failed integration or ethnic penalty".

The Islamophobic construction of the Muslim "problem"

Let us reiterate an undeniable fact: since 711, Islam and Muslims have obsessed and captured the European imagination, first as conquerors, then as a competing religion and finally as the internal "Other" with the new waves of migration. Thus, Islamophobia as a fear or a prejudiced opinion of Islam and Muslims is not a new phenomenon; it would suffice to read the thousands of books on "Islam and Europe" since the Islamic conquest of the Iberian Peninsula until now. During the last centuries, we have had polemists and historians who described Islam as the "mirror of Europe"— it is what Europe is not (or no longer): fanatic, violent, intolerant and misogynous. In such an essentialised image, Islam has been perceived as a homogeneous mass, static and unresponsive to change. Edward Said, in his book *Covering Islam*, has shown the intellectual fallacy of such a postulate, as it falls in the trap of regarding Islam monolithically and does not grasp the complex heterogeneity of a historical phenomenon.

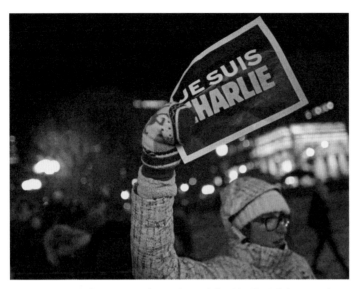

Demonstrations of support to the workers of the *Charlie Hebdo* magazine.

What is really intriguing and somehow disturbing is that Islamophobia is not fading in the 21st century. On the contrary, it is gaining salience. Why? There is no consensus among intellectuals about the factors that trigger this modern Islamophobia. Many intellectuals, both Muslims and non-Muslims, are convinced that Islamophobia is the natural outcome of extreme violence in Muslim countries, anti-Western terrorist attacks, reprehensible behaviour of certain groups of migrants and the radicalisation of some young native European Muslims.

Other intellectuals claim that the West's disdain of Islam and Muslims has historic roots and is ingrained in Europe's culture of superiority. Others go even further by arguing that there is a well-structured and well-financed Islamophobia industry that has managed to capture public opinion without serious contestation. In this regard, some media, including electronic media, are pinpointed as major contributors to the surge of Islamophobia. This argument has been brandished by John Richardson's book, *(Mis)representing Islam: racism and British broadsheet newspapers* (2004), and by Jack Shaheen's article, "How the media created the Muslim Monster Myth" (Nation, July 2012).

All of these claims are debatable as they oversimplify a complex issue. First, there is plenty of cruelty in the world, and religiously-motivated violence has erupted in many places, not only in Islamic countries. But

one has to admit that Islamist violence has surpassed all other forms of faith-based violence, not necessarily in terms of magnitude, but in terms of the "theatrilisation" of jihadi violence through social media and the spill-over of terrorist attacks in Europe itself (see the book published by the Transatlantic Academy: *Faith, freedom and foreign policy*, NY, 2015).

The argument that Western vilification of Islam is inherent to Western culture is also a gross exaggeration, as it considers the West as a monolith incapable of empathy and trapped in its closed views of Islam and Muslims. This is historically erroneous since many European intellectuals have come to the defence of Muslims in the past and in present times (see Edwy Plenel's book: *Pour les Musulmans*, 2014) and have even highlighted the magnificent contribution of Islam to world civilisation.

While speaking about an Islamophobic industry may suppose that there is a sort of intellectual and political conspiracy against Islam and Muslims, this is something I am not fond of. What is sure is that Islamophobia is related to identity politics since it allows its adherents to construct their identity in opposition to a negative image of Muslims, their culture and religion. The permanent settlement of Muslim migrants, or Muslims of migrant origin, in Europe has brought the "outside inside" and has transformed Islam and Muslims into a domestic issue and an internal threat. This change has been exacerbated by the Iranian Fatwa attacks against the novelist Salman Rushdie, the riots in the suburbs of France, the terrorist attacks, the cartoon controversy, the assassination of Dutch filmmaker Theo Van Gogh and the latest attacks against Charlie Hebdo's cartoonists.

In a context in which European states are facing an identity crisis, an economic slump and high rates of unemployment, all of these events could only rekindle anti-Islamic sentiment. Europe's Islam has become a scapegoat and a scarecrow. It is not surprising, therefore, that Islam's critics among European intellectuals are becoming best sellers: Oriana Fallaci, in Italy (*La rabbia e l'orgoglio*, 2001), Thilo Sarrazin, in Germany (*Deutchsland schafft sich ab*, 2010), Houellebecq, in France (*Soumission*, 2015), Christopher Caldwell (*Reflections on the revolution in Europe: immigration, Islam and the West*, 2009) and Bruce Bawer (*While Europe slept: how radical Islam is destroying the West from within*, 2006) in England and many others.

At the popular level, anti-Islam sentiment is also dramatically increasing, as revealed by a special study on Islam by Bertelsmann Foundation (2015). Taking Germany as a case study, the 2014 public opinion survey

shows the following alarming percentages: 57% of Germans believe that Islam poses a threat; 61% are convinced that Islam is incompatible with the West; 40% say that "because of Islam I feel as a stranger in my country"; and 24% think that Muslims should not be allowed to immigrate to Germany. An October 2012 YOU GOV survey in England also revealed that 49% agreed that there would be a clash of civilisations between Muslims and native white Britons.

These percentages are quite telling. Muslim countries would be ill-advised to ignore them because they are also responsible for the degradation of the image of Islam and Muslims. They cannot simply shun their responsibility by sidestepping the issue and suggesting that Islamophobia is a sort of incurable Western illness or that Islamist terrorists and jihadists, such as the European-native jihadists, Al-Qaeda, ISIS, BOKO HARAM, etc., do not represent real Islam and even tarnish the image of Islam, which is a religion of peace. This argument is politically correct, but it is self-serving and not credible. After all, radical Islam is the religious form through which a particular kind of violent political rage expresses itself. It is somehow the "voice of protest" against the states that failed to live up to their pledges, against the prevailing acquiescence and anomie of Muslim societies and against the ruling elites who harnessed religion in the service of political power.

Thus, instead of blaming the West for its hatred of Muslims, Muslim countries should ask themselves this difficult question: What went wrong in terms of political participation, economic efficiency and religious education? Why does such a destructive, nihilistic rage come from within the Muslim community? Why do some rich Arab countries finance and export fundamentalist movements while keeping a tight grip on protest and dissent at home? Unless these questions are correctly addressed, it will be arduous to uproot radical ideologies, to stifle religious violence in the name of God and, consequently, to dampen the appeal of the Islamophobic discourse.

Counter-radicalization and de-radicalization in European policies

Since the first terrorist attacks in Europe, strategies have been devised, specialised study centres have been set-up and policies have been adopted to counter violent extremism. The array of policies includes, among other things, the promotion of Muslim integration in European

countries by establishing structures for dialogue between representatives of Islam and the governments. In 2003, for example, France established the French Council of Muslim faith (*Le Conseil Français du Culte Musulman*), Muslim ministers were appointed to government cabinet positions and a new policy for the suburbs (*Une nouvelle politique pour les banlieues*) was adopted, among other actions.

ANTI-ISLAM SENTIMENT IS DRAMATICALLY INCREASING, AS REVEALED BY A SPECIAL STUDY ON ISLAM

For decades, Germany perceived its migrants as temporary guest workers and showed no hurry in facilitating their integration. Naturalisation was restricted until the 1990s. But a law passed in 1999 allowed second-generation foreigners to apply for citizenship. A 2005 Immigration law provided funding for mandatory integration courses. In 2006, the German government inaugurated the National Conference on Islam, and in 2007, the Federal Government adopted the First National Integration Plan, focusing on the promotion of German values of equality and civil engagement. In July 2010, the German Interior ministry announced the launch of an exit program to provide assistance to violent radicals seeking to turn their backs on extremism. Although Germany escaped large-scale terrorist attacks like those of Madrid, it has not been totally immune to terrorism. On March 2, 2011, a Muslim Kosovar opened fire on a bus carrying US soldiers and killed two of them.

Holland took a series of measures to promote the integration of its migrants. Already, in 1998, the government enacted the Newcomers Integration law. Contrary to France, veils have not been prohibited, but the use of the full veil (burka) by educators and government employees has been banned. A Muslim-oriented broadcasting organisation was set up in 1986. A Muslim and government contact group has been put in place to foster dialogue. In June 2009, the government passed a law on municipal non-discrimination services. In the same year, there were seven Muslim members of the House of Representatives, one in the Senate, one in the Cabinet, and the Mayor of Rotterdam was also a Muslim. Like Germany, Holland has not been the theater of large-scale terrorist acts, but in May 2002, Pim Fortuyn, an anti-Islamic critic, was gunned down, and in 2004, the filmmaker Theo Van Gogh was stabbed to death.

Spain has been a transit country for illegal migration and, after 1990, became a country of final destination. Most Muslims in Spain are Moroccan Arabs and Berbers who gained a living in various booming sectors. Given the vicinity to Morocco, its southern neighbour and economic and fishing partner, Spain generously gave legal status to the vast majority of illegal Moroccan immigrants. Yet, in March 2004, Spain suffered the worst terrorist attack in Europe.

Spain's reaction could have been harsh, but, on the contrary, the media and government officials showed restraint, avoiding the stigmatisation of all Muslim immigrants. In 2006, a forum for the social integration of migrants (*Foro para la integracion social de los inmigrantes*) was launched, and over the period of 2007 to 2010, a Strategic Plan for Citizenship and Integration was adopted and was allocated $2 billion Euros for programs in education, employment, housing, social services, women and youth. The government liaises with the Spanish Islamic Commission (CIE), which officially represents Spain's Muslims and which coordinates two major Muslim Associations: the Spanish Federation of Islamic Religious Groups (FEERI) and the Union of Islamic Communities. A split in the CIE led to the formation of the Spanish Islamic Council.

Although the policies related to immigration, integration and counter-terrorism are primarily the responsibility of European states, the EU has not remained on the side lines. In May 2004, it published a Handbook on Integration. In September 2005, it adopted a Common Agenda for Integration. A Special Fund for the Integration of Third-Country Nationals was launched in 2007, and in 2009, a European Integration forum was established. These are only a few examples of European states' integration policies and the EU's measures. Whether these policies and measures have been successful or not goes beyond the scope of this article. What is alarming, however, is that all integration policies did not prevent some young Muslim radicals from perpetrating horrific violent attacks in European countries and thousands from joining the fighting groups such as ISIS or Al-Qaeda.

Thus, the focus of states' policies is now shifting towards de-radicalisation and counter-radicalisation. In 2005, the EU set the tone by adopting a wide counter-terrorism strategy based on four types of action: Prevent, Protect, Pursue and Respond. In the recent years, this counter-terrorism strategy became the pillar of all European states' policies. Grosso modo, all European states have adopted a wide array of measures in response to terrorism and to radicalisation. These include

stricter security and surveillance; greater efforts to prevent radicalisation in prison, in Mosques or through Internet; the promotion of diversity training in schools; the re-assertion of the secular character of the State; the training of local imams; and the re-insertion of returnees from combat zones. All of these measures move in the right direction. But they may prove insufficient if European states persist in ignoring some disturbing facts.

The first fact is that the power of ideas has to be taken into account. Islamist radicalisation is the natural offshoot of the fundamentalist ideology that is infiltrating the social media, invading conservative mosques, and mushrooming through generously-financed TV channels. As long as European countries tolerate, in their midst, radical imams who preach intolerance and hatred, accept that foreign Muslim countries continue to finance the construction of Mosques, exert structural influence by reinforcing close religious ties with their migrants and look to the other side when conservative Muslim regimes crackdown on their reformists, the fight against radicalisation may prove an uphill endeavour.

The second disturbing fact is that it is grossly misleading to assert that only a tiny minority of Muslims back the actions of extremists and jihadists or that groups, such as ISIS, are completely unrepresentative. The reality speaks to the contrary. Radicals enjoy sufficient support not only because they are perceived as an Islamist vanguard that refuses Western dictates, but also because many Muslims still dream of returning Islam to its past glory. It suffices to read some religious school textbooks in Muslim countries to see the glorification of the Muslim past and how the West is portrayed as a crusader, infidel or *kafer* (unbeliever). The European Union can use its current policies, such as the European Neighbourhood Policy, the Union for the Mediterranean or EU-Gulf dialogue, to tackle these delicate matters.

The third disturbing fact relates to EU policies themselves. In its dealings with Mediterranean, Arab and Muslim countries, European policies have not been coherent. Very often, commercial or strategic interests eclipsed European values. After the democratic Palestinian elections of 2006, the EU did not recognise the legitimacy of the Hamas victory. After the eviction, by General Sissi of Egypt, of President Morsi, the first democratically-elected Egyptian president, the EU reaction was shy, at best. For decades, the EU turned a blind eye on the occupation and colonisation of Palestine by Israel, often described in European media as the sole democracy in the region. France and Britain took a leading

role in the military operations in Libya without any serious analysis, ex ante, of the possible dramatic consequences of the regime's implosion. For too long, the Iraqi Shiite-dominated government has been allowed to impose its sectarian policies without being reprimanded or punished. The Syrian regime has been allowed to destroy its country and slaughter its people, forcing millions to flee the country.

These few examples are only reminders that the fight against radicalisation at home and abroad starts by asserting the power of values and ideals in domestic and foreign policies. Communism was not defeated by the power of arms, but by the power of ideals. By the same token, fighting domestic radicalisation by security means only, or bombing ISIS into surrender and submission, is a sure path of failure.

Conclusion

The vast majority of Muslims in Europe are immigrants or sons of immigrants, and almost half of Muslims in Denmark and Scandinavian countries are political refugees. The bulk of the 235.000 immigrants who have crossed the Mediterranean since January 2015 are refugees and asylum-seekers. The number of Syrians, Iraqis, Afghans and Eritreans among them is ample proof that human tragedies are today the main drivers of forced migration. The European states are caught by surprise by the magnitude of the phenomenon and somehow concerned by the truth that the vast majority of the newcomers are Muslims who are perceived to be inflating and swelling the European Muslim population of 25 million, a number which already sparks fears in European societies.

The article examined the various stages of migration flows, from temporary labour migration to permanent settlements, and showed the gradual construction of the Muslim problem in Europe and the emergence of far-right anti-Muslim parties. It tackled the issue of radicalisation of some young European Muslims and discussed the de-radicalisation policies adopted by European states. The message which the article tried to convey is simple: Muslims are settling in Europe, and their numbers will increase in the years to come. Given this reality, European states should do their utmost to further their integration, and Muslims should contribute by showing their attachment and loyalty to their new home countries.

JULIA KRISTEVA is an author, psychoanalyst, professor emeritus at the University of Paris Elle 7 – Diderot and a titular member of the Paris Psychoanalytical Society. She is a Doctor Honoris Causa of numerous universities, Commander of the Legion of Honor (2015), Commander of the Order of Merit (2011), first laureate of the Holberg Prize and she was awarded the Hannah Arendt Prize and the Vaclav Havel Prize. She is the author of thirty works, among them: *Revolution in Poetic Language*, the trilogy of *Female Genius: Hannah Arendt, Mélanie Klein and Colette*, and the recent story *Thérèse, My Love*.

What does it mean to feel European? Does a European culture exist? This chapter will analyse the history, challenges and potential of the feeling behind this political entity defined by multilingualism, which, like a patient, is going through real depression, losing its image as a great power and finding itself mired in a deep financial, political and existential crisis. Having succumbed to the dogmas of identity to a criminal extent, the concept of a European "us" is emerging. Given this, Europe now faces a historical challenge: Will it be able to deal with the crisis of universal belief and build bridges between religions and cultures?

HOMO EUROPAEUS:
DOES A EUROPEAN CULTURE EXIST?*

Is Europe KO? On the contrary:
"Without Europe, chaos would reign". Why?

As a European citizen of French nationality, Bulgarian by birth and American by adoption, I am not insensitive to harsh critiques, but among them I hear a desire to grow a European identity and culture. Despite facing a financial crisis, the Greeks, Portuguese, Italians and even the French do not question their belonging to a European culture; they "feel" European. What does this sentiment—so obvious, apparently, that the Treaty

> EUROPEAN CULTURE COULD
> BE THE MAIN ROAD THAT LEADS
> EUROPEAN NATIONS

of Rome makes no mention of it—mean? It has only recently made an appearance on the political stage via initiatives backing European heritage, for example, but these lack a prospective vision. I believe European culture could be the main road that leads European nations to a federal Europe. However, this begs the question: What is European culture?

Which identity?

In contrast to the cult of identity,[1] European culture never ceases to unveil the paradox that identity does exist, both mine and ours, but it is infinitely constructible and de-constructible. To the question "Who am

* This text is largely taken from a talk given at the international symposium "Europe or Chaos", at the Théâtre du Rond-point des Champs Elysées, on January 28, 2013.
1 In the name of which the modern conscience, trying to clear itself, continues to wage, even today, wars that destroy freedom.

I?" the best European response is not certitude but a love of the question mark. After having succumbed to identity-focused dogmas, to the point of criminality, a European "we" is now emerging. Although Europe resorted to barbaric behavior in the past—something to remember and examine always—, the fact that it has analyzed its behavior thoroughly perhaps allows it to offer the world an understanding and practice of identity as a questioning inquietude.

It is possible to rethink European heritage as an antidote to tensions of identity, both ours and others. Without enumerating all the sources of this questioning identity,[2] let us remember that on-going interrogation can turn to corrosive doubt and self-hatred: a self-destruction that Europe is far from being spared. We often reduce this heritage of identity to a permissive tolerance of others. But tolerance is only the zero degree of questioning; when not reduced to simply welcoming others, it invites them to question themselves and to carry the culture of questioning and dialogue into encounters that problematize all participants. This reciprocating questioning produces an endless lucidity that provides the sole condition for "living together". Identity thus understood can move us towards a plural identity and the multilingualism of the new European citizen.

Diversity and its Languages

"Diversity is my motto", said Jean de La Fontaine, in his "Pâté d'anguille[3]". Europe is a political entity that speaks as many languages, if not more, as it has countries. This multilingualism is the basis of cultural diversity, and it must be saved and respected along with national character; moreover, it

2 I hear this attitude in the words of the Jewish God: *Eyeh asher eyeh* (Ex 3, 14), taken up by Jesus (Jean 8, 23) as an identity without definition, which sends the "I" to an eternal return to its very being. I understand it in a different way, in the silent dialogue of the thinking I with itself, according to Plato, which is always "two in one" and whose thoughts don't provide an answer but rather break down answers into questions. In Aristotle's *philia politikè*, he announces a social space and a political project by calling for individual memory and personal biography. In the sense of Saint Augustin, there is only one homeland, which is the voyage itself: In via in patria. Montaigne, in his *Essais*, devoted to the polyphonic identity of the "I", writes "We are all lumps, and of so various and inform a contexture that every piece plays, every moment, its own game". In the *Cogito* by Descartes, we hear "I think therefore I am". But what is it to think? I hear it again in Goethe's Faust: "Ich bin der Geist der stetz verneint" (I am the spirit who always denies). And in the endless analysis of Freud: "There where it [id] was, I must become".

must be open to exchange, mixing and cross-pollination. This is a novelty for Europeans that merits reflection.

After the horror of the Shoah, the bourgeois of the 19th century as well as the rebels of the 20th century began to confront a new era. Now, Europe's linguistic diversity is creating kaleidoscopic individuals capable of challenging the bilingualism of "global" English. Is this possible? Everything would prove the contrary. Yet, this new species is emerging little by little: a polyphonic subject and polyglot citizen of a plurinational Europe. Will the future European be a singular subject, with an intrinsically plural—trilingual, quatrilingual, multilingual—psyche? Or will they be reduced to Globish?

More than ever, Europe's plurilinguistic space calls upon the French to become polyglot, to explore the diversity of the world and to bring their singularity to the understanding of Europe and the world. What I say for the French holds true for the other twenty-eight languages of the European polyphony. It is by making incursions into other languages that a new passion for each language will arise (Bulgarian, Swedish, Danish, Portuguese, etc.) This passion will not look like a shooting star, nostalgic folklore or vestiges of academia, but rather it will function as the index of a resurgent diversity.

Emerging from National Depression[4]

Whether lasting or not, the national character can experience real depression, just as individuals do. Europe is losing its image as a world power, and the financial, political and existential crises are palpable. But this has also occurred in many European nations, including France, whose history is one of the most prominent.

When a psychoanalyst treats a depressed patient, he begins by shoring up her self-confidence. In this way, a relationship is established between the two protagonists in the cure, and spoken words become fertile once again, enabling a critical analysis of the suffering. Similarly, a depressed nation requires an optimal self-image before taking on,

3 Cf. "Diversité c'est ma devise" (Diversity is my motto) In *Pulsions du temps*, edited by J. Kristeva, 601. Fayard, 2013.

4 Cf. "Existe-t-il une culture européenne?" ("Does a European Culture Exist?") and "Le message culturel français" ("The French Cultural Message"), in *Pulsions du temps*, edited by J. Kristeva, 601 and 635. Fayard, 2013.

for example, industrial expansion or a more open reception of immigrants. "Nations, like men, die of imperceptible impoliteness", wrote Giraudoux. Poorly understood universalism and colonial guilt have led politicians and ideologues to behave with imperceptible impoliteness, often disguised as cosmopolitism. They act with arrogant spite towards the nation. They aggravate national depression and then infuse it with a maniacal exaltation, both nationalistic and xenophobic.

NATIONAL CULTURAL DIVERSITY IS THE ONLY ANTIDOTE TO THE EVIL OF BANALITY

European nations are waiting for Europe to emerge, and Europe needs proud and valued national cultures that offer the world the cultural diversity that we have requested Unesco to protect. National cultural diversity is the only antidote to the evil of banality, or this new version of the banality of evil. A federal Europe, thus comprised, could play an important role in the search for global balance.

Two Conceptions of Freedom

The fall of the Berlin Wall, in 1989, clearly demarcated the difference between European culture and North-American culture. It is a question of two conceptions of freedom played out by democracies. Different but complementary, these two versions are equally present in international institutions and principles, both in Europe and North America.

By identifying liberty with "self-beginning", Kant opens the way to an apologia of enterprising subjectivity, subordinated to the freedom of Reason (pure or practical) and a Cause (divine or moral). In this order of thought, favoured by Protestantism, freedom appears as the liberty to adapt oneself to the logic of cause and effect or, to quote Hannah Arendt, as an adaptation to or "calculation of the consequences" of the logic of production, science or the economy. To be free is to have the opportunity to benefit to the best of one's ability from cause and effect in order to adapt to markets and their profits.

But another model of freedom exists, also of European stock. It appears in the Ancient Greek world, developed under the Pre-Socratics and through Socratic dialogue. Not subordinated to a cause, this fundamental

freedom is deployed in the speaking being who presents and gives himself to others, as well as to himself, and in this sense is liberated. This freedom of the Being of the Word, through the encounter between "One" and "Other", inscribes itself as an infinite question, before freedom gets roped down into a cause and effect relationship. Poetry, desire and revolt are its privileged experiences, revealing the incommensurable (though shareable) singularity of each man and woman.

One can see the risks of this second model founded on the questioning attitude: ignoring economic reality, isolating corporatist demands, limiting tolerance, fearing to question the demands and identity politics of new political and social actors, not standing up to global competition and reverting to archaic behavior and laziness. But one can also see the advantages of this model, used by European cultures, which don't culminate in a schema but rather in a taste for human life in its shareable singularity.

In this context, Europe is far from being homogenous and united. First of all, it's imperative that "Old Europe", and France in particular, takes the economic and existential difficulties of "New Europe"[5] seriously. But it is also necessary to recognize cultural differences and, most particularly, religious differences that are tearing apart European countries from the inside and separating them. It is urgent to learn to respect differences (for example: Orthodox and Muslim Europe, the persistent malaise in the Balkans, and the distress in Greece over the financial crisis.)

The Need to Believe, the Desire to Know

Among the multiple causes of the current crisis is one that politicians overlook: it is the denial of what I call the pre-religious, pre-political "need to believe" inherent to speaking subjects, such as ourselves, which expresses itself as an "ideality illness" specific to the adolescent (whether native or of immigrant origin.)

Contrary to the curious, playful, pleasure-seeking child who wants to know where he comes from, the adolescent is less a researcher than a believer; he needs to believe in ideals to move beyond his parents,

5 According to the controversial catchphrase used by American Defense Secretary, Donald Rumsfeld, during the diplomatic confrontations on the war in Iraq.

separate from them and surpass himself. (I've named the adolescent a troubadour, romantic, revolutionary, extremist, fundamentalist, third-world defender). But disappointment leans this malady of ideality towards destruction and self-destruction, by way of exaltation: drug abuse, anorexia, vandalism and attraction on the one hand, and to fundamentalist dogmas on the other. Idealism and nihilism, in the form of empty drunkenness and martyrdom rewarded by absolute paradise, walk hand in hand in this illness affecting adolescents, which can explode under certain conditions in the most susceptible among them. We see its current manifestation in the media in the cohabitation of Mafia traffic and the djihadist exaltation raging at our doors, in Africa and Syria.

AT THE CROSSROADS OF CHRISTIANITY, JUDAISM AND ISLAM, EUROPE IS CALLED TO ESTABLISH PATHWAYS BETWEEN THE THREE MONOTHEISMS

If a "malady of ideality" is shaking up our youth and, with it, the world, can Europe possibly offer a remedy? What ideas can it volunteer? Any religious treatment of this malaise, anguish and revolt proves ineffective in the face of the paradisiacal aspiration of this paradoxical, nihilistic belief held by the de-socialized, disintegrated teen in the context of unforgiving globalized migration. This rejected, indignant fanatic can also threaten us from the inside. This is the image we have of the Jasmine Revolution, brought about by youth avid for freedom and the recognition of its singular dignity, but that another, fanatic need to believe is snuffing out.

Europe finds itself confronted by an historic challenge. Is it able to confront this crisis of belief which the religious lid can no longer hold down? The terrible chaos of the tandem nihilism-fanaticism, linked to the destruction of the capacity to think and associate, takes root in different parts of the world and touches the very foundation of the bond between humans. It's the idea of the human, forged at the Greek-Jewish-Christian crossroads, with its graft of Islam, in this unsteady universality, both singular and shareable, which seems threatened. The anguish paralyzing Europe in these decisive times expresses doubt before these stakes. Are we capable of mobilizing all our means—judicial, economic, educational, therapeutic—to fight with a fine-tuned ear and the necessary training and generosity the malady of ideality that disenfranchised adolescents (and others), even in Europe, express so dramatically?

At the crossroads of Christianity (Catholic, Protestant, Orthodox), Judaism and Islam, Europe is called to establish pathways between the three monotheisms—beginning with meetings and reciprocating interpretations, but also with elucidations and transvaluations inspired by the Human Sciences. Moreover, a bastion of secularism for two centuries, Europe is the place par excellence to elucidate a need to believe. Enlightenment, in its rush to combat obscurantism, underestimated its power.

A Culture of Women's Rights

From the time of the Enlightenment to the suffragettes, without forgetting the likes of Marie Curie, Rosa Luxembourg, Simone de Beauvoir and Simone Weil, the emancipation of women through creativity and the struggle for political, economic and social rights offers a federating arena for national, religious and political diversity among European citizens. This distinctive trait of European culture is also an inspiration for culture and emancipation. Recently, the Simone de Beauvoir Prize for the Liberty of Women was given to the young Pakistani Malala Yousafzai, gravely wounded by the Taliban for having supported the right to education for young girls on her blog.

Countering the two monsters—the political lockdown by the economy and the threat of ecological destruction—, the European cultural space can offer an audacious response. And perhaps it is the sole response that takes the complexity of the human condition seriously, including the lessons of its history and the risks of its freedom.

Am I too optimistic? To highlight the character, history, difficulties and potentialities of European culture, let us imagine some concrete initiatives: for example, organizing a European Forum in Paris on the theme "European Culture Exists", with the participation of eminent intellectuals, artists and writers from 28 countries, representing a linguistic, cultural and religious kaleidoscope. The idea would be to reflect on history and current events in this plural and problematic ensemble, which is the EU, and to raise questions around its originality, vulnerability and advantages. This Forum could lead to the creation of an Academy or a College of European Cultures, perhaps even a Federation of European Cultures, which would serve as a trampoline for or the precursor of a political Federation. Multilingualism would be a major actor in this dream.

THE UNSOLVED LIMITS OF EUROPE AND THE NEW GLOBAL POWERS

GEOPOLITICS

HARD POWER Military spending in billions of dollars

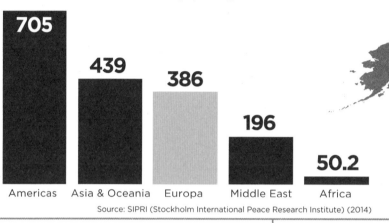

- Americas **705**
- Asia & Oceania **439**
- Europa **386**
- Middle East **196**
- Africa **50.2**

Source: SIPRI (Stockholm International Peace Research Institute) (2014)

SOFT POWER

Ability to persuade by cultural, ideological or diplomatic means

#	Country	Score
1	United Kingdom	75.61
2	Germany	73.89
3	United States	73.68
4	France	73.64
5	Canada	71.71
6	Australia	68.92
7	Switzerland	75.61
8	Japan	66.86
9	Sweden	66.49
10	Netherlands	65.21
11	Denmark	63.20
12	Italy	63.09
13	Austria	62.00
14	Spain	61.70
15	Finland	75.61
16	New Zealand	60.19
17	Belgium	58.85
18	Norway	57.96
19	Ireland	55.61
20	South Korea	54.32

- Europe
- Rest of world

Source: The soft power 30 (2014)

REGIONAL RISK MAP

Ranking by region and risk category

- Economic
- Environmental
- Geopolitical
- Societal
- Technological

	NORTH AMERICA	SOUTH AMERICA & CARIBBEAN
1	Cyber attacks	Profound social inestability
2	Failure of critical infrastucture	Failure of urban planning
3	Failure of climate change adaptation	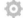 Failure of national gobernance

GLOBAL PEACE INDEX

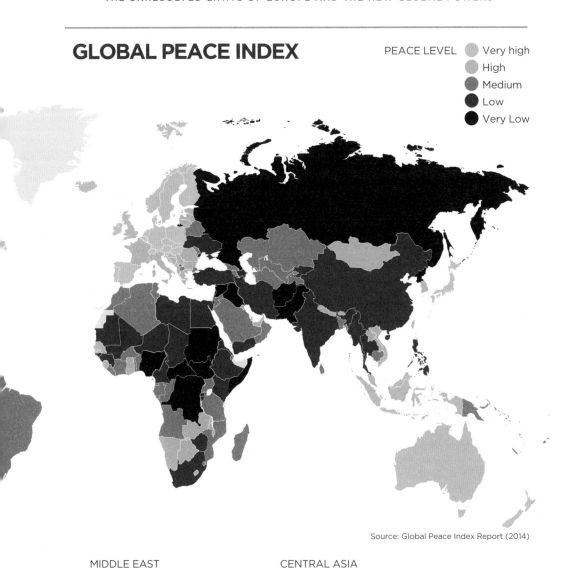

PEACE LEVEL — Very high / High / Medium / Low / Very Low

Source: Global Peace Index Report (2014)

EUROPE	MIDDLE EAST & NORTH AFRICA	SUB-SAHARAN ÁFRICA	CENTRAL ASIA (INCLUDING RUSIA)	EAST ASIA & PACIFIC	SOUTH ASIA
Unenployment	Water crises	Unenployment	Energy price shock	Interestate conflict	Failure of urban planning
Large scale involuntary migration	Profound social inestability	Food crises	Terrorist attacks	Failure of urban planning	Water crises
Profound social inestability	Interestate conflict	Spread of infectious diseases	Interestate conflict	Man-made environemental catastrophes	Terrorist attacks

Source: Global Risk Perceptions Survey. World Economic Forum (2014)

GLOBAL REDISTRIBUTION OF ECONOMIC POWER

ECONOMIC OUTLOOK

Regional GDP as a percentage of global GDP

34.5 — Emerging and developing Asia

16.1 — USA

15.4 — EU

8.0 — South America & Caribbean

6.8 — Middle East & North Africa

3.3 — Sub-Saharan Africa

Source: International Monetary Fund

URBAN GROWTH

Estimated contribution to urban growth by region, 2010-2025 (In percentages)

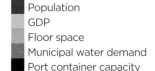

- Population
- GDP
- Floor space
- Municipal water demand
- Port container capacity

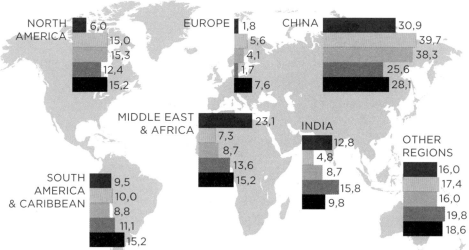

NORTH AMERICA
6,0
15,0
15,3
12,4
15,2

EUROPE
1,8
5,6
4,1
1,7
7,6

CHINA
30,9
39,7
38,3
25,6
28,1

MIDDLE EAST & AFRICA
23,1
7,3
8,7
13,6
15,2

INDIA
12,8
4,8
8,7
15,8
9,8

OTHER REGIONS
16,0
17,4
16,0
19,8
18,6

SOUTH AMERICA & CARIBBEAN
9,5
10,0
8,8
11,1
15,2

Source: Urban World, cities and the rise of the consuming class

POPULATION PROJECTIONS

● Africa ● Asia ◐ Europe ● South America & Caribbean ● North America ● Oceania

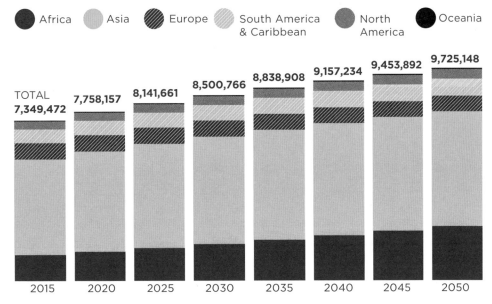

Source: United Nations

SHIFTING ECONOMIC POWER

Until the 16th century, Asia was the world's economic centre of gravity. In the 18th and 19th centuries, Europe and North America became the global economic hubs thanks to urbanization and industrialization processes. Today the balance is shifting back towards Asia at a speed and on a scale never seen before. Cities in emerging countries, led by the accelerated urbanization of China, are the driving forces behind this transformation.

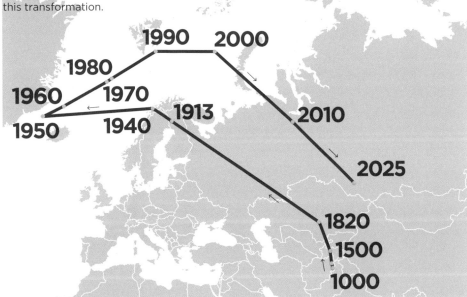

Source: McKinsey Global Institute

JOHN PEET is Political Editor of *The Economist*, covering notably Britain and the European Union. He was Europe Editor from 2003 to 2015. He has contributed to books including *The Frontiers of Europe* and *The Foreign Policy of the European Union* (Brookings) and, with a colleague, Anton La Guardia, published *Unhappy Union: how the euro crisis—and Europe—can be fixed* in May 2014.

Britain has always been a reluctant European. It only became a member in 1973, and it has repeatedly complained: about the budget, the agricultural policy, fisheries, the European Parliament and regulation. Why does Britain have this attitude? In the early 1950s the British still considered their country to be a world power with a large empire, not just a medium-sized European country. This has left them with a more transactional approach to Europe. Membership of the European Union is seen in cost-benefit terms. Will the referendum in 2016 settle the argument and make Britain a more committed EU member?

THE UK AND EUROPE

Britain is by nature and political inclination a reluctant European. In this respect, it is quite unlike any other member of the European Union. The original six countries (France, West Germany, Italy and the Benelux) formed the club in the 1950s because it seemed the best way to put behind the memory of a war that had damaged not only their economies and societies, but also their moral fibre. Most of the countries that joined later, from the Mediterranean to Central and Eastern Europe, similarly saw the European project as a way of escaping from their often unhappy, recent history. Britain, however, felt that the war had been a glorious period from which it had emerged as a winner, both militarily and morally. In this sense, the war boosted the British belief that they still had a global role and responsibility, as well as a large empire to run. All of this meant that there was, in Britain's eyes, no need for any retreat to a position built around Europe alone.

BRITAIN CONSIDERS THE EU ON AN ESSENTIALLY PRAGMATIC AND TRANSACTIONAL BASIS, NOT AS AN IMPORTANT PART OF THEIR IDENTITY AND AS AN UNDERPINNING OF THEIR SECURITY, LIKE OTHER MEMBERS

These historical sentiments may have proved misguided. But they remain important because they inform British attitudes about the European Union (EU) even now. Almost all of the other member countries see the EU in emotional terms as an important part of their identity and often, also, as an underpinning of their security and prosperity. Britain is different: it considers the EU on an essentially pragmatic and transactional basis. If membership seems to be desirable because it boosts trade and employment, fosters the success of British companies and protects the interests of the financial services industry in the City of London, then Britons will support it. But if the British people were to

be persuaded that these were no longer strong enough reasons to be members of the club, they would be perfectly happy to no longer belong.

This way of thinking about Europe helps to explain two particular oddities about Britain compared with other countries. The first was its decision not to join the nascent European club in the 1950s. It deliberately stood aside from both the European Coal and Steel Community when it was formed, in 1951, and from the Messina conference that agreed, in 1956, to set up the European Economic Community. By the time the British government had belatedly decided to apply for membership, in 1961, France had acquired a president, Charles de Gaulle, who was mistrustful of the British and virulently against the entire Anglo-American establishment. De Gaulle vetoed two attempts by Britain to join, which is why the country managed to get in only in 1973, after his death.

IN 2015, BRITAIN IS THE ONLY COUNTRY STILL HAVING A DEBATE ABOUT ITS CONTINUING MEMBERSHIP IN THE EUROPEAN UNION

The second oddity about Britain is that today, in 2015, it should still be having a debate about its continuing membership in the European Union. It is true that ever since the British joined, they have complained about various aspects of the European project: their heavy budget contribution, the common agricultural policy, the common fisheries policy, excessive red tape and regulation and the continuing drive towards ever closer union. But other countries, like Denmark, Sweden and even some of the newest members, have also had their complaints. Where Britain is alone is in continuing to discuss the question of whether it might be better off leaving the EU altogether. And that is the debate that the new Conservative government of David Cameron has now relaunched by promising that before the end of 2017, it will hold an in/out referendum, asking voters if they want Britain to remain a member of the EU.

Mr Cameron has said that before such a referendum, he will renegotiate certain aspects of Britain's membership. The implicit threat is that if he does not get most of what he wants, he will be happy to advocate withdrawal. Yet, the reality is that all British governments, whether Tory, Labour or coalitions, have quickly come to appreciate that it would be better to remain full members, if only because the alternatives to membership are unattractive, unattainable or both. So,

Mr Cameron is almost certain to campaign to stay regardless of whatever he wins from his renegotiation.

This conclusion is reinforced because what Mr Cameron has actually asked for seems to be relatively minor. He would like to change the rules to make clear that migrants from the rest of the European Union cannot claim benefits, including in-work benefits, for the first four years after they arrive in Britain. He wants some form of exemption from the treaties' aspiration of pursuing ever closer union among the peoples of Europe. He seeks to give national parliaments a bigger say in policing and occasionally blocking EU legislation. He wants a renewed commitment to complete the single market in services, digital and energy. And he hopes to secure some guarantees that, as the euro zone pursues deeper political and economic integration, it will not discriminate in any way against countries, like Britain, which have chosen not to join the single currency.

Mr. Cameron has presented these proposed reforms as fundamental changes in Britain's relationship with the EU. In reality, they are nothing of the sort. What he is in fact seeking is a set of measures that he has reason to believe his European partners are prepared to accept, but that he also hopes he can present, both to his Eurosceptic backbenchers and to the British people, as significant concessions, even if they seem relatively modest. In effect, he is trying to repeat the success of Harold Wilson, who came to power as Labour prime minister in 1974 with a promise to renegotiate the terms of Britain's membership of the then European Economic Community and to put the results to an in/out referendum.

In the event, Wilson succeeded spectacularly. Before he began his purported renegotiation, opinion polls suggested that there was a substantial majority in favour of leaving. He won almost nothing in his renegotiation and even eschewed any treaty change. And yet, helped by a strong cross-party consensus and the support of almost the entire media and British business, he managed to win a two-thirds majority for staying in the EEC in the referendum in June 1975. That settled the issue for more than a generation. But now Mr Cameron has reopened it.

On the face of it, he seems to be in a better position than Wilson was. Just as in 1975, his demands for change are not so significant as to threaten the entire project, so his European colleagues can surely agree to enough of them to allow him to proclaim victory. Unlike 1975, moreover, most of the opinion polls have suggested that there is already

a majority in favour of remaining a member of the EU. It seems likely that the Labour Party, despite having chosen a new Eurosceptic leader in Jeremy Corbyn, will back staying in. The Liberal Democrats, several leading newspapers and most of British business will do the same. In these circumstances, it certainly should be possible for a politician as skilled as Mr Cameron has shown himself to be to win his referendum.

Yet, possible is not the same as certain. Wilson, in 1975, had one huge advantage over Mr Cameron, 40 years later: the perception that the British economy was lagging behind the rest of Europe. Indeed, this view had been crucial to the first application to join, lodged by the Conservative government of Harold Macmillan, in 1961. Throughout the 1960s and 1970s, the thinking in London was that continental Europe, especially West Germany, but also France and the Benelux trio, was leaving Britain behind economically. In the post-war euphoria of 1945, Britain reckoned that it was the richest country in Europe. Only 15 years later did it come to realise that several continental economies had overtaken it. By 1975, when Wilson held his in/out referendum, the perception that Britain was the sick man of Europe had taken a deep hold among voters. Only a year later, after all, Britain became the first developed country to call on the International Monetary Fund for a rescue loan.

As Mr Cameron will recognise only too well, that is all a big contrast with today. Instead, the perception over the past 15 years has been that a combination of Margaret Thatcher's liberalising reforms of the 1980s and the troubles of the euro zone since 2008 has created a situation in which the UK economy is consistently outperforming most of the rest of Europe. In 2015, indeed, the British economy was the fastest-growing among the G7 group of rich countries, which is one reason why Mr Cameron's Tories won the general election in May. As British voters approach a referendum on whether to stay in or to leave the EU, they will be conscious of Britain's relative economic success. And at least some may be vulnerable to the lure of a key message from the United Kingdom Independence Party (UKIP): that Britain suffers from being "shackled to a corpse" instead of engaging with more dynamic, faster-growing countries across the Atlantic and in Asia.

Here is also a second reason why the "In" campaign will find it harder to win than it was in 1975. The "Out" campaign is now both better financed and better organised. UKIP, which won 4 million votes but only one parliamentary seat in the May 2015 general election, has over the

past few years managed to energise a core of supporters who consider leaving the European Union to be their top priority. In 1975, almost all mainstream newspapers were in favour of staying in the EEC (the sole exception was the communist *Morning Star*). This time, a number of papers, including the *Daily Express*, the *Daily Mail*, the *Daily Telegraph* and, possibly, *The Sun*, may be campaigning to leave. In 1975, the government managed to paint the Out campaign as a group of eccentrics and nationalists. This time, it will find it much harder to repeat that trick.

And there is a third big reason for Mr Cameron to worry about the referendum: immigration. UKIP, in particular, has managed to conflate Britain's EU membership with the issue of its inability to keep down

UNLIKE 1975, MOST OF THE OPINION POLLS HAVE SUGGESTED THAT THERE IS A MAJORITY IN FAVOUR OF REMAINING A MEMBER OF THE EU

immigration, especially with the sight of hundreds of thousands of refugees from Africa, Afghanistan and Syria, who have been trying to reach European shores. The simple proposition that UKIP advances is that Britain cannot control its own borders and choose its own immigrants so long as it remains in the EU since it is bound to accept the treaty-guaranteed right to free movement of people. Should there be a renewed immigration or refugee scare in Europe at just the moment when the referendum is being held, there is a risk that the vote may turn into one about immigration, not EU membership, and that it may then be lost.

Referendums are, in any case, risky affairs. Over the past 25 years, there have been numerous examples of national referendums on European Union issues that have been lost, often unexpectedly and despite solid campaigning on the Yes side by the entire political elite, most of business and the mainstream media. Denmark and Ireland have both rejected EU treaties, only to be asked to approve them in a second vote. The Danes and Swedes have also voted against joining the euro. And in 2005, the voters of France and the Netherlands spectacularly rejected, by large majorities, the draft European Union constitutional treaty (much of whose content was later included in the Lisbon treaty, which was passed without a referendum anywhere except in Ireland, whose voters accepted it only at a second attempt). Then, there is the example of the Scottish referendum on independence that was held in

September 2014. At first, opinion polls suggested that this would be easily won by the unionist side. But as the vote drew closer, the gap narrowed, and in the end, the margin was much tighter than anybody outside of Scotland had expected.

For all of these reasons, and despite the reassuring precedent from 1975, it would be a huge mistake to assume that the in/out referendum, when it comes, will be easy for Mr Cameron to win. He will be under fire from his own Eurosceptics and from sections of the press for failing to win big enough concessions in Brussels. There is every chance that the world economy will be less benign in 2016 than it was in 2015. The euro crisis remains unresolved, with a serious risk that Greece, in particular, could again become a controversial issue. Migration will still be a cause for public concern. And Mr Cameron's government, like all governments, may well be suffering from mid-term unpopularity.

Given these circumstances, how best can the government (and the In campaign) try to win? One answer is to lay as much emphasis as it can on the economics of EU membership. It is inherently impossible

IF BRITAIN LEAVES THE EU, THERE WOULD BE LOWER GDP AS A RESULT OF TRADE DISRUPTION, LOST EXPORTS AND LOST FOREIGN INVESTMENT

to prove either way what the consequences of British exit (or Brexit) would be for the British economy, in large part because nobody can be sure what precise arrangement Britain would make with the EU after leaving. But most reputable studies, even from Eurosceptic think-tanks, suggest that there would be some cost in lower GDP as a result of trade disruption, lost exports and lost foreign investment. The only circumstances in which economists manage to predict any gain in GDP would be if a post-Brexit Britain were to adopt highly liberal policies of ultra-low taxes, minimal regulation, low wages, unilateral free trade and complete openness to immigration. None of these, most notably the last, seem politically likely to follow a decision to leave the EU.

Yet, economics alone is unlikely to win the day against powerful counterarguments. So a second option is to talk up the broader case for continuing EU membership. Opinion polls suggest that voters see advantages in working with other European countries in such areas as trade talks, climate change, counter-terrorism and even in foreign policy. The antics of Russia's Vladimir Putin in Ukraine have put more emphasis on

David Cameron at press conference after
Scottish referendum in September 2014.

the importance of the EU's common foreign and security policy. Indeed,
right across Europe, support for the EU has risen in recent years in
part because of a perceived growing threat from the Kremlin, as well
as fears of a resurgence of violence and war across the Middle East.

The trouble with this line, however, is that it is extremely hard for a
prime minister and party, which have spent so many years denigrating
Brussels and all of its activities, to suddenly start praising the EU as a
bulwark of foreign policy in a dangerous world. There would be gasps
of disbelief were Mr Cameron to start saying that he is pleased to have
a nascent European external action service in Brussels or that he wel-
comes EU summits discussing what to do about Mr Putin. The Tories
have spent too long arguing that the North Atlantic Treaty Organisation
(NATO) is the only valid defender of European security for them now
to talk up the EU's foreign and security policy with any credibility.

Hence, the third and most likely option for Mr Cameron, as he seeks
to win an endorsement for staying in the EU, is to play up the negative
consequences and risks associated with withdrawal. This tactic worked,
in the end, in the Scottish referendum. On the EU, as on Scotland, it
would start with an assumption that when voters are in doubt about
any issue, they will tend to prefer the status quo to any big change.
Pollsters reckon that as many as a quarter of British voters would back
withdrawal in any circumstances; a slightly smaller number would want

to stay no matter what. It is the remaining 50% or so of the electorate that will be open to persuasion, and the natural tendency will be for the largest chunk of this group to prefer that things remain as they are.

There are also some obvious risks associated with withdrawing from the EU that the government can emphasise. Simple uncertainty is one. Although the Lisbon treaty provides, in its article 50, for the possibility that a member country can declare its intention to leave and then be given two years to negotiate the terms of doing so, nobody has ever used this provision. So nobody knows how hard it would be to negotiate a new deal, nor how long it might take.

POLLSTERS RECKON THAT A 25% OF BRITISH VOTERS WOULD BACK WITHDRAWAL FROM THE EU; A SLIGHTLY SMALLER NUMBER WOULD WANT TO STAY NO MATTER WHAT

A second grave source of uncertainty is the precise model that a post-Brexit Britain might choose to adopt. It could seek to join the European Economic Area, a club of non-EU members that consists of Norway, Iceland and Liechtenstein. These three countries are required to apply practically all of the European Union's rules and regulations and even to contribute heavily to its budget in order to retain full access to the EU single market. Yet, they have no say over the legislation that they are obliged to implement. Many Norwegians are dissatisfied with this situation on the grounds of loss of democratic input into law making.

An alternative might be Switzerland, which is not forced to implement European Union legislation, but in practice is expected to do so in order to keep full access to the single market for goods. But the bilateral arrangements between Switzerland and the EU are cumbersome and took many years to negotiate, so Brussels will not want to replicate them for Britain. Besides, the Swiss do not have full access to the single market for services, including financial services, which is a serious potential drawback for the British economy, which is heavily oriented towards services. Like the EEA countries, Switzerland also has to accept free movement of people from the EU, an issue that is now extremely problematic as Swiss voters in 2014 said yes to a referendum that proposed limits on migration from the EU. At least for now, the EU is refusing to accept this proposal.

If not Norway or Switzerland, what other alternative is there? Britain could seek a customs union like Turkey's or a deep, comprehensive

free-trade agreement like that negotiated by some other applicant countries. But in most of these cases, access to the single market for services remains restricted, and there is still an expectation that countries will observe most or even all of the EU's directives and regulations. Or, Britain could simply rely on the rules of the World Trade Organisation, of which both it and the European Union would be members. But in such a case, there might be tariffs on certain British exports, notably of cars, chemicals and foodstuffs. The odds are that this would at minimum create much uncertainty, and it would also be likely to divert foreign investment away from Britain.

Eurosceptics have responded to these uncertainties over alternatives to full membership with three assertions. One, which is probably correct, is that both sides of such a significant trading relationship would have an interest in some kind of free-trade deal. A second is that because Britain imports much more from the rest of the EU, especially from Germany, than it exports, Britain has greater bargaining clout in putting together such a deal. Yet, this seems implausible: the rest of the EU is a much more important market for British exports (45% of the total) than Britain is for the EU (10%).

The third suggestion is that Britain, the fifth or sixth-biggest economy in the world, has special clout for negotiating favourable treatment in Brussels. Yet, this seems overly optimistic. A big reason why countries like Norway, Switzerland and even Turkey have managed to strike relatively favourable deals with the EU was that they have all been seen as potential members. A post-Brexit Britain, on the other hand, would have just decided to leave. The temptation for the EU institutions and the other 27 national governments not to be too generous to Britain would be clear. Indeed, it might become an imperative: too kind a deal with Britain might just mean that some other countries would choose to follow it through the exit door.

The upshot of all of this is that Britain after Brexit might face, at best, grave uncertainty over its future relationship with the EU, leading to some leakage of foreign investment and possibly to some multinationals choosing to move location. Or, at worst, it might find itself obliged to stick to all the EU rules and regulations that Eurosceptics badly want to avoid, with the added sting that it would lose any say over how they are drawn up. The In campaign should certainly be able to make something of these risks to help secure a vote to remain full members of the EU.

Supporters of the "Better Together" campaign in London.

There is one more area in which negative campaigning might work: the likely effect on Scotland. Scotland's independence referendum in September 2014 produced, after some last-minute wobbles, a decisive ten-point victory for those wanting to remain in the union. Yet, it was followed only nine months later by a massive election victory in Scotland for the Scottish Nationalist Party, which now has 56 of the 59 Scottish seats in the Westminster parliament. At the time of the Scottish referendum, the SNP promised that the result would settle the issue for a generation. But the leader of the SNP, Nicola Sturgeon, has since made clear that if British voters were to back Brexit from the European Union, that might create new conditions for holding a fresh Scottish referendum on independence. In short, Brexit might well mean not only British withdrawal from the European Union, but also the break-up of the British union, the United Kingdom, as well.

The odds in advance of a referendum campaign are that a combination of such negative factors with a Tory government, under Mr Cameron, which is advocating a vote to stay in the European Union, ought to produce a clear decision by British voters to remain. But it is unlikely to be won by as large a margin as the two-thirds majority won by Wilson in 1975. And right up until the vote itself, the outcome may remain uncertain, as last-minute events, differential turnout or a host of extraneous factors might affect the result. Were the vote to go against Mr Cameron,

the political fallout in Britain would be huge. It is hard to see him remaining as prime minister. His party might well split between pro- and anti-Europeans. There might even be an early election in which Labour and the Liberal Democrats could expect to do well. In short, much is riding on the result of the EU referendum in Britain.

The question that much of the rest of Europe will be asking, however, is much simpler: will the referendum definitively settle the issue, meaning that Britain will at last become a fully committed and active member of the European Union, with no reservations to hold it back? The answer to this question is, sadly, no, for two reasons.

The first is that the campaign for Britain to leave the EU is unlikely to die just because a referendum returns a decision to stay, especially if the margin of victory is reasonably close. UKIP, which took 4 million votes in the May 2015 election, is not going to disappear, and neither are the Tory party's backbench Eurosceptics. Some will claim to have been robbed by an unfair campaign. Others will, like the Parti Quebecois in Canada, see one referendum loss as merely a prelude to a reinvigorated second campaign at some future date. There seems likely always to be a sizeable rump of British politicians who will want to get out of the EU.

THE PROBLEM IS THAT THE REFERENDUM WILL NOT SETTLE THE ISSUE DEFINITIVELY, AND BRITAIN WILL STILL HAVE ITS RESERVATIONS ABOUT THE EU

The second reason is more subtle. It is that already, before and also after any referendum result, Britain is semi-detached from so much of what the European Union does. For many years, there was a popular notion in Brussels that the EU was a two-speed organisation: more enthusiastic countries would proceed more rapidly to full political and economic integration, leaving the less enthusiastic to catch up later. Economic and monetary union has shattered that idea. Now, there are countries, foremost among them Britain, which seem almost certain never to join the euro. This means that the club is no longer one of two speeds; instead, it has turned into one of different ultimate destinations.

The notion of what is known in Brussels jargon as variable geometry has become entrenched ever since the Maastricht treaty on economic and monetary union was ratified in 1992. Britain and Denmark secured opt-outs from the treaty provisions requiring countries to join a single

currency. Other countries were also required to comply with the so-called Maastricht criteria before they could join the euro. In this way, a division of the European Union into those that are in the euro and those that remain outside was created.

It is mirrored in a number of other, albeit less significant, areas. Several EU countries are not in NATO (Ireland, Austria, Finland and Sweden) and so take a minimal role in European security and defence policy. Similarly, a number of the EU members are not in the passport-free Schengen zone (Ireland and Britain by choice, Bulgaria, Croatia and Romania because they are not ready). Britain and Denmark have opted out of substantial parts of the EU's justice and home affairs policy. In effect, the European Union has turned into a sort of Swiss cheese with holes in it. But Britain stands out in some respects as having more holes than cheese.

THE BRITISH WILL NOT TRY TO STOP FURTHER POLITICAL AND ECONOMICAL INTEGRATION, BUT THEY WILL STAND ASIDE FROM THE PROCESS

Will a Britain that votes in its referendum to remain in the EU decide that it wants to join more fully in all of its other policies? It seems highly unlikely. There is zero prospect of Britain joining the euro. Indeed, Mr Cameron's government is using much of its negotiating capital persuading euro-zone countries to accept a requirement that they must not discriminate against non-members in discussions over the EU's single market. There is equally little chance of Britain signing up to Schengen. In effect, Britain under Mr Cameron has decided to remain in a broadly semi-detached position. The British will not try to stop the euro zone, in particular, from becoming more integrated politically and economically. But they will stand firmly aside from the process.

In short, even after a positive result in the EU referendum, Britain will continue to be somewhat on the margins of the club, especially of a more deeply integrated euro zone. It is to be hoped that Mr Cameron and his government will still throw themselves more actively into normal EU business, ranging from foreign affairs to climate-change to trade policy (a notable part of this is the current negotiations on the Transatlantic Trade and Investment Partnership with America). But Britain will remain what it always has been: a reluctant European.

In this chapter, we document a change in the character and quality of Turkish economic growth, with a turning point around 2007. We link this change to the reversal in the nature of economic institutions. This institutional reversal, we argue, is a consequence of a turnaround in political factors. The first phase coincided with a deepening of the Turkish democracy under the prodding and guidance of the European Union. As Turkey-European Union relations collapsed and checks against the dominance of the governing party were removed, these political dynamics began to reverse and paved the way for the institutional slide.

DARON ACEMOGLU is Elizabeth and James Killian Professor of Economics in the Department of Economics at the MIT. He has received a BA in economics at the University of York, MSc in Mathematical Economics and Econometrics and a PhD in Economics, both at the London School of Economics. He has received many awards, including the John Bates Clark Medal and Honorary Doctorates from the University of Utrecht, Bosporus University, and the University of Athens. He has published four books, among them, *Economic Origins of Dictatorship and Democracy* (joint with James A. Robinson).

MURAT ÜÇER serves as Global Source's consultant in Turkey and is co-founder of Turkey Data Monitor, as well as a senior lecturer at Koç University. Formerly, he worked as an economist at the Institute of International Finance, Credit Suisse, and the IMF. He was an advisor to the Minister of Treasury at the Turkish Treasury in 2001 and the Governor of the Central Bank of Turkey in 1997. Mr. Üçer received his BA and PhD in Economics from BoĐazici University and Boston College. He has published several articles on the Turkish economy, including a book on the 2001 crisis in this country.

THE UPS AND DOWNS OF TURKISH GROWTH, 2002–2015: POLITICAL DYNAMICS, THE EUROPEAN UNION, AND THE INSTITUTIONAL SLIDE*

Though EU-Turkey relations are multifaceted, in this essay we focus on one specific aspect: the role of the EU in the improved institutional structure of Turkey during the early 2000s—and the rapid growth that this engendered—and its subsequent, more ominous contribution to the unraveling of these political and economic improvements. We start with a seldom addressed macroeconomic puzzle of Turkish growth: following its severe financial crisis in 2001, Turkey enjoyed five years of rapid economic growth, driven in large part by structural changes, productivity growth, and a broadening base of economic activity, both geographically and socially. This process stopped and reversed, however, even as the foreign and the Turkish media touted a new Turkish model immune to the "stop-go cycles" so characteristic of its economy in the 20th century.

TURKISH GROWTH IS UNDERPINNED BY INSTITUTIONAL IMPROVEMENTS AND IS BEING REVERSED BY A TURNAROUND IN THE VERY SAME INSTITUTIONAL FOUNDATIONS

From about 2007 onwards, economic growth slowed significantly, as government spending became the mainstay of the economy, and productivity growth almost fully stagnated. Underpinning the sea change was likely the reversal of the productivity-enhancing structural changes that had played a pivotal role in the previous five years. Although one could label this as just another example of the stop-go cycles, we note that it has an arguably different character. Rather than the typical stop-go cycle, in which the growth phase is unsustainable and heralds the inexorable contraction phase (because it plays out in a weak institutional environment), we argue that we are witnessing

* We thank Izak, Atiyas, Ilker Domac, Soli Ozel, Martin Raiser, Dani Rodrik, and Sinan Ulgen for very useful comments on an earlier draft. The usual caveat applies.

growth—underpinned by institutional improvements—being reversed by a turnaround in the very same institutional foundations.

Why did Turkey undergo unusually rapid institutional improvements starting in 2001? Our answer emphasizes a confluence of factors, partly external and partly internal. First, the 2001 crisis forced Turkey's lethargic and conservative political system to accept a slew of fairly radical structural reforms imposed by the International Monetary Fund (IMF) and the World Bank. These reforms not only brought under control the persistently high inflation but also imposed discipline on the budgetary process, shifted decision-making and regulatory authority towards autonomous agencies in an effort to cultivate rule-based policy-making, and introduced transparency in the notoriously corrupt government procurement procedures.

WE ANALYSE WHY TURKEY UNDERWENT UNUSUALLY RAPID INSTITUTIONAL IMPROVEMENTS STARTING IN 2001 AND WHY POSITIVE INSTITUTIONAL CHANGES CAME TO AN END

Second, these economic reforms, after their introduction by a caretaker government, were overseen by the popularly elected AK party (the Justice and Development Party), which, for all practical purposes, had ended the Turkish military's tutelage over politics, which had characterized the Republic's entire history. Third, and most relevant for this essay, both the economic reforms and the political changes undergirding them received a substantial boost from the general warming of EU-Turkey relations and the blossoming hopes in Turkey that accession to the EU was a real possibility if economic and political reforms continued.

We are, of course, aware that it is impossible to conclude with any certainty whether a five-year growth spell reflects the flourishing of an economy under new economic institutions and reforms, or the first phase of yet another stop-go cycle. Nevertheless, not only were the changes in economic institutions we have just described potentially far-reaching, but several pieces of evidence we describe below bolster the case that absent the institutional about-face, economic growth in Turkey could have continued without morphing into the low-quality growth observed in the post-2007 period.

Why then did these positive institutional changes come to an end, also bringing down both the rate and quality of economic growth in

Turkey? Once again, several factors played a role. First, the reforms initiated by the IMF and the World Bank gradually came to be reversed, with Turkey's recently institutionalized, rule-based policy framework increasingly shifting back toward discretion. The procurement law tells the story most sharply: more and more industries and items were declared exempt from the law by the ruling AK party, removing this fairly substantial barrier against corruption.

Second, and even more importantly, the AK party government, which had earlier supported the economic opening, made an about-face once it became sufficiently powerful. Gradually, the de jure and de facto control of the ruling cadre of the AK party intensified, amplifying corruption and arbitrary, unpredictable decision-making. Finally, the collapse of EU-accession talks played an arguably oversized role, both removing a powerful anchor that had tied the AK party to the reform process and undermining the support for institutional change that had grown in a fairly broad segment of the Turkish population. The turnaround in economic and political reforms was reflected very closely in the macroeconomic picture, impacting the pace and nature of economic growth from about 2007 onwards.

This causal story, which begins with a variety of internal and external factors, including the EU, and moves to institutional changes and then macroeconomic outcomes, is far from widely accepted. Though parts of it have been emphasized in other writings,[1] we are not aware of other works that have formulated it in this fashion. We do not pretend that our arguments conclusively establish these causal links, nor do we expect that this story will convince those skeptical of the critical role of institutional factors in the macro economy or the experts who view this episode of Turkish macroeconomic history as another example of the unsustainable stop-go cycles of a structurally unhealthy, emerging economy.[2] We do, nevertheless, hope that this perspective will invite further work on this fascinating and rather unusual episode of Turkish history and on the role that various external and internal factors have in triggering rapid institutional reform in emerging economies suffering from a myriad of institutional ills.

The speculative nature of our story notwithstanding, we would like to emphasize the potential lessons it contains. First, it is a hopeful story on the ability of emerging economies with weak institutions to reform rapidly and enjoy the fruits thereof. This hopeful reading is counterbalanced,

1 See, for instance, World Bank (2014).
2 For a recent statement of this view, see Rodrik (2015).

however, by two considerations. First, this process of rapid institutional change was triggered by Turkey's deep financial crisis in 2001, which left few other choices to the political elites, and second, it didn't last. All the same, it does suggest that other countries, and Turkey in particular, have an option to restart structural change and productivity growth if they can overcome their admittedly gargantuan political problems.

In addition, it does suggest that the current stalemate notwithstanding, the EU can again play a transformative role in Turkish institutional and economic developments in the near future if its priorities change once more towards enlargement or if another formula for closer engagement with Turkey can be found. We also argue, in closing, that this type of re-engagement would be not only hugely beneficial for Turkey but also for Europe.

The rest of this essay is organized as follows. In the next section, we provide a more detailed description of the ups and downs of the Turkish economy since 2002, from a macro perspective. The following section provides the institutional background for Turkey in the early 2000s and how this changed, first in a positive direction and then towards a worse institutional equilibrium. This section also provides a brief overview of the EU-Turkey relations and how these played an essential role in both the positive and negative institutional dynamics of the last decade. The last section concludes with a further discussion of the future of EU-Turkey relations.

Section I—The Ups and Downs of the Turkish Economy Since 2002

In this section, we contrast the period from 2002 to 2006—the five years that followed Turkey's devastating financial crisis of 2001—with the subsequent macro developments in the Turkish economy. Our key point is that this was a period of solid, inclusive, and reasonably high-quality growth from which there is much to learn.

Basic statistics tell the story rather well. Chart 1 shows that the Turkish economy grew at almost 6% per capita (per annum), its fastest per capita growth since the 1960s. Turkey's growth performance during this period was notable not only because it was above the rates experienced by most peers, barring some exceptional cases like China and India,[3]

3 See, for instance, Table 1 in Kutlay (2015) or the broader discussion in Akat and Yazgan (2012).

but also because it came with relatively high productivity growth.[4] In sharp contrast to the earlier periods of paltry total factor productivity (TFP) growth, about half of the growth in per capita GDP during this period stemmed from TFP growth, which increased by about 3% per annum between 2002 and 2006.[5]

Chart 2 further shows that during this five-year interval, private investment rebounded sharply from a post-crisis low of 12% of GDP to around 22%. The rebound was driven largely by investment in machinery and equipment; construction investment also picked up, but by no means dominated investment during this period. Contrary to a common

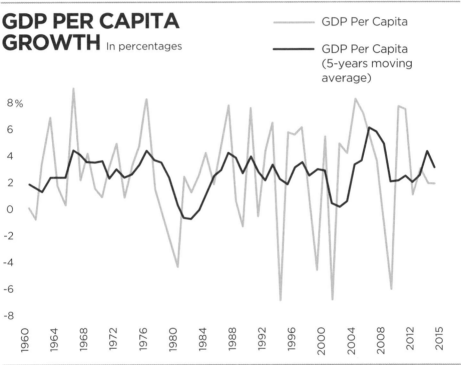

GDP PER CAPITA GROWTH In percentages

———— GDP Per Capita

———— GDP Per Capita (5-years moving average)

Source: TURKSTAT: Development Ministry; Turkey Data Monitor

Chart 1

4 In addition, using a "synthetic Turkey" approach, Meyersson (2015) finds that Turkey's GDP per capita increased at a faster rate after the AK Party came to power than before.
5 See, for instance, Ungor (2014). In their analysis of decadal TFP trends, Atiyas and Bakis (2014) find that 2002-2011 not only outperforms all other decades in terms of TFP growth, but it also does very well in international comparisons, with Turkey ranking seventh among 98 countries. While much of this TFP growth was driven by the "structural" shift in employment from agriculture to industry and service sectors, this shift has probably reflected broader.

misperception, the manufacturing sector also did reasonably well during this period. Thanks to very strong productivity growth at around 7% per annum, the share of manufacturing in GDP in constant prices increased from around 22% in 2001 to almost 24% in 2007.[6]

These developments reflected a host of structural changes. Inflation, which had averaged around 80% in the 1990s, swiftly fell to single digits, while public sector debt also declined sharply from a post-2001 crisis peak of 75% of GDP to about 35%. These improvements helped pave the way for the private-sector led boom that would follow.

Importantly for our story, there was also a major broadening of the economic base in two senses. Through most of the Republic's history, economic growth had been driven by growth in the major industrial cities in the Western part of the country and spearheaded by large conglomerates in these same cities. This began to change during the first half of the 2000s, resulting in a convergence of living standards between the more advanced West and the so-called "Anatolian Tiger" cities (e.g., Konya, Kayseri, and

PRIVATE GFCF
SHARE IN GPD
(exp. side, 1998 prices, in percentages)

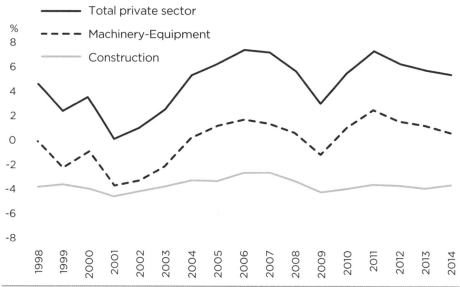

Source: TURKSTAT; Turkey Data Monitor

Chart 2

6 In current prices (nominal terms), the share of manufacturing declined from 19% to 17% during the same period, as service deflator outpaced manufacturing deflator. But

Gaziantep). This was, in turn, driven by firm-level productivity catch-up, thanks to investments in physical and social infrastructure as well as improvements in the quality of public services in the inland regions.[8]

The second dimension of the broadening of the economic base may be even more important. The extreme levels of inequality concerning income and access to public services started declining, with some signs of "shared" prosperity previously unseen in Turkey. As comprehensively

MANY PUBLIC SERVICES UNDERPINNING THE FUTURE PRODUCTIVITY OF THE TURKISH WORKFORCE HAVE EXPANDED

detailed in a recent World Bank report, examples of this transformation are many, but they all point to the same conclusion: poverty rates declined, the middle class expanded, and income inequality contracted.[9] For example, the headline Gini coefficient, measuring income inequality, dropped from a very high 42% in 2003 to about 38% in 2008.[10] This contraction in inequality was, in part, driven by labor income growth at the bottom of the distribution, resulting from both wage growth and employment expansion.[11]

Many public services underpinning the future productivity of the Turkish workforce, such as education, healthcare, and infrastructure, have expanded and become more equally distributed. There was also a sharp improvement in basic social services, narrowing the gap between Turkey and the rest of the OECD. This was achieved through a combination of reforms in public service delivery, significant increases in budget allocations, and changing priorities towards service delivery

importantly, as noted, real growth in the manufacturing sector kept up with broader growth in GDP. In addition, Rodrik (2009) notes that the composition of investment moved toward tradeables (i.e., manufacturing) during this period.

7 Chapter 4 of World Bank (2014) documents the regional as well as firm-level convergence story comprehensively. See also Hakura (2013), which includes a brief and useful discussion on the Anatolian Tigers.

8 See Annex I as well as Chapter 7 in World Bank (2014). See also Raiser (2014) for a brief discussion on the "inclusive" nature of Turkish growth, based on the World Bank study.

9 See World Bank Development Indicators.

10 World Bank staff observes that Turkey's experience in this sense is more akin to East Asia and Eastern Europe than Latin America.

11 The World Economic Forum's Competitiveness Index also shows significant improvements in Turkey's infrastructure quality, at least after its first year of availability, 2006.

in less-advantaged areas. Chart 3 shows a rapid catch-up of infant mortality and life expectancy to OECD averages, with particularly striking gains in rural areas and among poorer households. The gains in education are no less noteworthy. Chart 4 shows Turkey recording the largest improvements within the OECD in the quality of education as measured by OECD's Program for International Student Assessment (PISA) scores, with gains once again disproportionately concentrated among poorer households and in rural areas.[12]

The budget allocations that have centrally contributed to these trends have been made possible by the greater fiscal space that lower interest expenditures created. This has enabled the share of health expenditures in total government expenditures to increase by about 6 percentage points from 11% in 2002 to 17% in 2007, and that of education from about 10% to almost 14%.[13]

HEALTH: THE GAP BETWEEN TURKEY AND THE OECD IS SHRINKING

Source: World Bank (2014)

Chart 3

12 Our estimates, based on Ministry of Development data.

13 The government spending over GDP figures are computed from national income accounts data.

Equally important were the changing priorities in public service spending and delivery, which largely reflected the AK party's political objectives and payback to its base, comprising the less advantaged segments of the population living either in provincial towns or poorer neighborhoods of the major cities. Chart 5, for example, shows a striking reallocation of education spending away from the more prosperous areas in the major cities towards rural areas in the East.

All of this did not go unnoticed by the population, particularly by the AK party's base. As reported by Gurkaynak and Sayek-Boke (2012), in a poll conducted in 2008, approximately 85% of the respondents who had voted for the AK party said they had done so "because of the economy," largely accounting for the party's ongoing support from these less advantaged, more rural, and conservative demographics.

Many aspects of this story began to change sharply around 2007. Notable is the fact that this reversal in the character of macroeconomic

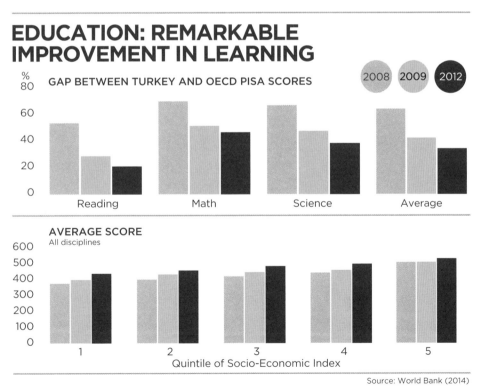

EDUCATION: REMARKABLE IMPROVEMENT IN LEARNING

Source: World Bank (2014)

Chart 4

growth predated the global economic crisis. As chart 1 shows, average per capita income growth decelerated to little over 3% from 2007 to 2014, markedly lower than the aforementioned 6% growth during 2002 to 2006. The chart also makes it clear that the loss in momentum started earlier than the deepening of the global economic crisis in late 2008. The economy grew by a less impressive 4.7% in 2007, with the slowdown continuing throughout 2008, even before the global crisis hit. Corroborating this timing, chart 2 shows a deceleration in private investment around 2007, which, except during the short-lived, post-2009 rebound, stayed at levels lower than those reached in 2006 and 2007.

In this sense, the global economic crisis may have helped mask the growing weaknesses in Turkey's growth dynamics. After a sharp contraction in 2009 (by about 5%), growth rebounded during 2010 to 2011 to an unsustainable, near 9% per annum pace, fanned by massive monetary and fiscal stimulus. The Central Bank's policy rate was reduced by over 10 percentage points, with the real interest rate declining to zero-to-negative territory from the pre-crisis 7% to 8% levels. Fiscal stimulus was also substantive, increasing government spending relative

THE EQUITY OF EXPENDITURES INCREASING INVESTMENT IN UNDERSERVED REGIONS

Geographical distribution of per capita government expenditure in education

2001

High

Low

2011

Source: World Bank (2014)

Chart 5

to GDP from 13% around 2006 to near 16%, almost completely eroding Turkey's hitherto impressive public sector primary surplus.[14] As a consequence, the contribution of government spending to GDP growth rose from about 10% from 2002 to 2006 to 25% in the later period.[15]

Though monetary and fiscal stimulus did bring growth back briefly during 2010 to 2011, growth in the post-2007 period as a whole has been markedly low-quality. Productivity growth has almost fully stalled, while TFP growth has also come down from its highs during 2002 to 2006 and, by some estimates, is now hovering in negative territory.[16] Manufacturing productivity, growing at about 1% per annum since 2007, has been lackluster as well. There has also been no repeat of the broadening of the economic base witnessed in the early 2000s. The Gini coefficient of inequality, for example, has edged up to 40% in 2011 from 38% in 2008.

GDP GROWTH CAPITAL INFLOWS AND SAVINGS

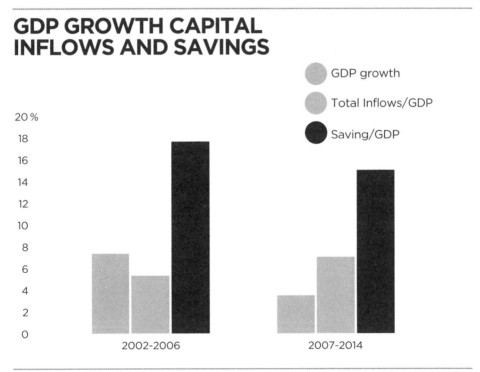

Source: TURKSTAT, CBRT, Turkey Data Monitor and the authors' calculations

Chart 6

14 This contribution is calculated as the change in government consumption and investment spending as percent of change in GDP.
15 See Conference Board Total Economy Database.
16 See Akcay and Ucer (2008) for a discussion of these dynamics.

Perhaps one of the most important manifestations of this low-quality growth has been the changing nature of the current account-growth relationship. High growth was accompanied by a relatively moderate current account deficit, mostly financing the rebound in domestic investment in the 2002 to 2006 period (as depicted in chart 2 above). However, chart 6 indicates that the post-2007 pattern is quite different in nature: it combines lower growth with higher current account deficits and a sharply lower saving rate—and no higher investment rate as shown in chart 2—suggesting that the higher inflows have been largely financing higher consumption.[17] The way the current account deficit has been financed during these two periods also bolsters this interpretation, with fairly long-term financing and foreign direct investment in the first period, and shorter-term flows in the second.[18]

Section II—Turkey's Institutional Backdrop and the EU Relations

Though causality is much harder to establish, it is noteworthy that Turkey's high growth episode overlapped with a period of major institutional and political changes. During this brief period of five years, Turkey's broader institutional setting has taken a conspicuous break from the past, moving from extreme discretion towards a rule-based environment, accompanied by major structural reforms. The deepening of Turkish democracy at the time appeared potentially epochal. The relations with the EU also experienced a hopeful turn with the decision to start the accession negotiations in October 2005. In what follows, we provide the broad contours of the ebb and flow of Turkish economic institutions and then turn to political factors and the political institutional dynamics undergirding the economic changes.

The consensus view among Turkey experts is that there has been a significant break in the 2000s in terms of "delegation of the decision-making power to relatively independent agencies, and the establishment of rules that constrain the discretion of the executive" (Atiyas 2012).[19]

17 See Akcay and Ucer (2008) for a discussion of these dynamics.

18 Though some of the foreign direct investment in the early phase was linked to privatization, much of it was driven by mergers and acquisitions in the private sector.

19 Prominent examples of these independent, autonomous agencies that were established in the early 2000s include Public Procurement Authority (established in 2002), Banking Regulatory and Supervision Agency (established in 1999 but commenced op-

This institutional shift from unchecked discretion of the 1990s to a more rule-based framework has had significant effect on the implementation of monetary and fiscal policies, the regulatory environment, and privatization practices. The key reform on the monetary policy front was undoubtedly the greater independence granted to the Central Bank, implemented as early as 2001. The new law defined the sole objective of the Central Bank as achieving and maintaining price stability in a context of first implicit and then formal inflation targeting, and it prohibited direct lending to the government.

On the fiscal front, institutional overhaul was substantial as well. The important steps here were the passing of two crucial laws—the Public Finance and Debt Management (PFDM) Law, of 2002, and the Public Financial Management and Control Law (PFMCL), of 2003—targeted at breaking with the destructive fiscal legacy of the 1990s with runaway off-budgetary expenditures, non-transparent borrowing practices, and lack of fiscal accountability. The objective of the PFDM was to bring all central government borrowing and guarantees under strict rules and to impose reporting requirements on all debts and guarantees. The PFM-CL, on the other hand, set the main framework of the fiscal management system by establishing "principles and merits, multi-year budgeting, budget scope, budget execution, performance management and strategic planning, internal control, accounting, monitoring and reporting."[20]

Finally, a Procurement Law, enacted under pressure and guidance from the World Bank, in 2002, sought to ensure effectiveness, transparency, and competitiveness in the public procurement system. The Law replaced the notoriously politicized and corrupted State Procurement Law, which had been in place since the 1980s. The changes on the regulatory front were similar and also relied on the establishment of a number of independent autonomous agencies (sometimes dubbed the "European Model") in order to strengthen rule-based decision-making and insulate the regulators from political influence.

erations in late 2000), Energy Market Regulatory Authority (established in 2001), the Telecommunications Authority (established in 2000 and recently renamed to ICTA), and Tobacco, Tobacco Products and Alcoholic Beverages Market Regulation Authority (established in 2002). The Competition Authority (established in 1994 and commenced operations in 1997) and the Capital Markets Board (established in 1981) were affected by these changes as well.

20 See Kaya and Yilar (2011) for details, which also provide a comprehensive assessment of the evolution of Turkey's fiscal structure over the past two decades.

The bottom line is that thanks to the enactment of these comprehensive and best-practice laws, governmental control over public expenditures was enhanced and Turkey's out-of-control, off-budget expenditures (including so-called "duty losses") were greatly restricted.[21] The early 2000s also witnessed improvements in Turkey's broader institutional environment, as can be gauged from the World Bank governance and doing business indicators depicted in chart 7, where Turkey shows solid progress in all key areas.

The corruption perception index compiled by Transparency International, depicted in chart 8, tells a similar story. There are tangible signs of lower corruption starting in 2003 (corresponding to higher values of the index), and Turkey's rank improves from around the high 70s among 175 countries in 2003 to the low 50s in the late 2000s[22]. However, things began to change for the worse around the time of the global crisis, with

INSTITUTIONAL REFORMS HAVE SLOWED SINCE THE MID-2000s

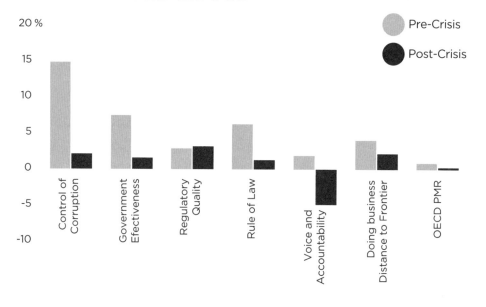

Source: WGI, Doing Business, OCDE and World Bank (2014)

Chart 7

21 Nonetheless, these reforms were highly incomplete; potential reforms aimed at increasing overall efficiency in public administration and accountability in public expenditure were shelved (Atiyas, 2012), and many inconsistencies and loopholes remained in fiscal transparency and reporting (OECD, 2014).

the pace of deterioration accelerating during the AK party's third term, which began in June 2011. This has taken the form of a virtual stalling of the structural reform efforts as well as a marked weakening in the institutional environment.

The gutting of the aforementioned procurement law is indicative of the de facto and de jure changes in economic institutions during this period. In some sense, the AK party was never at ease with the new law, seeing it from the very beginning as a major constraint on its grandiose investment projects (such as "15,000 kilometers of double-lane highways") and the funneling of state resources toward its own constituencies. As the party gained confidence and control, the procurement law began to be altered dramatically via various mechanisms, including a continuously expanding set of "exceptions," changes in the tender rules (open vs. restricted), various advantages for domestic bidders, and the introduction of rather high minimum monetary limits,

CORRUPTION PERCEPTIONS INDEX

CPI scores ranges between 10 (highly clean) and 0 (highly corrupt)

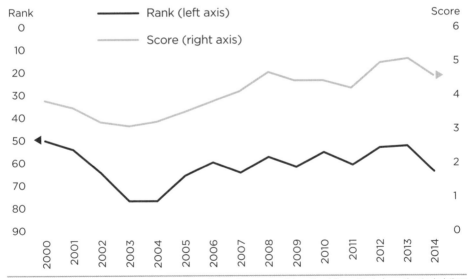

Source: Transparency International Corruption Index, authors' calculations

Chart 8

22 We interpret the fact that there is continued, albeit slight, improvement in Turkey's score and rank in the late 2000s as a consequence of the backward-looking nature of this corruption perception index.

below which procurement of goods and services would be exempted from the law.[23]

As documented by Gurakar and Gunduz (2015) in their very comprehensive account, both the number and the value-share of public procurement contracts that were left outside the transparent public procurement practices increased substantially during the period from 2005 onwards, reaching 44% in 2011.[24]

One giant entity that was fully left outside the purview of the procurement law, alongside public-private partnerships and defense spending, was the State Housing Development Administration, TOKI, which is directly attached to the Prime Minister's Office. As reported in Atiyas (2012), although TOKI's exemptions were originally limited to procurement for public housing projects, in 2011 these were extended to all construction undertaken by TOKI. Given that TOKI is now also exempted from PFMCL or any other budgetary rules, this means that the organization has wielded tremendous power over and a completely free hand in the redistribution of urban land throughout the country.

Perhaps unsurprisingly, in light of these changes, chart 8 shows declines both in the corruption perception index and Turkey's rank, with the latter sliding 11 notches to 64, in 2014 (out of 175 countries). It is probably also not a coincidence that land and construction deals were at the very heart of Turkey's largest corruption scandal, which broke out in December 2013, and the then Minister of Environment and Urban Planning was one of the four ministers implicated in the scandal.[25]

Setbacks can also be seen in crucial reform proposals that fully stalled. Two proposals that had been floated during the IMF program negotiations,

23 EU's 2014 Accession Report complained about both the state of the procurement law and its implementation, writing: "Turkey's public procurement legislation remains not in line with the acquis in a number of aspects. This includes numerous derogations and exemptions from the scope of the law. Both the classical and utilities sectors are formally subject to the same law and procedures, thus making the legislation for the utilities sector more restrictive than envisaged by the EU Utilities Directive. [...] There have been various allegations of political influence on public tenders."

24 They report that "the number of contracts awarded via open auctions fell from 100,820 in 2005 to 77,151 in 2011; the number of contracts covered by exclusions rose from 41,157 to 59,680. The share of the latter in total number of public procurement contracts rose from 29% to 44%. Similarly, contracts covered by exclusions and direct buying quadrupled from TL10.3 billion per annum in 2005 to 39.1 billion in 2011. In terms of value-share in total public procurement, this indicated an increase from 34 percent in 2005 to 44 percent in 2011."

25 For a timeline of the investigation and government's response, see Muller (2014).

which were held throughout 2009 during the apex of the global crisis, were first resisted and then shelved for good by the AK party leadership. One of these was about creating an independent tax authority, which was greatly needed not only to insulate tax collection activities from political influence, but also to alter Turkey's tax structure, which heavily relies on indirect consumption taxes, towards direct taxes. The other proposal was about adopting a "Fiscal Rule," which would consolidate Turkey's fiscal adjustment and contain the deterioration experienced during the crisis. Though early on promoted by Ali Babacan, the Deputy Prime Minister and the Treasury Minister in charge of economic coordination, this also never got off the ground.

LAND AND CONSTRUCTION DEALS WERE AT THE VERY HEART OF TURKEY'S LARGEST CORRUPTION SCANDAL, WHICH BROKE OUT IN DECEMBER 2013

Arguably more ominous were the aggressive attacks by the government on autonomous agencies. As explained in Ozel (2015), after some de facto meddling in the affairs of these agencies (e.g., in the form of influencing the election of board members or the hiring and firing of staff), the government took formal steps by signing two decrees to law in 2011 that paved the way for more explicit intrusion from respective ministries. Of these, one (Decree No. 649) explicitly stated that the respective minister would have "the authority to inspect all transactions and activities of the related, attached and affiliated agencies" (which included the autonomous regulatory agencies), thus giving the ministers and their staff the ability to restrict the independence of these agencies. Around that time, the idea of independent regulatory institutions was been dealt another blow, with Mr. Babacan, the main reform advocate within the government, stating that "it was time for some independent agencies to re-delegate their authority" (Ozel 2015).[26]

Meanwhile, the Central Bank, already eager to accommodate the excessively low interest rate policies pushed by the then Prime Minister

26 Another episode that showed AK party's growing intolerance toward independent scrutiny was witnessed around Turkey's Court of Audits (TCA). After adopting a best-practice law with some 5-year delay in 2010, the government attempted to curb the Court's powers and the Parliament's access to proper financial reporting by way of passing new legislation in 2012. After a repeal of the Law by the Constitutional Court, the government pressed ahead with another draft law, which could, as stated in EU's

Recep Tayyib Erdogan, came under even heavier pressure for not re-
ducing interest rates quickly enough to support growth. The whole
episode was damaging not just because of its implications for macro-
economic policy, but because it demonstrated the unwillingness of the
government to be restrained even by the most pliable organizations.

We have argued that the turnaround in Turkey's economic performance
is a reflection of the turnaround in economic policies and institutions,
including the stalling or reversals in the process of much needed struc-
tural reforms. But this only provides a proximate answer to the deeper
question of why economic policies and institutions improved in the
first phase and then went into a reversal. We argue that both the initial
improvements in economic institutions and their subsequent slide are
related to political factors.[27]

To put it simply, during its first five years of rule, the AK party be-
came, partly unwittingly and perhaps even unwillingly, an instrument
of deep-rooted political reform. This period witnessed the broadening
of the political base as the military tutelage in Turkish politics—prob-
ably the most important factor holding back Turkish democracy and
civil society—ended. A confluence of factors came together to make the
early 2000s a propitious time for such a fundamental transformation in
Turkish politics. Four deserve to be emphasized in particular.

First, as already noted, the AK party came to power after a basic
structure of economic reforms had been put in place following the 2001
financial crisis. This, and the inexperience of their top echelon, limited
what they could do.

Second, the AK party came to power as a representative of an increas-
ingly disenfranchised (or at least feeling disenfranchised) segment of
Turkish society: provincial, conservative businessmen; urban poor (who
were often recent migrants); and rural populations, except Kurds and
Alevis (who were always viewed suspiciously by the almost entirely Sunni
AK party leadership). These social groups, which were less Western, more

Progress Report of 2013, "[...] result in a distortion of the TCA's mandate and its ability
to carry out independent and effective audit." The Law is now on hold, having been
withdrawn because of objections from both within and outside the Parliament.

27 This emphasis on the role of political institutions in shaping economic policies and
institutions builds on Acemoglu and Robinson (2012).

religious, and more conservative, were never welcomed by the rulers of Turkey in the 20th century, the so-called "Kemalist elites" (named after their ideological commitment to the principles of the Republic's founder, Mustafa Kemal Ataturk; often defined to include the military, the bureaucracy and big, urban-based conglomerates; and argued to be represented by the state's party, the Republican People's Party). This is not to deny that the conservative ideology of these groups has all too often influenced school curricula or formed the foundational rhetoric of several military regimes, most notably the one catapulted to power by the 1980 coup.

But both traditionally, and specifically during the 1990s, these groups felt increasingly excluded and were at one end of a culture war, with seemingly stronger forces on the other side—a culture war summarized, even if bombastically, by Prime Minister Recep Tayyip Erdogan's famous statement: "In this country there is a segregation of Black Turks and White Turks. Your brother Tayyip belongs to the Black Turks."[28] The AK party's rise to power thus came to be seen as the enfranchisement of this previously-excluded group. During their early rule, they had to defend democracy (which they interpreted as respecting the electoral results rather than succumbing to a military intervention against them) as a survival strategy.

Third, the AK party came to power in 2002 with a limited mandate, receiving only 34% of the national vote. They had little choice but rule inclusively, especially given the suspicious and almost hostile attitude of the military towards it from the start.

Fourth, the AK party came on the scene when EU-Turkey relations were undergoing perhaps their most constructive period and presented itself as a staunch supporter of EU accession. To be sure, the process leading up to the accession negotiations, launched on October 2005, was anything but smooth. Yet, the process started reasonably earnestly and with significant momentum in 2006 and had the strong backing of the Turkish public, as illustrated by chart 9.[29]

The view at the time was that Turkish accession to the EU could proceed relatively rapidly, as summarized by a high-profile report: "Our starting assumption is that it is likely that accession negotiations would

28 While the exact timing of this statement is a matter of debate, it first rose to prominence when quoted in a New York Times interview with the newly-elected Erdogan by Deborah Sontag in May 2003.

29 As detailed in Morelli (2013), while the EU Council agreed to a "Negotiating Framework" and opened the negotiations, language of the Framework was kept deliberately

start during 2005, but that they would last for quite some time, with membership materialising only around 2012-15. We therefore take a long-term perspective and explore particular areas in which the EU and Turkey could cooperate during the long interim negotiating period" (Dervis et al. 2004).

The EU accession process had at least two sorts of effects on Turkish institutions. First, on the political side, the EU shouldered a role similar to the one that the IMF and the World Bank had played on the economic side of the aftermath of the 2001 financial crisis, providing both pressure for reform and a template for best-practice legislation in the areas of civil and political rights, civilian-military relations, and judicial reform. As part of the engagement process with the EU, a number of far-reaching and difficult reforms were thus set in motion, even if many of these were finally enacted in the late 2000s. A non-exhaustive list includes improved property rights for non-Muslim religious foundations; the lifting of draconian penalties against speech construed as a critique of Turkish identity; the introduction of the ability of civilian courts to try military personnel and the banning of the trials of civilians in military

TURKISH PERCEPTION OF TURKEY'S MEMBERSHIP IN THE EUROPEAN UNION

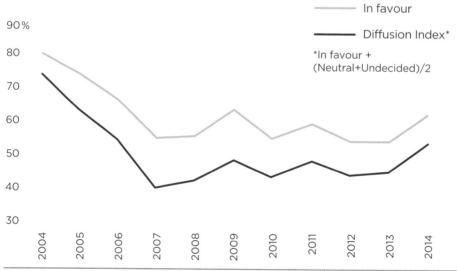

Source: authors' calculations based on GMF Transatlantic Trends

Chart 9

courts; laws protecting children; improved trade union rights, including permission for workers to become members of more than one union simultaneously; permission for public service workers to sign collective labor agreements, removing previous bans on political and solidarity strikes; and permission for individuals to apply to the Constitutional Court in cases where their freedoms of fundamental rights are violated.[30]

In addition, the lifting of bans against Kurdish protests and legislation allowing state-run Turkish radio and television to broadcast in Turkish; the ending of the emergency rule over the last two of the 13 Kurdish-majority provinces; the introduction of broad civilian supervision over defense expenditures; and the removal of National Security Council presence in the oversight of cinema, video, musical works, radio, and television; as well as a shift in the government's willingness to generally respects rulings by the European Court of Human Rights were also steps long-advocated by the EU and are generally interpreted as being a direct result of EU-Turkey engagement.[31]

Second, as already noted, the prospect of EU accession acted as an anchor and a carrot to the ruling party—there were major economic gains from closer ties with Europe. It wasn't just the economic benefits of EU accession that motivated the AK party, however. Since the AK leaders viewed themselves under constant threat from the military, closer ties to EU appeared as an attractive bulwark against a military coup. Since Turks were increasingly keen on becoming part of Europe, the cards were stacked against any moves that would alienate Turkey's European partners.

All of these factors would disappear or change their character by the middle of the 2000s. The effect of the economic institutional framework put in place after the 2001 crisis ceased to have much of a determining role as the AK party elites and mayors found ways of circumventing the regulations and laws or changing them, as we recounted in the case of the procurement law, to benefit themselves or their party. The 2002 election brought the beginnings of the end of the two major center-right parties, with their votes going almost in block to the AK party in the

loose (meaning no guarantee of eventual membership was extended). Cyprus was a thorny issue from day one, exacerbated by Turkey's refusal to extend Customs Union to Greek Cyprus. This has subsequently led to EU Council blocking 8 chapters. See the annex table for a time line of EU- Turkey relations since 2005.

30 See Hale (2011).

31 See Kirisci (2011) and Gursoy (2011).

2007 elections, making it a much more formidable force in electoral politics. By 2011, the AK party commanded almost 50 percent of the vote. More importantly, the balance between the AK party (and its base) and the Kemalist forces changed significantly. Because these events are important both for understanding how the center of gravity of Turkish

THE EU'S ANCHOR FOR TURKISH INSTITUTIONAL REFORMS AND LEVERAGE OVER TURKISH POLITICIANS CAME TO AN END IN 2010 AS THE ACCESSION PROCESS STALLED

politics shifted, and how the AK party came to define itself and understand its power, it is useful to recount them in some detail.

The backdrop is the political history of Turkey in the 20th century, which was dominated by the military and state bureaucracy. The one-party rule imposed by Ataturk came to an end in the first semi-democratic elections of 1950,[32] creating the Democratic Party, which fashioned itself as a representative of the same provincial business interests and conservative cultural values for which the AK party later came to speak. In 1960, the military moved against the Democratic Party and proceeded to hang its leader, Adnan Menderes. The military then engineered two more coups, in 1971 and 1980, and also brought down another Islamist party in 1997 with the threat of a coup (and subsequent action by the Constitutional Court closed the party). The generals were already unhappy about both the AK party's rise to power and their increasingly marginalized role in the 2000s, when the AK party nominated its number two, Abdullah Gul, for the presidency. The military and its civilian allies were alarmed by the fact that Gul's wife wore a headscarf and would represent Turkey in international forums and inhabit Ataturk's presidential palace.

This, combined with their general unease about the political direction of the country, made the military top brass move to threaten another coup with a web memorandum in April 2007, following the confirmation that Gul would be the next president of Turkey. Ominously, the Constitutional Court started proceedings to close the AK party for anti-secular

32 The first multi-party election in 1946 was not only called early by the ruling Republican People's Party before the opposition could organize itself, but was also marred by widespread vote-rigging (Zurcher 2004).

activities. But the situation was different in 2007 than it had been in 1960 or 1997. The AK party had already organized deeper social networks within modern Turkish society and had taken control of large parts of the bureaucracy and the increasingly heavily militarized police, while the status of the military within Turkish society was at an all-time low. This time, the military's threat came to nothing.[33]

This episode not only sidelined perhaps the most powerful opponent of the AK party, the Kemalist generals, but also further radicalized the AK leadership. According to some insider accounts, leading AK figures are reported to have packed their bags during the events of April 2007, fully expecting the military to come to power and put them in jail. Their David and Goliath reading of Turkish history—where the victimized "Black Turks" are stamped out by the conspiracy of Kemalist "White Turks"—was both confirmed and embellished. They may have concluded that they had to destroy not only the anti-AK party military elites, but also tear down the institutional structures that they saw as supporting these hostile groups. It is therefore natural to see the roots of the sham Ergenekon and Sledgehammer trials that the AK party and their allies organized against journalists, former mid-ranking soldiers, and generals, in their increasingly urgent need to weaken and remove their enemies.[34]

And, finally, the EU's anchor for Turkish institutional reforms and leverage over Turkish politicians came to an abrupt end around 2010 as the accession process almost completely stalled. Several factors played a role in this. The first stumbling block was Cyprus. The collapse of the UN-sponsored talks on a comprehensive settlement and Turkey's unwillingness to extend the Customs Union to Cyprus brought relations to a standstill and caused the suspension of eight ongoing chapters in 2006. Second, the government and, to a degree certain, segments of the population were also resistant to many of the legal and human rights reforms. Third, there was a backlash against Turkey in some of the key European countries, most notably in France's referendum and the rise of Nicholas Sarkozy, with an explicitly anti-Turkish accession platform. Finally, these developments

33 This dynamic was greatly assisted by a symbiotic alliance between the ruling AK party and the so-called "Gulen Movement" (named after the self-exiled preacher Fetullah Gulen, in the Unites States), which soured in the course of various power struggles and then acrimoniously broke up over Turkey's historic corruption investigations in December 2013.

34 On the Ergenekon trials, see Jenkins (2011). On the Sledgehammer case, see Rodrik (2014)

also started changing support for the EU within the Turkish population. As disillusionment set in, support for EU took a tumble, falling from above 70% in 2004 to a low of 40% in 2007, as detailed in chart 9.

As enthusiasm and support for EU accession among Turks waned, and as the AK party turned East (a process that had many causes), Turkish institutions became increasingly unanchored, further damaging Turkey-EU relations. Recent remarks by Jean-Claude Juncker, President of the European Commission, summarize what has become a common stance among many European policymakers and bureaucrats: "[...] under my Presidency of the Commission [...] no further enlargement will take place over the next five years. As regards Turkey, the country is clearly far away from EU membership. A government that blocks twitter is certainly not ready for accession" (The Official Website of the EC President, My Foreign Policy Objectives, April 2014).

Though these comments emphasize the Turkish bans on social media, they are a reaction to a culmination of increasingly authoritarian policies and institutional changes adopted by the AK party as a result of the turnaround in all of the factors that were previously pushing it to adopt pro-democratic, pro-civil society reforms. EU's 2014 Accession Report, for example, was alarmed by the government and the judiciary's response to the December 2013 corruption scandal, concluding:

> The response of the government following allegations of corruption in December 2013 has given rise to serious concerns regarding the independence of the judiciary and separation of powers. The widespread reassignments and dismissals of police officers, judges and prosecutors, despite the government's claim that these were not linked to the anti- corruption case, have impacted on the effective functioning of the relevant institutions, and raise questions as to the way procedures were used to formalise these.

The implications of all of these trends for the Turkish political institutions and freedoms are striking. The World Justice Project, a comprehensive snapshot index of a country's legal environment, ranked Turkey 80th among 100 countries (down from 59th previously). In press freedoms, Turkey was labeled "not free" by the Freedom House and was ranked 149th place among 180 countries by another independent watchdog, Reporters Without Borders. Chart 7 above further indicates that Turkey's progress in terms of broader governance and reform indices has come to a complete halt.

It is, of course, natural to ask why Turkish political institutions and civil society organizations failed to defend the advances and the freedoms

gained in the early 2000s. The most likely answer is that these institutions were not as strong as one might have hoped and that civil society organizations did not wake up to the slide until it was too late. The weakness of the institutions that were supposed to guard society against the usurpation of power probably lies in the fact that the judiciary and state bureaucracy in Turkey have never been independent, and their allegiance, which firmly lay with the military before 2000, shifted quickly to the AK party, which exploited its power to make appointments and promotions.

> ## THE WEAKNESS OF THE INSTITUTIONS PROBABLY LIES IN THE FACT THAT THE JUDICIARY AND STATE BUREAU- CRACY IN TURKEY HAVE NEVER BEEN INDEPENDENT

The AK party also came to have a heavy, almost stifling influence on print media and TV—not unlike the influence of the Kemalist elites in earlier periods—as indicated by the aforementioned deterioration in Turkey's standing in press freedoms. It also took time for civil society organizations, which were just finding their voice during this period, and foreign media to recognize how the political balance was shifting in Turkey, partly because they were still celebrating the eclipse of the military.

Section III – Concluding Remarks and the Way Forward

In this brief essay, we have advanced several key arguments. The Turkish economy's most recent ups and downs, with a turning point around 2007, are not an exemplar of the typical stop-go cycle experienced by many emerging economies (including Turkey itself in the past), but rather the consequence of a first phase of structural reforms and unprecedented (by Turkish standards) improvements in economic institutions, followed by a total about-face in a second phase, during which all of these improvements were reversed.

The roots of the ups and downs of economic institutions is to be found in the political dynamics of Turkey, which created a propitious environment for a major political opening in 2002, with the governing AK party as its unwitting agent, but then enabled the AK party to become too powerful for the always-weak checks and balances presented by Turkish civil society, judicial institutions, and parliamentary opposition.

Though several other factors, including the waning effect of World Bank/IMF reforms and the ending of the fight between the AK party leaders and the military, decisively in favor of the former, set in motion the slide in Turkish political and economic institutions. EU-Turkey relations arguably played the critical role. Even though both the reforms adopted in the process of EU accession and the anchoring role of the relations with the EU facilitated the difficult economic and political reforms of the first phase, as relations with the EU soured subsequently, these dynamics played in reverse.

EU MIGHT BE CAPABLE OF MOVING TURKISH INSTITUTIONS IN THE DIRECTION OF DEEPER AND STRONGER DEMOCRACY

In conclusion, we draw several lessons for the future of the Turkish institutions, Turkey-EU relations, and more broadly. The most important lesson, which, in our view, applies both to Turkey and to other emerging economies, is that even starting with weak institutions and political imbalances, rapid and high-quality growth appears feasible if the political opening for deep structural reforms and improvements in economic institutions can be found. We are fully aware that such a political opening is far from trivial, and in the Turkish case, it may have been made feasible only because the bastions of the old order, the military and other parts of the Kemalist elites, were particularly weakened. In addition, many of the traditional politicians were blemished because of incompetence and widespread corruption during the 1990s, and a deep financial crisis left no choice to a caretaker government and its successor, the AK party, but to work with the IMF and the World Bank. All the same, the rapidity with which these reforms bore fruit is a surprise to many commentators who view them as either ineffective or slow-acting.[35]

Second, this episode also underscores the closely linked nature of political and economic reforms. In our account, what enabled the structural and economic reforms of the first phase were the favorable political winds of change that strengthened democracy and representation in Turkey. But these political factors went in sharp reverse in the second

[35] Though they are consistent with other findings, such as Acemoglu, Naidu, Restrepo, and Robinson (2014), showing fairly rapid improvements in economic growth following democratization.

phase, and as a result, so did economic institutions. The slide of political institutions reflected the unrestrained domination of the AK party, enabled partly because of the inherent weakness of Turkish civil society and judicial institutions, and partly because the AK party elites were able to establish their unrivaled control over the judiciary and media via appointments and intimidation.

Finally, we believe there are also important lessons from this episode for the future of EU-Turkey relations. Though these appear to have hit bottom at the moment, there are plenty of grounds for future engagement. To start with, closer trade ties that were initiated by the Customs Union are ongoing, and "upgrading" these ties, which seems inevitable given the developments in the global economy over the past two decades, could be one such vehicle.[36] More importantly, perhaps, once the current European economic crisis and the mounting refugee crisis are brought under control in the next several years, EU's priorities may shift once

PROPORTION OF POPULATION

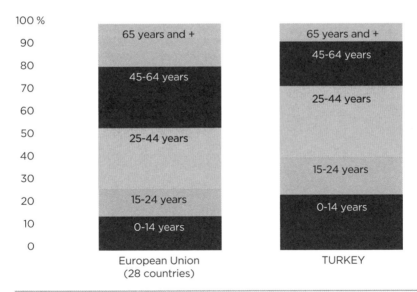

Source: Authors' calculations based on Eurostat

Chart 10

36 See Ulgen (2012), Pierini and Ulgen (2014) and Kirisci and Ekim (2015).

again towards enlargement. Even without a full-scale turnaround of this sort, European leadership might find different formulas for closer engagement with Turkey.[37] An important reason for such engagement for the EU is highlighted by our account: under the right type of engagement, the EU might have significant power over Turkish institutions, capable of moving them in the direction of deeper and stronger democracy under the EU's pressure and anchor. Although this power most likely requires a willing, or at a very least pliable, partner at the helm on the Turkish side, internal political dynamics may yet nudge Turkish leaders towards such a position in the near future. Our essay also suggests that such re-engagement can generate sizable economic gains for Turkey.

But the gains are not all one-sided. This institutional power is an argument for EU engagement precisely because the EU can reap two types of major gains from closer relations with Turkey and improvements in Turkish institutions. The first one, though almost trite because of its frequent emphasis in many debates, is still important: Turkey can play a stabilizing role in the Middle East (especially in contrast to its current complicating role in the Syrian crisis).[38] With European nations, large and small, increasingly drawn into conflicts in the broader region and feeling their aftershocks, there is arguably a greater need for a holistic engagement with the Middle East and North Africa. This is a strategy for which a democratic Turkey, engaged with the EU, could be an invaluable asset, not only as a partner in foreign policy, but also as an exemplar of a successful Muslim democracy for the rest of the region.[39]

The second pertains to demographic benefits that Turkish membership would grant the EU, although the short-term economic costs, and perhaps the medium-term social costs of Turkish membership are not to be downplayed. As chart 10 shows, Turkey has a much younger population than Europe. As Europe grows older, the gains from integrating Turkey's younger population into the European economy could be substantial—both for the labor market and for the sustainability of the ever-evolving set of social welfare programs that are so important for Europe's population—even if the demographic window of opportunity presented by possible Turkish accession will inevitably get narrower over time.

37 For an assessment of Turkey's Syria policy, see Hope (2013). Stein (2015) looks at the more recent developments.
38 Ahtisaari et al, (2015).
39 Ahtisaari et al. (2015).

TIMELINE OF TURKEY-EU RELATIONS: 2005-PRESENT

	CHAPTERS	OTHER DEVELOPMENTS
2005		Council adopts negotiating framework, and negotiations are formally opened.
2006	Chapter on Science & Research (25) opened and provisionally closed.	Due to the Cyprus conflict, EU decided that negotiations on 8 chapters could not be opened and no chapters could be provisionally closed. These were: Free Movement of Goods (1), Right of Establishment & Freedom To ProvideServices (3), Financial Services (9), Agriculture& Rural Development (11), Fisheries (13),Transport Policy (14), Customs Union (29), External Relations (30).
2007	Five chapters are opened: Enterprise & Industrial Policy (20), Consumer & Health Protection (28), Trans-European Networks (21), statistics (18) and Financial Control (32).	France declared it will not allow opening of negotiations on 5 chapters because these chapters are directly related to the membership. These were: Agriculture and Rural Development (11), Economic and Monetary Policy (17), Regional Policy and Coordination of Structural Instruments (22), Financial and Budgetary Provisions (33), Institutions (34).
2008	Four chapters are opened: Free Movement of Capital (4), Company Law (6), Intellectual Property Law (7) and Information Society & Media (10).	Council adopts a revised Accession Partnership framework for Turkey.
2009	Two chapters are opened on Taxation (16), Environment and Climate Change (27).	Cyprus unilaterally declares that it would block the opening of 6 chapters: Freedom of Movement for Workers (2), Energy (15), Judiciary and Fundamental Rights (23), Justice, Freedom and Security (24), Education and Culture (26), Foreign, Security and Defense Policy (31).
2010	Chapter on Food Safety, Veterinary & Phytosanitary Policy (12) is opened.	
2011	No Activity	
2012		Positive Agenda launched, intended to bring fresh dynamics into the EU-Turkey relations.
2013	Chapter on Regional Policy & Coordination of Structural Instruments (22) is opened.	France lifted its blockage on Chapter 22, Regional Policy & Coordination of Structural Instruments.

Fuente: "Relations between Turkey and the European Union" (MFA)

ORLANDO FIGES is professor of History at Birkbeck College, University of London. He graduated from the University of Cambridge, where he was a professor of History and a fellow of Trinity College. He is a member of the Royal Society of Literature, a regular contributor to *The New York Review of Books* and the author of numerous books on the history of Russia, including *A People's Tragedy: The Russian Revolution, 1891-1924*—which won the Los Angeles Times award as well as many others—*Natasha's Dance: A Cultural History of Russia* or *The Whisperers: Private Life in Stalin's Russia* (2007).

The Russians have always been uncertain about their place in Europe. That ambivalence is an important aspect of their cultural history and identity. Living on the margins of the continent, they have never been quite sure if their destiny is there. Are they of the West or of the East? Feelings of ambivalence and insecurity, of envy and resentment towards Europe, have long defined the Russian national consciousness—and they still do today.

RUSSIA AND EUROPE

1

From the reign of Peter the Great and the founding of St. Petersburg (his "window on the West") in 1703, educated Russians looked to Europe as their ideal of progress and enlightenment. St. Petersburg was more than a city. It was a vast, almost utopian, project of cultural engineering to reconstruct the Russian as a European man. Everything in the new capital was intended to compel the Russians to adopt a more European way of life. Peter forced his noblemen to shave their "Russian" beards (a mark of devoutness in Orthodox belief), adopt Western dress, build palaces with classical facades, and adopt European customs and habits, including bringing women into society. By the early nineteenth century, much of the nobility spoke French better than they spoke Russian. French was the language of the salon, and French loan-words made their way into the Gallicized literary language of Russian writers such as Alexander Pushkin (1799-1837) and Nikolai Karamzin (1766-1826) at this time.

RUSSIA'S WESTERNISTS SOUGHT EUROPE'S APPROVAL, AND WANTED TO BE RECOGNIZED AS EQUALS

For the Russian intelligentsia, Europe was not just a place: it was an ideal—a region of the mind that they inhabited through their education, their language and their general attitudes. "In Russia we existed only in a factual sense," recalled the writer Mikhail Saltykov-Shchedrin (1826-89). "We went to the office, we wrote letters to our relatives, we dined in restaurants, we conversed with each other and so on. But spiritually we were all inhabitants of France." Russia's Westernists identified themselves as "European Russians". They sought Europe's approval, and wanted to be recognized as equals by it. For this reason, they took a certain pride in the achievements of the imperial state, greater and more mighty than any other European empire, and in Petrine civilization with its mission to lead Russia to modernity. Yet at the same time

they were painfully aware that Russia was not "Europe"—it constantly fell short of that ideal—and perhaps could never become part of it.

When Russians travelled to Western Europe, they were aware of being treated as inferiors. In his *Letters of a Russian Traveller* Karamzin managed to express the insecurity that many Russians felt about their European identity. Everywhere he went he was reminded of Russia's backward image in the European mind. On the road to Königsberg, two Germans were amazed to learn that a Russian could speak foreign languages. In Leipzig, professors talked about the Russians as "barbarians" and could not believe that they had writers of their own. The French were even worse: They combined condescension towards the Russians as students

THE SLAVOPHILES HAD THEIR ROOTS IN THE NATIONALIST REACTION TO THE SLAVISH IMITATION OF EUROPEAN CULTURE

of their culture with contempt for them as "monkeys who know only how to imitate." As Karamzin travelled around Europe, it seemed to him that the Europeans had a different way of thinking, that perhaps the Russians had been Europeanized in only a superficial way: European values and sensibilities had yet to penetrate the Russian's mental world. Karamzin's doubts were shared by many educated Russians as they struggled to define their "Europeanness." In 1836, the philosopher Petr Chaadaev (1794-1856) despaired that the Russians were able only to imitate the West—they were unable to internalize its essential moral principles.

In the 1850s the Russian writer, socialist philosopher and émigré in Paris Alexander Herzen (1812-70) wrote: "Our attitude to Europe and the Europeans is still that of provincials towards the dwellers in a capital: we are servile and apologetic, take every difference for a defect, blush for our peculiarities and try to hide them." This inferiority complex engendered complicated feelings of envy and resentment of the West. The two were never far apart. In every educated Russian there was both a Westernizer and a Slavophile. If Russia could not become an equal part of Europe there were always those who were prepared to argue that it ought to take more pride in being different.

The Slavophiles emerged as a distinct grouping in the 1830s, when they launched their famous public disputes with the Westernists. They had their roots in the nationalist reaction to the slavish imitation of European culture, as well as to the French invasion of Russia in 1812.

The horrors of the French Revolution led the Slavophiles to reject the universal culture of the Enlightenment and to emphasize instead those indigenous traditions that distinguished Russia from the West. They looked to the virtues they discerned in the patriarchal customs of the countryside. They idealized the common folk (*narod*) as the true bearer of the national character (*narodnost*). As devout upholders of the Orthodox ideal, they maintained that the Russian was defined by Christian sacrifice and humility. This was the foundation of the spiritual community (*sobornost*) by which Russia—in contrast to the secular law-based states of Western Europe—was defined. The Slavophiles were never organized, except by the intellectual leanings of various journals and discussion groups, mostly in Moscow, which was seen as a more Russian capital, closer to the customs of the provinces, compared to St. Petersburg. Slavophilism was a cultural orientation, a mode of speech and dress (in the Russian manner), and a way of thinking about Russia in relation to the world. One notion shared by all those who were Slavophiles in this loose sense—and here we might count both the writers Fyodor Dostoevsky (1821-81) and Alexander Solzhenitsyn (1918-2008)—was a special "Russian soul", a uniquely Russian principle of Christian love, selfless virtue and self-sacrifice, which made Russia different from the West and spiritually superior to it. The West might have its Crystal Palaces, it might be technologically more advanced than Russia, but material progress was the seed of its own destruction because it fostered selfish individualism, from which Russia was protected by its collective spirit of sobornost. Here was the root of the messianic concept of Russia's providential mission in the world to redeem humanity. And here too was the origin of the idea that Russia was no ordinary territorial state; it could not be confined by geographical boundaries, but was an empire of this mystical idea. In the famous words of the poet Fyodor Tiutchev (1803-73), a Slavophile and militant supporter of the Pan-Slav cause:

> Russia cannot be understood with the mind alone,
> No ordinary yardstick can span her greatness:
> Her soul is of a special kind -
> In Russia, one can only believe.

2

Such ideas were never far away from the foreign policies of Nicholas I (1825-55). Nicholas was a firm upholder of autocratic principles. He

established the political police, tightened censorship, tried to seal off Russia from European notions of democracy, and sent his armies to crush revolutionary movements in Europe. Influenced by Slavophile ideas, he equated the defence of the Orthodox religion outside Russia's borders with the pursuit of Russia's national interests. He took up the Greek cause in the Holy Lands against the rival claims of the Catholics for control of the Holy Places, which led him into a protracted conflict with the French. He mobilized his armies to defend the Orthodox Slavs under Ottoman rule in the Balkans. His aim was to keep the Turkish Empire weak and divided and, with Russia's mighty navy in the Crimea, to dominate the Black Sea and its access through the Straits, which was of great importance to the Great Powers in order to connect the Mediterranean with the Middle East. There were dangerous policies of armed diplomacy that would lead to the Crimean War in 1854-56.

NICHOLAS I ESTABLISHED THE POLITICAL POLICE, TIGHTENED CENSORSHIP AND TRIED TO SEAL OFF RUSSIA FROM EUROPEAN NOTIONS OF DEMOCRACY

The first phase of the Crimean War was the Russian invasion of the Turkish principalities of Moldavia and Wallachia (more or less today's Romania) where the Russians counted on the support of the Orthodox Serbs and the Bulgarians. As Nicolas I contemplated his decision to launch the invasion, knowing it might bring the Western powers to intervene in the defence of Turkey, he received a memorandum on Russia's relations with the European powers written by the Pan-Slav ideologist, Mikhail Pogodin, a professor of Moscow University and founding editor of the influential journal *Moskvitianin* (Muscovite). Filled with grievances against the West, the memorandum clearly struck a chord with Nicholas, who shared Pogodin's sense that Russia's role as the protector of the Orthodox had not been recognized or understood and the Great Powers treated Russia unfairly. Nicholas especially approved of the following passage, in which Pogodin railed against the double standards of the Western powers, which allowed them to conquer foreign lands but forbade Russia from defending its co-religionists abroad:

> France takes Algeria from Turkey,[1] and almost every year England annexes another Indian principality: none of this disturbs the balance of power; but

1 In 1830.

Cossacks watching a screen featuring Vladimir Putin in Simferopol, the capital of the Republic of Crimea, on April 2015.

when Russia occupies Moldavia and Wallachia, albeit only temporarily, that disturbs the balance of power. France occupies Rome and stays there several years in peacetime:[2] that is nothing; but Russia only thinks of occupying Constantinople, and the peace of Europe is threatened. The English declare war on the Chinese,[3] who have, it seems, offended them: no one has a right to intervene; but Russia is obliged to ask Europe for permission if it quarrels with its neighbour. England threatens Greece to support the false claims of a miserable Jew and burns its fleet:[4] that is a lawful action; but Russia demands a treaty to protect millions of Christians, and that is deemed to strengthen its position in the East at the expense of the balance of powers. We can expect nothing from the West but blind hatred and malice, which does not understand and does not want to understand (*comment in the margin by Nicholas I*: "This is the whole point").

Having stirred the Tsar's own grievances against Europe, Pogodin encouraged him to act alone, according to his conscience before God, to defend the Orthodox and promote Russia's interests in the Balkans. Nicholas expressed his approval:

Who are our allies in Europe (comment by Nicholas: "No one, and we don't need them, if we put our trust in God, unconditionally and willingly.") Our

2 A reference to the expeditionary force of General Oudinot in 1849-50 which attacked the anti-papal Roman Republic and brought back Pius IX to Rome. The French troops remained in Rome to protect the Pope until 1870.
3 In the Opium Wars of 1839-42.
4 A reference to the Don Pacifico affair.

only true allies in Europe are the Slavs, our brothers in blood, language, history, and faith, and there are ten million of them in Turkey and millions in Austria... The Turkish Slavs could provide us with over 200,000 troops—and what troops!—All this without counting the Croatians, Dalmatians, Slovenians, etc. (comment by Nicholas: "An exaggeration: reduce to one-tenth and it is true.") [...] By declaring war on us, the Turks have destroyed all the old treaties defining our relations, so we can now demand the liberation of the Slavs, and bring this about by war, as they themselves have chosen war (*comment in the margin by Nicholas*: "That is right.")

If we do not liberate the Slavs and bring them under our protection, then our enemies, the English and the French [...] will do so instead. In Serbia, Bulgaria and Bosnia, they are already everywhere among the Slavs, featuring their Western parties. If they succeed, where will we be then? (*comment in the margin by Nicholas*: "Absolutely right.")

Yes! If we fail to use this favorable opportunity, if we sacrifice the Slavs and betray their hopes, or leave their fate to be decided by other powers, then we will have ranged against us not only one lunatic Poland but ten of them (which our enemies desire and are working to arrange) [...] (*comment in the margin by Nicholas*: "That is right.")

At the heart of this deliberation was the conviction that if Russia did not step in to defend its interests in the Balkans, the European powers would do so instead; hence, a clash of interests, influence and values between the West and Russia was unavoidable.

For the European powers the spread of Western power was synonymous with liberty and liberal values, free trade, good administrative practice, religious toleration, and so on. Western Russophobia was central to this push-back against Russian expansionist ambitions. The rapid territorial expansion of the Russian Empire in the eighteenth century and the demonstration of its military might against Napoleon had left a deep impression on the European mind. There was a frenzy of alarmist publications—pamphlets, travelogues and political treatises—about "the Russian menace" to the continent. These fears had as much to do with the imagination of an Asiatic "other" threatening the liberties and civilization of Europe as they had to do with any real and present threat. The boundaries of Europe were being drawn to exclude the "other" that was Russia, which emerged from these writings as a savage power, aggressive and expansionist by nature, hostile to the principles of liberty which culturally defined the Europeans. The Tsar's suppression of the Polish and Hungarian revolutions, in 1830-31 and 1848-49 respectively, reinforced this position of drawing divisions between European freedom and Russian tyranny, eventually cementing

the anti-Russian European alliance (Britain, France, Piedmont-Sardinia) during the Crimean War.

But from the Tsar's point of view the European powers were behaving hypocritically: their promotion of liberty was based on spreading free trade, which was in their economic interests. Their defence of Turkey was a strategy to restrain Russia, whose growth was a threat to their own imperial ambitions in the area, not least the route to India.

Defeat in the Crimean War left the Russians with a profound resentment towards the West. The peace treaty imposed by the victorious European powers was a humiliation for Russia, which was forced to destroy its Black Sea Fleet. No compulsory disarmament had ever been imposed on a Great Power previously. Not even France had been disarmed after the Napoleonic Wars. The way Russia had been treated was unprecedented for the Concert of Europe, which was supposed to be based on the principle that no Great Power should be humbled by others. However, the allies did not really believe that they were dealing with a European power, but regarded Russia as a semi-Asiatic state. During the negotiations at the Paris Conference, Count Walewski, the French Foreign Minister, had asked the British delegates whether it would not be overly humiliating for the Russians that the Western powers installed consuls in their Black Sea ports to police the demobilization. Lord Cowley, the British Ambassador in Paris, insisted that it would not be the case, pointing out that a similar condition had been imposed on China by the Treaty of Nanking after the First Opium War.

3

Defeated by the West, Russia turned towards Asia following her imperial plans after the Crimean War. Tsar Alexander II (1855-81) was increasingly persuaded that Russia's destiny lay as the major European power in Asia and that only Britain stood in its way. The climate of mutual suspicion between Russia and Britain after the Crimean War deeply influenced Russia to the extent of defining its policies in the Great Game and its imperial rivalry with Britain for supremacy in Central Asia in the final decades of the nineteenth century.

As a Christian civilization on the Eurasian steppe, Russia could face west or east. From the beginning of the eighteenth century, it had looked at Europe from the vantage point of its most eastern state. Along with

Vladímir Putin in front of an image of Tzar Nicolas II.

southern Spain, it could be said to form part of Europe's private East World—that "other" by which Europe was defined. However, if it faced the East, Russia would become the most western state in Asia, the carrier of a Christian-European civilization across eleven time zones of the globe.

The Russian conquest of Central Asia from the 1860s encouraged the idea that Russia's destiny was not in Europe, as had so long been supposed, but rather in the East. In 1881, Dostoevsky wrote:

> Russia is not only in Europe but in Asia as well. We must cast aside our servile fear that Europe will call us Asiatic barbarians and say that we are more Asian than European. This mistaken view of ourselves as exclusively Europeans and not Asians (and we have never ceased to be the latter) has cost us very dearly over these two centuries, and we have paid for it by the loss of our spiritual independence. It is hard for us to turn away from our window on Europe; but it is a matter of our destiny... When we turn to Asia, with our new view of her, something of the same sort may happen to us as happened to Europe when America was discovered. For, in truth, Asia for us is that same America which we still have not discovered. With our push towards Asia we will have a renewed upsurge of spirit and strength... In Europe we were hangers-on and slaves, while in Asia we shall be the masters. In Europe we were Tatars, while in Asia we can be Europeans.

This quotation is a good illustration of the Russians' tendency to define their relations with the East in reaction to their self-esteem and

status in the West. Dostoevsky was not arguing that Russia is an Asiatic culture; only that the Europeans thought of it as so. And likewise, his argument that Russia should embrace the East did not mean that it should seek to be an Asiatic force: on the contrary, that only in Asia could it find new energy to reassert its Europeanness. The root of Dostoevsky's turning to the East was the bitter resentment which he, like many Russians, felt at the West's betrayal of Russia's Christian cause in the Crimean War.

RESTORING SOVIET HISTORY IN RUSSIA WAS AN IMPORTANT PART OF PUTIN'S NATIONALIST AGENDA

A resentful contempt for Western values was a common Russian response to the feeling of rejection by the West. During the nineteenth century, the "Scythian temperament"—barbarian and rude, iconoclastic and extreme, lacking the restraint and moderation of the "cultivated European citizen"—entered the cultural lexicon as a type of "Asiatic" Russianness that insisted on its right to be "uncivilized". This was the sense of Pushkin's lines:

> Now temperance is not appropriate
> I want to drink like a savage Scythian.

And it was the sense in which Herzen wrote to French anarchist Pierre-Joseph Proudhon in 1849:

> But do you know, Monsieur, that you have signed a contract [with Herzen to co-finance a newspaper] with a barbarian, and a barbarian who is all the more incorrigible for being one not only by birth but by conviction? [...] A true Scythian, I watch with pleasure as this old world destroys itself and I don't have the slightest pity for it.

The "Scythian poets"—as that loose group of writers that included Alexander Blok (1880-1921) and Andrei Bely (1880-1934) called themselves—embraced this savage spirit in defiance of the West. Yet at the same time their poetry was immersed in the European avant-garde. They took their name from the ancient Scyths, the nomadic Iranian-speaking tribes that had left Central Asia in the eighth century BC and had ruled the steppes around the Black and Caspian seas for the following 500 years. Nineteenth-century Russian intellectuals came to

see the Scyths as a sort of mythical ancestor race of the eastern Slavs. In the final decades of the century, archaeologists led excavations of the Scythian *kurgans*, the burial mounds which are scattered throughout southern Russia, the south-eastern steppe, Central Asia and Siberia, in an effort to establish a cultural link between the Scyths and the ancient Slavs.

This prehistoric realm fascinated the Scythian poets. In their imaginations the Scyths were a symbol of the wild rebellious nature of primeval Russian man. They rejoiced in the elemental spirit (*stikhiia*) of savage peasant Russia, and convinced themselves that the coming revolution, which everybody sensed in the wake of that of 1905 would sweep away the dead weight of European civilization and establish a new culture where man and nature, art and life, were one. Blok's famous poem *The Scythians* (1918) was a programmatic statement of this Asiatic posturing towards the West:

> You are millions, we are multitudes
> And multitudes and multitudes.
> Come fight! Yes, we are Scythians,
> Yes, Asiatics, a slant-eyed greedy tribe.

It was not so much an ideological rejection of the West as a threatening embrace, an appeal to Europe to join the revolution of the "savage hordes" and renew itself through a cultural synthesis of East and West: otherwise it ran the risk of being swamped by the "multitudes". For centuries, argued Blok, Russia had protected a thankless Europe from the Asiatic tribes:

> Like slaves, obeying and abhorred,
> We were the shield between the breeds
> Of Europe and the raging Mongol horde.

But now the time had come for the "old world" of Europe to "halt before the Sphinx":

> Yes, Russia is a Sphinx. Exulting, grieving,
> And sweating blood, she cannot sate
> Her eyes that gaze and gaze and gaze
> At you with stone-lipped love and hate.

Russia still had what Europe had long lost—"a love that burns like fire"—a violence that renews by laying waste. By joining the Russian

Revolution, the West would experience a spiritual renaissance through peaceful reconciliation with the East.

> Come to us from the horrors of war,
> Come to our peaceful arms and rest.
> Comrades, before it is too late,
> Sheathe the old sword, may brotherhood be blest.

But if the West refused to embrace this "Russian spirit", Russia would unleash the Asiatic hordes against it:

> Know that we will no longer be your shield
> But, careless of the battle cries,
> We shall look on as the battle rages
> Aloof, with indurate and narrow eyes
> We shall not move when the savage Hun
> Despoils the corpse and leaves it bare,
> Burns towns, herds the cattle in the church,
> And the smell of white flesh roasting fills the air.

4

In March 1918, with German planes bombing Petrograd, as St. Petersburg had been renamed, the Bolsheviks removed the Soviet capital to Moscow. The move symbolized the growing separation of the Soviet Republic from Europe. By the Treaty of Brest-Litovsk, signed that month to end the war with the Central Powers, Russia lost most of its territories in Europe—Poland, Finland, the Baltic states, and Ukraine. As a European power, Russia was reduced to a status on a par with seventeenth-century Muscovy.

In the early years of Soviet power the Bolsheviks had hopes of their revolution spreading to the rest of the European continent. As Lenin saw it, socialism was unsustainable in a backward peasant country such as Russia without the revolution spreading to the more advanced industrial states. Germany was the focus of their highest hopes. It was the home of the Marxist movement and had the most advanced labour movement in Europe. The November 1918 Revolution was greeted with joy by the Bolsheviks. Its workers' and soldiers' councils seemed to suggest that Germany was moving on the Soviet path. But there was no German "October". The German socialists put their weight behind a democratic republic by entering government and crushing Communist uprising in January 1919. No other European state came even close to

a Moscow-aligned revolution: the post-war social and economic crises that radicalized workers began to ease, and by 1921 it had become clear that for the immediate future, until Europe was shaken by another war or crisis, Soviet Russia would have to survive on its own ("socialism in one country").

For the next seventy years Soviet Russia was isolated from the West, politically and culturally. There were brief spells when cultural channels opened up—during the Second World War, for example, when Western books and films were sent by the Allies and made available to the Soviet people; or during the Khrushchev Thaw of the late 1950s and early 1960s when cultural exchanges between the Soviet Union and the West took place. With the Soviet take-over of Eastern Europe after 1945, Soviet citizens could also travel to the Eastern Bloc countries, from which they received some elements of European culture in a form acceptable to the Communist authorities. But otherwise, in general terms, they were cut off from the universalism of the European tradition to which Petrine Russia (1703-1917) was attached.

THE RUSSIANS HAD FREELY INTERMINGLED WITH THE FINNO-UGRIC TRIBES, THE MONGOLIANS AND OTHER NOMAD PEOPLES FROM THE STEPPE

Among the scattered émigrés who fled Soviet Russia after 1917 was a group of intellectuals known as the Eurasianists. Eurasianism was a dominant intellectual trend in all the émigré communities. Many of the best-known Russian exiles, including the philologist Prince N. S. Trubetskoi (1890-1938), the religious thinker Father George Florovsky (1893-1979), the historian George Vernadsky (1887-1973) and the linguistic theorist Roman Jakobson (1896-1982), were members of the group. Eurasianism was essentially a phenomenon of the emigration insofar as it was rooted in the sense of Russia's betrayal by the West in 1917-21. Its largely aristocratic followers reproached the Western powers for their failure to defeat the Bolsheviks in the Revolution and civil war, which had ended with the collapse of Russia as a European power and their own expulsion from their native land. Disappointed by the West, but not yet hopeless about a possible future for themselves in Russia, they recast their homeland as a unique, "Turanian" culture on the Asiatic steppe.

The founding manifesto of the movement was *Exodus to the East*, a collection of ten essays published in Sofia in 1921, in which the Eurasianists

foresaw the West's destruction and the rise of a new civilization led by Russia or Eurasia. As argued Trubetskoi, the author of the most important essays in the collection, Russia was at root a steppeland, Asian culture. Byzantine and European influences, which had shaped the Russian state and its high culture, barely penetrated the lower strata of Russia's folk culture, which had developed more through contact with the East. For centuries, the Russians had freely intermingled with the Finno-Ugric tribes, the Mongolians and other nomad peoples from the steppe. They had assimilated elements of their languages, their music, customs and religion, so that these Asiatic cultures had become absorbed in Russia's own historical evolution.

Such folklore had little in the way of ethnographic evidence to be supported. They were but polemic and resentful posturing against the West. In this respect, they came from the same stable as that notion first advanced by Dostoevsky that the empire's destiny was in Asia (where the Russians could be Europeans) rather than in Europe (where they were "hangers-on"). Yet because of their emotive power, Eurasianist ideas had a strong cultural impact on the Russian emigration of the 1920s and 1930s, when those who mourned the disappearance of their country from the European map could find new hope for it on a Eurasian one, and these same ideas have been revived in recent years, following the collapse of the Soviet Union, when Russia's place in Europe has been far from clear.

5

With the collapse of the Soviet regime, there were hopes that Russia would rejoin the family of European states, where it had belonged before 1917. Western governments and their advisers believed that Russia—perhaps more so than the Eastern European states that had emerged from the Soviet bloc—would become "like us": a capitalist democracy with liberal European values and attitudes. That belief was mistaken, for historical and cultural reasons which should by now be clear; any hopes were dashed by what took place in Russia after 1991.

For millions of Russians, the collapse of the Soviet Union was a catastrophe. In a few months they lost everything: an economic system that had given them security and social guarantees; an empire with a superpower status; an ideology; and a national identity shaped by the version of Soviet history they had learned in school. The "capitalist

system" that was introduced—with hurried privatizations at a time of hyperinflation—resulted in the theft of state assets by corrupt oligarchs. The boom in criminality did not help the capitalist cause. All this fuelled a profound resentment of the West, which was blamed for this new system. Beyond the small intelligentsia, confined to Moscow and St. Petersburg, the majority of Russians, in provincial Russia did not share the liberal values of democracy (freedom of expression, religious toleration, equality for women, LGBT rights, etc.), all of which seemed foreign to the Soviet and older Russian ways by which they had been brought up. Russians felt these values were imposed on them by the "victorious" West in the Cold War.

Putin expressed their hurt pride and resentment of the West. In the first term of his Presidency, from 2000 to 2004, he had seemed to signal an interest in closer ties to Europe, if only to create a counterweight to American influence. He continued Boris Yeltsin's rhetoric of a "Greater Europe", a community of European states, including Russia in some form, which could act as a "strong and truly independent centre of world politics" (i.e. independent of the U.S.), albeit without Yeltsin's stress on liberal democratic principles. But two things altered Putin's stance on Europe during 2004. First, NATO expansion into Eastern Europe and the Baltic states aggrieved the Kremlin, which saw this as a betrayal of NATO promises on the dissolution of the Warsaw pact not to move into the former Soviet sphere of influence. Secondly, the Orange Revolution in Ukraine fuelled the insecurities of the Putin government, which saw the democratic movement as a Western (U.S.-led) offensive against Russia's influence in its near abroad (the Commonwealth of Independent States). Ukraine was, and still remains, a crucial border country in Russia's national identity and relations with Europe. Kiev was the birthplace of Russia's Christian civilization. As Putin often says, many Russians regard the Ukrainians as the same people, or family of peoples, as themselves.

Fearful of a similar democratic movement spreading from Ukraine into Russia, Putin buttressed his authoritarian power with a nationalist base of popular support built on anti-Western rhetoric. The U.S. and the E.U. were fostering democratic revolutions in countries of the former Soviet Union to destroy Russia—which, in brief was, and still is, his view. The regime strengthened its relations with the Church. It promoted the ideas of Eurasianist philosophers such as Ivan Ilyin (1883-1954), a White émigré, whose remains, on Putin's orders, were returned from

Switzerland to Russia in 2009. Eurasianist ideas began to be voiced by Kremlin ideologists. Putin backed the idea (originally proposed by the President of Kazakhstan Nursultan Nazarbayev) of creating a Eurasian Economic Union, and in 2011 the presidents of Belarus, Kazakhstan and Russia agreed to set a target of establishing one by 2015. Putin was determined to include Ukraine in this Eurasian Union, but the Ukrainians in Maidan were equally determined to join Europe.

Restoring Soviet history in Russia was an important part of Putin's nationalist agenda.

TWO PROPOSALS THAT HAD BEEN FLOATED DURING THE NEGOTIATIONS WERE FIRST RESISTED AND THEN SHELVED BY THE AK PARTY

Whilst acknowledging the "mistakes" of the Stalin era, his euphemism for the terror in which countless millions of people died or languished in the Gulag, Putin insisted that there was no need for the Russians to dwell on this aspect of their recent past, let alone to listen to the moralizing lectures of foreigners about how bad their history was. They could take pride in the achievements of the Soviet period—the industrialization of the country, the defeat of Nazi Germany and Soviet science and technology—which had given meaning to their lives and to the sacrifices they had made. For millions of Russians, Putin was restoring national pride.

The constant refrain in his speeches is the need for Russia to be given more respect, to be treated as an equal by the West. He has frequently complained about the hypocrisy and double standards of the West, which invades Iraq in the name of freedom but imposes sanctions on Russia when it defends what it describes as its legitimate interests in the Crimea. The parallels with the resentment of Nicholas I about double standards on the eve of the "first" Crimean War are striking here. Just as Nicholas I regarded the defence of Russia's co-religionists in the Balkans as his Christian duty, as the Tsar of All the Russias, so Putin has equated the defence of Russian speakers in Crimea (and thus in east Ukraine) with the defence of Russia's national interests. Both men share a mystical conception of Russia as an empire that is not defined by territorial boundaries.

Putin admires Nicholas I for standing up against all of Europe in the defence of Russia's interests. Today, on his orders, a portrait of the Tsar hangs in the antechamber of the presidential office in the Kremlin.

THOMAS CHRISTIANSEN holds a Chair in European Institutional Politics in the Department of Political Science at Maastricht University, The Netherlands, and is Director of the University's Brussels-based, part-time PhD Programme in European Studies. He is Executive Editor (with Simon Duke) of the *Journal of European Integration*, co-editor (with Sophie Vanhoonacker) of the *European Administration Governance* book series at Palgrave Macmillan and member of the board of the Research Committee on European Unification of IPSA. He has published widely on different aspects of European integration.

Europe and Asia may be geographically distant but they have strong ties not least due to their mutual dependence on trading with one another. Over the past two decades, this relationship has become institutionalised in multiple ways. This chapter charts the nature of inter-regional cooperation between the EU and its Asian partners, while also identifying the obstacles that both sides have had to confront, and puts into the context of the internal and external challenges that the EU has confronted in recent years. It also argues that despite these adverse conditions, EU-Asia relations have good foundations and will continue to strengthen in years to come.

THE STRENGTH OF DISTANT TIES: EUROPE'S RELATIONS WITH ASIA IN A CHANGING WORLD

Introduction

In the context of an emerging multipolar world, Europe and Asia are two regions that play an important role in the way in which global politics are being reconfigured. Given the size and the significance of their respective economies, as well as the importance of their mutual trade, both the European Union and its Asian partners hold great stakes in the international economic order, and consequently, both regions also share a mutual interest in stability and economic growth. In recognition of this, the EU has developed strategic partnerships with the major powers in Asia—China, India, Japan and South Korea—and, in recent years, has made a concerted effort to be more visible in the Asian-Pacific region, not least in response to the American "pivot" to Asia and the prospect of the US-led Trans-Pacific Partnership Agreement bringing together key countries around the Pacific rim.

> EU, IN RECENT YEARS, HAS MADE A CONCERTED EFFORT TO BE MORE VISIBLE IN THE ASIAN-PACIF IC REGION, IN RESPONSE TO THE AMERICAN "PIVOT" TO ASIA

The EU's interest in Asia, and Asia's interest in Europe, is largely commercial. The EU is China's largest trading partner, and for many Asian economies, the EU is the most important trading partner behind China. As a result, there is a high degree of interdependence between the European and the Asian economies, a fact that was driven home by the impact of the financial crisis that struck Europe much harder than Asia. For the EU, exports to China were seen as a way out of the economic crisis, while China and other Asian countries realised that declining demand for their goods posed a threat to their export-oriented growth model. Also, in response to these developments, there was

a rise of foreign direct investment flows from Asia to Europe, partially to make use of a strategic opportunity, but in the process, they also assisted the economic recovery in Europe.

Trade and investment are therefore key factors in shaping EU-Asia relations. However, security concerns also play a greater role, particularly in the post-Cold War/post-9/11 era in which the global security environment has become less stable. It is in this regard that the geographical distance between Europe and Asia has some curious effects. First, given the importance of trade for both sides, the question of securing trading routes is a mutual concern. This is one reason why Operation Atalanta, the EU's anti-piracy naval force mission off the Horn of Africa, which secures shipping traffic between Asia and Europe, has been one of the few examples of active military cooperation between China and the EU.

Second, the geographical distance between the EU and Asia means that neither side has a meaningful military presence in the other region. On the one hand, this entails a lack of relevance as a security actor, but on the other hand, it also implies that neither side perceives the other one as a threat—something which is markedly different from the relationship that China has with the United States, for example, or that Russia has with the European Union.

EUROPE IS HISTORICALLY CLOSELY ALIGNED TO THE UNITED STATES, WHEREAS IN ASIA, THERE ARE DIVISIONS BETWEEN THOSE COUNTRIES THAT ARE CLOSE US ALLIES AND OTHERS THAT HAVE A HOSTILE RELATIONSHIP WITH WASHINGTON

EU-Asian relations rely on the benign foundations of economic interdependence, without being threatened by any malign security considerations. The EU and the main powers in Asia regard one another as partners rather than rivals, and certainly not as adversaries. However, in the context of the wider geopolitical alignments in both regions, this relationship is more complex. Europe is historically closely aligned to the United States, whereas in Asia, there are divisions between those countries that are close US allies and others, particularly China, that have a predominantly antagonistic relationship with Washington.

China, in particular, has been challenging the perceived Western dominance of global economic governance, while the United States has sought to reorient its diplomatic and military attention to the Pacific in

response to the perceived assertiveness of China—a clash of interests that has both an economic (the formation of rival free trade agreements) and a security dimension (the confrontation between China and US allies in the South China and East China Seas). This means that the EU's relations with Asia have to navigate both the continuing relevance of the North Atlantic alliance and the increasing antagonism between the US and China.

Europe's search for a role in East Asia has to be seen in this wider global context. A partnership between Europe and Asia has great benefits and the potential for significant global influence, but at the same, such inter-regional cooperation faces serious limitations which prevent both regions from effectively influencing the shape of things to come. This is partly due to the adverse circumstances in the global context, partly due to the complications arising from relations with other global powers, namely the United States and Russia, and partly due to the inherent and fundamental differences that continue to prevent stronger and more effective cooperation among the two regions.

At the same time, the EU's search for a deeper relationship with Asia comes at a difficult period in its own development, happening as it does against the background of the significant political, economic, social and institutional challenges that Europe has had to face in the mid-2010s, including the momentous changes in its neighbourhood. If, in 2004, European leaders were confident enough to sign a "Treaty establishing a Constitution for Europe", and in 2012, the EU was the recipient of the Nobel Peace Prize, the atmosphere had radically transformed only a few years later. By 2015, the EU had been gripped by crisis, distracted by short-term problems and weakened by internal differences. For many, Europe in the 21st century is not only a continent in decline, but also a Union in crisis.

In order to illuminate this problematic "domestic" background to the EU's relations with Asia, this chapter begins with a brief account of the state of the European Union, highlighting both its distinctive character and its current problems. It then proceeds to discuss the institutionalised nature of inter-regional cooperation between EU and Asia, before then identifying the obstacles in this relationship. The chapter closes with an outlook of how these relations will develop in the future.

The Hybrid Nature of the European Union

Over the past 65 years, Europe has witnessed a unique project of regional integration. The integration process, bringing together a growing number of member states, has created a regional polity, which, over time, has acquired substantial competences to make policies and allocate resources. As a result of this process, the European Union is more than merely a "bloc" or an alliance of 28 countries. It is defined by the presence of a number of powerful supranational institutions acting for the common interest of the Union, independently of the individual states. Chief among these are the European Commission, the Union's executive employing some 35.000 civil servants and led by a political leadership of 28 Commissioners; the European Parliament, composed of 751 directly elected members representing the people across the continent; the European Central Bank, empowered to autonomously set interest rates and manage the money supply for the European single currency, the Euro; and the Court of the European Union, which is the final arbiter in disputes among the member states and the common institutions.

The presence of these institutions is a hallmark of the integrated Europe, as is the fact that these are involved in taking legally binding decisions that are directly applicable to the EU. The setting-up of independent institutions and their empowerment to create binding laws above the level of the state are fundamental departures from the kind of inter-state relations that used to govern Europe and that are still dominant elsewhere in the world. A quasi-constitutional framework for decision-making, common policies across the entire range of governmental activity, common external representation of the EU's interests through a European diplomatic service, and even joint military missions in other parts of the globe are all testimonies to the way in which the EU has developed a new kind of politics.

To emphasize these distinctive features of the integrated Europe is not to deny the continuing power of the individual states. States remain the key players in the European Union; indeed, some would argue that they are becoming increasingly powerful as the continent is confronting a series of challenges in the 2010s. The European Union has clearly not replaced the states in Europe and, to some extent, can even be said to have strengthened them, despite the fact that it provides a framework that has transformed their relations with one another and with the outside world. This is because the EU is hybrid, combining the novel,

supranational elements mentioned above with the continuation of state power in Europe.

The EU is *not*, despite the image frequently portrayed in the media, set up in opposition to the states. It is set up by the states in order to work for them, to carry out tasks that are more efficiently done jointly and to project their common interests more effectively towards third countries. While this may well imply that the EU occasionally confronts one or several member states that are at odds with a particular decision or policy, it does not mean that there is a fundamental conflict between national interests and the common European interest as pursued through the EU's institutional framework.

EU IS A HYBRID ORGANISM, COMBINING THE NOVEL, SUPRANATIONAL ELEMENTS WITH THE CONTINUATION OF STATE POWER

The result of the co-existence of nation-states and the integrated European polity is, therefore, not a contradiction or a paradox, but it does lead to tensions on a regular basis. The Union hardly ever achieves an equilibrium between the expectations put into it and its capacity to address a particular problem. Often, the expectations exceed what the EU is capable of delivering, while on other occasions, it is seen as overreaching and doing more than member states or the public are willing to countenance. Such imbalance has left the EU exposed in the face of a series of crises—Eurozone, Ukraine and refugees—all of which came to a head in the mid-2010s. In view of the potential impact that these crises may have for EU-Asia relations, the following section will briefly discuss the nature of these developments.

Europe—A Continent in Crisis?

In the Eurozone crisis, the EU was confronted with the limitations in its governance structure that were caused by a highly integrated monetary policy and a strongly decentralized fiscal policy. This meant that individual member states remained comparatively free to run up public debts even though they were united by a single currency managed by the European Central Bank (ECB). In the aftermath of the global financial crisis of 2008, this situation was exacerbated through national stimulus

packages, which relied on further deficit-spending and pushed several Eurozone member states to the brink of sovereign debt default. This situation created a crisis for the EU because there were no provisions for either centralized bail-outs or for a formal withdrawal of a member state from the single currency, leaving the EU with no way of assisting or sanctioning states that faced default.

The way out of the crisis required long, drawn-out negotiations among the Eurozone members about ad hoc bail-outs of individual countries, agreements on structural reform programmes, a series of intergovern-mental treaties that set up new institutional arrangements to monitor fiscal discipline and macroeconomic stability, and additional powers given to the European institutions that supervise banks. It has been

THE EU WAS SIDELINED IN THE INTERNATIONAL DIPLOMACY SEEKING A RESOLUTION TO THE CONFLICT BETWEEN UKRAINE AND RUSSIA, WHICH HAS BEEN A "STRATEGIC PARTNER" OF THE UNION

an acrimonious process that also sapped public confidence in the EU, politicised fiscal transfers in the Eurozone and gave rise to political parties and social movements sceptical about further integration.

The pinnacle of this crisis has been the difficulties encountered be-tween Greece and its partners in the European Union. When two large bail-out programmes and the corresponding structural reform pro-grammes did not improve but rather worsened the social and economic satiation in the country, the Greek people elected a government commit-ted to an anti-authority platform, objecting to the conditionality and the institutional mechanisms that were attached to the various bail-outs.

The February 2015 election of the government under Alexis Tsipras and the rejection of the terms of bail-out programme pitched Greece against the rest of the Eurozone; in other words, it pitted anti-austerity beliefs against the neoliberal orthodoxy in the political mainstream. The election also created a sense that institutional decision-making may be different from, if not opposed to, the popular choice, and that European technocracy is in conflict with national democracy. It also put on the agenda, for the first time in the history of the single currency, the threat of the exit of a member state from the Eurozone, something that was not supposed to happen after the "irrevocable" fixing of national exchange rates.

In the process, the prospect of a "GREXIT", whether chosen by the elected government of Greece, forced upon it by Greece's partners in the Eurozone unwilling to underwrite further debts, or occurring accidentally, became a very real possibility during this period. A lot of time, energy and political capital was spent on avoiding such an outcome. A lot of decision-makers had tied their own political future to the idea that "the Euro must not fail", making it clear why, even after the negative vote in the popular referendum, the Greek government ultimately accepted the terms of a further bail-out programme and still won re-election in October 2015.

In 2015, the integrity of the Eurozone was preserved and the possible crisis of a potential GREXIT was averted, but this does not mean that a long-term solution to the structural problems of Greece and of the Eurozone has been found. In fact, far-reaching reform proposals have been made, in 2015, by EU elites about the way in which the institutional framework will need to be strengthened. In addition, a series of intergovernmental treaties will need to be brought into the framework of EU law in order to make Eurozone governance fit for the future, but these proposals are unlikely to be implemented any time soon.

The Ukraine crisis presented the EU with a whole host of different challenges. Ironically, it was the Ukrainian government's attempt to negotiate an association agreement with the EU that, when abandoned abruptly by the then President Yanukovich, fuelled a popular rebellion, which ushered in a new pro-Western government and led to a break with Ukraine's post-Soviet alliance with Russia. However, when Russia, in return, annexed Crimea and supported an anti-government insurgency in the Donbass border regions in Eastern Ukraine, the EU had difficulty in responding quickly and effectively to the changed circumstances. Support, including massive financial aid, for the new Ukrainian government went hand in hand with limited sanctions against Russia—sanctions that only became more severe after a civilian airliner originating from Amsterdam was brought down by a Russian missile over rebel-held territory in Eastern Ukraine, with the loss of 298 lives, most of which were Dutch.

However, beyond economic assistance and limited sanctions, the EU was rather sidelined in the international diplomacy seeking a resolution to the conflict between Ukraine and Russia, which has, after all, been a long-standing "strategic partner" of the Union. The ceasefire that was eventually agreed between the warring parties in Minsk, in February 2015, was mediated by the leaders of France and Germany, rather than

the EU as a whole, demonstrating once again that in critical moments when issues of security are at stake, the larger member states are those that matter when dealing with third countries. Above all, at the time of writing in mid-2015, it appears as if neither the EU, nor the West more broadly, has found a way of dealing with the more aggressive foreign policy of the "new Russia", as controversies about the Russian involvement in the Syrian civil war have also shown.

In response to these and other challenges facing Europe, the EU's High Representative Federica Mogherini launched, in 2014, a process of reviewing the European security strategy that had originally been devised in 2003. While it is widely acknowledged that the original security strategy is somewhat outdated, the question is whether or not it will be possible for the EU in the current circumstances to look beyond the problems in the immediate environment and to focus on long-term objectives and strategic thinking.

It was the war in Syria that also contributed to the third crisis of 2015 confronting the EU, namely the arrival of hundreds of thousands of refugees in Central Europe. With the intensification of the fighting there and diminishing hopes of a foreseeable end to the quagmire, a steady stream of refugees left the country—many staying in refugee camps in neighbouring countries, but an ever-larger number also crossing Turkey, the Aegean Sea and the Balkans to seek asylum in Germany and other countries in Central and Northern Europe. What has undeniably been a humanitarian crisis for the Syrian people, a logistical challenge for the authorities in the transit and recipient countries and a source of political contestation between pro- and anti-refugee movements across Europe has also plunged the EU into a serious political conflict.

The refugee crisis has become an issue for the EU as a whole—as opposed to some of its member states—because it threatens the long-established achievement of open borders within the Schengen Zone. As several member states sought to close their borders in response to the arrival of large numbers of refugees, the EU was confronted with three distinct yet related challenges: the effort of maintaining a regime of open internal borders (an objective that is closely linked to the functioning of the Single Market), the perceived need of enhancing the protection of the common external border of the EU, and the desire by member states, such as Germany, to establish a mechanism for sharing the burden of accepting large numbers of refugees among the member states. Again, in its initial response to the crisis, the EU

decision-making process has been found wanting, and no obvious solution to the conundrum was in sight at the time of writing in late 2015.

Each of these crises demonstrated that the EU, despite its long track record of dealing with complex problems and achieving compromise among different national positions, is facing serious limitations when confronted with the need for rapid and unified action. These challenges have set the scene for public and acrimonious disagreements among national governments, provided opportunities for the mobilisation of anti-European movements and Eurosceptic political parties, and carried with them the threat of disintegration of key policies that had been developed over the previous decades—even if the Eurozone crisis also demonstrated that successful management of the crisis ultimately required the strengthening of the institutional framework.

FOR MANY OBSERVERS, THE OVERRIDING IMPRESSION OF THE EU, IN THE SUMMER OF 2015, WAS THAT OF A POLITICAL EXPERIMENT FAILING

Beyond these internal problems, all of these developments combined to damage the EU's reputation: images of seemingly endless crisis meetings, the perception of a highly divided continent with countries and peoples looking after themselves rather than pursuing their common interests, and the appearance of an ineffective institutional structure to summon the political will to act collectively. For many observers in Europe and beyond, the overriding impression of the EU, in the summer of 2015, was that of a political experiment failing rather than succeeding, of a continent united in name rather than in practice and of a European Union in crisis.

In addition to the EU's difficulty in dealing with these challenges, it also has had to deal with the prospect of further fragmentation. The UK government has promised its citizens an "in/out" referendum to decide about the future of British membership in the EU, raising the spectre of a British exit—a "Brexit"—from the Union. While Britain has long been recognised as an awkward partner in the EU, the first-ever withdrawal of a member state from the EU would be a huge upheaval and a further sign of crisis and decline. To complicate matters further, in addition to the EU, some of its member states also faced the possibility of disintegration, with both separatist political parties gaining ground in important regions, such as Scotland and Catalonia.

However, while this image of a European Union in crisis resonates in the light of these experiences, it is not entirely accurate. A focus on the EU's poor record in crisis-management neglects the significant achievements that it has made in many other, more long-term endeavours. The European Single Market continues to function well, constituting the largest internal market in the world. The EU also leads the world with regard to trade and foreign direct investment, and it is in the process of negotiating trade and investment agreements with numerous economic partners around the globe, including the US and China. The EU has been at the forefront of the push for a global agreement to limit CO_2 emissions and combat climate change, and for a long time, it has been the biggest donor of development aid in the world. And while the EU has generally failed to create a zone of peace and stability in its neighbourhood, it has at least banished violent conflict within its own territory.

EU TRADE, INVESTMENT AND ASSOCIATION AGREEMENTS WITH ASIA REGULARLY INCLUDE REFERENCES TO GOOD GOVERNANCE, THE RULE OF LAW AND RESPECT FOR INTERNATIONAL AGREEMENT

At its inception, the EU was a political rather than an economic project. Its essence was the search for lasting reconciliation between France and Germany. Market integration and the creation of supranational institutions were the means towards this wider goal, rather than an end in themselves. The award of the Nobel Peace Prize to the EU, in 2012, was a reminder of this original and underlying purpose of the integration process—an achievement that is often forgotten in the context of economic crisis, political turmoil and regional instability.

This necessarily brief discussion of the current state of the European Union sketches out the foundations on which its relations with Asia have to be conducted. It demonstrates the critical state in which the EU finds itself in the early stages of the 21st century and the problems it faces regardless of past achievements. It also highlights the difficulties of prioritising a concerted effort to develop better relations with Asia, despite the significance of that region for Europe and for global governance more generally.

EU-Asia Relations: Institutionalising Inter-regional Dialogue

The previous discussion has demonstrated the preoccupation in Europe with internal problems and conflicts in its neighbourhood. That leads to a concern that these current and "domestic" challenges may distract the EU leadership from a focus on global issues and structured relationships with more distant partners. More specifically, these preoccupations risk marginalising the development of stronger relations with Asia, despite the efforts that have been set in motion in past decades.

Historically, the EU "came late" to Asia, given that it had long-established relations with the United States through the North Atlantic partnership, with the states of Africa and the Caribbean through the Lomé Convention, and—since the accession of Spain and Portugal in 1986—also with Latin America. However, with the rising economic and geopolitical importance of Asia since the 1980s, the EU has responded to the shifts in global tectonics and, over the past 20 years, has developed closer ties with partners in Asia. This includes both partnerships with individual countries and multilateral arrangements with regional groupings.

One of the hallmarks of the EU's interaction with Asia is the institutionalisation of these inter-regional relations. In the context of the EU's bilateral "strategic partnerships" with Asian countries, such as China or India, the partners have set up an entire dialogue architecture, covering a wide range of issues and formalising regular contact across all levels of the administration. At the top, the strategic partnership foresees regular summit meetings between the political leadership of both sides. There are also ministerial meetings, high-level committees and a large number of working groups deliberating issues across different "pillars"—political affairs, economic and trade issues and so-called "people-to-people dialogues". In the case of the EU-China strategic partnership, there are, for example, more than 40 such dialogue venues active.

While the substance of each such partnership depends on the country involved, there are common formats and elements. The dialogue architecture can be more or less extensive and, in some cases, goes beyond that into legally binding agreements. Thus, the EU signed Free-Trade Agreements with South Korea in 2011, with Singapore in 2014, and in 2013 launched negotiations with China towards the conclusion of an Investment and Partnership Agreement.

For the EU, the purpose of this policy of institutionalising relations in such a manner is to ensure that there is more to the partnership than

purely economic relations. Even though the EU's relations with Asian partners are, on the whole, dominated by the mutual interest both sides have in encouraging and regulating trade—facilitating market access, settling trade disputes and protecting intellectual property rights—, the EU's external relations are also driven by normative concerns. One immediate corollary of that ambition towards a value-based foreign policy is the EU's insistence on including political elements in its agreements and dialogues with third countries. As a result, EU trade, investment and association agreement regularly include references to good governance, the rule of law and respect for international agreement. For the same reason, human rights dialogues have been set up with strategic partners, providing a forum in which such issues will be discussed between EU officials and representatives of Asian countries—even if such "dialogues" do not necessarily consist of actual deliberations but rather of making (dissenting) statements of principles.

Beyond its reliance on bilateral agreements, the EU has put the emphasis on multilateral diplomacy with Asia. It has a long track record of cooperation with the Association of Southeast Asian Nations (ASEAN), which is often regarded as the most far-reaching example of regional cooperation outside Europe. ASEAN has set up a number of institutions that are, at least superficially, in the mould of the EU, and it also has high ambitions to develop an internal market—the ASEAN Economic Community—that mirrors that of the EU. The EU has been supporting the institutions of ASEAN with financial assistance and technical advice, and group-to-group relations between the two blocs have been traditionally strong.

In 2007, there had been an attempt to negotiate an EU-ASEAN Free Trade Agreement, but it faltered on the inability of ASEAN as an organisation to legally commit its member states to international obligations—a sign that there are limitations to the symmetry between institutional capacity on the two sides. On the other hand, there has been long-standing and effective cooperation in the security area through the EU's membership in the ASEAN Regional Forum (ARF), providing opportunities for consultation on political and security issues, for confidence-building and for preventive diplomacy—a suitable way for the EU to become involved in security dialogues in Asia, considering its generally weak presence in the region in this regard.

The overarching institutional structure for Europe to relate to Asia as a whole is the Asia-Europe Meeting (ASEM). ASEM is a fairly informal

Times Square shopping mall in Hong Kong

process consisting of meetings, dialogues and initiatives, which culminate in an annual summit. It is a comprehensive approach involving more than 50 countries across both continents, including not only the member states of the EU and ASEAN but also a large number of additional countries in both regions. Indeed, one of the challenges for ASEM is its popularity, with new applications for membership arriving on a regular basis and the overall number of members making interaction increasingly cumbersome (as well as creating significant administrative burdens and logistical challenges for smaller states that chair meetings and host events). Participating members are European and Asian representatives (heads of state and government officials), the European Commission and the ASEAN Secretariat. At any one time, two countries—one European, one Asian—share the chairing role, and the hosting of summits and ministerial meetings alternates between Europe and Asia.

Since its conception in 1996, ASEM and its concomitant activities maintain an informal approach among its members, as the underlying intention of inter-regional engagement was for Europe and Asia to "re-discover" each other. The discussions, debates and plenary

sessions are primarily aimed at promoting dialogue between its members. ASEM employs a three-pillar (political/economic/social) approach in determining the range of topics that can come under discussion. In the beginning of ASEM, political dialogue was the key element in the process, but as ASEM grew in size and importance, more emphasis was placed on developing the economic and social pillar as well.

THE CREATION OF THE ASIAN INFRASTRUCTURE INVESTMENT BANK CONSTITUTES A BROADER CHALLENGE TO WHAT CHINA REGARDS AS US-DOMINATED INSTITUTIONS OF GLOBAL ECONOMIC GOVERNANCE, SUCH AS THE IMF AND THE WORLD BANK

There has been occasional criticism that the ASEM approach is more of a "talking shop" than one that actually achieves results, something which reflects more generally the frustration seen in some quarters about the way in which the EU engages in such institutionalised dialogue settings. However, that criticism ignores both the long-term objectives of the EU in engaging with (groups of) third countries as well as the nature of such diplomacy, which is more about building trust and raising awareness than being goal-oriented.

While many of these initiatives for institutional cooperation have come either from Europe or from Southeast Asia, China has also been active in terms of institution-building. A prime example of this trend is the creation of the Asian Infrastructure Investment Bank (AIIB). Ostensibly set up to support its economic expansion through initiatives, such as "One Belt, One Road" or the "New Silk Road", with funding for infrastructure projects, the AIIB also constitutes a broader challenge to what China regards as US-dominated institutions of global economic governance, such as the IMF, the World Bank and its affiliate, the Asian Development Bank. The fact that not only many countries across the Asia-Pacific region, including traditional US allies, such as Australia, New Zealand and South Korea, but also most of the EU member states decided to join the AIIB demonstrates the attraction that Chinese-led, multilateral institutions hold in the context of regional and global economic governance. And it demonstrates the importance that EU member states attach to being part of this development, even at the risk of disagreement with their traditional ally in North America.

Through these various mechanisms, the EU has developed a strong presence in Asia. This presence is sometimes strengthened, but sometimes also resisted by EU member states that seek to promote their own national agendas vis-à-vis individual countries in Asia—which reflects the hybrid nature of the EU discussed earlier. In any case, the institutionalisation of inter-regional relations, as described here, does provide a strong foundation for the EU on which to engage with the key players in the Asian region across a range of issues, be it economic, security or societal.

However, the wide-ranging efforts with which the EU seeks to engage Asian partners on multiple levels also have to confront a number of challenges. This is not only due to the current problems facing the EU itself, which were discussed earlier, but also because of a number of underlying differences in the attitudes of actors on both sides. The following section will briefly discuss such obstacles in EU-Asia relations, which may stand in the way of closer cooperation.

The EU and Asia: Conflicting Interests and Contrasting Worldviews

Much as there is mutual interest in trade and investments linking Europe and Asia together, there are also numerous differences and potential conflicts hampering closer cooperation. Even in terms of trade itself, the EU and its Asian partners often do not see eye to eye. In Europe, there are long-standing concerns about the (lack of) protection of intellectual property rights in China and other Asian jurisdictions, as well as frequent disputes about alleged dumping and the corresponding protectionist measures. The 2013 solar panel dispute between China and the EU is a case in point.

The wider problem here is that the past pattern of Asia exporting low value-added goods to Europe, and Europe in turn exporting high-tech and luxury goods to Asia, is increasingly under threat from the development of higher value-added production chains in the emerging economies of Asia. As it happens, the EU as a whole and the majority of EU member states have a widening trade deficit with China. Following the export-led success of Japan and, subsequently, of the so-called "Four Asian Tigers"—the economies of Taiwan, South Korea, Singapore and Hong Kong—,European manufacturers are now also confronted with increasing competition by Chinese producers in their traditional markets. Consequently, the symbiotic trade relationship of the past may give way to greater competition—something which also limits the

desire of Europe to support the Chinese demand for market economy status in the World Trade Organisation and the negotiation of a free-trade agreement between the EU and China.

Arguably, however, what complicates relations between the EU and Asia, more than conflicting material interests, are deeper-seated differences about values and norms. Two prominent examples of such differences are disputes about human rights and disagreements about environmental standards. As mentioned earlier, the EU, as a matter of standard practice, seeks to promote norms such as human rights and the rule of law in its foreign policy. In relating to authoritarian governments in Asia, this leads to frequent clashes and the insistence from Asian partners not to intervene in their internal affairs. There is an inherent tension between the promotion of what the EU regards as universal values and what Asian governments often brand as Western interference in their domestic affairs.

Diverging responses to the suppression of the democracy movement and systematic violations of human rights in Myanmar/Burma after the 1990 general election was illustrative of these different attitudes. Whereas the EU (together with the United States and others) imposed sanctions on the military regime, Burma's partners in ASEAN continued to engage with the leadership—a policy which actually led to strains in the otherwise good relations between the EU and ASEAN.

With regard to environmentalism, a key "battleground" has been the international climate change negotiations, which have seen the EU pitched against the emerging powers of Asia, in particular large emitters such as China and India. While the EU has been pushing for binding reductions in CO_2 emissions, the large Asian countries have emphasised their development status and demographic situation, arguing that they should not be forced to reduce their emissions as rapidly as Europe (even if by the time of the 2015 Paris Climate Conference, China appeared to have moved closer to the European position).

Even if disputes about human rights and climate change may also be linked to different levels of economic development, they are above all signs of deep-seated differences in the respective world views on each side about key principles such as state sovereignty and the primacy of international law. For the European Union, the idea that state sovereignty can be pooled, shared or, indeed, be given up is a living reality. The very meaning of European integration implies the interference by an external authority in the internal affairs of the EU member states. Even

though national governments in Europe may not agree with the outcome on every occasion and will frequently protest against "impositions" from Brussels, EU member states have fundamentally accepted that binding laws, having a direct effect on their citizens, governments and businesses, are being made at a level above the nation-state. The idea that states are subject to binding law is an everyday practice in the European Union and, as such, is also promoted by the EU in its external relations.

WHAT COMPLICATES RELATIONS BETWEEN THE EU AND ASIA ARE DIFFERENCES ABOUT HUMAN RIGHTS AND ENVIRONMENTAL STANDARDS

The Asian experience is very different and, arguably, diametrically opposed to the European one. State sovereignty is regarded as non-negotiable by Asian states, and the principle of non-intervention is derived from this strong belief in the continuing relevance of sovereignty, creating a very different foundation for international diplomacy. In the case of regional cooperation through ASEAN, for example, it means that states rely on decision-making by consensus, mutual respect among governments and informal agreements, rather the enforcement of binding law. States in Asia are willing to cooperate extensively, but without giving up any notion of remaining sovereign and in control of their own affairs.

These divergent attitudes towards state sovereignty and international law lead to rather different views about multilateralism. Even though European and Asian partners have entered into numerous institutionalised forms of cooperation, as discussed in the previous section, they hold rather different assumptions about the purpose of such institutions. Whereas for the EU, multilateral institutions are seen as an expansion of rule-based international governance, Asian partners, such as China, tend to view these in the context of their geo-strategic thinking, as a form of "soft balancing" vis-à-vis the US.

Such differences complicate EU-Asia relations and may be the cause of greater difficulties in the future, but they do not stand in the way of closer cooperation in the current context. On certain issues, secular trends help to offset disagreements in principle. China, for example, has become more cooperative in global climate change negotiations as a result of its own domestic fight against pollution, and the EU, in the face of its internal crises, has become more modest in its efforts to promote its own norms and values. But even though principled differences

remain, these do not undermine a general sense that the EU and the states of Asia have a lot to offer each other and can be partners in a changing world.

Outlook: EU-Asia Relations in a Time of Change

This chapter has sought to discuss the opportunities and the challenges for EU-Asia relations at a time when global politics are in a period of flux. We have seen that the prospects of EU-Asia relations are subject to developments on various levels: at the level of individual states, as these make choices about their economic orientation and political alliances; at the regional level, in particular on the European side, as the EU is in the grips of multiple crises, creating a challenging time in which to pre-serve normative principles and develop strategic relations with distant partners in Asia; and at the global level, as both European and Asian countries need to come to terms with the changing and unpredictable nature of the emerging multipolar world. Developments on each of these levels of policy-making have the potential to impact EU-Asia relations in either a supportive or a detrimental manner.

> THE GEOGRAPHICAL DISTANCE BETWEEN THE
> EU AND ASIA CAN BE WHAT LIMITS THE CHANCES OF
> CONFRONTATION AND ALLOWS TO MAINTAIN THE
> PARTNERSHIP THAT HAS GROWN IN THE PAST

While this makes it difficult to make predictions about the future evo-lution of EU-Asia relations, it appears safe to say that the underlying conditions remain encouraging for the maintenance of good relations in times to come and, indeed, favour the assumption that there will be closer cooperation in the future. The institutionalisation of inter-region-al cooperation is set to continue through further bilateral agreements and multilateral arrangements, bringing the EU and its Asian partners closer together. The mutual reliance of both Europe and Asia on trade to facilitate their economic growth also means that both sides have a strong interest in regional stability and effective global governance. Dif-ferences are likely to remain on how best to achieve such stability, but on balance, Europeans and Asians have every interest to look for negotiated solutions and cooperative arrangements, rather than confrontation.

Yet, it also needs to be remembered that the EU and Asia do not relate to one another in a vacuum; the nature of inter-regional cooperation is subject also to influences from other actors at the global level. The importance of the US as a traditional ally of Europe and as a divisive power in Asia has already been mentioned. It remains to be seen how US diplomacy will affect EU-Asia relations in the future, in particular after the Presidency of Barack Obama, as none of his potential successors is likely to engage as much with Asia as his administration did. The resurgence of Russia under Vladimir Putin adds further uncertainty to this calculation. It provides a new rationale for deeper cooperation between Russia and China, but it may also reinforce a shift of American attention away from the Pacific and back to Europe.

Global politics are changing, creating a context that holds both challenges and opportunities for EU-Asia relations. The EU and Asia have come much closer to one another over the past two decades, as their economic interdependence has deepened, and their relations have become increasingly institutionalised. Efforts are under way, from both sides, to bridge the geographical distance and facilitate yet more trade, investment and political cooperation. Yet, it may just as well be the geographical distance between the EU and Asia that limits the chances of possible confrontation and allows actors on both sides to maintain the partnership that has grown in the past. The EU and Asia have close ties, made stronger by the distance that remains between them.

JAVIER SOLANA is president of ESADE Center for Global Economy and Geopolitics. He is a distinguished fellow at Brookings Institution, senior fellow at the Hertie School of Governance, chairman of the Aspen Institute Spain, honorary president of the Centre for Human Dialogue and advisor to the Institute of Modern International Relations of Tsinghua. He is a member of the board of the International Crisis Group, and the European Council on Foreign Relations, among others, and professor at the LSE. He has been Secretary General of the Council of the EU, High Representative for CFSP and Minister for Foreign Affairs in Spain.

The EU is more than an economic and monetary union, it is a political integration project. Unison is necessary to face the enormous challenges posed by our globalized world and the emergence of new actors. The challenges faced at our borders make the need for greater integration more evident. The world we live in, which is multipolar and interdependent, faces global problems and threats; solutions must be adopted multilaterally. The ample experience of the EU building multilateral institutions and in collective dispute resolution is a great input to global governance.

EUROPEAN FOREIGN POLICY AND ITS CHALLENGES IN THE CURRENT CONTEXT

The Complexity and Necessity of a European Foreign Policy

The European Union is still the world's first economic and trade power, despite the fact that European nations have been hard hit by the recent recession while other countries have experienced rapid growth. However, these years of economic crisis have made us concentrate our efforts on the EU's internal problems, with the consequent loss of clout in international affairs. We must return to the front line.

THE CFSP IS DIRECTLY RELATED TO HUMAN RIGHTS, THE RULE OF LAW, INTERNATIONAL LAW, AND EFFECTIVE MULTILATERALISM

The European Union's external actions convey its way of understanding the world, freedom, personal rights, and its idea of justice. The common foreign and security policy (CFSP) is directly related to European values: human rights, the rule of law, international law, and effective multilateralism. However, the CFSP is also important at the internal level, as it facilitates cooperation among member states and creates more opportunities for inter-member consensus and compromise. The EU, like all institutions, is defined by its actions.

European foreign policy cannot continue to be a mere declaration of intent, a matter of secondary importance for which its member states are unwilling to relinquish one iota of their sovereignty. We must decide where we want to go, what role we want to play in international affairs, and how to achieve those goals. But we also need to address something even more basic: we must agree on a definition of our common interests as a European Union.

When analysing European foreign policy from both the institutional and operational perspectives, we have to consider the characteristics of the present moment and the forecast for the future. Many of

today's security risks, such as cybercrime or transnational terrorism, are global and cannot be dealt with fully or effectively from a position of national sovereignty.

The scenario has changed substantially since the early days of the European Union. Many countries that have emerged in recent years already surpass the EU states in population, size, and economic growth. All of them want to participate in global decision-making processes and influence the course of world events. In this new context, European countries have to understand that, in order to be an international actor, the EU must act in unison and speak with one voice. If each member state acts individually, Europe will find itself relegated to the role of mere spectator in the arena of major world events, with neither the capacity nor the power to influence their outcome.

> **IF EACH MEMBER STATE ACTS INDIVIDUALLY, EUROPE WILL FIND ITSELF RELEGATED TO THE ROLE OF MERE SPECTATOR IN THE ARENA OF MAJOR WORLD EVENTS**

Unfortunately, the task of materializing European foreign policy has proved to be quite complicated. The EU member states have very different historical backgrounds, and consequently their understanding of foreign policy varies widely. Geographical location is undoubtedly a key factor in defining the interests and agenda of each country, as are cultural and linguistic ties. Some European states are permanent members of the United Nations Security Council, while others are more interested in handling their border problems. Getting so many different voices to sing the same tune is a task that requires a great deal of finesse as well as a strong commitment from each member.

The channels and structures for developing European foreign policy have evolved since the ratification of the Maastricht Treaty, and the process is still underway. We have already made great strides, especially since the signing of the Treaty of Lisbon, which expanded the mandate of the High Representative and the European Exterior Action Service, charged with representing the EU abroad. Nevertheless, we must continue working to achieve greater integration and a clearer sense of direction.

Current Challenges in Foreign Policy

At this point in time, international issues largely dominate the European political scene. Many of the world's most volatile and troubled regions lie just across Europe's borders, and this proximity increases our responsibility to design and implement solutions.

Challenges in the East

On the EU's eastern border, in Ukraine, a conflict broke out a little over one year ago that has substantially complicated relations with Russia, reviving dynamics we assumed had been extinguished at the end of the Cold War. The EU has maintained relations with Ukraine since it became an independent state in 1991. Later, in 2007, the EU and Ukraine began negotiations on the Association Agreement, a free trade treaty with a few political ramifications. However, ratification of the agreement was postponed after the case of former Prime Minister Yulia Tymoshenko led to a diplomatic dispute.

In 2013, when everything was finally ready for the agreement to be signed at the Eastern Partnership Summit in Vilnius, President Yanukovych refused to ratify the treaty. Instead, he accepted the Russian counteroffer to buy eleven billion euros' worth of Ukrainian bonds and substantially lower the price of gas exports to Ukraine. From that moment on, protests by citizens and the pro-European opposition against the Yanukovych government and its alignment with Moscow grew more frequent and intense. The diplomatic and economic crisis led to an escalation of violence and tension between pro-Russian and pro-European factions, with notorious consequences in Crimea and the eastern regions of Ukraine.

After the Crimean referendum and declaration of independence, in March 2014 President Putin signed a treaty confirming the peninsula's annexation to the Russian Federation and acknowledging that Crimea had always been a part of Russia. A few months later, the provinces of Donetsk and Luhansk proclaimed themselves independent republics, a decision which, according to the Kremlin, had to be respected.

The Russian government's actions during these events amounted to a violation of international law, to which the European Union and others have responded with sanctions. We cannot overlook the fact that, since 1991, when Ukraine declared its independence from the Union of Soviet

Socialist Republics, Russia has acknowledged the country's territorial integrity in several international treaties.

Firstly, Moscow's decision to challenge Ukrainian sovereignty over the Crimean Peninsula and the eastern region of Donbas represented a breach of the security order established by consensus in the Helsinki Final Act of 1975. In this agreement, which planted the seed of the Organization for Security and Cooperation in Europe (OSCE), the participating states committed to respect the inviolability of frontiers, the territorial integrity of states, and non-intervention in internal affairs, among other principles.

Furthermore, in the Budapest Memorandum (1994), the United States, the United Kingdom, and Russia specifically agreed to respect the territorial integrity of Ukraine, and in exchange Kiev gave up its nuclear weapons. For its part, the European Union has always desired to maintain good relations with Ukraine, though ideally without straining EU-Russian relations or being forced to choose between Russia and Ukraine as a trade, security, or other type of partner.

Russia's failure to honour the commitments made when it signed these agreements must be analysed in the context of a specific juncture in Moscow's history. For some time, the Kremlin has been overt in its attempts to maintain very close ties to former Soviet bloc countries, owing to a perception of the United States and the European Union as its main competitors who are striving to draw the USSR's former members closer to themselves. Since the second NATO expansion into Eastern Europe, rapprochement between certain countries and the European Union has been interpreted as a threat to Moscow's spheres of influence, with the potential to lessen its influence in the international arena. Russia has proved, as it already did in Georgia in 2008, that it is prepared to use force and ignore its contractual obligations.

After nearly a year of fighting, in February 2015, Germany, France, Ukraine, and Russia signed the Minsk II Agreement. From a military standpoint, the agreement basically entails a ceasefire and the withdrawal of heavy weapons. Politically, it calls for a constitutional reform to give the provinces of eastern Ukraine greater autonomy. At the end of the process, the central government in Kiev will once again have full control over the Ukrainian-Russian border, currently in the hands of the rebels.

For months, a ceasefire has been in effect in the conflict zone, albeit with frequent accusations of truce violations on both sides. Although it seems that Moscow, currently plagued by serious economic troubles, has no intention of resuming military action, it is not yet clear whether

it is willing to negotiate. We will have to wait and see how events unfold in the coming months, once the local elections in Ukraine have been held. These are scheduled to take place across the country except in the eastern territories controlled by pro-Russian separatists, who have called their own independent elections in violation of the Minsk II terms.

Given the tremendous magnitude of the dispute with Russia, resolving the situation needs to be a priority on the European agenda. It is worrying that countries which are neighbours of both the EU and Russia believe they must choose between strengthening ties with Europe and being loyal to Moscow. The EU is set to review the sanctions regime against Russia in January 2016, at which point the measures will almost certainly be renewed unless Moscow's position changes substantially.

Challenges in the South

Europe is affected, to a large extent, by political instability in North Africa and the Middle East given their geographical proximity. For many years, the United States has had the self-appointed mission of ensuring security in the Middle East, motivated by the need to protect its own interests there, but America's declining fuel dependency and the shift in its foreign policy towards Asia has altered the nature of US involvement in the region. Meanwhile, Europe's heavy reliance on fuel imports and the security risks posed by instability make EU involvement an inevitable necessity.

> THE NUMBER OF PEOPLE SEEKING ASYLUM IN OTHER
> COUNTRIES IS GROWING EXPONENTIALLY, SURPASSING
> THE FIGURES RECORDED DURING WORLD WAR II

The spread of war and violence across the region is creating a major humanitarian crisis. The number of people seeking asylum in other countries is growing exponentially, surpassing the figures recorded during World War II. At present, there are more than four million refugees from Syria alone, according to data supplied by the UN Refugee Agency. Although the majority seek asylum in neighbouring countries and remain in the region, every day many of them risk their lives to reach Europe. This situation represents a major challenge for European nations. We must be quick in our humanitarian response and honour our legal obligation to give asylum to those fleeing from persecution. This dire emergency

should also spur us to step up our involvement in the search for solutions to the conflicts that have forced so many to seek refuge in Europe.

Regional troubles have intensified particularly since 2011, in the wake of the riots popularly known as the "Arab Spring". Unfortunately, these uprisings—a product of social tensions caused by the difficult economic situation and the people's widespread frustration with the socio-political scenario in their countries—have not had the hoped-for results and, in some cases, have actually degenerated into terrible conflicts.

In Libya, the nation has been in a state of chaotic upheaval since Gaddafi's death, with immediate consequences for other Mediterranean countries. The growing division of the country, which culminated in the creation of two governments and allowed Islamic State militias to gain footholds in parts of eastern Libya (such as the city of Derna), makes it even harder to maintain security as the country is assailed by myriad internal and external challenges. In addition to terrorism, the repercussions of the Libyan conflict for migratory pressure and the possibility that it may spread to the rest of this already debilitated region pose real threats to Europe. In fact, some are already saying that Libya is poised to become the "Mediterranean's Somalia".

THE RISE OF THE ISLAMIC STATE AND AL-QAEDA FACTIONS HAVE MADE THE SITUATION EVEN MORE DRAMATIC FOR SYRIAN CIVILIANS

In the early days after the overthrow of Hosni Mubarak, in 2011, it looked like Egypt was on the verge of a transition to democracy. In the 2012 presidential elections the Muslim Brotherhood, led by Mohamed Morsi, was voted into power, albeit with a very slim majority and a highly polarized electorate. With Morsi as president, the country had to face the serious economic troubles that had plagued it for years and the new administration's attempts to incorporate the precepts of Islamic law into the Egyptian legal system. Ultimately, however, the greatest trigger of social unrest was the attempt to legislate an expansion of the government's executive powers. On 3 July 2013, after days of mass demonstrations demanding Morsi's resignation, the Egyptian army staged a coup and the head of the Armed Forces, Abdel Fattah el-Sisi, became president. Since then, although violence has diminished, the country has been governed by a military dictatorship.

A group of Egyptian demonstrators in Cairo express their support to the Syrian Revolution.

In Yemen, the instability ushered in by the January 2011 protests was compounded in early 2015 by the uprising of the Houthis, an insurgent Shiite group, which managed to seize control of the nation's capital. This clash has once again evidenced the rift between Shiite and Sunni Muslims, a determining factor of many other conflicts in the region, and the role of Iran and Saudi Arabia as the respective leaders of these factions.

There are several causes underlying the dynamics of confrontation in the region, but one is fundamental for understanding the current situation: the antagonism between Sunni and Shiite Muslims. The division between these branches of Islam is, of course, religious, but it also has strong geopolitical implications: Iran, with a Shiite majority, and Saudi Arabia, where the majority are Sunni Muslims, have been vying for supremacy in the region for years. This tension is at the root of many ongoing conflicts.

In Syria, the civil war still raging between the regime of Bashar al-Assad and rebel forces has already caused more than 200,000 deaths and the forcible displacement of over twelve million people (both within Syria and to other countries). This means that, of the total Syrian population at the start of the conflict, over half has been displaced. Many of the people forced to flee from their homes by the threat of persecution and lack of protection take refuge in neighbouring countries such as Turkey, Lebanon, or Jordan, which are suffering the consequences of

a massive refugee influx—a phenomenon we are also seeing now on Europe's borders. The radicalization of the rebels opposed to Al-Assad, the involvement of so many foreign powers in the conflict in one way or another, and the terrifying rise of extremist terrorism all represent enormous obstacles on the road to peace.

Al-Assad's regime has been backed by Russia and Iran from the outset, while the Sunni opposition has garnered the support of Saudi Arabia, Turkey, and Qatar. Meanwhile, the rest of the international community has been hesitant and reluctant to get involved, influenced by the memory of past experiences in Afghanistan and Iran. Since the chemical weapons disarmament deal between the United States and Russia, there have been several attempts to open a new dialogue, though none have prospered. In the interim, the Syrian opposition has splintered and the more radical factions have gained considerable ground. The rise of terrorist groups, namely the Islamic State and al-Qaeda factions, have made the situation even more dramatic for civilians and significantly complicated the task of designing a solution to the conflict, a solution that would also be critical for resolving many other regional conflicts.

Today there is only one bastion of hope in the region, though even there it is increasingly tenuous: Tunisia, where a successful political transition was carried out after deposing the dictator Ben Ali, and today the country is a democracy. However, the situation is fragile and the threat of terrorism is also present, as confirmed by the tragic events that took place several months ago.

The intensity of civil conflicts is exacerbated by another highly destabilizing element with disastrous consequences: fundamentalist terrorism, with the main concern today being the terrorist group that calls itself the Islamic State, also known as ISIS. Although this organization was established in Iraq in 2003 and played an important role in the Iraq War during the early years of its existence, the Syrian civil war was where it grew and flourished. In 2014 the group severed its ties to Al-Qaeda and is steadily gaining ground in Syria and Iraq, where it already controls a significant part of the territory.

Despite being a local organization, ISIS has global ambitions whose scope has already been made apparent to us. To date, it has recruited over 25,000 members from more than one hundred different countries, vastly increasing the organization's field of action and dangerousness. These statistics also suggest that the roots of fundamentalism are not limited to the region where this and other like-minded terrorist groups

were spawned, for there are numerous individuals in many other parts of the world who seem to share their intentions.

Global Challenges

In addition to the risks posed to Europe by conflicts and disputes along its borders, we must consider other challenges of a global nature. As stated earlier, today we live in a global world where borders are increasingly permeable, and many of the security threats we now face are global as well. Security issues such as the proliferation of nuclear weapons, organized crime, arms and human trafficking, inequality, and pandemics affect us all.

CYBERATTACKS ARE ON THE RISE AND CLIMATE CHANGE THREATENS TO DESTROY OUR ENVIRONMENT

Cyber risks are one of the most obvious global threats today. Information and communication technologies have become a fundamental part of daily life for the majority of the world's population, as well as a cornerstone of innovation and economic growth. These technologies have enormous benefits, but they also entail substantial risks, as the information they contain or convey can be accessed and used for criminal purposes. The number, magnitude, and impact of cyberattacks are on the rise, and so is the level of concern about the high vulnerability of the internet, a tool on which practically every economic activity relies in this day and age. The internet was designed as an essentially open platform, because its creators did not anticipate that it would be used to offer a wide range of critical services requiring tighter security.

The difficulty with cyberattacks is that they take place in a setting—cyberspace—characterized by its broad accessibility, which by definition makes it less secure. Moreover, cyberattacks can be perpetrated with total anonymity. The difficulty of tracing attacks and the fast pace of technological change makes it very hard to come up with a response capable of dissuading hackers. IT security mechanisms cannot be designed for just one jurisdiction, because there are no political borders in cyberspace. The only effective path is multilateral action.

The same is true of climate change, which threatens to destroy our environment and means of subsistence, especially for future generations.

Even though scientists have been studying the phenomenon of climate change since 1988, and despite the fact that 195 states agreed to prevent dangerous climate changes by joining the United Nations Framework Convention on Climate Change (UNFCCC) in 1992, diplomatic progress in this area has been very slow.

The European Union is responsible for a significant part of past and current CO_2 emissions, and must therefore play a leading role in the efforts to mitigate climate change and help other countries, especially developing nations, to do the same. The UNFCCC Conference in Paris has been held in December. This has been the most important summit of recent years, and it is imperative that all participating countries reach a consensus and set ambitious goals for the future. In this respect, European states have a duty to take the lead, set a good example, show strong political will (especially with regard to climate finance), and use their diplomatic experience and power to facilitate an effective agreement in Paris.

New Balances of Power on the World Stage

Europe ceased to be the centre of the modern world long ago. Other countries have now come to the fore, propelled by strong economic growth, and are claiming their rightful place in the international political arena. European countries should draw two important conclusions from this new scenario.

Firstly, we need to focus our attention on the evolution of emerging powers like China, India, and Brazil. We must make it an urgent priority to study and thoroughly comprehend their reality, the track record of their growth, their values, histories, and interests, because the balance of world power is shifting towards them, forcing us to alter our perspective. It is vital that the European Union revise its strategic interests and the framework of its relations with China and other Asian countries.

The Asia-Pacific region has recently acquired great strategic importance in international relations. We have already witnessed the reorientation of US interests in Asia, negotiating and signing the TPPA and establishing trade ties with these countries.

The region is marked by numerous territorial and border disputes, nationalist movements, and a considerable level of distrust among countries. When analysing this part of the world, security issues are often overshadowed by its spectacular economic growth. However, there are

enough elements in place for important security challenges to emerge, and the EU should monitor them closely.

One potential risk is located in the South China Sea. Many of the world's nations are linked by the maritime trade that passes through this sea, which bathes the shores of seven countries: China, Indonesia, Malaysia, Vietnam, the Philippines, Brunei, and Taiwan. All of them have claimed sovereignty over these waters on more than one occasion. Some offer historical justifications, while others base their claims on the United Nations Convention on the Law of the Sea. The South China Sea is a vital intersection of maritime traffic for all seven countries. In particular, the Strait of Malacca is the shortest route between Asian oil consumers and their suppliers in Africa and the Persian Gulf. In 2013, 27% of all oil carried by sea and over half of all liquefied natural gas passed through this channel. Moreover, this sea has an abundance of rich fishing grounds and estimated reserves of eleven billion barrels of oil and 190 trillion cubic feet of natural gas. Thus far, disputes over the waters of this sea have been fairly low-key. However, China's growing economic and military power in the region could break the status quo and lead to full-blown conflict.

Tensions between these countries mark the South China Sea as a new centre of interest for global security and, more generally, for international relations. Although this region may seem far removed from Europe and its interests, problems here could have devastating consequences for the global economy.

The second conclusion is that, given the influence they have acquired of late, the emerging economies must be included in global governance structures. Recently we have seen how China is taking steps to create global governance organizations. China's large foreign exchange reserves have made it the world's biggest provider of finance to developing countries, and the China Development Bank now grants more loans than the World Bank. Additionally, in October 2014 China created the Asian Infrastructure Investment Bank (AIIB), which has already been joined by several European countries, including France, Germany, Italy, Spain, and the United Kingdom.

The AIIB has created a forty-billion-dollar fund to develop the "New Silk Road", which will affect Europe directly. This project includes an overland economic belt that will begin in Xi'an and run westward to Venice, passing through Central Asia, Turkey, Russia, and Germany. It will also incorporate a maritime route stretching from China's east coast to Venice, with stops at Singapore, Calcutta, Colombo, Mombasa,

Athens, and other ports. The two routes will form a network linking Asia and Europe. The project's investments will affect approximately 60 countries, and one of the principal ports of call will be that of Piraeus, in Greece. This plan to improve connectivity, which will consolidate China as the EU's number-one trade partner, confirms the Chinese government's determination to prioritize Euro-Asian relations.

In this new scenario, it is crucial that the EU continue to strengthen international and trade ties with the Asian continent. An example of success in this area is the free trade agreement signed with Vietnam in August 2015. However, although Asia is often analysed primarily from an economic standpoint, there are other aspects of Euro-Asian relations worth noting.

WE NEED TO FOCUS OUR ATTENTION ON THE EVOLUTION OF EMERGING POWERS LIKE CHINA, INDIA, AND BRAZIL

For example, in an Asian continent that has achieved economic but not political integration, the EU can offer the benefit of its extensive experience in regional integration, something that would contribute decisively to promoting long-term stability in the region.

While acknowledging the limitations and shortcomings of the European project, a greater degree of EU involvement in Asia's existing regional integration structures—such as ASEAN or the ASEAN Regional Forum, the only security dialogue forum in the Asia-Pacific in which the EU has its own seat—would be highly beneficial.

The Road Ahead

The EU must offer an appropriate response to the magnitude of the challenges it faces and what is expected of it in the world. Knowing this, the EU's High Representative for Foreign Affairs, Federica Mogherini, has been mandated to prepare a new global strategy on foreign policy, with the perspective and focus needed to promote EU external action and increase its effectiveness. Approval of this policy, slated for June 2016, will be a major step forward for the EU and hopefully will address the most pressing needs in this area.

The EU's Diplomatic Work

One of the ways in which the EU can implement its foreign policy quite successfully is through diplomacy. The EU is regarded by many as an experienced mediator in settling numerous conflicts, and it is precisely in the role of negotiator that it manages to achieve many of its goals.

The nuclear deal with Iran, signed this past July, is a good example of what the EU can accomplish thanks to its diplomatic skills. It was the EU who initiated negotiations with Iran in 2003, and at the time we Europeans were the only ones involved in the talks. Later on, the EU joined forces with the permanent members of the UN Security Council and Germany to form a group called the E3/EU+3. The agreement recently signed with Iran regarding its nuclear programme has opened a window of opportunity for bringing greater stability to the Middle East. Teheran's ties with the Iraqi government, the Al-Assad regime in Syria, the Houthis in Yemen, and Hezbollah in Lebanon make it a key player in regional politics.

As for our relations with Russia, it is very important that we attempt to strengthen ties and recover the mutual trust that has been lacking since the beginning of the Ukraine dispute. However, the EU must firmly insist on the observance of international law; this has to be our red line. The harmonious coexistence of Europe and Russia in the Euro-Asia region is undoubtedly a very positive thing for both countries. However, it will undeniably take some time for the tensions created by this conflict to die down so that we can rebuild a climate of mutual trust.

Another of the EU's objectives must be to promote stability and democracy in the countries of Eastern Europe and the Balkans. It would be advisable for the EU to pay special attention to voices outside government channels, in order to gain a better understanding of each society's needs. Civil society demands, with growing insistence, better governance and more respect for civil rights.

In the Middle East, the EU cannot be expected to solve the conflicts, but it can use diplomacy to become a key facilitator in orchestrating regional agreements. Bringing Sunni and Shiite Muslims together is the key to peace in the Middle East, and promoting this should be the goal of all other actors with an interest in ensuring the region's stability. Peace cannot be achieved with a solution imposed by outsiders; this would only plant the seed of a new and perhaps even deadlier conflict in an area whose population has already been devastated by too many

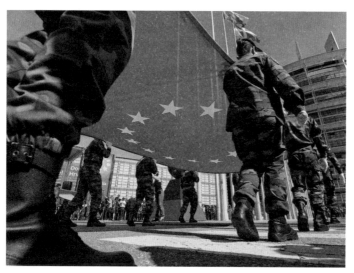

Members of the Eurocorps service hold the
European flag in front of the Parliament.

years of war. It is therefore essential that the EU maintains a constant
dialogue with regional powers like Iran and Turkey.

The European Union has another major task ahead of it: contributing
to the improvement of governance in countries where state institutions
do not operate efficiently. Helping to build more capable and effective
government bodies is the best way to wrest power away from terrorist
groups and organized crime and place it back in the hands of the state,
where it belongs. In fact, in the countries of the Sahel this seems to be
the only viable way of achieving the stability that is so necessary for
their inhabitants and security.

European Neighbourhood Policy

One of the instruments through which the EU develops its foreign re-
lations is the European Neighbourhood Policy (ENP). Designed to ar-
ticulate relations with our closest neighbours, this policy currently has
two subdivisions: one for the countries of Eastern Europe, and one for
the southern states. The EU does, in fact, have one sphere of action that
takes precedence above all others—namely, its borders—and relations
with neighbouring countries must therefore be handled with special care.

However, grouping many different countries together under the
concept of southern or eastern neighbourhood has proved inefficient

because each neighbouring state evolves at a different pace. Tunisia's current situation is not comparable to Egypt's. And other countries, such as Turkey, though not really neighbours in a technical sense, are key pieces for addressing many current problems. It is a mistake to believe that we can apply a single policy, almost automatically, to very different countries. Having a separate policy for each nation may be more complicated, but it is far more efficient.

As the preparatory reports on the new European foreign policy accurately point out, EU external action needs to be more flexible to increase the effectiveness of all its measures. Adopting an approach to other countries that is more political, via diplomatic channels, and less bureaucratic and regimented is a more effective way of increasing the EU's commitment to improving living conditions, democratization, and economic and social progress.

Security

The European Union has a responsibility to create the necessary conditions (political, social, etc.) for averting war. We cannot hope to combat the many threats to European and global security unless we work to perfect a common security policy.

In terms of military might, the individual relevance of European countries is waning, and conflicts on our borders underscore the need to be prepared for any contingency. Over the past several years, the economic recession in Europe has caused governments to be less concerned with international security issues and apply budget cuts in the area of defence.

Yet during those same years, as mentioned above, the problems facing Europe have multiplied, and they are too great for any one country to solve on its own. In fact, in this global, multi-polar world, no nation can guarantee its own safety without assistance. The distinction between internal and external security is also increasingly blurred, with two obvious implications: security and defence policy must now be perfectly aligned with foreign policy; and security risks should be viewed as something common to all member states, for even those with conflict-free borders have to consider the impact of security threats on their territory.

The EU's security and defence policy is one of the most difficult tools to implement in the context of the European project. In matters of defence, differences between the domestic interests of member states

have been even more pronounced than in foreign policy. The countries of Central and Eastern Europe are more concerned about the insecurity that Russian policies might create, while southern members tend to prioritize the risks derived from conflicts in the Middle East and the challenge of mass migration in the Mediterranean.

The European Security Strategy, the framework that includes the common security and defence policy (CSDP), was approved in 2003. The world has changed substantially since then, and European strategy must take into account the current scenario. In December 2013, the European Council, aware of the need to reconsider European security and defence strategies in light of new threats, placed the CSDP at the centre of the debate. Since then, several security policies have been adopted on specific issues to serve as a guideline for the actions of member states.

However, now that the security strategy is being revised, we must take the opportunity to move decisively towards greater integration. The effectiveness of the EU's security strategy, which must go hand-in-hand with its foreign policy strategy, depends on the cooperation and real commitment of its member states.

Defence budgets need to be increased, but above all they need to be used more wisely, minimizing inefficiency. Better coordination among members will increase our global presence and capabilities, not by spending more but by optimizing resources. We must push for integration on security matters at the European level, with a strong emphasis on R&D+i, while reinforcing the role of the European Defence Agency. Another fundamental task is to ensure that the defence industry market works properly, making it more open and transparent to promote the beneficial exchange of technology and greater synergy between the civilian and military sectors.

Additionally, the EU needs to take the lead in designing global cybersecurity strategies. Over the last several years, many international, regional, and technical institutions have addressed the issue of security in cyberspace, including the United Nations, the Council of Europe, the G20, the G8, and the Organization for Security and Cooperation in Europe (OSCE). However, there is no consensus on what the guiding principles of global cyber security governance should be. The EU must actively participate in the process of drafting a basic regulatory framework, similar to that which the international community has adopted on matters of global health or weapons proliferation. We need to contribute to the debate and shape the agreements that are eventually reached; we cannot afford to

fall behind in the area where all of the world's economic activities are concentrated today. Let us not forget that, by the year 2020, two-thirds of the global population will be connected to the internet.

Conclusion: Our Role on the International Stage

A political union like the EU cannot allow its member states to face the challenges on their respective borders alone. In order to forge a foreign policy that is truly common to all members, we must work together to identify the risks we face and combine our individual perspectives to envision possible solutions and the EU's potential role in implementing them.

The best contribution that the EU can make to world peace is to stay united and prevent new conflicts in Europe. However, it cannot stop there. The EU, like every other global actor, has a great responsibility to act in the face of current problems and conflicts, and there are many important ways in which it can contribute to the design of conflict resolution mechanisms and multilateral institutions.

It goes without saying that the countries which make up the European Union have made great efforts to reconcile their diverse individual identities and seek common interests, and that experience can be very helpful in many present-day scenarios. They have also created institutions and mechanisms for integration which, though imperfect, have proved to be successful.

The multi-polar world we live in needs multilateral institutions to address global threats—threats that can never be neutralized if each nation acts independently. Today's problems will be solved, not by confrontation and brute force, but through dialogue and consensus. The EU's past experience in this area is an invaluable resource.

Moreover, exterior action is a necessary tool that allows the EU to defend European interests. We cannot remain on the sidelines as mere spectators in such a rapidly changing world; we must act, because those changes also affect us. If we can agree on what the EU's stance should be towards the rest of the world, our responses will be swifter and work towards achieving a common goal.

Francisco González

Bouis, R. and R. Duval. 2011. "Raising Potential Growth after the Crisis: A Quantitative Assessment of the Potential Gains from Various Structural Reforms in the OECD Area and Beyond." OECD Economics Department Working Paper no 835.

Brynjolfsson, E. and A. McAfee. 2015. The Second Machine Age: *Work, Progress, and Prosperity in a Time of Brilliant Technologies.* New York and London: Norton.

CompNet Task Force. 2014. "Micro-Based Evidence of EU Competitiveness: the CompNet Database". ECB Working Paper Series no 1634.

Crafts, N. 2014. "Secular Stagnation: US Hypochondria, European Disease?" In *Secular Stagnation: Facts, Causes and Cures,* edited by C. Teulings and R. Baldwin, 91-100. London: CEPR Press.

Eichengreen, B. 2014. "Secular Stagnation: A Review of the Issues." *In Secular Stagnation: Facts, Causes and Cures,* edited by C. Teulings and R. Baldwin, 41-46. London: CEPR Press.

González, F. 2014. "Transforming an Analog Company into a Digital Company: The Case of BBVA". In *Reinventing the Company in the Digital Age.* Madrid: BBVA.

Gordon, R. 2012. "Is US Economic Growth Over? Faltering Innovation Confronts the Six Headwinds." NBER Working Paper 18315.

Hansen, A. 1938. Lecture published as Hansen, A. 1939. "Economic Progress and Declining Population Growth." *American Economic Review* 29: 1-15.

McKinsey. 2015. "The Fight for the Customer: McKinsey Global Banking Annual Review 2015."

Mokyr, J. 2014. "Secular Stagnation? Not in Your Life." In *Secular Stagnation: Facts, Causes and Cures,* edited by C. Teulings and R. Baldwin, 83-90. London: CEPR Press.

Summers, L. 2014. "US Economic Prospects: Secular Stagnation, Hysteresis and the Zero Lower Bound." Keynote address delivered at the National Association for Business Economics (NABE) Economic Policy Conference on 24 February 2014.

Barry Eichengreen

Blustein, Paul. 2015. "Laid Low: The IMF, the Euro Zone and the First Rescue of Greece." CIGI Paper 61. Waterloo: Centre for International and Global Governance.

Claeys, Gregory. 2014. "The (not so) Unconventional Monetary Policy of the European Central Bank since 2008." Directorate General for Internal Policies. European Commission.

Cole, Harold and Timothy Kehoe. 1998. "Self-Fulfilling Debt Crises." Staff Report 211. Research Department. Federal Reserve Bank of Minneapolis.

Corsetti, Giancarlo and Luca Dedola. 2014. "The "Mystery of the Printing Press": Monetary Policy and Self-Fulfilling Debt Crises." Unpublished manuscript. Cambridge University and European Central Bank.

Couré, Benoit. 2014. "Outright Monetary Transactions, One Year On." Unpublished manuscript. European Central Bank.

Eichengreen, Barry. 2015. *Hall of Mirrors: The Great Depression, the Great Recession, and the Uses— and Misuses—of History.* New York: Oxford University Press.

European Central Bank. 2010. "ECB's Replies to the Questionaire of the European Parliament Supporting the Own Initiative Report Evaluating the Structure, the Role and Operations of the 'Troika' (Commission, ECB and the IMF) Actions in Euro Area Programme Countries." Frankfurt: ECB.

Folkerts-Landau, David and Peter Garber. 1992. "The ECB: A Bank or a Monetary Policy Rule?" In *Establishing a Central Bank: Issues in Europe and Lessons from the US,* edited by Matthew Canzoneri, Vittorio Grilli and Paul Masson. Cambridge: Cambridge University Press.

Galí, Jordi. 2002. "Monetary Policy in the Early Years of EMU."

Unpublished manuscript. CREI and Universitat Pompeu Fabra.

Micossi, Stefano. 2015. "The Monetary Policy of the European Central Bank (2002-2015)." CEPS Special Report 109.

Reis, Ricardo. 2015. "Different Types of Central Bank Insolvency and the Role of Seniorage." NBER Working Paper 21226.

Trichet, Jean-Claude. 2009. "The ECB's Enhanced Credit Support." CES Working Paper 2833.

Xafa, Miranda. 2014. "Sovereign Debt Crisis Management: Lessons from the 2012 Greek Debt Restructuring." CIGI Paper 33. Waterloo: Centre for International and Global Governance.

Indermit Gill, Martin Raiser and Naotaka Sugawara

Acemoglu, D. and M. Ucer. 2015. "The Ups and Downs of Turkish Growth, 2002-2015: Political Dynamics, the European Union and the Institutional Slide." Article prepared for this Volume.

Andrle, M., J. Bluedorn, L. Eyraud, T. Kinda, P. Koeva Brooks, G. Schwartz, and A. Weber. 2015. "Reforming Fiscal Governance in the European Union." IMF Staff Discussion Note 15/09. Washington.

Arias, O., and A. Schwartz. 2014. *The Inverted Pyramid.* Pension Systems Facing Demographic Challenges in Europe and Central Asia. The World Bank. Washington DC.

Baldwin R., and F. Giavazzi. 2015. *The Eurozone Crisis. A Consensus View of the Causes and a Few Possible Solutions.* A VoxEU.org eBook. Center for European Policy Research. London.

Benassi-Quere, A. 2015. "Maastricht Flaws and Remedies." In *The Eurozone Crisis. A Consensus View of the Causes and a Few Possible Solutions,* edited by R. Baldwin, and F. Giavazzi, 72-84. A VoxEU.org eBook. Center for European Policy Research. London.

Bussolo, M., J. Koettl, and E. Sinnott. 2015. *Golden Aging. Prospects for Health, Active and Prosperous Aging in Europe and*

Central Asia. The World Bank. Washington DC.

Dall'Olio, A., M. Iooty, N. Kaneira, and F. Saliola. 2013. "Productivity Growth in Europe." World Bank Policy Research Working Paper 6425. Washington DC.

"Doing Business." 2015. The World Bank. Washington DC.

Enderlein, H., and J. Pisani-Ferri. 2014. *Reforms, Investment and Growth. An Agenda for France, Germany and Europe*. Report to the Minister of Economic Affairs and Energy of Germany and the Minister for the Economy, Industry, and Digital Affairs of France. Berlin and Paris.

Gill, I., and M. Raiser. 2012. *Golden Growth: Restoring the Luster of the European Economic Model*. The World Bank. Washington DC.

Gill, I., N. Sugawara, and J. Zalduendo. 2014. "The Center Still Holds: Financial Integration in the Euro Area." Comparative Economic Studies 2014, (1): 1-25.

International Monetary Fund (IMF). 2015. "Euro Area Policies." IMF Country Report 15/204. Washington DC.

Iwulska, A. 2012. "Country Benchmarks." Background paper prepared for Golden Growth. Available at: www.worldbank.org/goldengrowth.

Organization for Economic Cooperation and Development (OECD). 2015. *Going for Growth*. Paris.

Raiser, M., and M. Wes. 2014. *Turkey's Transitions: Integration, Inclusion, Institutions*. The World Bank. Washington DC.

Schmieding, H. 2015. "Cruising Speed Despite Grexit Risk." Berenberg Economics Global Outlook. London.

Sugawara, N., and J. Zalduendo. 2010. "How much economic integration is there in the extended EU family?" ECAnomics Note 10/1. Office of the Chief Economist, Europe and Central Asia Region. The World Bank.

Colin Crouch

Avdagic, S. 2015. "Does Dereg-ulation Work? Reassessing the unemployment effects of employment protection." *British Journal of Industrial Relation* 53, 1:6-26.

Beck, U. 1986. *Risikogesellschaft*. Frankfurt am Main: Suhrkamp.

Bredgaard. T., F. Larsen, and P.K. Madsen. 2007. "The challenges of identifying flexicurity in action—a case study on Denmark." In *Flexicurity and Beyond: Finding a New Agenda for the European Social Model*, edited by H. Jørgensen and P.K. Madsen, 365-391. Copenhagen: DJOF Publishing.

Bredgaard. T., F. Larsen, and P.K. Madsen. 2008. "Transitional labour markets and flexicurity arrangements in Denmark: what can Europe learn?" In *The European Social Model and Transitional Labour Markets: Law and Policy*, edited by R. Rogowski, 189-208. Aldershot: Ashgate.

Crouch, Colin. 2015. *Governing Social Risks in Post-Crisis Europe*. Cheltenham: Elgar.

Esping-Andersen, G. 1999. *The Social Foundations of Post-Industrial Economies*. Oxford: Oxford University Press.

Esping-Andersen, G. and M. Regini, eds. 2000. *Why Deregulate Labour Markets?* Oxford: Oxford University Press.

European Commission. 1993. *Growth, Competitiveness and Employment*. Luxembourg: Office for Official Publication of the European Communities.

European Commission. 2005. *Working Together for Growth and Jobs. Integrated Guidelines for Growth and Jobs 2005–2008*. Luxembourg: Office for Official Publication of the European Communities.

European Commission. 2007. "Towards Common Principle of Flexicurity: More and better jobs through flexibility and security." Luxembourg: Office for Official Publication of the European Communities.

Förster, M., A. Llena-Nozal, and V. Nafilyan. 2014. "Trends in Top Incomes and Their Taxation in OECD Countries." *OECD Social, Employment and Migration Working Papers* 159. Paris: OECD.

Giddens, A. 1994. *Beyond Left and Right. The Future of Radical Politics*. Cambridge: Polity Press.

Giddens, A. 1998. *The Third Way: The Renewal of Social Democracy*. Cambridge: Polity Press.

Government of Greece. 2012. *Memorandum of Understanding on Specific Economic Policy Conditionality. February 9, 2012*. Athens: Government of Greece.

Hemerijck, A. 2012. *Changing Welfare States*. Oxford: Oxford University Press.

Höpner, M. 2008. "Usurpation statt Delegation: Wie der EuGH die Binnenmarktintegration radikalisiert und warum er politischer Kontrolle bedarf." MPIfG Discussion paper 08/12. Cologne: MPIfG.

Höpner, M. 2014. "Wie der Europäische Gerichtshof und die Kommission Liberalisierung durchsetzen." MPIfG Discussion paper 14/8. Cologne: MPIfG.

IMF. 2012. "Dealing with household debt." *IMF World Economic Outlook*, April. Washington, DC: IMF.

Jørgensen, H. and P.K. Madsen, eds. 2007. *Flexicurity and Beyond: Finding a New Agenda for the European Social Model*. Copenhagen: DJOF Publishing.

Knight, F.H. 1921. *Risk, Uncertainty and Profit*. Boston, MA and New York: Houghton Mifflin.

Muffels, R.J.A. and R. Luijkx. 2008a. "The relationship between labour market mobility and employment security: "trade-off" or "double bind."" *Work Employment and Society* 22, 2: 221–42.

Muffels, R.J.A. and R. Luijkx, eds. 2008b. *Flexibility and Employment Security in Europe: Labour Markets in Transition*. Cheltenham: Edward Elgar.

Muffels, R.J.A. 2013a. "Governance of sustainable security: the impact of institutions and values on labour market transitions using ESS and SILC data." Unpublished GUSTO paper. Tilburg: University of Tilburg.

Muffels, R.J.A. 2013b. "Young workers, job insecurity and employment uncertainty in times of crisis: exploring the impact of governance, economic resources and trust in Central-Eastern and Western Europe." Unpublished GUSTO paper. Tilburg: University of Tilburg.

Muffels, R.J.A., C. Crouch, and T. Wilthagen. 2014. "Flexibility and security: national social models in transitional labour markets." *Transfer*. 20, 1: 99–114.

OECD. 1994. *The Jobs Study*. Paris: OECD.

OECD. 2006a. "Has the Rise in Debt Made Households More Vulnerable?" *Economic Outlook 80*. Paris: OECD. 135-50.

OECD. 2006b. *Boosting Jobs and Incomes. Policy Lessons from Reassessing the OECD Jobs Study*. Paris: OECD.

OECD. 2011. *Divided We Stand: Why Inequality Keeps Rising*. Paris: OECD.

OECD. 2013. *OECD Factbook 2013*. Paris: OECD.

Scharpf, F. 1999. *Governing in Europe: Effective and Democratic?* Oxford: Oxford University Press.

Streeck, W. 2013. *Gekaufte Zeit: Die vertagte Krise des demokratischen Kapitalismus*. Berlin: Suhrkamp.

Taylor-Gooby, P., ed. 2004. *New Risks, New Welfare: The Transformation of the European Welfare State*. Oxford: Oxford University Press.

Vandenbroucke, F., A. Hemerijck, and B. Palier. 2011. "The EU needs a social investment pact." Opinion Paper, May 5, 2011. Brussels: Observatoire Social Européen.

Philip Cooke

Arthur, B. 1994. *Increasing Returns and Path Dependence in the Economy*. Ann Arbor: University of Michigan Press.

Arthur, B. 2009. *The Nature of Technology*. London: Penguin.

Balconi, M., S. Brusoni, and L. Orsenigo. 2010. "In defence of the linear model: an essay." *Research Policy* 39: 1-13.

Boschma, R., and R. Martin, eds. 2010. *The Handbook of Evolutionary Economic Geography*. Cheltenham: Edward Elgar.

Burt, R. 1992. *Structural Holes: The Social Structure of Competition*. Cambridge MA: Harvard University Press.

Chapain, C., P. Cooke, L. De Propris, S. MacNeil, and J. Mateos-García. 2010. *Creative Clusters and Innovation: Putting Creativity on the Map*. London: NESTA.

Chiang, C., M. Druy, S. Gau, A. Heeger, E. Louis, A. MacDiarmid, Y. Park, and H. Shirakawa. 1978. "Synthesis of highly conducting films of derivatives of polyacetylene (CH)x." *Journal of the American Chemical Society* 100: 1013.

Cooke, P., and D. Schwartz. 2008. "Regional knowledge economies: an UK-EU and Israel perspective." *Tijdschrift Voor Economische en Sociale Geografie* 99: 178-192.

Cooke, P., C. De Laurentis, S. MacNeil, and C. Collinge, eds. 2010. *Platforms of Innovation*. Cheltenham: Edward Elgar.

Cooke, P., ed. 2013. *Reframing Regional Development*. London: Routledge.

Cooke, P. forthcoming in 2016. "Four minutes to four years: the advantage of recombinant over specialised innovation—RIS3 versus smartspec." *European Planning Studies*.

David, P. 1985. "Clio and the economics of QWERTY." *American Economic Review* 75: 332-337.

European Commission. 2012. *Guide to Research and Innovation Strategies for Smart Specialisation*. Brussels: European Commission.

FCT. 2013. *An Analysis of the Portuguese Research and Innovation System: Challenges, strengths and weaknesses towards 2020*. Lisbon: Fundação para a Ciência e a Tecnologia/ National Research Council.

Felsenstein, D. 2011. "Human capital and labour mobility determinants of regional innovation." In *The Handbook of Regional Innovation & Growth*, edited by P. Cooke, B. Asheim, R. Boschma, R. Martin, D. Schwartz and F. Tödtling, 119-131. Cheltenham:

Edward Elgar.

Folke, C. 2006. "Resilience: the emergence of a perspective for social-ecological systems analysis." *Global Environmental Change* 16: 253-267.

Frenken, K. 2006. *Innovation, Evolution & Complexity Theory*. Cheltenham: Edward Elgar.

Garud, R., and P. Karnøe. 2001. "Path Creation as a Process of Mindful Deviation." In *Path Dependence and Creation,* edited by R. Garud and P. Karnøe, 1-38. London: Lawrence Erlbaum.

Geels, F. 2007. "Analysing the breakthrough of rock 'n' roll (1930-1970): multi-regime interaction and reconfiguration in the multi-level perspective." *Technological Forecasting & Social Change* 74: 1411-1431.

Grabher, G., ed. 1993. The Embedded Firm: on the Socioeconomics of Industrial Networks. London: Routledge.

Gunderson, L., and C. Holling, eds. 2002. *Panarchy: Understanding Transformations in Human and Natural Systems*. Washington DC: Island Press.

Hughes, T. 1977. "Edison's method." In *Technology at the Turning Point*, edited by W. Pickett, 5-22. San Francisco: San Francisco Press Inc.

Jacobs, J. 1961. *The Death & Life of Great American Cities*. New York: Vintage.

Janowicz-Panjaitan, M., and N. Noorderhaven. 2009. "Trust, calculation and interorganizational learning of tacit knowledge: an organizational roles perspective." *Organization Studies* 30: 1021-1044.

Jensen, M., B. Johnson, E. Lorenz, and B. Lundvall. 2007. "Forms of knowledge and modes of innovation." *Research Policy* 36: 680-693.

Johnson, M. 2010. *Seizing the White Space*. Boston: Harvard Business Press.

Johnson, S. 2010. *Where Good Ideas Come From*. New York: Riverhead.

Kauffman, S. 2008. *Reinventing the Sacred*. New York: Basic Books.

Kline, S., and N. Rosenberg. 1986.

"An overview of innovation." In *The Positive Sum Strategy*, edited by R. Landau and N. Rosenberg, 275-305. Washington, D.C.: National Academy Press.

Kroll, H. 2015. "Efforts to implement smart specialization in practice—leading unlike horses to the water." *European Planning Studies*. DOI:10.1080/09654313.2014.1003036.

Krugman, P. 1991. "Cities in Space: Three Simple Models." NBER Working Paper 3607. Cambridge: National Bureau of Economic Research.

Krugman, P. 1995. *Development, Geography & Economic Theory.* Cambridge: MIT Press.

Martin, R. 2010. "The Roepke Lecture in Economic Geography—Rethinking regional path dependence: beyond lock-in to evolution." *Economic Geography* 86: 1-27.

Martin, R., and P. Sunley. 2006. "Path dependence and regional economic evolution." *Journal of Economic Geography* 6: 395-438.

Martin, R., and P. Sunley. 2010. "The place of path dependence in an evolutionary perspective on the economic landscape." In *Handbook of Evolutionary Economic Geography*, edited by R. Boschma and R.L. Martin, 62-92. Cheltenham: Edward Elgar.

Myrdal, G. 1957. *Economic Theory and Underdeveloped Regions.* London: Duckworth.

Nunes, S., and R. Lopes. 2015. "Firm performance, innovation modes and territorial embeddedness." *European Planning Studies* 23: 9. DOI: 10.1080/09654313.2015.1021666.

Nystrom, G., A. Razaq, M. Strømme, L. Nyholm, and A. Mihranya. 2009. "Ultrafast, all-polymer, paper-based batteries." *Nano Letters* 9: 3635-3639.

Page, S. 2007. *The Difference.* Princeton: Princeton University Press.

Pisano, G., and R. Verganti. 2008. "Which kind of collaboration is right for you?" Harvard Business Review 86: 78-86.

Rosenstein-Rodan, P. 1943. "Problems of industrialisation of east-

ern and south-eastern Europe." *Economic Journal* 53: 202-211.

Schumpeter, J. 1934. *The Theory of Economic Development.* Cambridge: Harvard University Press.

Scott, A. J. 2008. *Social Economy of the Metropolis: Cognitive-Cultural Capitalism and the Global Resurgence of Cities.* Oxford: Oxford University Press.

Shirky, C. 2010. *Here Comes Everybody.* London: Penguin.

Strambach, S. 2010. "Knowledge-intensive business services." In *Platforms of Innovation*, edited by P. Cooke, C. De Laurentis, S. MacNeill, and C. Collinge. Cheltenham: Edward Elgar.

Veblen, T. 1898. "Why is economics not an evolutionary science?" *Quarterly Journal of Economics* 12: 373-397.

Vrba, E., and S. Gould. 1982. "Exaptation—a missing term in the science of form." *Paleobiology* 8:4-15.

Vivien Ann Schmidt

Armingeon, K. and L. Baccaro. 2013. "The Sorrows of the Young Euro: Policy Responses to the Sovereign Debt Crisis." In *Coping with Crisis,* edited by Nancy Bermeo and Jonas Pontusson. New York: Russell Sage Foundation.

Barbier, Jean-Claude 2008. *La Longue Marche vers l'Europe Sociale.* Paris: PUF.

Bickerton, Christopher and Carlo Invernizzi Accetti. 2015. "Populism and Technocracy: Opposites or Complements?" *Critical Review of International Social and Political Philosophy.* DOI:10.1080/13698230.2014.995504.

Blyth, M. 2013. *Austerity: The History of a Dangerous Idea.* Oxford: Oxford University Press.

Bosco, A. and S. Verney. 2012. "Electoral Epidemic." *South European Society and Politics* 17(2): 129-154.

Claessens, Stijn, Ashoka Mody, and Shahin Vallee. 2012. "Paths to Eurobonds." Bruegel Working Paper 2012/10. Available at http://www.bruegel.org/publications/publication-detail/publication/733-paths-to-eurobonds/.

Collignon, Stefan 2004. *Vive la*

République Européenne. Paris: Edition de la Martinière.

De Grauwe P. and Y. Ji. 2012. "Mispricing of Sovereign Risk and Macroeconomic Stability in the Eurozone." *Journal of Common Market Studies*, 50/6: 866-880.

De Grauwe, Paul 2013. "The Political Economy of the Euro." *Annual Review of Political Science* 16:153-70.

Dehousse, Renaud 2011. "Are EU Legislative Procedures Truly Democratic?" Paper presented at the Harvard University Center for European Studies. Boston, March, 2.

Dehousse, Renaud 2015. "The New Supranationalism." Paper prepared for presentation at the Council for European Studies Annual Conference. Paris, July, 8-10.

Enderlein, H. et al. 2012. *Completing the Euro—A road map towards fiscal union in Europe.* Report of the Tommaso Padoa-Schioppa Group. *Notre Europe Study* 92. Available at http://www.notre-europe.eu/media/completingtheeuroreportpadoa-schioppagroupnejune2012.pdf?pdf=ok.

Eurostat 2015. "Unemployment Statistics." Available at http://ec.europa.eu/eurostat/statistics-explained/index.php?title=Unemployment_statistics&oldid=232726.

Fabbrini, Sergio. 2013. "Intergovernmentalism and its limits: Assessing the European Union's Answer to the Euro Crisis." *Comparative Political Studies* 46(9): 1003-1029.

Gamble, A. 2013. "Neo-Liberalism and fiscal conservatism." In *Resilient Liberalism: European Political Economy through Boom and Bust,* edited by V. A. Schmidt and M. Thatcher. Cambridge, UK: Cambridge University Press.

Gómez-Reino, Margarita and Iván LLamazares. 2013. "The Populist Radical Right and European Integration: A Comparative Analysis of Party-Voter Links." *West European Politics* 36(4): 789-816.

Grimm, Dieter. 1997. "Does Europe Need a Constitution?" In *The Question of Europe*, edited by P. Gowan and P. Anderson. London: Verso.

Hobolt, Sara B. 2015) "Public Attitudes toward the Eurozone Crisis" in *Democratic Politics in a European Union under Stress,* edited by Olaf Cramme and Sara B. Hobolt. Oxford: Oxford University Press

Hobolt, Sara B. and Cristopher Wratil. 2015. "Public Opinion and the Crisis: The Dynamics of Support for the Euro." *Journal of European Public Policy* 22(2): 238-56.

Jacoby, W., forthcoming in 2015. "The Timing of Politics and the Politics of Timing." In *The Future of the Euro,* edited by M. Matthijs, and M. Blyth. New York: Oxford University Press.

Jones, Erik 2015. "Forgotten Financial Union: How You Can Have a Euro Crisis without a Euro." In *The Future of the Euro,* edited by Mark Blyth and Matthias Matthijs. New York: Oxford University Press.

Hanspeter, Kriesi, and Edgar Grande, forthcoming in 2015. "Political Debate in a Polarizing Union." In *Democratic Politics in a European Union under Stress,* edited by O. Cramme, and S. Hobolt. Oxford: Oxford University Press.

Kriesi, Hanspeter 2014. "The Populist Challenge." *West European Politics* 37(2): 379-99.

Kriesi, Hanspeter, Edgar Grande, and Robert Lachat. 2008. *West European Politics in the Age of Globalization.* Cambridge: Cambridge University Press.

Kriesi, Hanspeter, Edgar Grande, Martin Dolezal, Marc Helbling Dominic Höglinger, Swen Hutter, and Bruno Wueest. 2012. *Political conflict in Western Europe.* Cambridge: Cambridge University Press.

Laffan, B. 2014. "Testing Times: The Growing Primacy of Responsibility in the Euro Area." *West European Politics* 37(2): 270-287.

Mair, P. 2013. "Smaghi *vs.* the Parties: Representative Government and Institutional Constraints." In *Politics in the Age of Austerity,* edited by A. Schäfer, and W. Streeck, Cambridge: Polity.

Mair, Peter and Thomassen J. 2010. "Political representation and government in the European Union." *European Journal of Public Policy* 17: 2035.

Majone, G. 1998. "Europe's Democratic Deficit." *European Law Journal* 4(1): 5-28.

Mudde, Cas and Cristobal Rovira Kaltwasser. 2012. *Populism in Europe and the Americas: Threat or Corrective to Democracy.* Cambridge: Cambridge University Press.

Nicolaïdis, Kalypso. 2013. "European Demoicracy and its Crisis." *Journal of Common Market Studies* 51(2): 351-369.

Novak, S. 2010. "Decision rules, social norms and the expression of disagreement." *Social Science Information.* 49(1): 83–97.

Parsons, Craig and Matthias Matthijs. 2015. "European Integration Past, Present and Future: Moving Forward through Crisis?" In *The Future of the Euro,* edited by Matthias Matthijs and Mark Blyth. New York: Oxford University Press.

Puetter, U. 2012. "Europe's Deliberative Intergovernmentalism." *Journal of European Public Policy* 19(2):161–178.

Risse, Thomas. 2010. *A Community of Europeans?* Ithaca: Cornell University Press.

Risse, Thomas. ed. 2015. *European Public Spheres.* Oxford: Oxford University Press.

Sauerbrey, Anna. 2015. "European Political Poke." *International New York Times.* August, 10. Available at http://www.nytimes.com/2015/08/10/opinion/anna-sauerbrey-european-political-poker.html?_r=0.

Scharpf, F. W. 2013. "Monetary Union, Fiscal Crisis and the Disabling of Democratic Accountability." In *Politics in the Age of Austerity,* edited by A. Schäfer, and W. Streeck. Cambridge: Polity.

Schelkle, W., forthcoming in 2015. "The Insurance Potential of a Non-Optimum Currency Area." In *Democratic Politics in a European Union under Stress,* edited by O. Cramme, and S. Hobolt. Oxford: Oxford University Press.

Schmidt, Vivien A. 2006. *Democracy in Europe.* Oxford: Oxford University Press

Schmidt, Vivien A. 2009. "Re-Envisioning the European Union: Identity, Democracy, Economy." *Journal of Common Market Studies,* 47 Annual Review (2009): 17-42.

Schmidt, Vivien A. 2013. "Democracy and Legitimacy in the European Union Revisited: Input, Output *and* 'Throughput.'" *Political Studies* 61(1): 2-22

Schmidt, Vivien A. 2015a. "Forgotten Democratic Legitimacy: 'Governing by the Rules' and 'Ruling by the Numbers.'" In *The Future of the Euro,* edited by Matthias Matthijs and Mark Blyth. New York: Oxford University Press

Schmidt, Vivien A. 2015b. "Changing the policies, politics, and processes of the Eurozone in crisis: Will this time be different?" In *Social Developments in the EU 2015,* edited by David Natali and Bart Vanhercke. Brussels: European Social Observatory (OSE) and European Trade Union Institute (ETUI).

Schmidt, Vivien A. and Woll, C. 2013. "The State: Bête Noire of Neo-Liberalism or its Greatest Conquest?" In *Resilient Liberalism,* edited by V. A. Schmidt and M. Thatcher. Cambridge, UK: Cambridge University Press.

Taggart, P. and A. Szczerbiak. 2013. "Coming in from the Cold? Euroscepticism, Government Participation and Party Positions on Europe." *Journal of Common Market Studies* 51(1):17-37.

Usherwood, Simon, and Nick Startin. 2013. "Euroscepticism as a Persistent Phenomenon." *Journal of Common Market Studies* 51(1): 1-16.

Van der Eijk, C. and Franklin, M. 2007. "The Sleeping Giant." In *European Elections and Domestic Politics,* edited by W. Van der Brug and C. Van der Eijk. Notre Dame: Notre Dame Press 189-208.

Weiler, J. H. H. 1995. "The State 'uber alles.'" Demos, Telos and the German Maastricht Decision." Jean Monnet Working Paper Series 6/95. Cambridge: Harvard Law School.

Nieves Pérez-Solórzano Borragán

Berman, S. 1997. "Civil Society and the Collapse of the Weimar Republic." *World Politics* 49(3): 401-429.

Bernhard, Michael 1996. "Civil Society After the First Transition." *Communist and Post-Communist Studies* 29(3): 309-330.

Black, L. 2003. "Critical Review of the Capacity-Building Literature and Discourse." *Development in Practice* 13(1): 116-120.

Börzel, T.A. and A. Buzogány. 2010. "Governing EU accession in transition countries: The role of non-state actors." *Acta Politica* 45: 158-182.

Carmin, J. 2010. "NGO capacity and environmental governance in Central and Eastern Europe." *Acta Politica* 45: 183-202.

Cohen, Jean L. and Andrew Arato. 1990. *Civil Society and Political Theory*. Cambridge, MA: MIT Press.

Collier, David and Steven Levitsky. 1997. "Democracy with Adjectives: Conceptual Innovation in Comparative Research." *World Politics* 49: 430-451.

DG Enlargement Information Unit 2002. *Explaining Enlargement. A Progress Report on the Communication Strategy for Enlargement*. March, 2002. Available at http://ec.europa.eu/enlargement/archives/pdf/enlargement_process/past_enlargements/communication_strategy/explaining_enlargement_en.pdf

Dimitrova, A. 2002. "Enlargement, Institution-building and the EU's Administrative Capacity Requirement." *West European Politics* 25(4): 171-190

Drauss, F. 2002. "La société civile organisée en Pologne, République tchèque, Slovaquie et Hongrie." Luxembourg, Office des publications officielles des Communautés européennes.

Eurobarometer 2013. *Eurobarometer 80: Public Opinion in the European Union*. Available at http://ec.europa.eu/public_opinion/archives/eb/eb79/eb79_publ_en.pdf.

Eurobarometer 2014. *Eurobarometer 81: Public Opinion in the European Union*. Available at http://ec.europa.eu/public_opinion/archives/eb/eb81/eb81_publ_en.pdf.

EUROCHAMBRES 2003. "Central European Business Community Still Lacks Preparedness for Single Market." Brussels, 22 May 2003.

European Commission. 2000a. Press Release "EU Commission launches a comprehensive communication strategy on enlargement." Brussels: European Commission, 11 May 2000.

European Commission. 2000b "Communications Strategy for Enlargement." Brussels: European Commission. Available at http://ec.europa.eu/enlargement/archives/pdf/enlargement_process/past_enlargements/communication_strategy/sec_737_2000_en.pdf.

European Commission. 2001. "European governance: A white paper." Brussels: European Commission.

European Commission. 2005a. "Plan-D for Democracy, Dialogue and Debate." Communication from the Commission to the Council, the European Parliament, the European Economic and Social Committee and the Committee of the Regions.Brussels: European Commission.

European Commission. 2005b. "Dialogue between the EU and Candidate Countries." Communication from the Commission to the Council, the European Parliament, the European Economic and Social Committee and the Committee of the Regions. Brussels: European Commission, 29 June 2005.

European Commission. 2006. "The Western Balkans on the Road to the EU: Consolidating Stability and Raising Prosperity." Communication from the Commission to the Council, the European Parliament, the European Economic and Social Committee and the Committee of the Regions. Brussels: European Commission.

European Commission. 2008. "Launch of new Civil Society Dialogue Programme." Brussels: European Commission, April 2008. Available at http://ec.europa.eu/enlargement/docs/civil-society-development/leaflet_taiex_version_90408_en.pdf.

European Commission. 2013. *Guidelines for EU support to civil society in enlargement countries, 2014-2020*. Brussels: European Commission. Available at http://ec.europa.eu/enlargement/policy/policy-highlights/civil-society/index_en.htm.

European Commission. 2014. "Enlargement Strategy and Main Challenges 2014-15." Brussels: European Commission. Available at http://ec.europa.eu/enlargement/pdf/key_documents/2014/20141008-strategy-paper_en.pdf

European Commission. 2015a. "Overview—Instrument for Pre-accession Assistance." Brussels: European Commission. Available at http://ec.europa.eu/enlargement/instruments/overview/index_en.htm.

European Commission. 2015b. "Europe for Citizens Programme." Brussels: European Commission. Available at http://ec.europa.eu/citizenship/europe-for-citizens-programme/index_en.htm.

European Commission 2015c. "Civil Society." Brussels: European Commission. Available at http://ec.europa.eu/enlargement/policy/policy-highlights/civil-society/index_en.htm.

Fagan, A. 2005. "Civil society in Bosnia ten years after Dayton: International Peacekeeping." 12(3): 406-419.

Fagan, A. 2010. "The new kids on the block—Building environmental governance in the Western Balkans." *Acta Politica* 45: 203–228.

Forest, M. 2006. "Emerging Gender Interest Groups in the New Member States: The Case of the Czech Republic." *Perspectives on European Politics and Society* 7(2): 170-184.

Gershman, C. and M. Allen. 2006. "The Assault on Democracy Assistance." *Journal of Democracy*. 17(2): 36-51.

Glenn, John K. 2001. *Framing Democracy. Civil Society and Civic Movements in Eastern Europe.* Stanford: Stanford University Press.

Grabbe, H. 2001. "How does Europeanization affect CEE governance? Conditionality, diffusion and diversity." *Journal of European Public Policy* 8/6: 1013-31.

Grugel, J. 2002. *Democratization. A Critical Introduction.* Basingstoke: Palgrave.

Marc Morjé Howard. 2003. *The Weakness of Civil Society in Post-Communist Europe.* Cambridge: Cambridge University Press.

A. Ishkanian. 2007. "Democracy promotion and civil society." In *Global Civil Society 2007/8: Communicative Power and Democracy. Global Civil Society,* edited by Martin Albrow, Marlies Glasius, Helmut K. Anheier, and Mary Kaldor, Sage: 58-85 Available at http://eprints.lse.ac.uk/37038/.

Juncker, J.C. 2014. *A New Start for Europe: My Agenda for Jobs, Growth, Fairness and Democratic Change. Political Guidelines for the next European Commission. Opening State-ment in the European Parliament Plenary Session.* Available at http://ec.europa.eu/priorities/docs/pg_en.pdf.

Juncos, A.E. and N. Pérez-Solórzano Borragán, forthcoming. "Enlargement." In *European Union Politics,* edited by M. Cini. and N. Pérez-Solórzano Borragán. Oxford: Oxford University Press.

Juncos, A.E. and Whitman, R. 2015. "Europe as a Regional Actor: Neighbourhood Lost?" *Journal of Common Market Studies, Annual Review* 53: 200–215.

Kaldor, Mary. 2003. *Global Civil Society: An Answer to War.* Cambridge: Polity Press.

Kohler-Koch, B. and C. Quittkat. 2013. *De-Mystification of Participatory Democracy: EU Governance and Civil Society.* Oxford: Oxford University Press.

Kopecky, P. and C. Mudde. 2003. "Rethinking Civil Society." *Democratization* 10(3): 1-14.

Kostovicova, D. 2006. "Civil Society and Post-Communist Democratization: Facing a Double Challenge in Post-Milosevic Serbia." *Journal of Civil Society* 2(1): 21-37.

Liebert, U. and H-J. Trenz. 2011. "The 'New Politics of European Civil Society': Conceptual, Normative and Empirical Issues." In *The New Politics of Civil Society,* edited by U. Liebert. and H-J. Trenz. Abingdon: Routledge.

Manners, I. 2002. "Normative Power Europe: A Contradiction in Terms?" *Journal of Common Market Studies* 40: 235–258.

Mendza-Drozd, M., K. Kamieniecki, T. Czajkowski, J. Mulewicz, D. Stulik, I. Plechata, et al. 2004. *Letter to Ms. Anne-Marie Sigmund.* Warsaw, December, 7, 2013.

O'Brennan, J. 2013. "Enlargement Fatigue and its Impact on the Enlargement Process in the Western Balkans." In *The Crisis of EU Enlargement.* LSE Ideas Report. Available at http://www.lse.ac.uk/IDEAS/publications/reports/SR018.aspx.

Obradovic, D. and José M. Alonso Vizcaíno. 2007. "NEWGOV, New Modes of Governance: Eastern Europe as an Accountability Constituency in the Commission Consultations." Deliverable Ref. no. 24/D07.

Ost, D. 1993. "The Politics of Interest in Post-Communist East Europe." *Theory and Society* 22: 453-486

Papadimitriou, A. and B. Stensaker. *Capacity building as an EU policy instrument: the case of the Tempus program.* Available at http://www.pef.uni-lj.si/fileadmin/Datoteke/Mednarodna/conference/wher/papers/Papadimitriou.pdf.

Pérez-Solórzano Borragán, Nieves. 2006. "Postcommunist Interest Politics: A Research Agenda." *Perspectives on European Politics and Society* 7(2): 134-154.

Pérez-Solórzano Borragán, N. and S. Smismans. 2008. "The European Economic and Social Committee: After Enlargement." in *The Institutions of the Enlarged European Union: Continuity and Change,* edited by E. Best, E. T. Christiansen, and P. Settembri. Edward Elgar.

Pérez-Solórzano Borragán, N. and S. Smismans. 2012. "Representativeness: A Tool to Structure Interest Intermediation in the European Union?" *Journal of Common Market Studies* 50: 403-421.

Putnam, R. with Robert Leonardi and Raffaella Y. Nanetti. 1993. *Making democracy work: civic traditions in modern Italy.* Princeton, NJ: Princeton University Press.

Quitkatt, C. 2011. "The European Commission's Online Consultations: A Success Story?" *Journal of Common Market Studies* 49(3): 653-674.

Rehn, O. 2008. "Civil Society at the Heart of the EU's Enlargement Agenda." Speech delivered at the Conference on Civil Society Development in Southeast Europe Building Europe Together. Brussels, 17 April 2008.

Schimmelfennig, F. and U. Sedelmeier. 2004. "Governance by conditionality: EU rule transfer to the candidate countries of Central and Eastern Europe." *Journal of European Public Policy,* 11/4: 661–79.

Schimmelfennig, F. and U. Sedelmeier. eds. 2005. *The Politics of European Union Enlargement. Theoretical Approaches.* London: Routledge.

Sedelmeier, U. 2011. "Europeanisation in new member and candidate states." *Living Reviews in European Governance* 6(1).

Sedelmeier, U. 2014. "Anchoring Democracy from Above? The European Union and Democratic Backsliding in Hungary and Romania after Accession". *JCMS: Journal of Common Market Studies* 52: 105-121.

Vachudova, M. A. 2005. *Europe Undivided: Democracy, Leverage and Integration after Communism.* Oxford: Oxford University Press.

Kees Van Kersbergen

Adema, Willem, Pauline Fron, and Maxime Ladaique. 2014. "How Much Do OECD Countries Spend on Social Protection and How Redistributive Are their

Tax/Benefit Systems?" *International Social Security Review* 67 (1): 1–25.

Barr, Nicholas. 2001. *The Welfare State as Piggy Bank: Information, Risk, Uncertainty, and the Role of the State*. Oxford: OUP Oxford.

Barroso, José Manuel Durão. 2012. "State of the Union 2012 Address." European Commission: http://europa.eu/rapid/press-release_SPEECH-12-596_en.htm.

Begg, Iain, Fabian Mushövel, and Robin Niblett. 2015. "The Welfare State in Europe. Visions for Reform." Chatham House Research Paper: https://www.chathamhouse.org/sites/files/chathamhouse/field/field_document/20150917WelfareStateEuropeNiblettBeggMushovel.pdf.

Blyth, Mark. 2013. *Austerity: The History of a Dangerous Idea*. Oxford: Oxford University Press.

Crozier, Michel, Samuel P. Huntington, and Jöji Watanuki. 1975. *The Crisis of Democracy: Report on the Governability of Democracies to the Trilateral Commission*. New York: New York University Press.

Esping-Andersen, Gøsta. 1990. *The Three Worlds of Welfare Capitalism*. Cambridge: Polity Press.

European Commission. 2013. *Communication from the Commission to the European Parliament, the Council, the European Economic and Social Committee and the Committee of the Regions, Towards Social Investment for Growth and Cohesion—including implementing the European Social Fund 2014-2020*. Brussels: European Commission.

European Commission. 2015. *The 2015 Ageing Report: Economic and Budgetary Projections for the 28 EU Member States (2013–2060)*. Brussels: European Commission.

Hemerijck, Anton. 2013. *Changing Welfare States*. Oxford: Oxford University Press.

Hennock, Ernest P. 2007. *The Origin of the Welfare State in England and Germany, 1850–1914: Social Policies Compared*. Cambridge: Cambridge University Press.

Ipsos MORI. 2014. "Public Perceptions of the NHS and Social Care Tracker Survey Winter 2013 Wave." https://www.ipsos-mori.com/Assets/Docs/sri-health-nhstracker-report-winter2013.pdf

Jensen, Carsten, and Kees van Kersbergen, forthcoming in 2016. *The Politics of Inequality*. Houndmills: Palgrave Macmillan.

Korpi, Walter, and Joakim Palme. 1998. "The Paradox of Redistribution and Strategies of Equality: Welfare State Institutions, Inequality, and Poverty in the Western Countries." *American Sociological Review* 63 (5): 661–687.

Kuhnle, Stein, and Anne Sander. 2010. "The Emergence of the Welfare State." In *The Oxford Handbook of the Welfare State*, edited by Francis C. Castles, Stephan Leibfried, Jane Lewis, Herbert Obinger, and Christopher Pierson, 61-80. Oxford: Oxford University Press.

Kvist, Jon. 2015. "A Framework for Social Investment Strategies: Integrating Generational, Life Course and Gender Perspectives in the EU Social Investment Strategy." *Comparative European Politics* 13, 131–149.

Levell Peter, Barra Roantree, and Jonathan Shaw. 2015. "Redistribution from a Lifetime Perspective." Institute for Fiscal Studies Working Paper W15/27, http://www.ifs.org.uk/uploads/publications/wps/WP201527.pdf.

Morel, Nathalie, Bruno Palier, and Joakim Palme. eds. 2012. *What Future for Social Investment?* Stockholm: Institute for Futures Studies.

OECD (2013), Social Expenditure (SOCX), www.oecd.org/social/expenditure.htm.

OECD (2014), Social Expenditure Update, Paris: OECD.

Petmesidou, Maria, and Ana Guillén. 2015. "Economic crisis and Austerity in Southern Europe: Threat or Opportunity for a Sustainable Welfare State?" OSE Research Paper.

Polanyi, Karl. 1944 (1957). *The Great Transformation: The Political and Economic Origins of Our Time*. Boston, MA: Beacon Press.

Quigley, Anna. 2014. "Maintaining Pride in the NHS: The Challenge for the New NHS Chief Exec." https://www.ipsos-mori.com/newsevents/blogs/makingsenseofsociety/1553/Maintaining-pride-in-the-NHS-The-challenge-for-the-new-NHS-Chief-Exec.aspx#gallery[m]/0/

Rothstein, Bo. 1998. *Just Institutions Matter: The Moral and Political Logic of the Universal Welfare State*. Cambridge: Cambridge University Press.

Scruggs, Lyle, Detlef Jahn, and Kati Kuitto. 2014. Comparative Welfare Entitlements Dataset 2. Version 2014-03. University of Connecticut and University of Greifswald.

Starke, Peter, Alexandra Kaasch, and Franca Van Hooren. 2013. *The Welfare State as Crisis Manager. Explaining the Diversity of Policy Responses to Economic Crisis*. Houndmills: Palgrave Macmillan.

Van der Wel, Kjetil A., and Knut Halvorsen. 2015 "The Bigger the Worse? A Comparative Study of the Welfare State and Employment Commitment." *Work, Employment and Society* 29 (1): 99–118.

Van Kersbergen, Kees, and Anton Hemerijck. 2012. "Two Decades of Change in Europe: The Emergence of the Social Investment State." *Journal of Social Policy* 41 (3): 475–492.

Van Kersbergen, Kees, and Barbara Vis. 2014. *Comparative Welfare State Politics. Development, Opportunities, and Reform*. Cambridge: Cambridge University Press.

Van Kersbergen, Kees, and Jonas Kraft, forthcoming in 2016. "De-universalization and Selective Social Investment in Scandinavia?" In *The Uses of Social Investment*, edited by Anton Hemerijck. Oxford: Oxford University Press.

Robin Shields

Anderson, B. 1983. *Imagined Communities: Reflections on the Origin and Spread of Nationalism.* London: Verso.

Council of Ministers. 1987. Council Decision of June 15, 1987. "Adopting the European Community Action Scheme for the Mobility of University Students (ERASMUS)." *Official Journal of the European Communities* 166: 20–24.

Croché, Sarah. 2009. "Bologna network: a new sociopolitical area in higher education." *Globalisation, Societies and Education* 7(4): 489–503.

Decker, F. 2002. "Governance beyond the nation-state. Reflections on the democratic deficit of the European Union." *Journal of European Public Policy* 9(2): 256-72.

European Commission. 2013. "Erasmus Mundus Statistics." http://eacea.ec.europa.eu/erasmus_mundus/results_compendia/statistics_en.php.

European Commission. 2014a. "Erasmus: Facts, Figures and Trends." Brussels: European Commission, Directorate-General for Education and Culture. http://ec.europa.eu/education/library/statistics/ay-12-13/facts-figures_en.pdf

European Commission. 2014b. "Memo: Erasmus 2012-13: the figures explained." Memo 14-476. http://europa.eu/rapid/press-release_MEMO-14-476_en.htm

European Commission 2015. "Erasmus+ Programme Guide." Brussels: European Commission.

Hartman, Eva. 2008. "Bologna Goes Global: A New Imperialism in the Making?" *Globalisation, Societies and Education* 6(3): 207-220.

Heckscher, C. 1994. "Defining the post-bureaucratic type." In Heckscher and A. *The Post-Bureaucratic. Organization: New Perspectives on Organizational Change* , edited by C. Heckscher and A. Donnellon, 14-62. London: Sage Publications.

Jayasuriya, Kanishka. 2008. "Regionalising the State: Political Topography of Regulatory Regionalism." *Contemporary Politics* 14(1): 21-35. DOI:10.1080/13569770801933270.

Jayasuriya, Kanishka. 2010. "Learning by the Market: Regulatory Regionalism, Bologna and Accountability Communities." *Globalisation, Societies and Education* 8(1): 7-22. DOI: 10.1080/14767720903574009.

Keeling, Ruth. 2006. "The Bologna Process and the Lisbon Research Agenda: the European Commission's expanding role." *European Journal of Education* 41(2): 203-223.

Papatsiba, V. 2006. "Making higher education more European through student mobility? Revisiting EU initiatives in the context of the Bologna Process?" *Comparative Education* 42(1): 93-111.

Parey, Matthias and Fabian Waldinger. 2010. "Studying abroad and the effect on international labour market mobility: Evidence from the introduction of Erasmus." *The Economic Journal* 121: 194-222.

Robertson, S.L. 2010. "The EU, 'regulatory state regionalism' and new modes of higher education governance." *Globalisation, Societies and Education* 8(1): 23-37.

Siglas, Emmanuel. 2010. "Cross-border mobility and the European identity: The effectiveness of intergroup contact during the ERASMUS year abroad." *European Union Politics* 11(2): 241-265.

Teichler, U. 2012. "International student mobility and the Bologna Process." *Research in Comparative and International Education* 7(1): 34-49.

Wächter, B. 2004. "The Bologna Process: developments and prospects." *European Journal of Education* 39(3): 265-273.

Daron Acemoglu and Murat Üçer

Acemoglu, Daron and James Robinson. 2012. *Why Nations Fail.*

Crown Publishing Group.

Acemoglu, Daron, Suresh Naidu, Pascual Restrepo, and James A. Robinson. 2015. "Democracy Does Cause Growth." NBER Working Paper P16, O10.

Ahtisaari, Martti, Emma Bonina, and Albert Rohan. 2015. "An EU-Turkey Reset." Project Syndicate.

Akat, Asaf SavaÐ, and Ege Yazgan. 2012. "Observations on Turkey's Recent Economic Performance." *Atlantic Economic Journal.*

Akcay, Cevdet, and Ucer Murat. 2018. "A Narrative on the Turkish Current Account." *Journal of International Trade and Diplomacy.*

Atiyas, Izak. 2012. "Economic Institutions and Institutional Change in Turkey during the Neoliberal Era." *New Perspectives on Turkey* 14: 45-69.

Atiyas, Izak, and Ozan Bakıs. 2013. "Aggregate and Sectoral TFP Growth in Turkey: A Growth Accounting Exercise." TÜSÐAD - Sabancı University Competitiveness Forum Working Paper No, 2013-1.

Dervis, Kemal, Michael Emerson, Daniel Gros, and Sinan Ulgen. 2004. "The European Transformation of Modern Turkey." Brussels: Centre for European Policy Studies. Istanbul: Economics and Foreign Policy Forum.

European Commission, Turkey Progress Report, Commission Staff Working Document (various issues).

"German Marshall Fund: Country Profiles, Turkey." 2014. German Marshall Fund of the United States.

Gurakar, Esra Çeviker, and Umut Gunduz. 2015. *Europeanization and De-Europeanization of Public Procurement Policy in Turkey: Transparency versus Clientelism (Reform and Transition in the Mediterranean).* Palgrave Pivot.

Gurkaynak, Refet S., and Selin S. Boke. 2013. "AKP Döneminde Türkiye Ekonomisi." *Birikim.* Aralık.

Gursoy, Yaprak. 2011. "The Impact of EU Driven Reforms on the Political Autonomy of the Turkish Military." *South European Society and Politics.*

Hale, William. 2011. "Human Rights and Turkey's EU Accession Process: Internal and External Dynamics." In Part I: "Turkey and the European Union: Accession and Reform." In *South European Society and Politics*, edited by Gamze Avci and Ali Carkoglu.

Hakura, Fadi. 2013. "After the Boom: Risks to the Turkish Economy." Chatham House Briefing Paper.

Jenkins, Gareth. 2011. "Ergenekon, Sledgehammer, and the Politics of Turkish Justice: Conspiracies and Coincidences." *Rubin Center.*

Kaya, Fatih, and Selihan Yilar. 2011. "Fiscal Transformation in Turkey over the Last Two Decades." *OECD* Volume 2011/1.

Kirisci, Kemal. 2011. "The Kurdish Issue in Turkey: Limits of European Union Reform." *Southern European Society and Politics.*

Kirisci, Kemal, and Ekim Sinan. 2015. "Turkey's Trade in Search of an External Anchor: the Neighborhood, the Customs Union or TTIP?" Global Turkey in Europe Series.

Kutlay, Mustafa. 2015. "The Turkish Economy at a Crossroads: Unpacking Turkey's Current Account Challenge." Global Turkey in Europe Series, Working Paper 10.

Meyersson, Erik. 2015. "AKP's Economic Track Record: A Synthetic Case Study." available at http://erikmeyersson. com/2015/06/05/akps-economic-track-record-a-synthetic-case-study/

Morelli, Vincent. L. 2013. "European Union Enlargement: A Status Report on Turkey's Accession Negotiations." *Congressional Research Service.*

Muller, Hendrik. 2014. "Turkey's December 17 Process: A Timeline of the Graft Investigation and the Government's Response." *Central Asia-Caucasus Program.*

Organization for Economic Cooperation and Development, Turkey Country Report, Economic Surveys (2014).

Ozel, Isik. 2015. "Reverting Structural Reforms in Turkey: Towards an Illiberal Economic Governance?" *Istituto Affari Internazional*, Policy Brief.

Pierrini, Marc, and Sinan Ulgen. 2014. "A Moment of Opportunity in the EU-Turkey Relationship." Carnegie Europe Paper.

Pope, Huge. 2013. "Turkey's Tangled Syria Policy." Combatting Terrorism Center.

Rodrik, Dani. "Turkish Economic Myths." Accessed in April 2015. http://rodrik.typepad.com/ dani_rodriks_weblog/2015/04/ turkish-economic- myths.html. "The Plot against the Generals", available at www.sss.ias.edu/ files/pdfs/Rodrik/Commentary/ Plot-Against-the-Generals.pdf (2014). "The Turkish Economy After The Global Financial Crisis" (2012).

Raiser, Martin. 2013. "Inclusive Growth in Turkey—Can it Be?" available at http://blogs.world-bank.org/futuredevelopment/in-clusive-growth-turkey-can-it-be (November, 2013).

Stein, Aaron. 2013. "Turkey's Role in a Shifting Syria." *Atlantic Council.*

Ulgen, Sinan. 2012. "Avoiding A Divorce A Virtual EU Membership for Turkey." The Carnegie Papers.

Ungor, Murat. 2014. "Some Observations on the Convergence Experience of Turkey." CBRT Working Paper, N10, O11, O40, O47, O57.

OECD. 2014. "Economic Surveys of TURKEY." Overview.

World Bank, *Turkey's Transitions: Integration, Inclusion, Institutions.* Country Economic Memorandum (2014, December).

Zurcher, Erik.J. 2005. *Turkey A Modern History.* I.B. Tauris.

Publisher
BBVA

Project direction and coordination
Chairman's Advisory, BBVA

Texts
Daron Acemoglu, Alberto Alesina, Christopher
Bickerton, Thomas Christiansen, Philip Cooke,
Colin Crouch, Barry Eichengreen, Orlando Figes,
Indermit Gill, Francisco González, Peter A. Hall,
Bichara Khader, Julia Kristeva, John Peet, Nieves
Pérez-Solórzano Borragán, Martin Raiser, Vivien
Ann Schmidt, Robin Shields, Murat Üçer, Naotaka
Sugawara, Bart Van Ark, Kees Van Kersbergen

Edition and production
La Fábrica

Publishing coordination
Miriam Querol

Graphic design
Feriche & Black

Layout
Mar Ferrer
Pabro S. Asperilla

Infographics
Esther Utrilla
Jaime Gómez Ximénez de Sandoval (content)

Translation
AiT, Art in Translation

Proofreading
AiT, Art in Translation

Images
Thomas Lohnes/Getty Images (pp. 14-15), Chris
Ratcliffe/Bloomberg via Getty Images (p. 27),
Ulrich Baumgarten via Getty Images (p. 34), Louis
Lanzano/Bloomberg via Getty Images (p. 41), Wes-
tend61/Getty Images (p. 53), Daniel Roland/AFP/
Getty Images (p. 60), Sean Gallup/Getty Images (p.
74), Hannelore Foerster/Bloomberg via Getty Images
(p. 87), Martin Leissl/Bloomberg via Getty Images
(p. 92), Odd Andersen/AFP/Getty Images (p. 97),
Joshua Roberts/Bloomberg via Getty Images (p.
100), Monty Rakusen/Getty Images (p. 135), Marc
Deville/Gamma-Rapho via Getty Images (p. 140),
Doug Armand/Getty Images (pp. 196-197), Paul
O'Driscoll/Bloomberg via Getty Images (p. 209),
Frederick Florin/AFP/Getty Images (p. 223, p. 436),
Mehdi Fedouach/AFP/Getty Images (p. 245), Georges
Gobet/AFP/Getty Images (p. 250), Michele Tantussi/
Getty Images (p. 259), Carsten Koall/Getty Images
(p. 313), Yana Paskova/Getty Images (p. 318), Lintao
Zhang/Getty Images (pp. 336-337), Dan Kitwood/
Getty Images (p. 349, p. 352), David Levenson/Getty
Images (p. 386), Max Vetrov/AFP/Getty Images (p.
391), Alexey Druzhinin/AFP/Getty Images (p. 394),
Xaume Olleros/Bloomberg via Getty Images (p. 415),
Gianluigi Guercia/AFP/Getty Images (p. 429).

ISBN: 978-84-16248-42-1 (softcover)
Legal Deposit: M-36843-2015

REINVENTING THE COMPANY IN THE DIGITAL AGE
2015

The digital era has unleashed a far reaching tsunami that many are still trying to understand and come to terms with. Almost on a daily basis the rules of the game for doing business are changing and we have to struggle to keep up with the fast moving, constantly changing landscape. This has had a colossal impact in the workplace, and nowhere more so than in the so called traditional sectors: to succeed in this new era, big organizations that up to now have been profitable and leading examples in their areas of business for decades are confronted with the need for swift, radical change.

CHANGE: 19 KEY ESSAYS ON HOW THE INTERNET IS CHANGING OUR LIVES
2014

As a tool available to a reasonably wide public, the Internet is only twenty years old, but it is already the fundamental catalyst of the broadest based and fastest technological revolution in history. It is the broadest based because over the past two decades its effects have touched upon practically every citizen in the world. And it is the fastest because its mass adoption is swifter than that of any earlier technology. It is impossible today to imagine the world without the Internet: it enables us to do things which only a few years ago would be unthinkable.

THERE'S A FUTURE: VISIONS FOR A BETTER WORLD
2013

This book seeks to integrate the various elements in the dissemination of knowledge:How do they interact with each other? Where are they leading us? And, more importantly, what can be done to ensure that this path, with all its acknowledged risks, leads us to improve people's quality of life in a sustainable way? The future seems to be hurtling towards us at full tilt. For this very reason, if predicting the future is particularly difficult today, preparing for it is also vital and urgent.

VALUES AND ETHICS FOR THE 21ST CENTURY
2012

The main topic of this book is ethics and values. That is because shared values and ethics are necessary, and vital for the proper functioning of the economic, political and social network and, therefore, for the well-being and development of the potential of every world citizen. The intention of this book is to discuss how we can understand and avail ourselves of universal ethical principles in order to meet the great challenges that the 21st century has placed before us.

INNOVATION. PERSPECTIVES
FOR THE 21ST CENTURY
2011

The decisive importance of innovation is the most powerful tool for stimulating economic growth and improving human standards of living in the long term. This has been the case throughout history, but in these modern times, when science and technology are advancing at a mind-boggling speed, the possibilities for innovation are truly infinite. Moreover, the great challenges facing the human race today—inequality and poverty, education and health care, climate change and the environment—have made innovation more necessary than ever.

FRONTIERS
OF KNOWLEDGE
2009

Prestigious researchers from all over the world, working on the "frontiers of knowledge", summarize the most essential aspects of what we know today, and what we aspire to know in the near future, in the fields of physics, biomedicine, information and telecommunications technologies, ecology and climate change, economics, industry and development, analyzing the role of science and the arts in our society and culture.

THE MULTIPLE FACES
OF GLOBALIZATION
2010

The book presents a panorama of globalization, a very complex and controversial phenomenon that is characteristic of present-day society and decisively influential in the daily lives of all the world's citizens at the beginning of the 21st century. Thus, the finest researchers and creators worldwide have been sought out so that, with the greatest rigor and objectivity, and in a language and approach accessible to non-specialists, they can explain and inform us of the advances in knowledge and the subject of the debates that are permanently active on the frontiers of science.

These books are available for reading on the OpenMind website: www.bbvaopenmind.com/en/books/